To Sharon and Martha

We gratefully acknowledge the directors of the workshops included in our book. Without their dedication to the fine art of lithography and their willingness to share their excitement and expertise, there would be no book.

We are most grateful to the following people and organizations who provided us with valuable help in creating this book:

Michael Drons, for his assistance and patience in editing our manuscript.

Sharon Knigin, who traveled untiringly throughout Europe with her husband, and then translated, provided secretarial aid and uncompromising emotional support.

Martha Zimiles, who gave encouragement and valuable editorial assistance.

Amy Baker, formerly head of the print department of the Martha Jackson Gallery.

Sylvan Cole, director of Associated American Artists Gallery.

Brooke Alexander, Brooke Alexander, Inc.

The Department of Prints and Drawings, The Museum of Modern Art.

The New York Public Library.

Larry Lowenstein and Local One, Amalgamated Lithographers of America.

Paul Jenkins, Norman Narotzky, and Leon Amiel.

Our thanks also to Patrick Kennedy, our illustrator, and Jean Callan King of Visuality, our designer.

And lastly to Moon, Pushkin, and Gordon Kluge.

CONTENTS

THE CONTEMPORARY LITHOGRAPHIC WORKSHOP AROUND THE WORLD

THE CONTEMPORARY LITHOGRAPHIC WORKSHOP AROUND THE WORLD

MICHAEL KNIGIN AND MURRAY ZIMILES

VNR VAN NOSTRAND REINHOLD COMPANY
NEW YORK CINCINNATI TORONTO LONDON MELBOURNE

VAN NOSTRAND REINHOLD COMPANY REGIONAL OFFICES:
NEW YORK CINCINNATI CHICAGO MILLBRAE DALLAS

VAN NOSTRAND REINHOLD COMPANY INTERNATIONAL OFFICES:
LONDON TORONTO MELBOURNE

LIBRARY OF CONGRESS CATALOG CARD NUMBER: 77-149257
ISBN 0-442-24480-0

DESIGNED BY VISUALITY
PRINTED IN JAPAN

PUBLISHED IN 1974 BY VAN NOSTRAND REINHOLD COMPANY
450 WEST 33rd STREET, NEW YORK, N. Y. 10001

1 3 5 7 9 11 13 15 16 14 12 10 8 6 4 2

Library of Congress Cataloging in Publication Data

Knigin. Michael.
 The contemporary lithographic workshop around the
world.

 1. Lithographic workshops. I. Zimiles. Murray,
joint author. II. Title.
NE2298.K64 763 77-149257
ISBN 0-442-24480-0

PREFACE

In this book we have attempted to present a comprehensive approach to the subject of lithography. We have tried to show the positions occupied by the artist, the printer, and the workshop. Our book includes a brief discussion of the art and technical history of lithography. It shows, through a step-by-step photo essay, how a lithograph is made. (While we have tried in this essay to suggest the basics of the technique, we refer our readers to our earlier book, *The Technique of Fine Art Lithography,* for a much fuller treatment of the complexities of lithographic chemistry, printing, and technique.)

We came to the conclusion that a book of this scope was necessary because little or nothing has been written about the people who help and often stimulate the artist in making a lithograph. Since both of us are painters and printmakers as well as teachers, our personal experience reinforced our belief that the general public should have an opportunity to experience the atmosphere that is present in a lithographic workshop. We hope that our photographs will supply the public, as well as artists, with an opportunity to see the environments that various workshops throughout the United States, Canada, and Europe present, and thereby allow them to select a workshop that they would like to work in or visit. Whenever possible, statements by the directors about the procedures they follow with artists are included. These illuminate their beliefs and experiences encountered through many years of personal contact with artists throughout the world. We hope that this personal touch will help further to present the environment of the different workshops discussed.

The logistics involved in obtaining this information were monumental, necessitating hundreds of letters and thousands of miles of travel. Literally hundreds upon hundreds of photographs were taken, and countless hours were spent interviewing the people connected with all of the workshops. Although our book includes the majority of the workshops throughout the world, we did encounter a small number who refused to partake in the project. Recently it has come to our attention that a few workshops have just opened. Unfortunately it was impossible to include them in our survey. We asked each workshop to fill out a comprehensive questionnaire. Apparently some workshops thought some questions more relevant than others. This accounts for the difference between the large quantities of information for some workshops and the small amounts for others.

In summary, our hope is that this book will stand as an intimate glance into the world of lithography.

Chapter One:

SENEFELDER

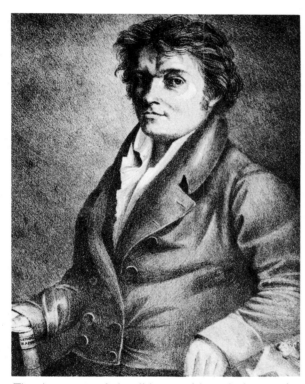

The inventor of the lithographic printing technique, Aloys Senefelder. (Photo, Malcolm Varon)

God grant that it may soon spread all over the world; that it may prove useful to mankind, and contribute to its improvement and that it may never be abused to any dishonourable or wicked purpose; and I shall then never cease to bless the hour in which I invented it.

—Aloys Senefelder

The unique and marvelous process of lithography was the invention of Aloys Senefelder in the year 1798. Although printing from the surface of a stone was done by Simon Schmid before Senefelder, we credit Senefelder with the invention, since he developed the chemical theory that is the basis of lithography as we know it today. The word "lithography" first appeared in France about 1803 and has since become the accepted name for this process. The first published use of the word "lithography" occurred in 1805 in the German portfolio entitled "Lithographische Künstprodukte," published by Professor Hermann Mitterer at his atelier, Kurfürstliche Druckerey, in Munich.

In 1789 Senefelder was studying law at the insistence of his father, who had stifled his son's true desire of becoming an actor, like himself, at the Theater Royal in Munich.

This frustrated young man satisfied his theatrical cravings by writing comedies in his spare time. He achieved a small success with his play, *Die Maedchenkenner.* At about this time his father died, releasing him from the burdens of law school and allowing him to pursue seriously his career as a dramatist. His next few dramatic attempts were unsuccessful. Senefelder came to the conclusion that he must become the composer, printer, and publisher of his own work. He experimented diligently with all the reproductive techniques, including steel engraving and etching. He finally found that etching could be used; however, the cost of copper (the surface upon which etchings are done) was prohibitive. He continued to experiment, this time using a Kellheim (Bavarian limestone), a cheap stone that was plentiful in the region. He discovered that these stones could be ground and polished. The resultant smooth surface could then be drawn upon with great ease; and when these stones were thick enough (about four inches), they could withstand the pressure necessary for printing.

Years later, Senefelder recounted how he actually discovered the process:

I had just succeeded in my little laboratory in polishing a stone plate, which I intended to cover with etching ground, in order to continue my exercises in writing backwards, when my mother entered the room, and desired me to write her a bill for the washerwoman, who was waiting for the linen; I happened not to have even the smallest slip of paper at hand, as my little stock of paper had been exhausted by taking proof impressions from the stone; nor was there even a drop of ink in the inkstand. As the matter would not admit of delay, and we had nobody in the house to send for a supply of the deficient materials, I resolved to write the list with my ink prepared with wax, soap, and lampblack on the stone which I had just polished and from which I could copy it at leisure.

 Sometime after this, I was just going to wipe this writing from the stone, when the idea all at once struck me, to try what would be the effect of such a writing with my prepared ink, if I were to bite in the stone with aqua-fortis; and whether, perhaps, it might not be possible to apply printing ink to it, in the same way as wood engravings, and so take impressions from it. . . . The application of the printing ink was easier than other methods, and I could take impressions with a fourth part of the power that was requisite for an engraving, so that the stones were not all liable to the danger of breaking; and, what was the greatest moment to me, this method of printing was an entirely new invention which had occurred to nobody before me. . . .

Lithography was born.

Senefelder, seeking commercial success, took Yoachim Anton André, a music publisher, for his partner. André immediately suggested patenting his invention. In 1800 Senefelder, accompanied by Philip André (Anton's brother), went to London; one year later the invention was patented with this proclamation:

To all to whom these presents shall come, John Aloysius Senefelder, of Gould Square, in the Parish of Gould Square, in the Parish of Saint Olave, Hart Street in The City of London, Gentlemen, sends greeting. Whereas, by His Majesty's Letters Patent under The Great Seal of the United Kingdom of Great Britain and Ireland, bearing date at Westminster, the Twentieth day of June last, reciting that the said John Aloysius Senefelder, had, by his Petition, humbly represented unto His Majesty, that he had, after much trouble, labor, and expense, found out and invented a new method and process of performing the various branches of the art of printing on paper, linen, cotton, woolen, and other articles; that he is the first and true Inventor thereof, and that the same had never been made or used by any other person or persons, to the best of his knowledge and belief; the Petitioner therefor most humbly prayed that His Majesty would be graciously pleased to grant unto him, his executors, administrators, and assigns. His Royal Letters Patent . . . and His Majesty being willing to give encouragement to all arts and inventions which might be for the public good, was graciously pleased to condescend to the Petitioner's request . . . etc.

July 18, 1801

Philip André, being an entrepreneur, realized that this new printing technique would be appropriate for reproducing artists' works. He solicited artists throughout England, sending them stones along with drawing instructions. The result was the publication issued in April 1803, entitled *Specimens of Polyautography.* This was the first published collection of lithographs. In order to produce this portfolio, André established an atelier in London. Aside from Senefelder's own ateliers in Munich and Offenbach, this was the beginning of the modern conception of a lithographic atelier.

The invention quickly spread throughout Germany, where, in 1804, Wilhelm Reuter published the first German portfolio, entitled *Polyautographische Zeichnungen volzüglicher Berliner Künstler.*

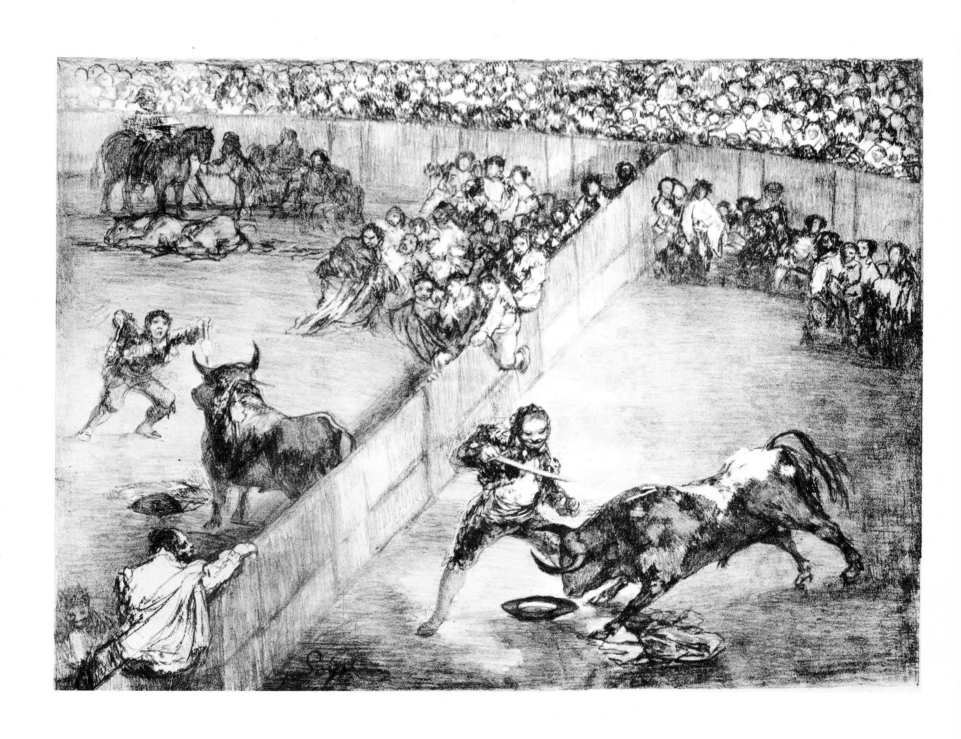

División de Plaza, O Plaza Partida, Francisco Goya.
(The Metropolitan Museum of Art, New York. Rogers Fund.)

Chapter Two:

ART HISTORY OF LITHOGRAPHY

By 1808 Senefelder's own establishment in Munich, having issued a highly successful copy of Dürer's *Prayer Book of Emperor Maximilian,* became a showplace and was often visited by the aristocracy. By 1809 Senefelder was appointed inspector of the "Royal Lithographic Establishment" in Munich.

Johann Christian Von Mannlich took over Senefelder's Munich workshop in 1809. As director of the galleries of Munich and Schleissheim, Mannlich was able to train printers and popularize lithography all over Europe.

As in England, lithography was started in France by an André (Peter Friedrich, brother of Johann André), who patented the invention in 1802. Experimentation followed, yet the perfected lithographic technique did not really emerge until Godefray Engelmann and Count Charles de Lasteyrie launched their enterprise. Godefray Engelmann became interested in the process in 1813, once he had seen examples of lithographs. Although a young man of twenty-six, he decided to master the technique and open his own shop in France. In 1814 he went to Munich to study the process. Finally, in 1815 he opened an atelier at Mulhouse and, a year later, one in Paris.

Count Lasteyrie's interests derived from his acquaintance with André's early establishment. He too went to Munich to study the technique.

At this time Napoleon was Emperor of France. He immediately realized the potential of lithography and, through his director general of the Imperial Museum, Dominique Vivant Denon, encouraged both Engelmann's and Count Lasteyrie's enterprises. As in Germany, both their establishments became the meeting places for society. In 1828 Engelmann entertained Charles X and received the appointment "Lithographe de la Chambre et du Cabinet du Roi," and a gold medal from the "Société d'Encouragement pour l'Industrie Nationale." In 1831 King Louis Philippe visited Mulhouse.

Although France was to become the great lithographic center in Europe, she arrived late. Early attempts at lithography were made by some French artists such as Ingres. In 1817 Géricault (1791–1824) launched into lithography and a year later produced one of his great works, *The Boxing Match.* He voyaged to England and there produced a large group of prints, including the *London Set.* He was perhaps the first artist to use drawing materials (especially crayon) in a highly personal way, releasing lithography from stifling conventions.

Goya, who at this time was in voluntary exile in Bordeaux, produced the series *The Bulls of Bordeaux,* which was to have a profound influence on Delacroix. Before continuing the discussion of lithography in France, we must briefly discuss the special place that Goya holds in the history of lithography. It is believed that Goya was introduced to lithography about 1817 by the establishment of J. Cardano in Madrid, who

was then the director of Establecimiento Litográfico de Madrid. His first attempts, *Old Woman Spinning* and *The Monk, Reading Aloud,* as well as other early lithographs, were executed using transfer paper, a specially treated paper that can be drawn upon and from which the image can be directly transferred to a lithographic stone or plate. Since the transfer paper had not been properly prepared for lithography, a poor transference of the image resulted, accounting for various losses within it. But these early attempts, and his association with Cardano, paved the way for the production of the masterpieces *The Bulls of Bordeaux.* Goya's method of working, as described by Matheron in his *Life of Goya,* published in 1858, is worth noting. "The artist worked at his lithographs at the easel, the stone placed like a canvas. He manipulated his crayons like brushes and never sharpened them. He remained standing, walking backwards and forwards every other minute to judge his effects. Usually he covered the whole stone with a uniform gray tone and then removed with the scraper those parts which were to appear light: here a head, a figure; there a horse, a bull. Next, the crayon was again employed to strengthen the shadows, the accents, or to indicate the figures, or to give them movement. In this way, using the point of a razor and without any retouching, he once made a curious portrait emerge from the dark ground tone (the portrait of Gaulon, given ten years ago to M. E. Delacroix). You would perhaps laugh if I said that all Goya's lithographs were executed under a magnifying glass. In fact, it was not in order to do very detailed work, but because his eyesight was going."

With Goya on his mind and his friend Géricault in view, Delacroix (1798–1863) launched into lithography in 1820 both in France and in England. By 1828 Delacroix was illustrating Goethe's *Faust,* which was followed by illustrations of Shakespeare, Scott, and Byron. With his bold and expressive style, Delacroix succeeded in changing the old ideas of illustration and set down precedents that illustrators follow to this day.

Charles Philipon founded two popular newspapers—*La Caricature* in 1830 and *Le Charivari* in 1832. He hired Honoré Daumier (1808–79) to do the illustrations. For the next forty years, through the use of satire and biting political and social commentary, cynicism, and his outspokenness against hypocrisy, Daumier produced an avalanche of lithographs. He attacked every aspect of society. What Delacroix did for the illustrated book, Daumier did for the illustrated editorial.

With the exception of Daumier, lithography as practiced by fine artists came to a halt until the early 1860s.

The name Godefray Engelmann once again appears at this time. In 1837 he patented the process called Lithocolour, later referred to as Chromolithography. Earlier attempts in 1809 by Senefelder himself were made with color printing, but it was not until Engelmann's technique became available that color lithography became widespread.

Lithography was now used chiefly to illustrate children's books, for reproductions, and for general commercial printing. For our purposes, the one benefit that did occur from these commercial applications was the continued training of artisans, which at least technically left lithography in competent hands.

Photography, which had just been discovered, became the rage. Society now wanted its images photographed instead of lithographed. Eventually these new inventions merged into photolithography.

It was not until the early 1860s that lithography was once again taken up by a major artist. Edouard Manet was asked by the French publisher Cadart to do a series of lithographs. This marks a major turning point in lithography; it may be said that with Manet the modern conception of fine-art lithography was born.

Edgar Degas (1834–1917) also tried his hand at lithography. He developed a novel technique that produced very strange but beautiful prints. Degas worked on copper plates (as if he were doing a mono print) with brush and lithographic ink. These

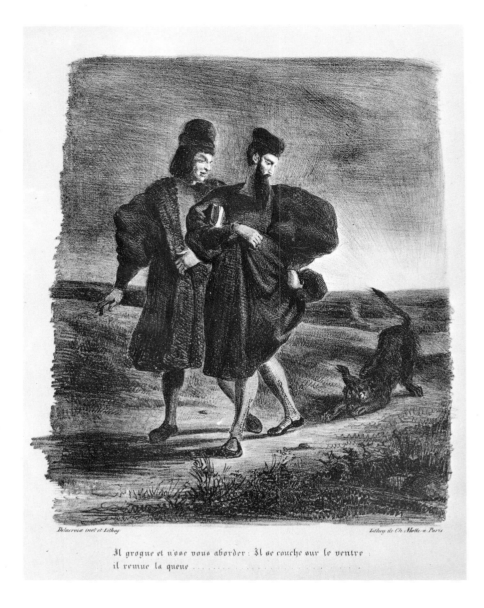

Illustration from *Faust,* by Goethe, Paris, 1828, Eugène Delacroix.
(The Metropolitan Museum of Art, New York. Rogers Fund.)

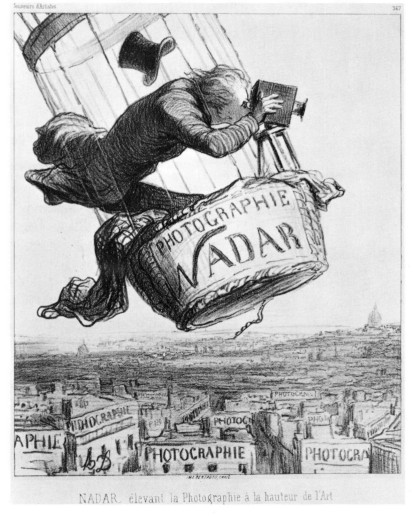

Nadar Élévant la Photographie à la Hauteur de l'Art, Honoré
Daumier. (The Metropolitan Museum of Art, New York. Harris
Brisbane Dick Fund.)

were offset on transfer paper, which was then used to fix the image to the stone upon which Degas finished his design by scraping and redrawing.

At this moment in history a number of interesting events occurred. Lithography presses were motorized. The large poster, first used in England during the Great Exhibition for advertisements, was introduced in France by the printer Rouchon. He began asking young artists to design posters. These posters were pasted all over Paris. In 1868 Rouchon asked Manet to do a poster for Champfleury's books, *Les Chats* and a lithograph, *L'Execution de Maximilian.* In 1872 he commissioned Daumier to do a poster for a coal merchant. Yet, the real development of the large French poster is credited to Jules Chéret (1836–1932), who had learned lithography in England. When he returned to Paris, he came with the idea of designing and printing colorful, gay, witty, and exciting posters advertising various functions or business enterprises. Chéret was the first to introduce Art Nouveau ideas to this new art form. His posters became collector's items; they were torn from Parisian walls; people began bribing the poster hangers for copies. Poster art became widespread and many artists became involved.

The popularity of the posters drew Henri de Toulouse-Lautrec (1864–1901) to the medium. He thought that he could gain public acclaim through the use of lithography. In 1885 he did his first lithograph, a design for the cover of a book of songs. Others followed, but it was not until 1891, when Lautrec was asked to do a poster for the Moulin Rouge, that he started to experiment and redefine the vocabulary of lithography. Using a screen, he stippled ink onto the stone. His color was new to lithography, and his ability to depict the *fin-de-siècle* atmosphere of Paris was extraordinary. Although Lautrec developed an individual style, his influences were many—Japanese prints, the art of Degas, and the style of Art Nouveau. He chose to depict a special part of Paris peculiar to his vision and taste—the Paris of the singers, dancers, showmen, and prostitutes. He wrote, "everywhere and always, ugliness has its beautiful aspects. It is thrilling to discover them where nobody else noticed them." All of this turns into bold silhouettes, unusual angles, figures cut in half, false perspective, and decorative bold design—as seen in *Reine de Joie, The Englishman at the Moulin Rouge,* and *Jane Avril at the Jardin de Paris.* Altogether he produced 370 lithographs, of which thirty were posters.

The revival and popularity of lithography at this point in French art encouraged André Marty in 1893 to found *L'Estampe Originale.* As the director and publisher of this extraordinary venture, he issued nine folios of original prints containing ninety-five prints (sixty lithographs, thirty-three in color) by seventy-four different artists. He published artists regardless of school; his only standard was quality. Quality he indeed produced, for here are some of the finest prints by Toulouse-Lautrec, Vuillard, Bonnard, Redon, and others.

To this day, *L'Estampe Originale* has served as the forerunner of most publishing ventures. *L'Epreuve* (1894), *Album des Peintre-Graveurs* (1896–97) directed by Vollard, and *L'Estampe Moderne* (1897–99) as well as the periodicals *Pan* and *La Revue Blanche* all were inspired by Marty's publication. Vollard went on to publish some of the most beautiful books of the century.

Odilon Redon (1840–1916) is a strange figure in the history of lithography. His virtuosity in the use of the medium, especially in the beautiful velvety blacks he obtained, was admired by all. His first folio, entitled *Dans le Rêve,* appeared in 1879. His other albums followed with dedications to Edgar Allan Poe and Goya. In 1886 he published *La Nuit.* He continued lithography for his entire life. For the first time the technique was used to express the inner energies of the soul and the unconscious. His imagery is bizarre, dreamlike, and visionary. Redon described his work as "bringing to life, in a human way, improbable beings and making them live according to the laws of probability by putting, as far as possible, the logic of the visible at the service of the invisible." This new approach to art endeared him to the symbolist writers, who found

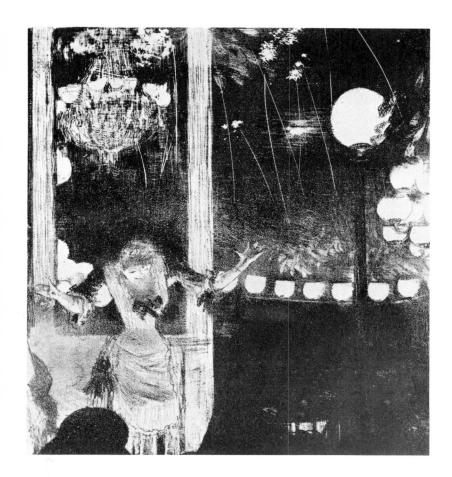

Aux Ambassadeurs: Mlle. Becat (ca. 1875), Edgar Degas. (Collection, The Museum of Modern Art, New York. Gift of Abby Aldrich Rockefeller.)

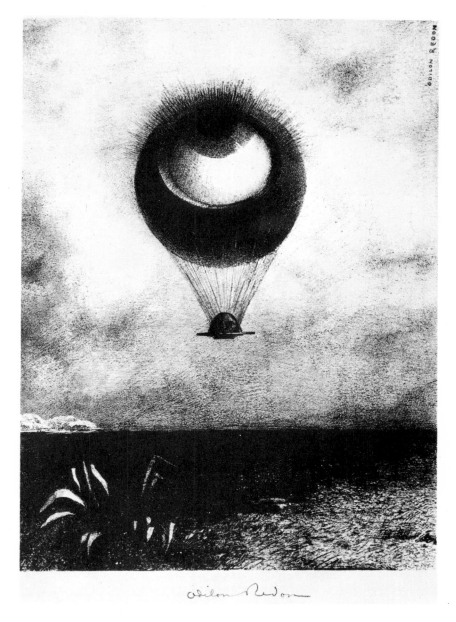

The Eye, like a strange balloon mounts toward infinity, Odilon Redon. Plate 1 from *Edgar Allan Poe,* 1882. (Collection, The Museum of Modern Art, New York. Gift of Peter H. Deitsch.)

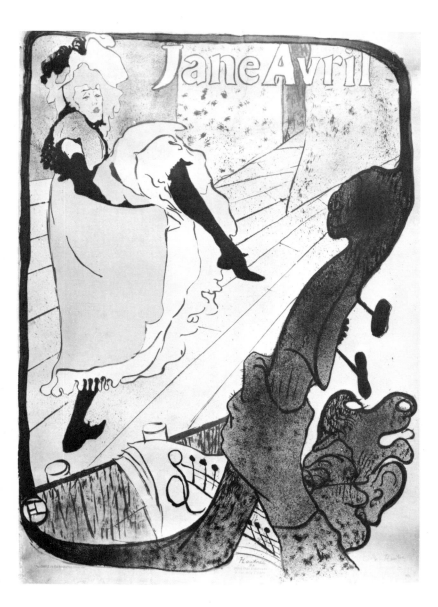

Jane Avril: Jardin de Paris (1893), Henri Toulouse-Lautrec. (Collection, The Museum of Modern Art, New York. Gift of A. Conger Goodyear.)

proof of their theories in his images. Redon was also admired by the Nabis group who considered him their mentor. The Nabis also had their own lithographers, particularly Bonnard and Vuillard.

Pierre Bonnard (1867–1947) was, like Lautrec and Redon, a prolific lithographer, and he produced approximately 300 lithographs. He, too, did many posters, often for the same publishers as Lautrec. Bonnard did his first lithograph in 1889—a poster for France-Champagne printed by Ancourt. In 1895 he published for Vollard his first folio of prints, entitled *Quelques aspects de la vie de Paris.* In these early prints he shows extraordinary mastery of the technique. His drawing is poetic; his rapid strokes and crosshatching capture the mood and feeling of the city. His colors, unusually muted— browns, grays, violets—are all used with exquisite sensitivity. By 1902 he had completed 175 pieces, including the illustrations for Paul Verlaine's *Parallelement.* He surrounded the text with beautiful drawings and had the lithographs printed in rose or blue. The colors, coupled with the delicate, sensuous drawings, truly captured the erotic spirit of Paul Verlaine. They were printed by Clot, an atelier that is still functioning today and of which more will be said later. He also contributed to *La Revue Blanche*, the review that published the most important artists and writers of the day. His interest in lithography was unrewarded, however; many of his lithographs were commercially unsuccessful. Discouraged, he abandoned lithography for twenty years, until 1925, when once again he became active. He continued doing lithographs until a year before his death in 1947.

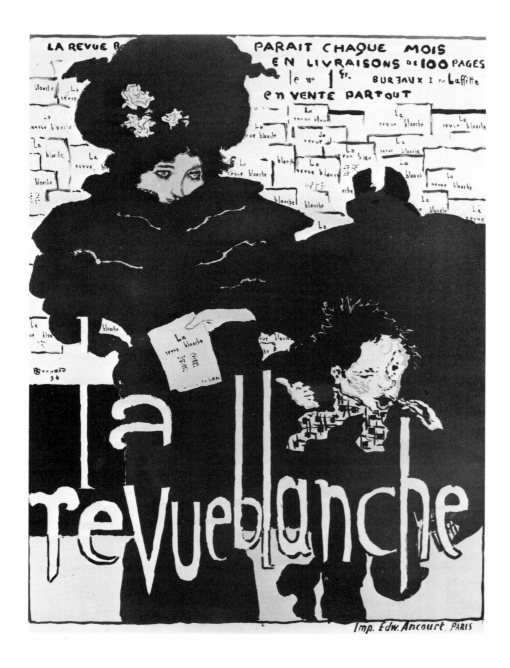

Poster for *La Revue Blanche* (1894), Pierre Bonnard. (Collection, The Museum of Modern Art, New York. Purchase Fund.)

Edouard Vuillard (1868–1940) produced about sixty lithographs, of which twenty-six are in color. He started in 1892 at the workshop of Ancourt, though much of his latter work was done at Clot's shop. A few years later his work was included in the collections of *L'Estampe Originale* and *La Revue Blanche.* His lithographs, like his paintings, capture the intimacy of the interior. His work often has the feeling of the prints of Bonnard in the use of line and color. Yet Bonnard showed a joyous attitude toward his images, whereas, with Vuillard, one feels a quiet, contemplative atmosphere.

Numerous other French artists tried their hands at lithography. Jean-Baptiste-Camille Corot (1796–1875), as an old man, found that transfer paper could be taken into the field and drawn upon as if it were a piece of drawing paper, and he produced a number of beautiful pastoral prints during the years 1871–74.

Paul Gauguin (1848–1903), who is most widely known for his woodcuts, in 1889 also experimented with lithography. Some of these prints were to prove an inspiration to many of the Nabis lithographers.

In fact, it may safely be said that most of the contemporary artists—Impressionists, Pointillists, Fauves, and unclassifiable independents—took to the technique. Van Gogh (1853–90) did a few lithographs, including one of his famous *Potato Eaters* painting. Cézanne (1839–1906) tried the technique by doing a self-portrait.

Renoir (1841–1919) did his first lithograph in 1892, a portrait of his son; in 1896, at Clot's atelier, he did a series of color prints. Renoir drew on transfer paper. After receiving a proof, he would watercolor the image to show the color scheme, and the printer would then add color, using the sketch as a guide. In all he produced thirty-one lithographs.

Of the other Impressionists, Camille Pissarro (1830–1903) did a large number of lithographs, most often of landscapes.

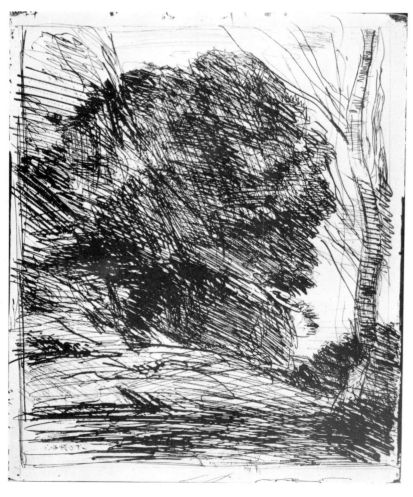

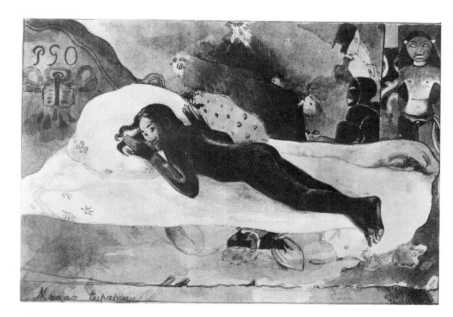

Les Arbres dans La Montagne, J. B. C. Corot. (The Metropolitan Museum of Art, New York. Schiff Fund.)

Watched by the Spirit of the Dead (1894), Paul Gauguin. (Collection, The Museum of Modern Art, New York. Gift of Abby Aldrich Rockefeller.)

Of the Neo-Impressionists, Paul Signac (1863–1935) produced a series of twelve lithographs in the pointillist style. They were printed at Clot and published by Vollard. In 1884 he met Seurat and invented Neo-Impressionism. Besides art, Signac's other passion was the sea; he was a skilled sailor and the owner of a number of racing yachts. *Port of St. Tropez,* a color lithograph, beautifully captures his Neo-Impressionist style and his love for the sea and sailing.

Maurice de Vlaminck (1875–1958), one of the founders of Fauvism in 1905, did his first lithograph in 1921. In 1924 he was commissioned by Frapier to do a series of lithographs. His bold, explosive style adapted itself to lithography beautifully. His production totaled about 100 lithographs, most of which were in black and white.

Another Fauve, André Derain (1880–1954) did his first lithograph in 1919, which was an illustration for Vlaminck's (who was also a writer) book, *À la Sauté du Corps.* In all, Derain did about 250 lithographs, mostly as illustrations.

Maurice Utrillo (1885–1955), an expatriate painter, started lithographing in 1924 by doing eleven illustrations for his friend Carco's book. He also did lithographs for Frapier. All were freely drawn from picture postcards, a technique he followed in his paintings as well. In all, he did twenty lithographs, one of which was in color.

Raoul Dufy (1877–1953) started lithography in 1924. In 1937 he did 100 illustrations for *Les Aventures de Tartarin de Tarascon.* Most of his 160 lithographs were done as book illustrations. His rapid, calligraphic, childlike spontaneity is beautifully expressed in the medium.

Several sculptors also practiced lithography. Aristide Maillol (1861–1944) printed on beautiful paper obtained from his own mill at Monval. He began lithography in 1924, using the medium in a classical way simply to draw the female form he loved so much.

Auguste Rodin (1840–1917), perhaps the greatest sculptor of the century, allowed Clot to work from his drawings and pull lithographs similar to his lovely wash drawings of the female torso.

Edvard Munch (1863-1944), a Norwegian, was often found working at the atelier of Clot with many of the other artists mentioned above. He, too, did prints for *La Revue Blanche.* Yet it is impossible to find a more different attitude toward the lithograph. Munch, unlike Bonnard, never sought out the beautiful in life. He was a tortured soul, having once said, "The black angels of disease and insanity stood guard at my cradle . . . I always felt that I was treated unjustly, motherless, sick, and threatened with punishment. . . ." In 1894, he produced his first lithograph, and one year later he was executing some of his masterpieces: *The Scream, The Munch Madonna,* and *Self-Portrait.* His work often contrasts the themes of sickness, death, fear, anxiety, and suffering with that of love. Munch's attitude toward technique and imagery had its greatest effects in Germany.

German art at the turn of the century came under many influences—Impressionism, Art Nouveau, Poster Art, and an aspect of Edvard Munch's work that was to be called Expressionism. The Germans, too, had their avant-garde magazines *Pan* and *Jugend,* which followed in the footsteps of *L'Estampe Originale* and *La Revue Blanche,* and in many instances published French works along with German ones.

The reviver of lithography in Germany was Max Slevogt (1868–1932). He was extraordinarily prolific, producing about 2,000 prints in his lifetime. Supported by the pulisher Bruno Cassirer, Slevogt became a skilled illustrator, doing drawings for everything from *Sinbad the Sailor* to Verlaine's *Parallelement.*

The Expressionists seized upon Munch's penchant for capturing the peak of the inner emotional experience. They were also influenced by Redon's soul images, Van Gogh's symbolic color and linear distortions, and Gauguin's fantastic imagination and insistence upon bold, pure color and primitive, powerful form.

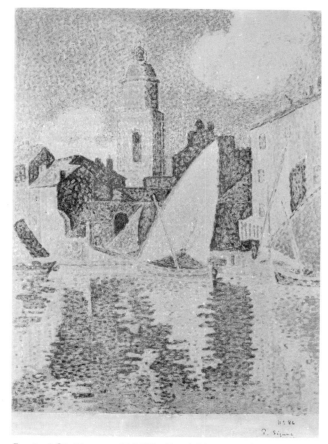

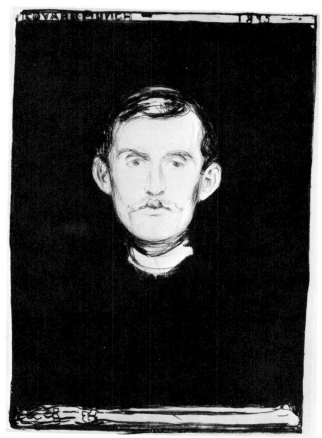

Port of St. Tropez (1897), Paul Signac. (Collection, The Museum of Modern Art, New York. Abby Aldrich Rockefeller Purchase Fund.)

Self-Portrait (1895), Edvard Munch. (Collection, The Museum of Modern Art, New York. Purchase.)

Many of the Expressionists, however, took to lithography independently: Barlach, Corinth, Beckmann, and Kokoschka, and the Brücke Group (Karl Schmidt-Rottluff, Kirchner, Mueller, Nolde, Heckel, and Pechstein) all responded to the lithographic technique in an exciting way. Lovis Corinth (1858–1925), one of the fathers of German Expressionism, was a famous etcher. Yet, at the end of his life, he took up lithography, to illustrate such works as *In Paradise, Apocalypse, Martin Luther, Anne Boleyn, William Tell, The Flood, The Tournaments from the Day of Henry the Eighth,* and *The Queen of Golconda*. His work displays the nobility and grandeur of man, his decline and resurrection, and the spirituality inherent in his life. Corinth wished to record not only what he saw, but also how this reality was transformed when it touched his special sensibility.

What to me seems interesting is to recover in the representation of an object the whole complex set of impressions we receive as we see it normally in everyday life, the manner in which it has touched our sensibility, and the forms it assumes in our memory.

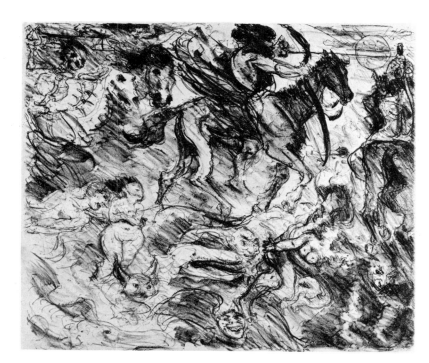

Apocalypse (1921?), Louis Corinth. (Collection, The Museum of Modern Art, New York.)

Max Beckmann (1884–1950) began to make lithographs in 1909. His work, like Munch's, reveals the terror and fear around him. Two world wars had nurtured his art. The titles of two of his many portfolios suggest his artistic viewpoint: *Hell, Man is not a Domestic Animal* and *The Apocalypse.*

Oskar Kokoschka's (1886–) lithographs are powerful statements that reveal a poignant vision. His first, *The Dreaming Boys,* was done in 1907. He has continued his lithography until the present day. Kokoschka's themes are wide ranging and vary from self-portraiture to the passion of Christ.

Ernst Ludwig Kirchner (1880–1938) first took up lithography in 1906. He immediately became enamored with the technique to such an extent that during his life he produced hundreds of lithographs. Kirchner lithographed much of his own work, since he felt that the actual technical production was of major importance to his art. The etching procedure that he used was incorporated as part of the drawing. His powerful etch contained large quantities of nitric acid in order to burn the surface of the stone to produce a grainy tonality. His other innovations consisted of using one stone to print many colors. This dedication to the technique produced a range of effects unknown to previous lithographers. Some of these innovations can be seen in his prints of 1908–1909—*Street-Car Passengers, Black Stallion, Love Scene,* and *Writer.*

In 1895 Emile Nolde (1867–1956) went to Munich to learn lithography. By 1913 he had created a number of his masterpieces, among them *The Three Kings* and *The Young Danish Woman.* In all he did about sixty-three lithographs. His bold use of color, his strong outlines, and his simplified shapes produced startling, immediate images and captured the expressionism of the medium. Many of his prints (for example, *Dusterer Mannerkopf* and *Junges Paar)* are among the greatest examples of the boldness one can achieve in a lithograph.

The Three Kings (1913?), Emil Nolde. (Collection, The Museum of Modern Art, New York. Abby Aldrich Rockefeller Purchase Fund.)

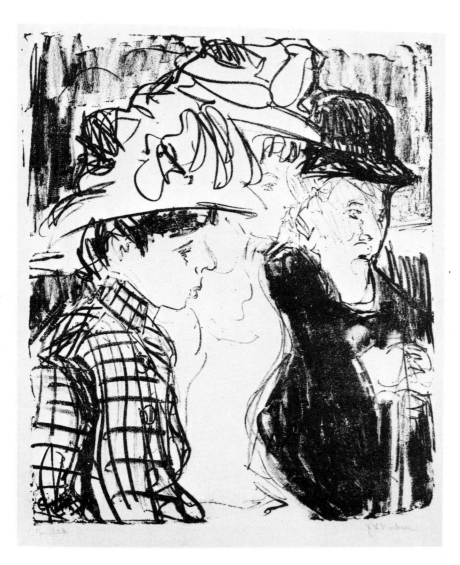

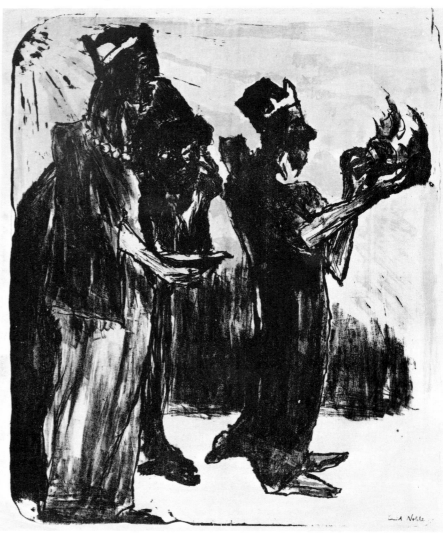

Street Car Passengers (1908), Ernest Ludwig Kirchner. (Collection, The Museum of Modern Art, New York. Purchase.)

Käthe Kollwitz (1867–1945) used the lithograph as a political vehicle. Her work is expressionistic, with overwhelming social overtones. "I hardly chose to portray anything other than the lives of the workers . . . the themes chosen from this sphere gave me, simply and unconditionally, that which I felt was beauty. The people from bourgeois life held no charms for me . . . but the workers affected me deeply."

Shortly before World War I, a second group of Expressionist painters in Munich formed the Blue Rider Group. This group was more international in its outlook than the Brücke group. The two chief exponents were Franz Marc and Wassily Kandinsky. Other artist members were Paul Klee, Macke, and Campendonk.

Franz Marc produced a few lithographs, but most of his graphic work of significance was in woodcuts.

Kandinsky did a number of lithographs. He produced his first lithograph in 1922. He wrote in 1926: "Lithography is getting closer and closer to the painting by the increasing use of color, and is, in any case, a certain substitute for painting." Kandinsky was one of the first artists to do entirely abstract lithographs.

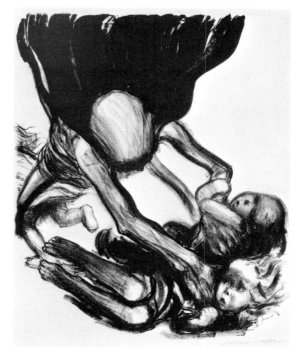

Death Reaching into a Group of Children (1934), Käthe Kollwitz. (Collection, The Museum of Modern Art, New York. Purchase.)

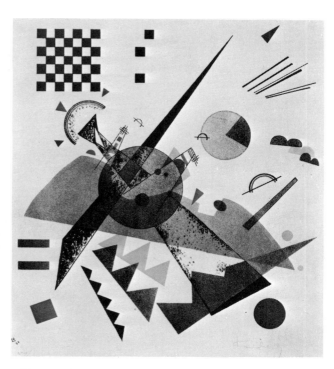

Abstraction (1922), Wassily Kandinsky. (Collection, The Museum of Modern Art, New York. Gift of Abby Aldrich Rockefeller.)

Paul Klee started his lithography in 1912. His approach was simply to use the technique to depict an image. He drew his images on transfer paper. Klee often tinted his black drawings with a transparent overlay of color. His themes, like his paintings, are playful statements powerfully colored and composed.

While all this was occurring in Germany a new group of artists in France was adopting and transforming lithography.

Henri Matisse (1869–1954) attempted his first lithograph in 1904. For him, lithography was simply a new way of drawing. The litho crayon became a shorthand for him. Matisse's prints capture the instant, as in *Crouching Nude with Black Hair*. He did an extraordinary number of illustrations for such works as Baudelaire's *Les Fleurs du Mal,* Rosard's *Florilese des Amours,* and Montherlant's *Pasiphe.* He especially loved the theme of the Odalisque. Matisse once said that "art should be enjoyed like a comfortable chair." This is the feeling one gets from his work. His prints are sumptuous; they

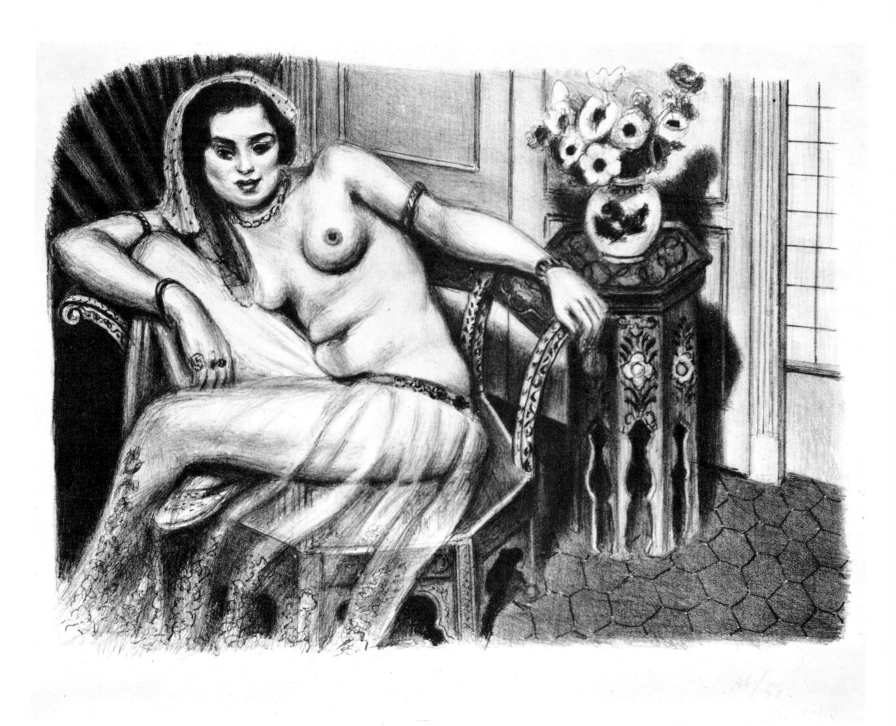

Odalisque in a Tulle Skirt (1928), Henri Matisse. (Collection, The Museum of Modern Art, New · York. Gift of M. Knodler and Co., Inc.)

delight in their ease of drawing and sensual color. They give us an intimate glance into Matisse's joyous world. "I can't distinguish between what I feel about life and how I render that feeling. A drawing must have an expansive force that enlivens the things that surround it." Matisse did many preparatory drawings before he attacked the stone. This enabled him to obtain a spirited and free-flowing line. He was a scrupulous craftsman, always watching the printing of the proofs, demanding that the intensity of some colors be increased or reduced at the last minute. He also experimented with different papers, often choosing one that enhanced the sensual quality of his imagery.

Georges Rouault (1871–1958) did his first lithograph in 1910, but he really began in 1924 by doing a group of prints for the publisher Frapier. They consisted of his usual themes—clowns, circus riders, and prostitutes. Rouault was a deeply religious man. This religiosity and his concern and passion for human frailty are what Rouault captured in his prints. His training as a stained-glass craftsman had a marked influence on his style. His production includes a group of six lithographs entitled *Souvenirs Intimes,* a series of portraits of his friends involved in the Catholic revival. In 1929 he did *Petite Banlieue,*

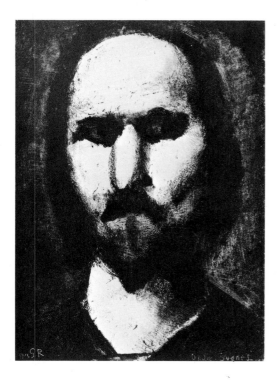

André Saurès, Georges Rouault. From *Souvenirs Intimes,* illustrated with six lithographs, Paris, E. Frapier, 1926. (Collection, The Museum of Modern Art, New York. Gift of Mrs. Edith Gregor Halpert.)

six prints about Les Faubourgs, the French workingclass suburb. The atmosphere is poverty, abandonment, and general hopelessness.

Pablo Picasso (1881–1973) fused joy and sorrow into his work. Each stimulus, every interaction with his environment, was a potential inspiration for his art. Picasso began lithography in 1919. His first print was a sketch used as an invitation card for his first show at the Paul Rosenberg Gallery. Before 1930, he drew about twenty-four lithographs, mostly on transfer paper. His true initiation into lithography occurred in 1945–46, at the Mourlot atelier in Paris. Here he seriously experimented with the technique. Picasso worked and reworked the same print many times, often pulling over twenty states (successive elaborations) from each stone. These prints became extraordinary documents revealing the interaction of a great artistic vision with the technique of lithography. He experimented with innumerable techniques, including collage prints (lithographs made by inking various objects such as rope and feathers and sending them through the press). His unorthodox use of drawing and erasing materials also produced a new range of lithographic effects.

Georges Braque (1882–1963) produced about 140 lithographs in his career. His interest and productivity in lithography parallels that of Picasso. His first attempt was a color still life done in 1921. Braque, like Picasso, seriously took up lithography in 1945 at Mourlot's. Much of his imagery paralleled his paintings. Among his many illustrated works are *Cahier de Georges Braque* (1948) and *Aventure Methodique* (1949). Braque's work is very intimate. His late birds, usually doves rising into flight, are spiritual images. They are beautiful creatures lifting themselves free and singing a song of peace. In all he did 180 lithographs, most of which were in color.

Marc Chagall (1887–) wrote in 1960: "When I held a lithographic stone or a copper plate in my hand, I thought I was touching a talisman. It seemed to me that I could put all my joys and sorrows in it. . . . Everything that touched my life through the years, births, deaths, weddings, flowers, animals, birds, the poor workers, my parents, lovers in the night, the Biblical prophet, on the street, in the home, in the Temple, and in heaven. And, as I grew older, the tragedy of life within us and roundabout us." Chagall did his first lithographs in 1922–23. He was immediately attracted to the technique and, within his first year, produced twenty-four prints. His production is enormous, including many illustrations such as *Four Tales from the Arabian Nights,* illustrations from the Bible, and *Daphnis and Chloë.* These lithographs are extraordinary examples of how close an artist can come to producing lithographs that truly resemble his paintings.

Joan Miró (1893–) once wrote that imagery and subject matter should function as "an immediate blow between the eyes before a second thought can interpose." These are harsh words for so delightful and poetic an artist. Miró's work is gay, playful, and joyous in its use of beautiful color. He has acquired a collection of intimate symbols all executed in a personal, surrealist graffito style. His forms delight both as shapes and as symbols. Miró did his first lithograph in 1930 for Tristan Tzara's *L'Arvre des Voyageurs*. An avalanche of lithographs followed. Among the highlights are a series of fifty lithographs produced during the war in Barcelona.

Another Surrealist of Spanish extraction who has done many lithographs is Salvador Dali (1904–). He too has placed great importance on the use of images of multiple symbolic meaning. His technique based on the study of seventeenth-century Dutch masters is meticulous realism used to delineate unrelated objects in unexpected situations. Most of the themes in his lithographs have paralleled those in his painting.

Antonio Tapiès (1923–) is distinctly Spanish. His work seems to capture the desolate, arid, yet monumental landscape of Spain. His use of color is subtle. Often he combines textures by embossing many of his lithographs. He also does this in his paintings, which often are three-dimensionally carved—that is, they are made of real materials, like sand, that are physically molded into shapes.

Matière et mémoire ou les lithographes à l'école (1944), Jean Dubuffet. (Collection, The Museum of Modern Art, New York. Louis E. Stern Collection.)

Jean Dubuffet (1901–) has done numerous lithographs, many of which have textures of extraordinary beauty. His prints are not only beautiful images; they are technical explorations into the art of lithography. Dubuffet is an exponent of *l'art brut*. This "raw" art is exemplified in the series *Matière et Memoire.* The art that surrounds the average man, that of walls displaying textures and shapes, is captured in the series *Les Murs.* The textures of nature are set down in the series *Les Phenomenes*—twenty-two albums with a total of ninety prints. This series is a tour de force of lithography. Many of the prints were made either by using transfer paper or by pressing plastic sheets with grease which are then impressed with various textures into a collage form. Often the identical plate is used and reversed. It is incorporated as one of the plates in a new print, the ultimate aim being to capture the myriad textures evident in nature.

Max Ernst (1891–), although German by birth, has lived much of his life in France. He founded the Cologne division of the Dada movement in 1919 and also became one of the pioneers of the Surrealist school. His approach to lithography is quite unique. Of particular interest are his frottage prints, which are rubbings from surfaces onto transfer paper. These are in turn transferred to stones. To date he has produced about seventy lithographs.

Hans Hartung (1904–), an exponent of the Abstract Expressionist school, has a rugged style, using crayon and tusche in an aggressive way to express an inner vitality. His lithographs are intense, vital, calligraphic statements.

Alberto Giacometti (1901–66), a Swiss sculptor long a resident of Paris, also produced a number of lithographs. His lithography resembles so many of his linear, calligraphic drawings. His mazes of lines make poignant portraits and figure studies.

In Italy, Giorgio de Chirico (1888–), the Italian metaphysician, was a precursor of Surrealism, and he rendered many of his ideas into lithographs. He uses a Renaissance space filled with massive architecture and robotlike figures to create his fantasy world.

Marino Marini (1901–) has done a large number of lithographs, most of which are in color. His prints are very reminiscent of the themes he uses in sculpture—stylized horses and riders. He started doing lithographs in 1940 and has continued to the present.

American Lithography

Before continuing our discussion of lithography in Europe, we would like to discuss the development of the lithograph in America. Lithography was introduced into the

United States in 1818. The first American lithograph, done in 1819 by Bass Otis, was a landscape published by the *Analectic Magazine.* Although some of the early practitioners of lithography, such as Rembrandt Peale, who in 1827 did a portrait of George Washington, were important early American painters, most were not well known. The early stages of lithography in America were left to Currier and Ives scenes. The few Americans who did engage in the medium at the turn of the century worked in Europe. James McNeill Whistler (1834–1903) did a number of lithographs in England at the shop of Thomas Way. They reflect his concern with the same misty, atmospheric quality found in his paintings.

In line with Whistler's advocacy of the art-for-art's-sake movement, most of his work deals with formalism derived from the influence of Japanese prints and the early Impressionists.

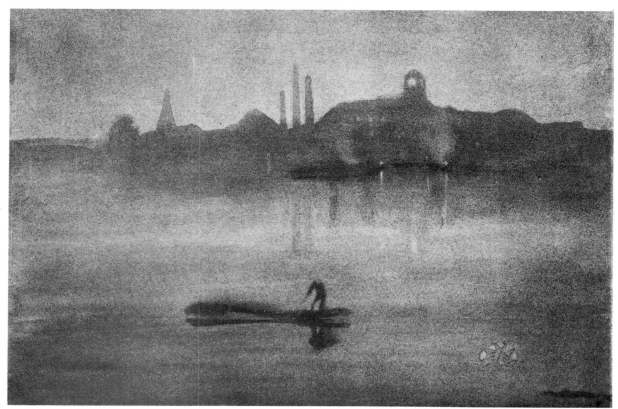

Nocturne, James Whistler. (The Metropolitan Museum of Art, New York. Harris Brisbane Dick Fund.)

Other American lithographers were Joseph Pennell and Childe Hassam. They developed a bold, free, sketchy approach to the medium.

Winslow Homer (1836–1910) was truly a Yankee painter. He was a realist who depicted the American landscape. Specifically, he was drawn to the scenes of men in their dories rowing over an angry sea. Homer did many prints, mostly as illustrations for periodicals. He often used the scraper to create various effects and tones on the stone—a method he developed while doing his *Campaign Sketches,* six Civil War prints.

Marsden Hartley (1877–1943) did 18 transfer lithographs, which were printed in Germany in 1923 and 1933–34. They deal with two subjects, still lifes and Bavarian Alp scenes. The latter series show the influence of the French school, especially Cézanne, Picasso, and Matisse. These influences were brought back to the United States and had an important effect on American art.

George Wesley Bellows (1882–1925) was a member of the Ash Can school—so named because the participating artists were influenced by prizefighting, the waterfront, tenements, and the general urban panorama. He was an exquisite draftsman and used his talents to create numerous lithographs, many of which were printed in the New York shop of Bolton Brown, the master printer of the day. Bellows' themes ranged from *The Crucifixion* to *Jack Dempsey.*

Thomas Hart Benton (1899–) did his first lithograph in 1929. He depicted the people of America—mountain people, farmers, cowboys, industrial workers, river men, and artists. His work displays the American panorama during the Depression and in times of war, peace, holocaust, and plenty.

Stuart Davis (1894–1964) did many lithographs, one of which became the first United States postage stamp to celebrate the arts. The Armory Show of 1913 in New York was the critical influence on him. He once made the following statement when referring to a picture: "... it is an object which has been formed by an individual in response to emotional and intellectual needs. His purpose is never to counterfeit a subject, but to develop a new subject."

Ben Shahn (1898–1969) learned his lithography as an apprentice at Hessenberg's shop in New York City in 1913–17. This early training was put to work in numerous lithographs. Shahn once said: "... art did, after all, have a mission ... its mission was to tell what I felt, to say what I thought, to be my declaration. ... Pictures would be my manifesto." Indeed they were. Shahn's lifework was dedicated to exposing and attempting to remedy man's inhumanity to man. His themes reflected his concerns—Sacco and Vanzetti, nuclear testing, Martin Luther King, and countless others.

Raphael Soyer (1899–) wrote of his art: "My art is representational by choice. In my opinion, if the art of painting is to survive, it must describe and express people, their lives and times." Soyer has done just that. His many lithographs describe his friends, street life, anything that appeals to him in his environment.

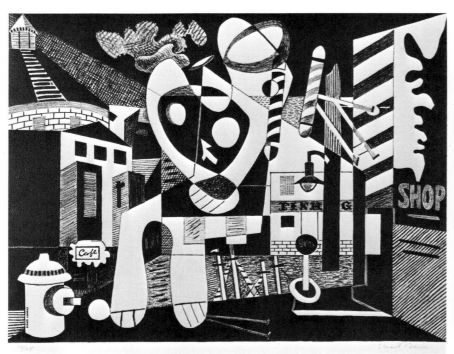

Barber Shop Chord (1931), Stuart Davis. (Collection, The Museum of Modern Art, New York. Gift of Abby Aldrich Rockefeller.)

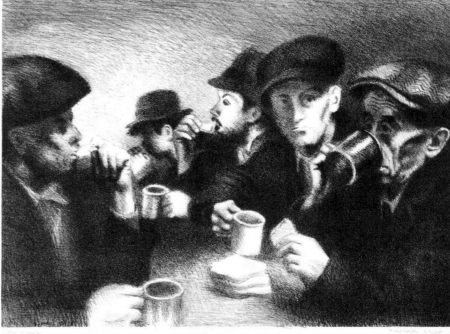

The Mission (1935), Raphael Soyer. (Collection, The Museum of Modern Art, New York. Gift of Mrs. Bertha M. Slattery.)

Sam Francis (1923–) is one of the few Abstract Expressionists who did lithographs. His work is an explosion of joyous color. The prints parallel the ideas of his painting. Since 1960 Sam Francis has produced lithographs all over the world.

Robert Motherwell (1915–) has done a large number of lithographs in the Abstract Expressionist idiom. His work is bold and powerful and usually executed quickly with pure tusche directly on the stone or plate.

Saul Steinberg (1914–), perhaps most famous for his beautiful drawings done for *The New Yorker* magazine, has done a large number of exquisite lithographs. They are whimsical satires often on the subject of art itself.

Although other Abstract Expressionist artists, such as De Kooning, did a few lithographs, it is the recent developments in America that have produced an overwhelming interest in lithography. This may be traced to the resurrection of the art by a number of outstanding workshops. Tamarind, Universal Limited Art Editions, Hollander Workshop, and Gemini were among the most influential in interesting a whole generation of artists in lithography. More will be said of these and other workshops later; our concern here is with the artists. During the fifties few lithographs were made in America. The period from the sixties to the present, however, has been the most productive lithography-producing era in American history.

Robert Rauschenberg (1925–) began doing lithographs in 1962. He once said that "... anything that creates an image on stone is potential material. The image that is made by a printer's mat, a metal plate, a wet glass, or a leaf plastically incorporated into a composition and applied to the stone, stops functioning literally with its previous limitations. They are an artistic recording of an action as realistic and poetic as a brush stroke." Rauschenberg, a leading artist in the evolution of contemporary American art, bridged the Abstract Expressionist movement with the Pop movement. He achieved this by integrating action-painting with the real popular object—for example, a Coca-Cola bottle or a photograph. This approach carried over to his lithographs. He revived frottage—transferring magazine photographs using a solvent to dissolve the image and a burnisher to transfer the photograph to the lithographic stone's surface. This use of the photograph and drawing combination created a new dimension for lithography. He expanded the medium further by silk-screening images onto the stone. These images—helicopters, rocketry, architecture, political figures, paintings by Rubens and Velázquez, as well as numerous other subjects constitute his personal sceneography of the real events that surround him. In 1969 he was invited by the National Aeronautics and Space Administration of the U.S. to watch the Apollo 11 launching. This resulted in one of his most exciting lithographic series.

Jasper Johns (1930–), who, like Rauschenberg is credited with bridging Abstract Expressionism and Pop Art, has also done a large number of lithographs. He did his first lithograph in 1960 at Universal Limited Art Editions. His use of the popularly seen object is combined with excellent draftsmanship in his lithographs: light-bulbs, ale cans, flashlights, paintbrushes, flags, numbers, alphabets, and coathangers. Johns was invited to Gemini in Los Angeles to further the use of the lithographic medium. He did a second series of numerals, and others. To date he has executed ninety-one lithographs.

Another artist having an influence on Pop Art is Larry Rivers (1925–). He did his first lithographs in 1957 in collaboration with the poet Frank O'Hara. He once said, "I am a political man. I am affected by what other men do and say and think and how they respond to what I do and say and think. Putting aside the surface manipulations of subject and style, what I have painted is my relationship to other men, and that relationship points out our differences and similarities. I see in my work every art from Rembrandt to the man who presents a No Smoking sign to us as art." His work is a diary of his experiences, revealing not only ideas about art, but those about life as well.

Another member of the Pop group is Jim Dine (1935–). He is well known for his happenings and assemblages. Dine's first lithographs were a series of five, entitled Car Crash. They are bold Expressionist images. He too has done many prints at Universal Limited Art Editions. He has said: "Prints are the reason for some of my paintings. Lithographs take enough time, more than anything else I do, so that they make me think about everything. . . ." The themes of his lithographs and paintings are generally the same—tools, palettes, hearts, toothbrushes, etc.

A number of the other Pop artists, such as James Rosenquist (1933–) and Claes Oldenburg (1929–), have also done lithographs. Rosenquist was trained as a billboard painter. He brought his technique indoors. Using an airbrush, he creates

advertising imagery transformed into a fine-art format, with an emphasis on everyday objects. He uses this same imagery and airbrush technique in many of his lithographs— *Spaghetti and Grass* is a typical example. Claes Oldenburg did his first lithographs at Pratt Graphic Center in 1961. The early prints dealt with the themes of food—*Pie, Still Life with Cake*, and *Frying Pizza*. In 1967 Oldenburg was invited to Gemini to do a suite of prints. The results, called *Notes*, required at times sixteen separate runs through the press. The folio consists of twelve lithos; 104 different colors were used in the entire printing. Oldenburg used *trompe l'oeil* techniques to create tension between the illusionistic object (masking tape, a page from a notebook) and the drawing. A myriad of photo- and color-printing techniques were used to produce this suite. His attitude toward lithography is summarized by this statement: "A print should be a concentration of several interests at a particular time and not just a souvenir of an artist. I want a print to be either a solution or a failure of some kind of problem."

Other trends in recent American art, such as color field and optical art, are well represented in lithography. Josef Albers (1880–), who was born in Germany but has lived in America for over twenty years, has done a number of lithographs. He too was invited to Gemini in 1966 and spent nine months producing a series of eight lithographs entitled *White Line Squares*. He wrote of this series: ". . . a white line within a color area instead of its contours, presents a newly discovered effect; it is placed within the middle of a color. Although evenly applied, it makes this one color look like two different shades or tints of that color. To recognize these often minute differences we need sensitive eyes. Such white lines dividing interesting colors are presented for the first time in *White Line Squares*." Albers has done other suites of lithographs, including his *Homage to the Square Lines.*

Of the younger group of color field artists involved in lithography, Frank Stella (1936–) has done a number of suites. Many are modeled after his paintings. They were executed at Gemini and include *Empress of India, Star of Persia, V Series,* and *The Black Series.* Stella used a variety of inks—matt, epoxy-coated metallic inks, and glossy types. He has utilized graph paper and has considered the margin as an integral part of the image. Many of his works, like the black stripe painting, foreshadow the minimal group of artists practicing in America today.

Another movement, environmental art, is represented by the sculptress Louise Nevelson (1900–), who started to do lithography in 1963 at Tamarind. She did twenty-six lithographs—nineteen black and white, seven with black, white, and another color—during her stay. Many were produced in collage form—that is, the drawings are done on transfer paper and then the pieces are cut out and transferred to the stones in the collage format. These prints are mysterious dark images evoking a strange, fantastic world. She states: "My total conscious search in life has been for a new seeing, a new image, a new insight. This search not only includes the object, but the in-between places, the dawns and the dusks, the objective world, the heavenly spheres, the places between the land and the sea. Whatever creation man invents the image can be found in nature. We cannot see anything of which we are not already aware. The inner and the outer equal one."

Mexican Lithography

Lithography was introduced into Mexico in 1826 by two Italians, Linati and Franchini. The earliest lithograph, executed by Linati, is found in the review *El Iris.* The print is of a multicolored figure in a red dress and bonnet. Lithography quickly spread throughout the country. The process was used to illustrate numerous books and newspapers such as *The Orchestra,* a politically oriented paper. It was not until the Revolution that three artists—Diego Rivera, José Clemente Orozco, and David Alfaro Siqueiros

—emerged as giants on the lithographic scene. They used lithography in a straightforward manner—to awaken the world clearly and powerfully to the plight of the Mexican people. Although versed in the styles of the European masters, they chose their own heritage as the influence to transmit their messages.

Diego Rivera (1886–1957) became involved in the revolutionary movement on his return from studying in Europe. His lithographs were often based on his frescoes. The themes depicted are from Mexican history—for example, Zapata, the Indian revolutionary.

José Clemente Orozco's (1883–1949) lithographs are powerful protests against the horror he witnessed. They are screams against the devastation, starvation, and misery that surrounded him.

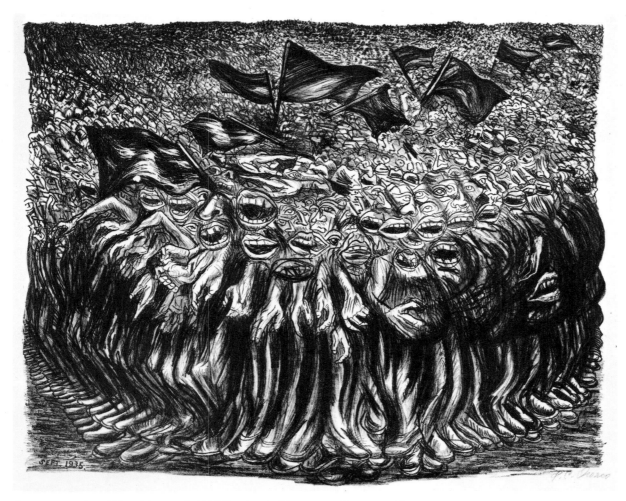

Demonstration (The Masses) (1935), José Clemente Orozco. (Collection, The Museum of Modern Art, New York. Inter-American Fund.)

David Alfaro Siqueiros (1898–) also used lithography to express the misery around him. His lithographs are statements of power. They are monuments demanding that men look upon the horror of starvation. They demand concern from the viewer. It is impossible to look at these images without being deeply affected.

Rufino Tamayo (1899–), unlike the above-mentioned artists, lies closer in attitude to the European lithographic tradition. His influences are Cubism, Abstraction, and Mexican folk art. Tamayo's prints deal wtih the myths and symbols of folk art—tradition coupled with a modernist format.

A younger artist, José Luis Cuevas (1934–), is an exquisite draftsman of Kafkaesque imagery. His imagery is of frightening hunchbacks, dwarfs, and monsters. He has done a folio of lithographs on the Marquis de Sade—a typical subject for this

artist. Cuevas understands the breadth of the lithographic medium. He couples the facility of this technique with his consummate draftsmanship to produce frightening but beautiful prints. Cuevas worked at Tamarind Lithographic Workshop in 1965–66, at Mourlot in New York in 1968, and at Editions Press since 1969.

British Lithography

Unlike France and Germany, England did not become a center for various art movements. The quality of the craft was quite high, but the talent was not there. Most of England's great painters were uninterested. As mentioned earlier, Géricault voyaged to London to produce some beautiful lithographs in 1817–18. In 1819 Senefelder's book was translated into English, further increasing the level of craftsmanship in lithography. Yet, for most of the nineteenth century, lithography was used only for illustration and, in the latter part of the century, for posters. The few artists who did lithographs at that time were foreigners such as James McNeill Whistler. It was an American, Joseph Pennell, who in 1910 started the Senefelder Club. He is to be credited for starting the small revival of lithography among English artists. He also invented "Pennell Paper," a lithographic transfer paper. Members such as Frank Brangrugn did prints of the plight of the oppressed classes. William Rothenstein, the society painter, Augustus John, and the World War I artist Muirhead Bone did numerous prints. Sickert, an English Impressionist influenced by Degas, also did lithographs. As in the United States, with a few exceptions, however, the real renaissance of lithography in England is a recent one.

Henry Moore (1898–), one of the world's leading sculptors, has done a number of lithographs. His most recent work was done at Curwen Studios in London and at J. E. Wolfensberger in Zurich. His images are powerfully drawn, and many are studies for his sculpture.

Graham Sutherland (1905–) started his career as a graphic artist between 1922 and 1932. His first prints were etchings, and he did his first lithograph in 1933. He has used many traditional Christian symbols and derived themes from the art of the Middle Ages. He has also done a Bestiary, which was printed at Mourlot in 1967. His bold contemporary execution of these subjects seems to parallel the religious revival of Rouault in France. Unlike Moore, whose forms seem to derive from the human figure, Sutherland is influenced by trees, rocks, insects, thistles, and flora.

Reginald Butler (1903–) owns his own press and does much of his own printing. Most of his prints deal with the abstraction of the human form. Many other English artists, in particular Lynn Chadwick, Kenneth Armitage, Eduardo Paolozzi, and John Piper, have done numerous lithographs.

A large number of the younger English artists have also taken to the technique. David Hockney (1937–) started in printmaking as an etcher. His concern with lithography is fairly recent, although his production is quite extensive. Hockney draws in a naïve, poetic fashion. His images are of simple everyday encounters with people and places—for example, *Picture of a Portrait of a Ticket Taker in a Silver Frame.*

Another Pop artist, Allen Jones (1937–), has also done numerous lithographs. He often uses photographic images or cartoonesque imagery along with his calligraphic style of drawing.

Contemporary European Lithography

Artists elsewhere in Europe also produced lithographs. The Cobra Group (an alliance of artists from Copenhagen, Brussels, and Amsterdam) have and continue to execute many prints. The group, consisting of Pierre Alechinsky, Asger Jorn, Karel

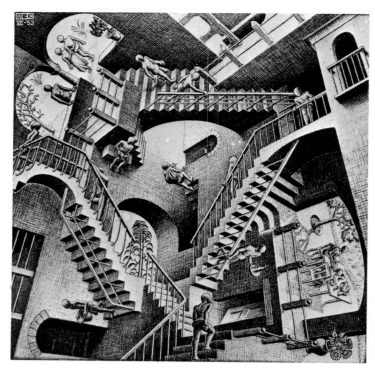

Relativity (1953), M. C. Escher. (Collection, The Museum of Modern Art, New York. Purchase.)

Appel, Corneille, and others, formed Cobra in 1940. The group disbanded in 1957, after having profoundly influenced a number of artists all over the world by executing works that were both expressionistic and surrealistic. Their forthright and spontaneous style was a revolt against the mannered elegance of the School of Paris and the Cubists. Their concern was that the individual artist make a powerful statement as a man rather than create an object to be admired.

The Dutch artist M. C. Escher wrote: ". . . as far as I have been able to discover, few or none of my fellowmen seem to be struck in the same way as I am by the things around them." Through the use of geometry, perspective, and juxtaposition of often unrelated objects and events, Escher produces shock and often terror. He transforms seemingly real objects into a personal fantastic world. Everything is drawn meticulously to create fascinating imagery, as seen in *Reptiles and Three Spheres.*

Germany today has many artists practicing lithography. Among them is Hans Richter (1902–), a prolific lithographer who started in 1919 and has produced hundreds of prints. His imagery carries on the tradition of German Expressionism. His themes vary from *The Song of Solomon* to *Children's Playground.*

A. Paul Weber (1893–) is a satirical artist who has illustrated *Reynard the Fox, Machiavelli, Simplicius Simplicissimus,* among others. His production of over a thousand lithographs is extraordinary. Weber seems to have taken up a crusade to make mankind aware of its lunacy. He disseminates his satirical lithographs through his own press, Clan Press, and through the yearly publication of his *Critical Calendar.*

Foremost among the younger group is Paul Wunderlich (1927–). One of the greatest lithographic colorists of all, he has produced and continues to produce beautiful prints. He is influenced by the old master German painters, Cranach, Dürer, and Grünewald, as well as Art Nouveau, Victoriana, Art Deco, and, perhaps most of all, by the photos of Karin Szekessy. Wunderlich has produced sexual, erotic, strange, and at times shocking images. His mastery of the technical aspects of lithography is extraordinary, yet it is the imagery that strikes one most of all. Among his themes are *The Anatomy, Leda and the Swan*, and *Song of Solomon.* He once said, "I am trying to reveal myself naked to the public, submit the darkest recesses of my mind to close scrutiny. In my job it's wrong to speak too loudly, or to be too shrill. I have no message. Whatever message you find is your own." Indeed, we find many messages. They involve strange worlds, beautiful images, and incredible technique.

The above brief history of lithography does not include many of the younger artists practicing lithography today. In the second part of this book, however, much of their work is shown as part of the art being created in the workshops of North America and Europe.

Chapter Three:

TECHNICAL HISTORY OF LITHOGRAPHY

I n 1798 Senefelder established in Munich the first lithographic atelier and used a copper-plate press with two cylinders. This cylinder press was far from perfect, but it enabled him to pull neat impressions from the stone. With the aid of an assistant, he was able to print 120 copies of twelve songs on this press in less than two weeks. This was the first known lithographic publishing venture in history. After proving that lithography was a profitable technique, Senefelder began redesigning his first press, and by 1799 he had invented the lever press, which greatly improved his production. The second lithographic atelier was opened in Offenbach, Germany, by Senefelder's partner, Anton André. André's atelier contained five lithographic presses, which were used exclusively for printing music. Senefelder and Von Hartl then opened in Vienna another atelier whose mainstay was the printing of music, but this time they also became involved with printing works of art. By now Senefelder was getting an enormous amount of publicity, and in 1803 he opened a larger atelier in Vienna, where music and works of art were printed on a huge scale.

Most of the early lithographic ateliers became involved with printing maps, art work, music, city plans, playing cards, tapestries, and calico. The owners of the early ateliers designed their own presses to handle specific printing jobs. Most of the early presses were designed for use with scraper bar and cylinder and were similar to the hand lithography presses in use today. The first presses in use in Germany during the early 1800s were the upright-lever press *(Fig. 1)* and the cylinder press *(Fig. 2)*. The early presses in Vienna were metal cylinder presses, while the ones in use in London were made with paper cylinders.

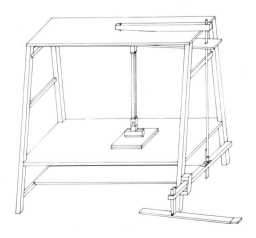

Fig. 1. Upright-lever press

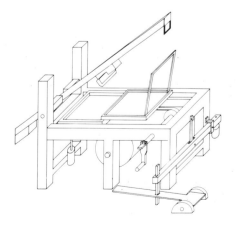

Fig. 2. Cylinder press

The first highly successful press used for mass production was the lever or pole press (*Fig. 3*). Its operation was simple; its only drawback was that it could only print from small stones, since it exerted very little pressure. It excelled in rapid printing of small pen-and-ink drawings.

In the lever press, the pressure is applied by a lever six to ten feet long. A hard wood scraper bar, as long as the width of the stone to be printed, is at one end of the lever. Each atelier then, as today, had many sizes of scraper bars in storage. The scraper bar passed over the leather (strong calfskin or young oxhide) tightly stretched over a frame, which also held the paper, which was then laid over the stone. The movement of the scraper bar produced enough pressure to transfer the ink from the stone to the paper.

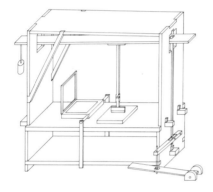 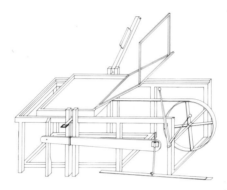

Fig. 3. Lever or pole press Fig. 4. Cylinder press with lever

The basic principles of the first lithographic presses are still those of the hand press in use today. The cylinder press, which was most widely used, was more convenient and easier to operate than the lever press and did not require as much exertion on the part of the printer. The star press (*Fig. 5*), which used a star wheel instead of a lever, is almost an exact replica of the presses in use today for direct hand printing in most of the ateliers throughout the world. Those early presses were constructed of wood, while those in use today are made mainly of cast iron and steel. It is still possible, however, to find the old wooden star wheel presses in use in some shops today.

In the star press, the scraper bar remains stationary. It does not move over the stone. The stone and press bed pass under the stationary scraper bar. This press may be operated by a single man with a minimum of pressure.

During the 1820s and 1830s, there were only a handful of lithographers active in the United States. Two brothers, William S. and John B. Pendleton, are considered the founding fathers of American lithography. John Pendleton, with the aid of Francis

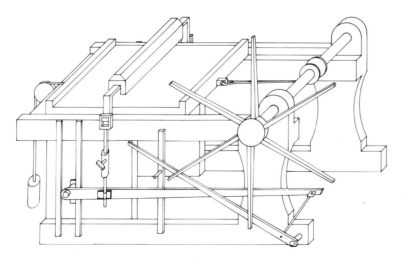

Fig. 5. Star press

Kearny and Cephas Childs, became the first lithographer in Philadelphia in 1819. Bass Otis published the first lithograph in the United States, which appeared in the *Analectic Magazine,* in August 1819. In 1825, William Pendleton and John B. Bowen set up the first lithographic atelier in Boston. But lithography did not begin to flourish in the United States until the 1840s. During the next few decades, chromolithography, printing in multicolors, became very popular. Up until the twentieth century, most printing of lithographs was done on stone. The beginning of this century brought great changes in the medium. Lithographs were now being produced without the use of stones and metal plates had replaced the hard-to-get, cumbersome lithographic stones. Thus, lithography became the most popular and economic means of reproducing pictures and illustrations. The public was being enlightened, becoming aware of contemporary events through lithographs. Currier and Ives were the leading exponents of this method of reproduction.

Within the last 150 years, lithography has made vast technical advances, utilizing photographic methods, halftone screens, metal plates, and offset presses. Without changing the basic principle—grease attracts grease, water repels grease—lithography has been revolutionized. The innovations of commercial industries have increased production and lowered costs.

In 1850 Eugues, a Frenchman, invented the first steam-driven press. The patent was later sold to Hughes and Kunker, who were building presses in London. The press was brought to the United States in 1866. At about the same time, steam presses were being manufactured in Massachusetts and were in use in ateliers in Boston and New York.

During the late 1800s lithographers could at last purchase their materials from local suppliers. The industry was growing rapidly. No longer did the printers have to manufacture their own supplies, although many still stayed with their own formulas.

At the beginning of the twentieth century, photoengraving was advancing by leaps and bounds, and, as a result, lithography was declining. The letterpress was producing high-quality picture reproduction, and it became possible to print more economically and efficiently with photoengraving than with lithography.

The flatbed presses were easily adapted to stone lithography, but they were not well suited for photographically prepared plates. Rotary lithographic presses appeared in the 1890s because of the scarcity and expense of large lithographic stones. The metal plate was replacing the stone, and the rotary press was extremely successful in the newspaper industry. Unfortunately, these rotary presses did not answer the real needs of the lithographic industry. They were very successful in producing large images and posters, but in general they failed. The industry was suffering.

The first use of photography in lithography was for reproducing the image on the stone or plate. The next most important contribution that photography made was the conversion from direct hand-drawing. Photography, through the discovery of the halftone process, could reproduce tones. In France, Lemercier developed the first successful photolithographic process in 1852.

The halftone process, originally developed for the letterpress, became the successful solution to the problem of rendering tonal values. Thus, reading matter and pictures could be combined in the same press run. The halftone process was greatly improved at the same time that the photographic revolution was taking place. Because of the advances that were produced by this revolution, a greater variety of subject matter was available for printing. Various types of film, improved lenses, and hand cameras made it possible to produce negatives more rapidly. This process enabled images to be printed more economically, and in greater quantities, in books, magazines, and newspapers. Soon after World War I, great advances were made in graphic-arts photography. Photography was then utilized in offset lithographic printing, in which the camera and halftone screens converted lines and tones to make true reproduction possible.

In 1869 Louis Ducos Haurons developed the color theory known today as four-color printing or process printing. Color balance in this process was sufficiently developed by 1890. At this time, as mentioned previously, lithography was almost at a standstill. Collotype was the only process that could successfully handle the four-color reproductive process. Collotype is a photogelatin method of printing that—before the invention of the rotary press—involved glass plates on a flatbed press. This four-color process was completely beyond the realm of stone lithography. The foundation of commercial lithography is and was the offset press and its photomechanical process. These photomechanical methods would not have worked out successfully in lithography if it were not for the offset press. The first patent for the offset press was obtained in England in 1875 by R. Barclay. By the early 1900s these offset presses were well modified and working successfully. The original uses for the offset presses were purely commercial: stationery, bank statements, business forms, etc., which were printed mainly in black and white. Offset printing was not intended for color lithography, which, at that time, was more concerned with labels, posters, and greeting cards. Before very long, however, the offset press dominated the field of lithographic color work. If it were not for the offset press, modern lithography would never have been feasible. After 100 years, stone lithography became a medium chiefly for artistic expression.

Today, a high-speed, single-color, offset lithographic press is composed of three cylinders: one that holds the plate, another that carries the offset blanket, and the impression cylinder, which presses the paper against the blanket. Ink distribution is provided by four form rollers of four different diameters. An automatic dampening system permits accurate control of the amount of moisture on the plate. The paper is fed into the press by a stream feeder, which causes the sheets to overlap as they proceed toward the press so that they move at less than press speed and can be controlled more easily. This system allows faster feeding and is capable of up to 9,000 impressions per hour, but when quality control is of the utmost importance the speed of the press must be adjusted according to the ink coverage for the specific job.

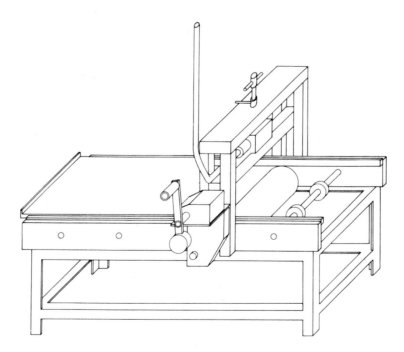

Fig. 6. Modern Charles Brand lithographic press

The barrier between the idea of the hand-printed impression as the original and the machine-printed impression as the reproduction seems to be vanishing. Yet, one thing remains certain: no machine has yet been invented that can supply the clarity, intensity, and depth of coloring, the ink penetration of paper, and the general surface beauty that a hand-printed impression can give.

Chapter Four:

THE ARTIST, THE ARTISAN, AND THE WORKSHOP

The lithographic atelier is the place where artists and artisans unite their individual talents, transferring the artist's image from mind to stone to paper. The skills of each are of equal importance; the artist supplies the conception, the artisan the execution. Suggestions flow back and forth, the artisan explaining the possibilities of lithography, the artist reacting and interpreting them. This relationship is born of necessity, because of the complexities of the medium. Unlike techniques of the past, such as wood engraving, metal engraving, etching, and aquatint, where a mistake in the printing of an artist's work meant the loss of the proof, in lithography excruciating care must be taken when printing, for a mistake here may mean the loss not only of the proof but also of the plate or stone.

The chemical process of lithography differs from that of other printing techniques. Lithography is a planographic technique: the printing is done solely from the surface of the stone or plate. In etching and engraving, however, lines and tones are produced by ink pressed into indentations on a surface.

Artists were naturally drawn to the lithographic medium, since it was the first printmaking technique that allowed them to see the results of their efforts instantaneously. Every line and every tone that an artist draws should print exactly as he drew them. They are absolutely the same—only multiplied by the number of prints that are pulled. The drawing the artist does on the zinc or aluminum plate, stone, or transfer paper is the final image.

As long as the artist uses tusche (a greasy substance that is translated into both liquid and solid substances such as crayons, liquid ink, or pencils) as the medium, he can do as he wishes. He can achieve the spontaneity of a wash drawing, the intricacy of a pen line, or the blunt, bold marking of a crayon.

An enormous range of special effects is also possible. By depositing a layer of tusche over a plate or stone, he can then scratch out layers or burn them with acid and create unique textural effects. Or he can choose to spray with an airbrush to further exploit surface effects. The image can also be reversed; all the positive areas can be turned to negative ones or all the negative ones turned to positive ones.

For the contemporary artist, lithography provides an enormous range of photographic possibilities. Photography allows drawings, paintings, photographs, and forms (two- or three-dimensional) to be reproduced exactly. If the artist desires, he can modify these images by the use of lenses or unusual lighting effects. After an image is produced either mechanically or by drawing, it can then be further modified to suit the artist's fancy. There is still much to be done with photolithography, and many fine-art lithographic ateliers today have facilities that will enable artists further to discover the possibilities inherent in this technique. Given the ease of drawing, the unique textural effects of the lithographic surface, the deep-penetrating velvety blacks, the vibrancy and brilliance of the color achieved, the potential of photography, and the short time that it takes to pull the impressions, it is no wonder that lithography has become one of the leading graphic techniques in both the fine and commercial arts.

Although a number of artists are qualified technicians, the majority are not. The task of the printer is to introduce the artist to all the possibilities of the craft that are relevant to the image the artist wishes to create. To achieve this, the printer must be a highly trained technician, and this usually takes years of practice. He must be acquainted with all the properties of stones and metal plates. He must know how to prepare their surfaces, to chemically sensitize and desensitize them. So he must understand a variety of chemicals. A skilled printer must be capable of operating various presses and highly complicated photographic equipment. He needs a vast knowledge of different papers, inks, and drawing materials. He must understand all the possible special effects employed by contemporary artists. Since artists are highly temperamental and sensitive individuals, they are often difficult to work with. Therefore, the printer must be a bit of a psychologist as well. He must also be physically strong, since lithographic stones, even the small ones, are very heavy—many weigh over a hundred pounds. In short, he must be a highly skilled, intelligent, physically sound individual with a deep knowledge of human nature.

The lithographic atelier functions for the artisan in the same way the studio functions for the artist. The layout, atmosphere, and organization all contribute to the atelier's ability to produce high-quality work. It must be a highly organized shop that is conducive to the work of both the artist and artisan. Lighting is of the utmost importance. Equipment must be in excellent order. Stocks of inks, papers, and drawing materials must be available. In sum, it must be a warehouse of supplies that is capable of stimulating the artist and displaying the possibilities of the medium to him.

Various types of equipment and, to a certain extent, much of the layout of a contemporary lithographic atelier can be attributed to commercial lithography. Much has been learned from the commercial world, especially in the areas of photolithography. Large sums of money were spent by large firms and the Lithographic Technical Foundation to develop many supplies such as inks, etches, and other solutions that are of high quality, and these in turn are being used in fine-art ateliers.

Commercial influences were not always helpful. With the advent of high-speed presses with zinc and aluminum plates, master printers who were skilled in hand-lithography declined.

For example, in the 1950s in Europe the artists of the School of Paris were extremely popular. Many collectors who could not afford their high-priced paintings were anxious to acquire original lithographs to represent these artists in their collections. But art dealers urged them to devote more time to their paintings for obvious financial reasons, and consequently the lithographs these artists produced had little of their personal involvement. In some cases the artists merely signed the finished print that was drawn on the litho stone from one of his original works by a *dessinateur* (draftsman). Some artists even signed the edition-paper before the edition was printed—with no concern for the appearance of the finished product. Some dealers encouraged this practice, since they only cared for the signature that gave the print its market value. A further

step toward impersonalization was the high-speed, automated press that produced signed editions.

These were definite signs of corruption in the ateliers of that period. Yet, it was not always this way. In the past, the printer had a mystique, a magical aura associated with his duties that to many artists was almost alchemical in nature. His work was shrouded in mystery and secrecy. The mystery was so profound that a long apprenticeship alone was necessary to prepare one to comprehend it. The secrets were so precious that only trade unions could guard and protect them. To enter a lithographic atelier was like approaching a holy ground; the artist was confronted and confused by elaborate, complicated, and intricate machinery, mysterious chemicals, an unknown language, and a general mistrust, suspicion, and refusal to reveal any more than was necessary. This situation probably arose because there was only a handful of printers in the major cities of Europe who understood the medium. The technique was a highly guarded secret that was only handed down within a family of printers, and most workshops during the nineteenth century were family enterprises. During an apprenticeship new printers learned from the master printer by observation and performance of various tasks. Only after years of grinding stones and conditioning rollers was the apprentice allowed, under the guidance of the master printer, to roll ink on a stone. To a certain extent this method is still in use today in Europe. Archaic as it sounds, it has produced a large number of master printers. But most lithographers now realize that there are no secrets, no mystery, and only with the intelligent cooperation of artist and printer can excellent work be created.

Unlike Europe, a continuous tradition of lithography did not exist in the United States. American artists traditionally went to Europe to do their lithographs. There were few master printers in the United States with the expertise and sophistication of European printers. In fact, there was only one atelier devoted entirely to the creation of fine-art lithographs in the United States until 1957.

In 1917, George Miller started the first American workshop exclusively for artists, but it was interrupted due to Miller's service in World War I. Bolton Brown, another printer, also worked for a number of artists at the time. But it was the Miller atelier that remained on the scene until the present day. With but a few exceptions, the only places left for an artist to do hand lithography were the art schools, and even there skillful technicians were hard to find.

In 1957, Tatyana Grossman opened Universal Limited Art Editions and proceeded to rekindle interest in lithography. She began attracting many well-known painters and sculptors and introduced them to the technique, which resulted in the production of some extraordinary prints.

Yet, the real dispersion of ateliers and printers throughout the country on a par with what has existed in Europe did not occur until the Tamarind Lithographic Workshop was founded by June Wayne in Los Angeles in 1960. During the period 1960–70, Tamarind, through the use of printer fellowships, artist fellowships, and curatorial fellowships in lithography, produced approximately 3,000 editions and gave grants to 103 artists, 252 guest artists, curatorial grantees, staff members, and printer trainees. Most of these printers went on to open their own workshops or to teach lithography throughout the United States and Canada. Tamarind literally created a renaissance for lithography.

Chapter Five:

PAPER

There is one essential element to a quality lithograph that can never be overlooked by the serious artist, printer or collector: the paper on which the lithograph is printed. For a good-quality stock is needed not only for performance and durability but also for the beauty of a lithograph.

There are two ways of distinguishing papers: how they are made and what they are made of. While both are important, it is the latter—the composition of paper—that is most crucial. We can categorically state that fine-art lithography demands the use of papers that are high in rag content. In the past this meant handmade papers. But today several quality papers are available that are rag papers and yet are made by machines. These are the so-called mold-made papers, and the best are marked W.F. (wood free).

In the western world, rag papers are generally made of cotton or linen or a mixture of the two. Not only do these ingredients produce a strong, durable and lasting paper, but they also provide a wider range of textures that enhance the beauty of lithographs. Some of the richest textures can only be found on handmade papers. On the other hand, handmade papers do tend to be slightly irregular in size and shape and especially in thickness.

These irregularities are due to the process involved in making paper by hand. After the rags have been macerated into a watery pulp, a *vatman* dips a mold—a wooden frame enclosing finely woven wires—into the solution. As he lifts the mold out, he shakes it to remove some of the water and to distribute the fibers evenly over the mold. Even the most skilled *vatman* cannot always produce sheets of uniform thickness. Next, another artisan, the *coucher,* takes the mold and turns it upside down to allow the sheet to drop onto a felt blanket. Successive layers of paper and blankets are built up, and then the stack is placed on a press, where the excess water in the paper is squeezed out. A *layman* then separates the paper sheets from the felt blankets, and finally a *dry worker* hangs up the sheets to dry in an area where air circulates freely. This long, piecemeal process understandably makes handmade papers very expensive.

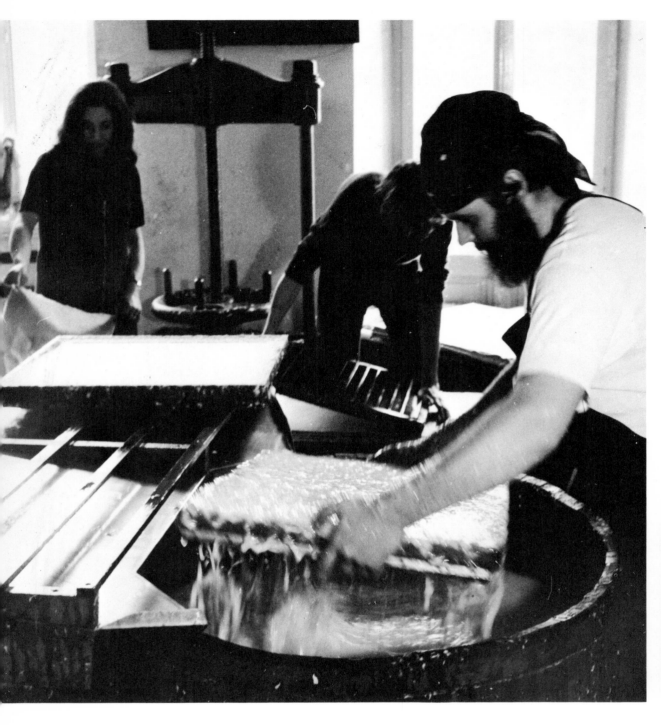

François Lafranca shakes a mold over the linen pulp that is used for his special "Carta Lafranca" paper. Behind him an assistant places a newly formed sheet onto a felt blanket. Next to the window is the press that squeezes the water from the sheets. (Courtesy of Lafranca)

Sheets of handmade linen paper frame a worker who has hung them to dry at the Lafranca workshop in Locarno, Switzerland. (Courtesy of Lafranca)

In the nineteenth century, such costly handwork, added to the scarcity of sufficient quantities of rags, led to the development of woodpulp papers. They were, however, a mixed blessing. Such inexpensive papers made quickly from the abundant wood resources allowed a wide dissemination of books and printed materials. Literacy, education, and culture benefited, but there was a hidden problem. Papers made of groundwood fibers are weaker, since wood fibers are shorter than rag fibers. There are also fugitive substances in woodpulp that make paper discolor and disintegrate. While such papers were fine for newspapers and other transitory printings, many valuable books and artworks—including lithographs—were damaged beyond repair long before the rag paper of works made hundreds of years earlier had even begun to show signs of age.

The artist and printer who are dedicated to excellence will choose the rag paper that is best fitted for their lithograph. The collector need only be sure that the lithograph he wishes to own is indeed printed on a rag paper.

Chapter Six:

HOW A HAND-PRINTED LITHOGRAPH IS MADE

Before showing in a step-by-step process the creation of a lithograph, we should briefly explain the fundamentals of lithography. Lithographic stones are almost pure limestone (94 to 98 percent calcium carbonate). They range in color from blue-gray to yellow. The color of the stone indicates its quality. The grayer stones are more desirable because grease penetrates them more uniformly; they are older, harder, and more dense, and accept a very fine grain. The yellow stones are softer and cannot be grained as finely, which may cause printing problems.

Lithography is based on the chemical principle of the antipathy between grease and water. The lithographic stone has a natural affinity for grease. The image to be reproduced is drawn on the stone with a greasy material. In order to reproduce the drawn areas and keep the negative (nondrawn) areas from printing, the stone is chemically treated. This process uses nitric acid and gum arabic. The nitric acid opens the pores of the stone, enabling the gum and grease to enter easily. The gum arabic surrounds the drawing and forms an insoluble surface film that clings to the nonprinting areas. This coating surrounding the image attracts water applied during printing and also establishes the water reservoir. It will not wipe off, and it prevents the grease from spreading and blurring the image.

Because of the antipathy between grease and water, the image will attract oily ink from the roller as it simultaneously repels water. Thus, when the stone is dampened and an ink-charged roller is passed over it, a film of printing ink is deposited on the greasy drawing and not on the remainder of the stone. Once the stone is fully inked, a piece of paper is placed upon its surface. This is covered by a protective piece of newsprint, and then by a blotter and tympan (a smooth sheet of zinc or phenolic resin upon which grease is placed, allowing the scraper bar to slide along smoothly). This package is sent through the press, imprinting the paper and producing a print.

We selected Chiron Art Workshop to illustrate the creation of a lithograph by Paul Jenkins. Jenkins has been collaborating with the printers at Chiron for more than four years. This collaboration between the artist and the printers has spurred Jenkins to new realms of creativity and has resulted in the development of new methods and techniques for both the artist and the printers.

Often artists arrive at the workshop with predetermined ideas, sketches, or even photographs of paintings that they wish to relate. At other times, they come with no ideas at all. Paul Jenkins has always arrived with a preconceived idea and allowed it to evolve through his drawing process.

1. Selecting the stone

The printer, who in this case is Andrew Vlady, director of Chiron Art, selects the stones to be used. He chooses dark gray stones of the highest quality. A separate stone is needed for each color. Each stone is hand-grained to remove old images (Ill. 1). The production of a specific grain is another important reason for this process. This grain provides the tooth for the drawing material and serves as a water reservoir in printing. The stones are then laid out on various tables adjacent to the drawing materials used to create the image.

2. Creating the image

Jenkins uses tusche combined with various solvents; distilled water, tap water, and, recently, alcohol and gasoline have all proved important to him in breaking the granular pigment in the tusche. Each of these different kinds of solvents has a unique wash effect and therefore creates unique textures when poured or drawn on the stone. In illustration 2, Jenkins pours water over the tusche-drawn image to dilute and create wash veils.

The poured line is consistent with his painting, and he achieves the veils that are identified with his painting. He brings to lithography the quintessence of his paintings but adheres to the honesty of the medium and respects the exciting limitation only the medium can offer.

The artist begins with the poured line, using a full, fine-haired French brush that allows him to pour the liquid granular fluid in a clean, precise line (Ill. 3). The sense of intention is there. There is tautness in a Jenkins line that is like a drawn bowstring. It is never random but tense and exact. That same exactness is expected for the superimposed lines or forms, which come from the preceding stones. In illustration 4, Jenkins tilts the stone to allow the tusche to flow across the surface and create a veil.

The challenge, for Jenkins, is to interpenetrate the whole rather than just to distribute local color and create balance, which is often the case in the lithographic medium.

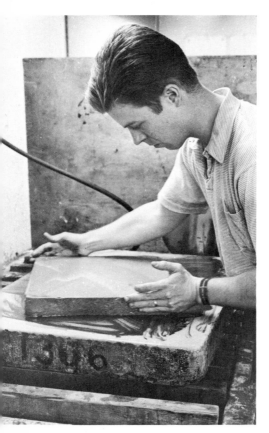

Ill. 1. Hand-graining a lithographic stone (Photo, M. Knigin)

Ill. 2. Pouring water on image (Photo, M. Knigin)

Ill. 3. Using French brush (Photo, M. Knigin)

Ill. 4. Allowing tusche to flow off stone (Photo, M. Knigin)

3. Etching or desensitization process

The purpose of the etching process is to make the image receptive to the printing ink. Before the etch, a protective coating of rosin must be applied, and talc must be dusted over the drawing (Ill. 5). The rosin, which is acid resistant, protects the image from the etch, while the talc absorbs the excess grease from the image enabling the etch to adhere to the edges of the drawing and thus assuring precise re-creation of the image. The etch, a mixture of nitric acid and gum arabic (Ill. 6), is applied to the surface of the stone

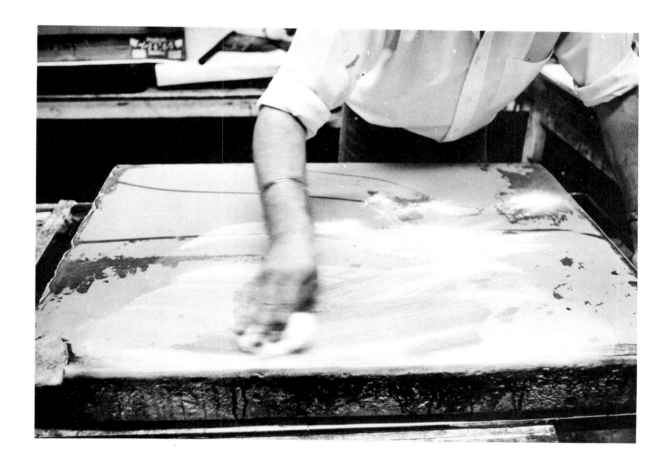

Ill. 5. Dusting image with talc (Photo, M. Knigin)

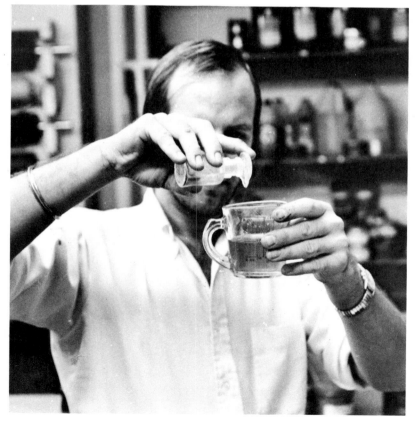

Ill. 6. Measuring mixture of acid and gum arabic (Photo, M. Knigin)

47

in varying strengths and for different lengths of time (III. 7). This process is called multiple-spot etching. The etch is buffed dry with cheesecloth (III. 8) and allowed to dry for at least two hours.

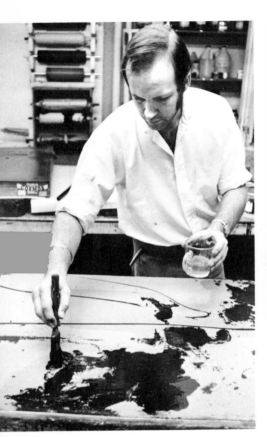

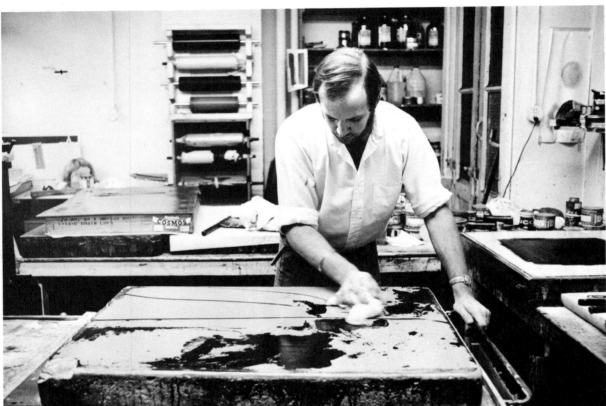

III. 7. Applying etch (Photo, M. Knigin)

III. 8. Drying etch with cheesecloth (Photo, M. Knigin)

4. *Washout, rollup, and proofing*

The tusche-drawn image is washed off the surface of the stone with turpentine. Ink is rubbed onto the surface of the stone, replacing the old tusche-drawn image and simultaneously providing a protective coating. This ink is allowed to dry. The stone is then dampened and rolled up with ink (III. 10). After a number of preliminary proofs are taken in black ink, the stone is etched again to stabilize it. Once again, it is proofed and etched to finally stabilize it for the running of the edition. After the third etch, the stone is proofed in the colors specified by the artist on handmade Arches paper, which is imported from France.

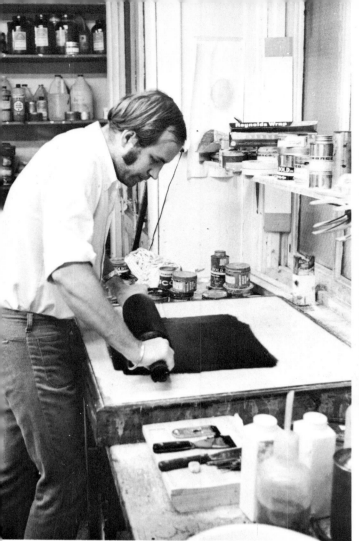

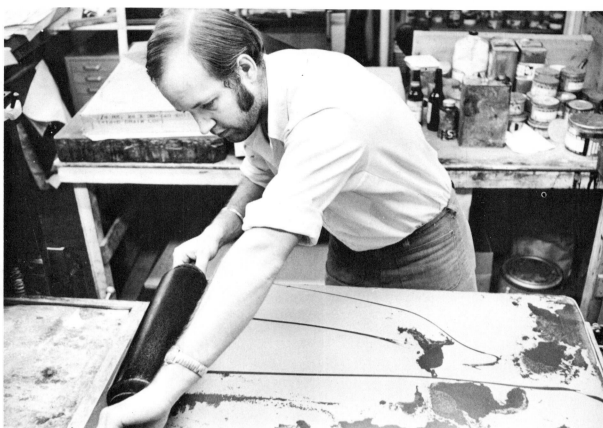

Ill. 9. Rolling even layer of ink onto ink slab before rolling stone (Photo, M Knigin)

Ill. 10. Rolling stone with ink

Ill. 11. Registering paper on stone

Ill. 12. Placing grease-covered tympan over paper and stone (Photo, M. Knigin)

Ill. 13. Adjusting the pressure of the press (Photo, M. Knigin)

Ill. 14. Pulling down lever of scraper bar (Photo, M. Knigin)

Ill. 15. Removing printed proof from stone (Photo, M. Knigin)

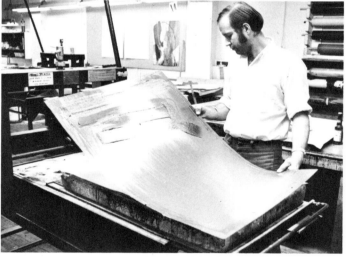

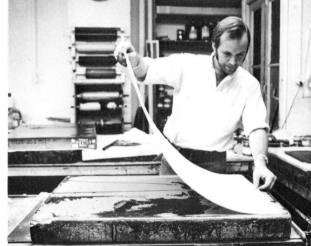

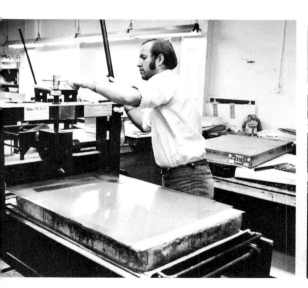

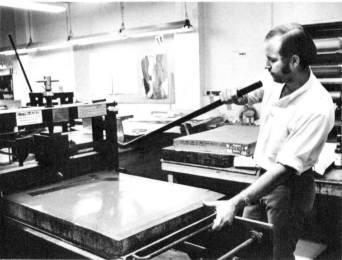

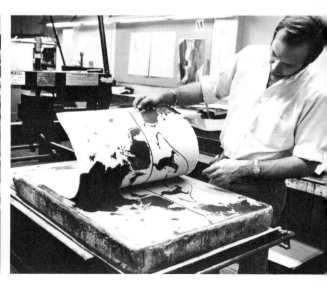

The same procedure as with the first stone is followed with the other stones. The second stone is proofed and printed over the first color, followed by the third, fourth, and fifth stones. Jenkins then carefully studies each result of the proofing (Ill. 16), changes colors, eliminates or adds where needed with each superimposition, and selects with the printer the final paper to be used for the edition. The final important decision for the artist is the choice of the *bon à tirer,* the print that will present the standard that all the other prints in the edition must conform to. After the edition has been pulled to the satisfaction of the artist, the prints are cleaned and then inspected by the artist. Any lithograph impression that does not meet the standard of the *bon à tirer* is eliminated. The edition prints are then signed (Ill. 17) and numbered, and the seal of the atelier (Ill. 18) is applied to all the prints.

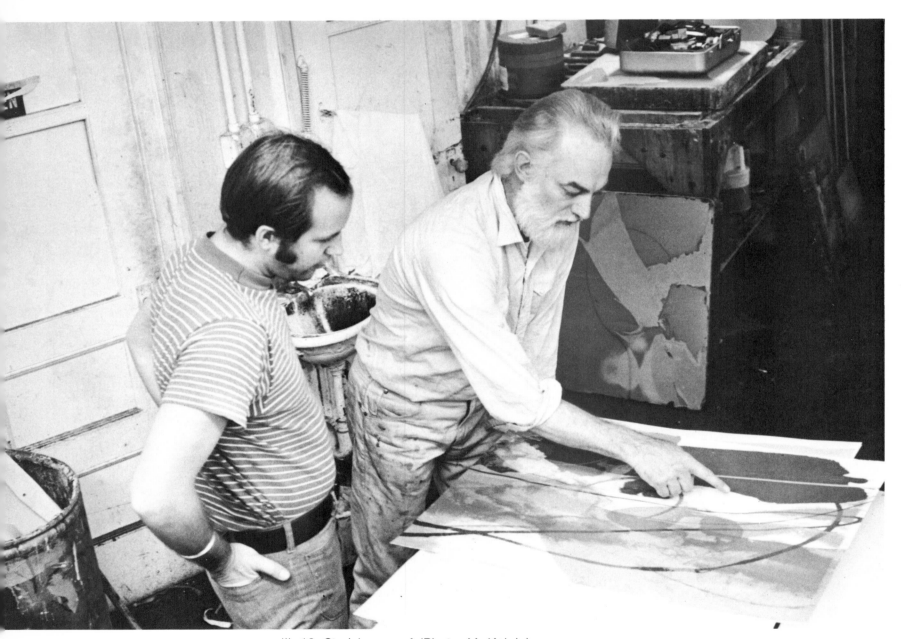

Ill. 16. Studying proof (Photo, M. Knigin)

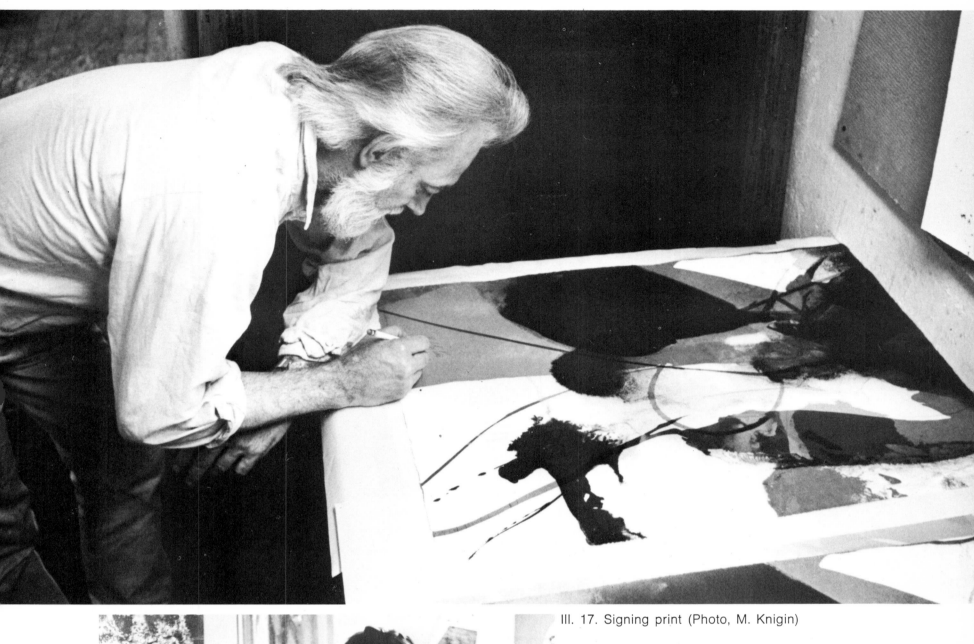

III. 17. Signing print (Photo, M. Knigin)

III. 18. Fixing seal (Courtesy of Editions Press)

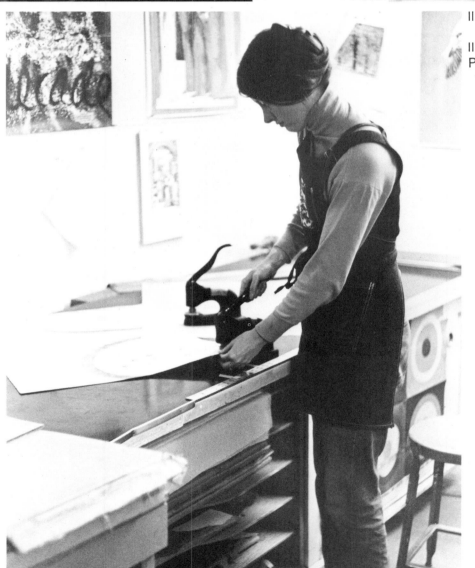

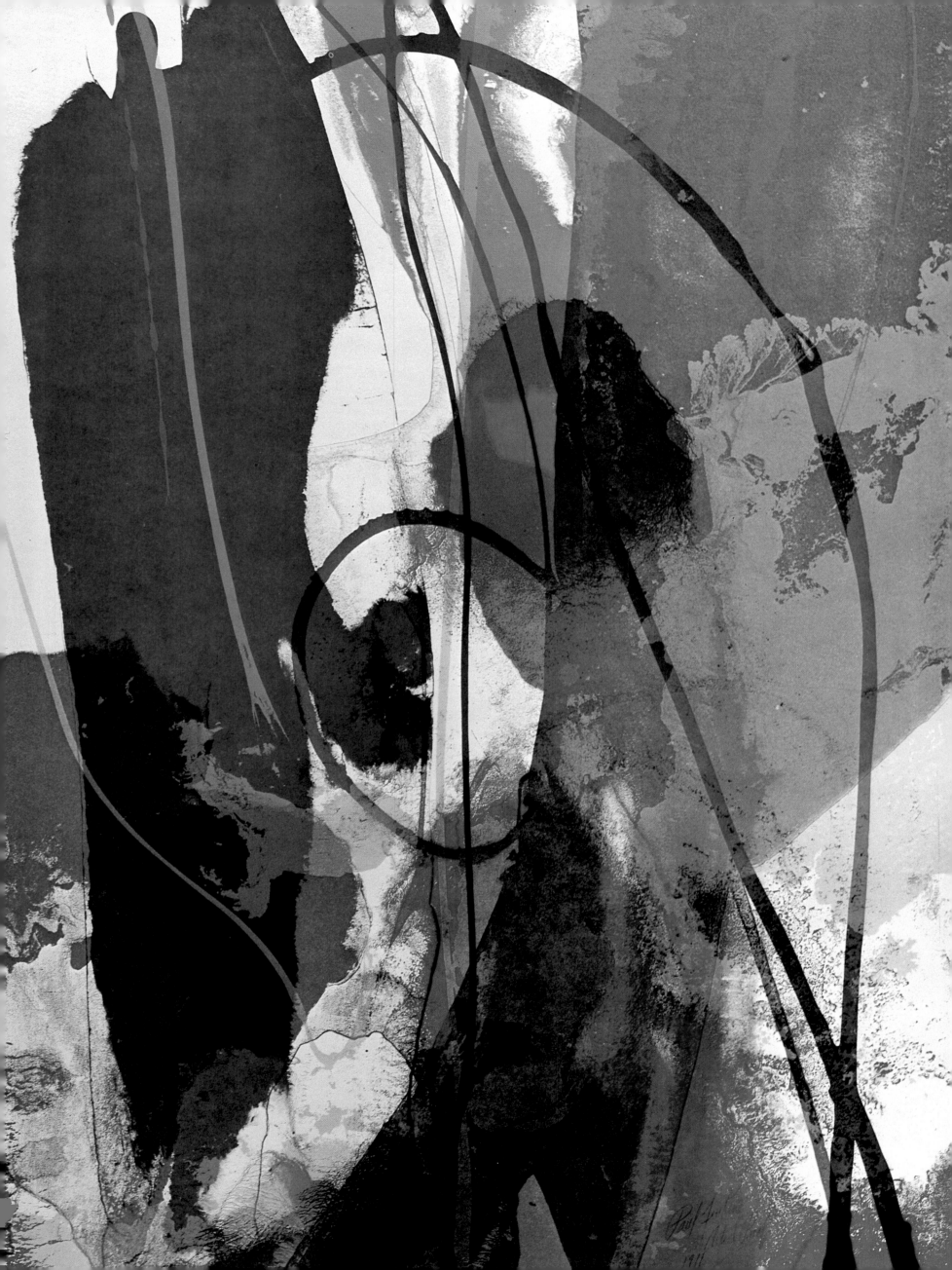

Untitled (1971), Paul Jenkins,
22¼ x 30 in.
(Courtesy of Chiron Press.
Photo, Malcolm Varon)

NORTH AMERICAN LITHOGRAPHIC WORKSHOPS

CHIRON ART

Chiron Art exists to publish and print editions and to do research in the field of preservation and restoration of modern works of art.

There is no doubt that technique is vitally important to printed art. Without entering into the drama of jealousy between various art firms and their appropriate techniques, it is a fact that techniques will always be improved and must always be improved for reasons that are most obvious.

I do not feel that lithography is an art form—it is a technique and a process of creating multiple images. It is the collaboration between artist and lithographer that is an art form.

The artist draws, paints, and assembles images but does not perform lithography. The lithographer in turn does not draw, paint, or assemble images but prepares and ensures that the sum of the parts will equal the whole.

Working procedures must change every time a new artist comes to the shop or when the same artist returns to do new work. A rigid working procedure, I feel, will give all work the "look" of a particular shop. I feel that "stylish" is a state to be avoided.

Director: *Andrew Vlady*

In 1967 Michael Knigin opened a lithography workshop at 831 Broadway in Manhattan. In September of the following year, he and Roger Loft formed a partnership which included the production of hand-printed lithographs and hand-printed silkscreens. Chiron Press was purchased from Steven Poleskie, and the name was retained. Chiron Press remained at the above address until 1969. In 1969 Chiron moved to 58 East 11th Street, and in 1971, after the dissolution of the partnership and sale of the Press, Andrew Vlady became owner and director of Chiron Art, which devoted itself solely to the hand-printed lithograph, utilizing its two Charles Brand presses.

Recently Chiron Art closed its New York operation and relocated in Mexico City, Mexico, under the name of Kyron Ediciones Graficas Limitadas, S.A.

Mariposa 1127
Mexico 13, D.F.

The following is a partial list of the artists who have worked at Chiron Art: Richard Artschwager, Jack Beal, Bob Beauchamp, James Brooks, Paul Cadmus, Albert Christ-Janer, Peter Deshar, Pedro Friedeberg, Matias Goeritz, Budd Hopkins, Ralph Humphrey, Paul Jenkins, Wolf Kahn, Gordon Kluge, Michael Knigin, Brice Mardin, Rodolfo Nieto, Ray Parker, Luccio Pozzi, David Prentice, Abel Quezada, Adolfo Riestra, Frank Roth, Bob Stanley, Andrew Stasik, Saul Steinberg, Wayne Thiebaud, Walasse Ting, Murray Zimiles, Francisco Zuñiga.

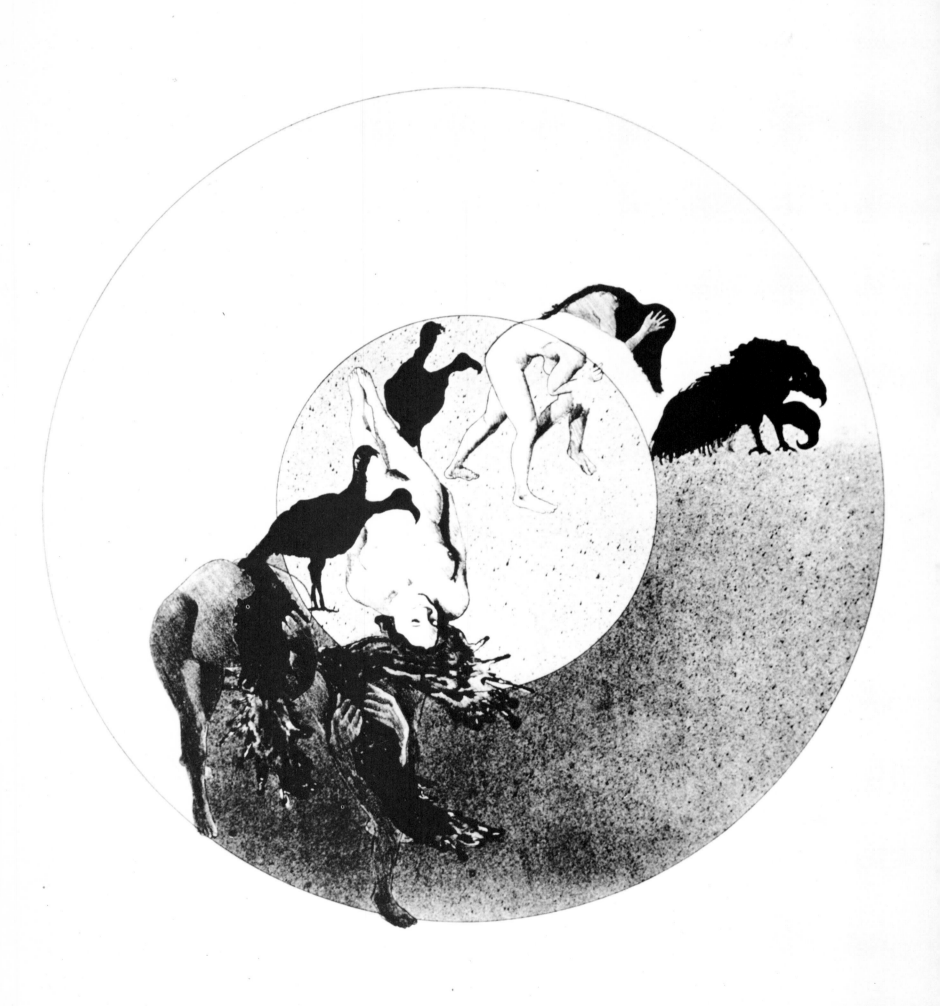

Hawk (1968), Murray Zimiles,
22¼ x 30½ in.
(Courtesy of the artist.
Photo, Malcolm Varon)

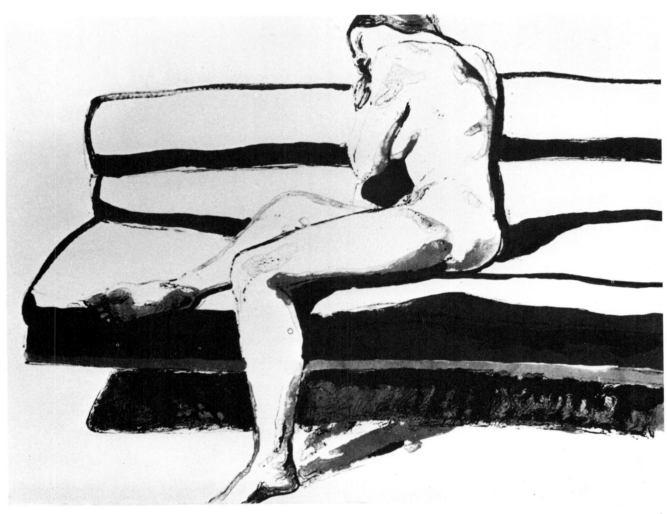

Nude on Couch (1969), Philip Pearlstein,
22¼ x 30½ in. (Courtesy of Brooke Alexander.
Photo, Caroline Goodden)

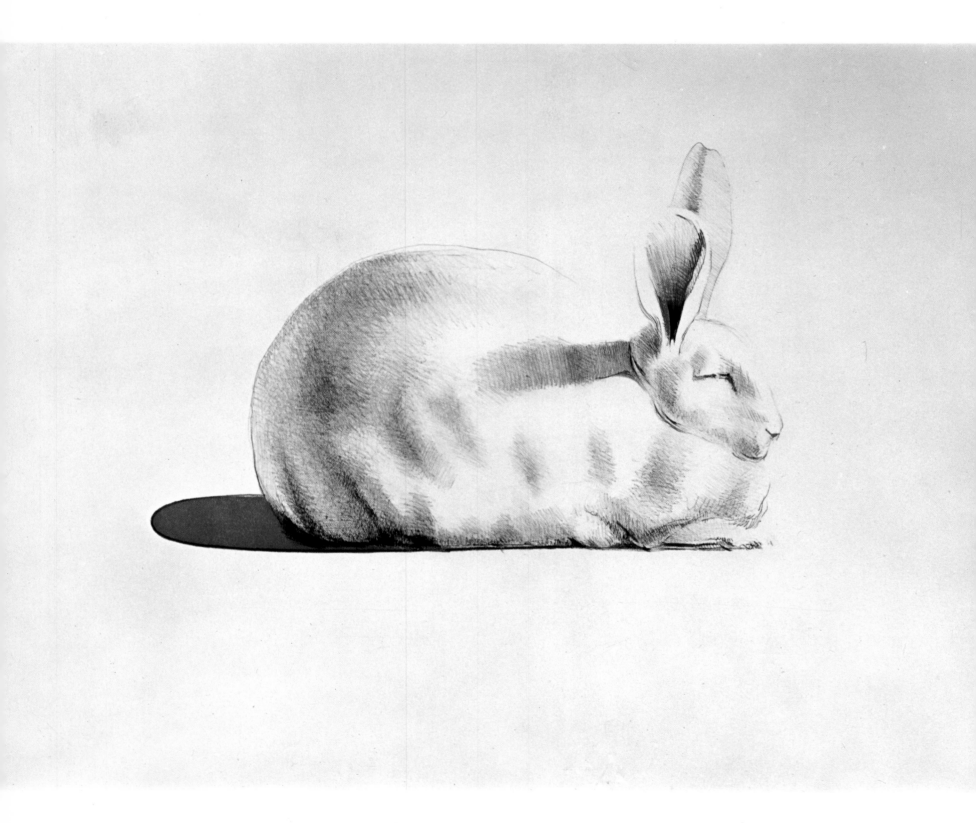

Rabbit (1971), Wayne Thiebaud, 22¼ x 30¼ in. (Courtesy of Parasol Press, Ltd. Photo, Malcolm Varon)

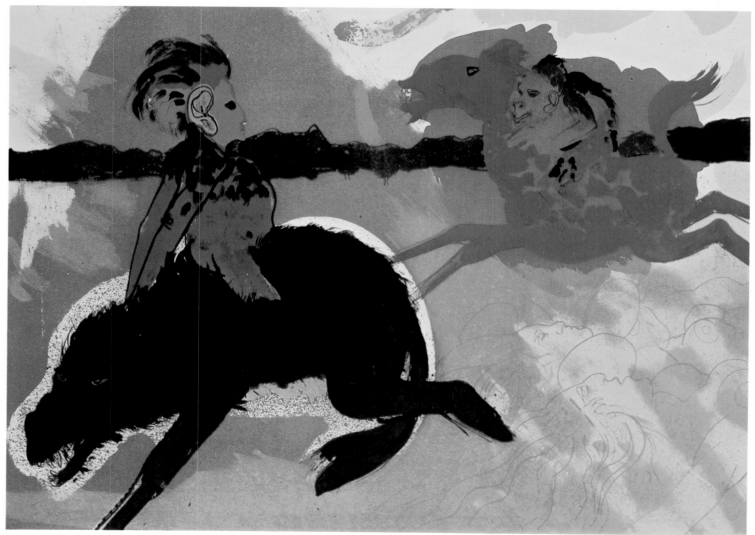

Untitled (1970), Robert Beauchamp, 18 x 26 in. (Courtesy of the artist. Photo, Malcolm Varon)

Moment I (1971), Andrew Stasik, 22½ x 30½ in. (Courtesy of the artist)

CIRRUS EDITIONS

Jean Milant, director of Cirrus Editions.
(Courtesy of Cirrus Editions)

The door to Cirrus Editions opened January 1, 1970. A few months later the Los Angeles Fine Arts Squad was called, and the façade was painted; the image is a cirrus cloud—white and filmy, the highest in the atmosphere. The entrance now reflects the name; the transformation of the material reflects the philosophy behind the workshop, the beliefs of its founder and director, Jean Milant. Milant, one of the youngest workshop directors, has an extensive background in both art and science. He holds a Master of Fine Arts degree from the University of New Mexico in Albuquerque. As a Ford fellow, Milant went to Los Angeles in 1968 to work at Tamarind Lithography Workshop; he became a Tamarind Master Printer in October 1969. Cirrus Editions printers Paul Clinton, Ed Hamilton, and David Trowbridge are also Tamarind Master Printers, providing the artist with a full inventive range through their complete expertise and technical knowledge. The resulting prints are scrutinized by a high-quality standard of checking and limiting editions. Extensive documentation, as established by Tamarind, is also maintained at Cirrus.

Milant likes the West Coast art world. He likes what the artists are doing. He foresees the transformation of ideas and energy into major aesthetic statements. Los Angeles, he feels, is a vital place to be, to run a workshop. He likes to work with younger artists—Terry Allen, Greg Card, Doug Edge—to introduce them to the medium, to have them extend their aesthetic through lithography. Milant remains open to new techniques and innovations; with each new artist he researches a variety of new materials and printing methods. The very flat, claylike surface of Ed Ruscha's *Sin* is achieved through screen printing. The use of varnish in the specific high-gloss areas in the recent Joe Goode series of lithographs is an instance of combining screen printing with lithography.

Cirrus Editions is primarily proprietary, but it also engages in the production of custom editions for the professional artist. Whether publishing or producing custom work, Cirrus maintains a standard policy of collaboration. The shop must become an extension of the artist's studio, a comfortable place in which to work. He is then familiarized with the full range of possibilities. The people working with the artist are in turn familiarized with his creative output so they may better understand his needs. These basics allow for the necessary interplay between concepts, collaborators, and equipment and allow for that meticulous pursuit of an artistic concept that is the basis for this type of production. The concept generates the collaboration, often extending the known possibilities in lithography to meet its demands. An artist's concept is never rejected because methods and materials cannot yield a tangible form; rather, methods and materials are remade or invented as the need arises.

The workshop in its first year completed thirty editions of lithographs and thirty editions of screen prints using one motorized Griffin lithography press and three screen tables.

Cirrus is financed partially through subscriptions to publications. It is currently

building a comprehensive portfolio, a combination of lithographs and screen prints, created by artists from the West Coast: Terry Allen, Greg Card, Vija Celmins, Doug Edge, Joe Goode, Craig Kaufman, Ed Moses, Ed Ruscha, and Stephen von Huene.

708 North Manhattan Place
Los Angeles, California 90038

Lisp (1970), Ed Ruscha, 20 x 28 in. (Courtesy of Cirrus Editions)

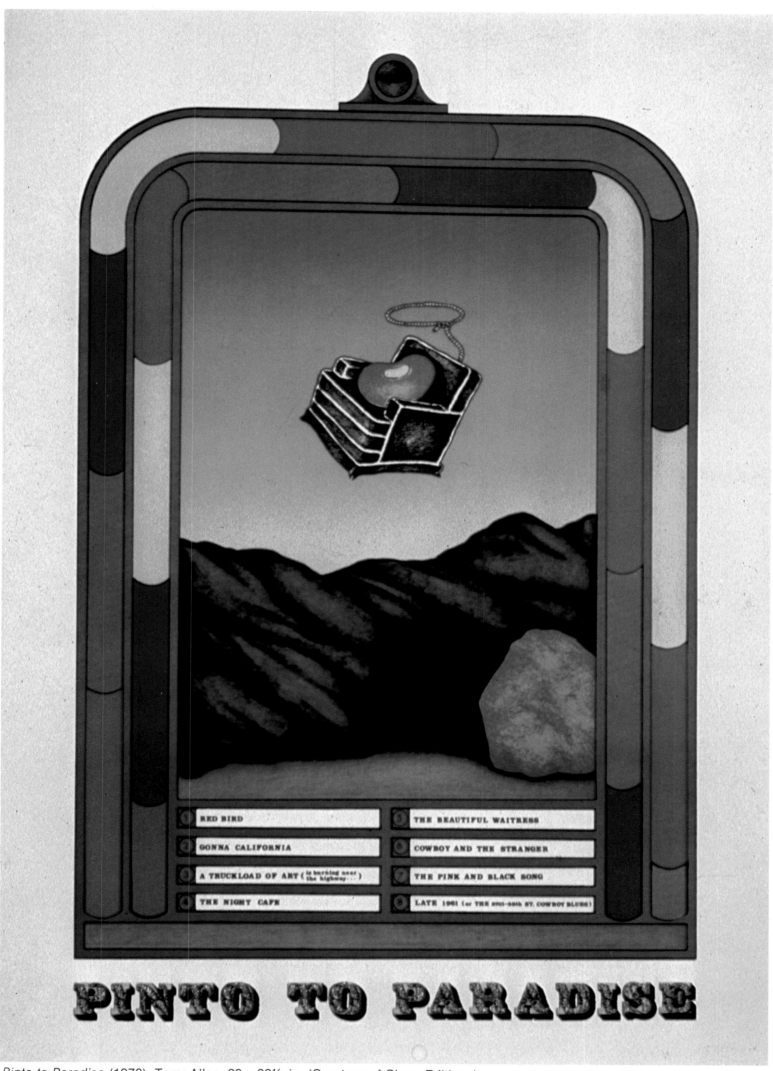

Pinto to Paradise (1970), Terry Allen, 29 x 22½ in. (Courtesy of Cirrus Editions)

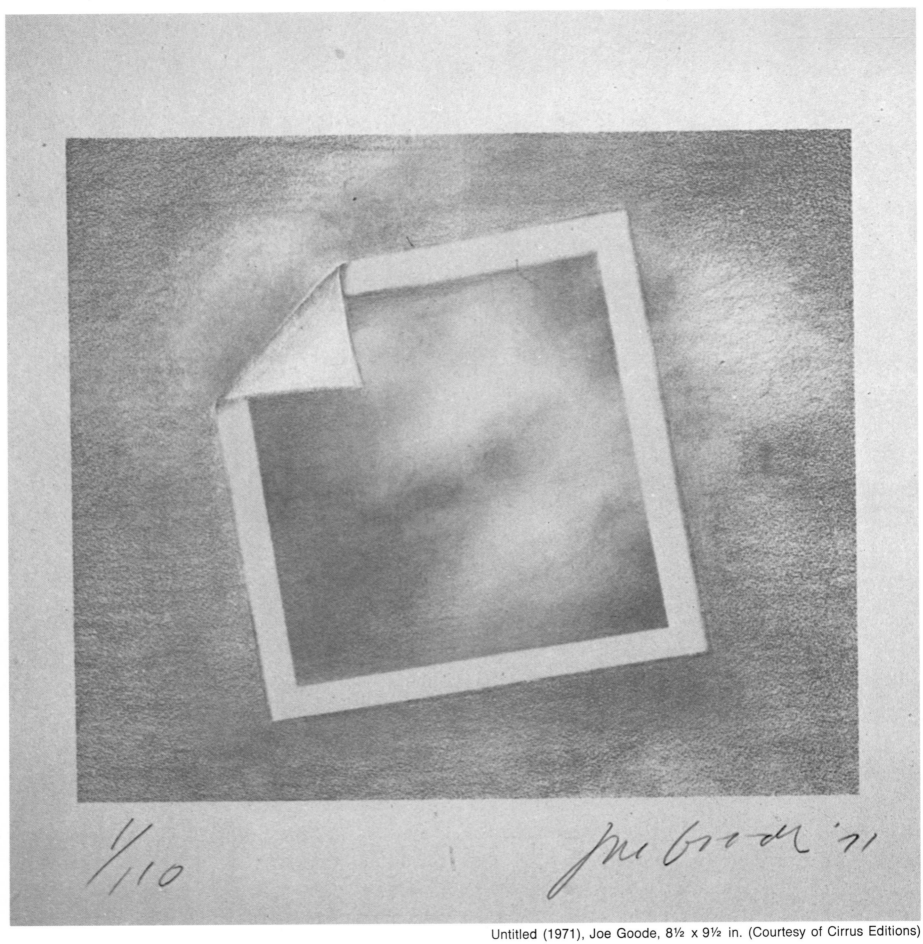

₁/₁₁₀

Untitled (1971), Joe Goode, 8½ x 9½ in. (Courtesy of Cirrus Editions)

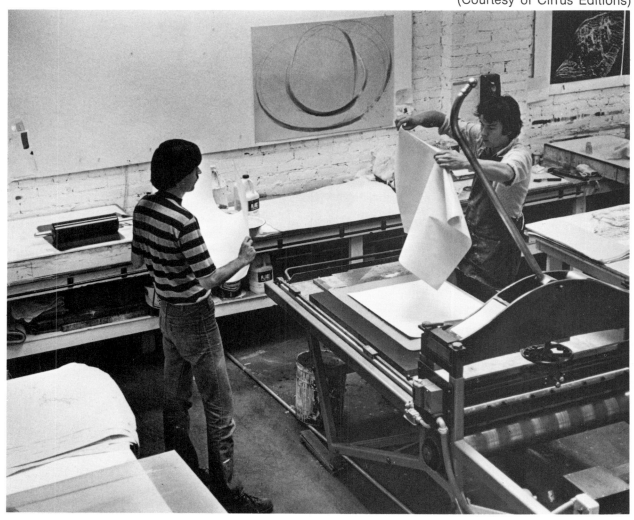

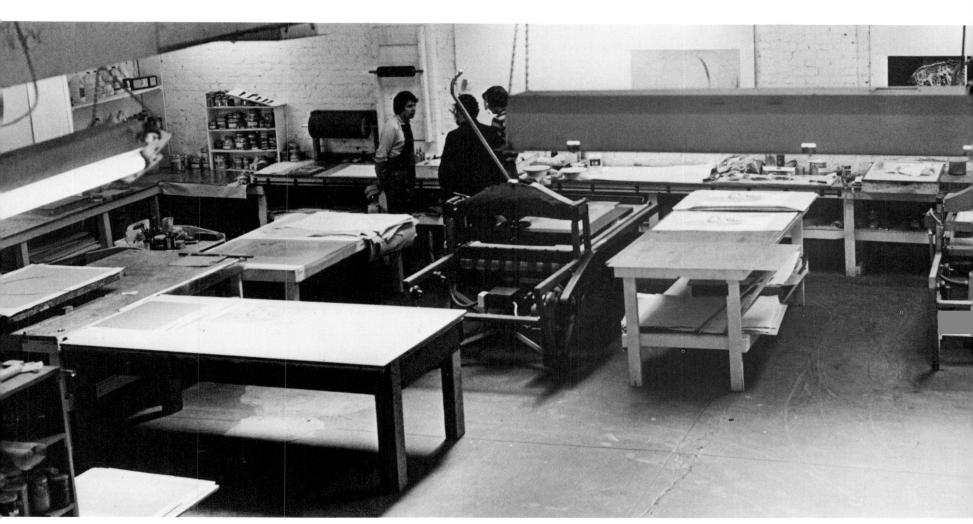

EDITIONS PRESS

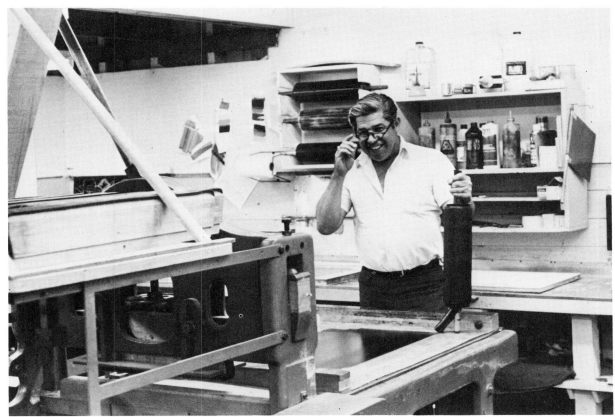

(Courtesy of Editions Press)

Editions Press is primarily a publishing concern, but it also does custom work for foreign and local artists. At present this work is done only in lithography, but in the near future silk screen and intaglio will also be offered.

After agreement has been reached in a contract between the artist and the Press concerning the number of images, the approximate number of colors in each, and the size of the edition, the master printer suggests the kind of materials and the kind of stock to be used. Examples of various techniques and possibilities are shown, and the artist then works on the premises for as long as is required for proofing and the arrival of the *bon à tirer*. The artist may remain until editions are completed, or he may return merely to sign the completed edition. Here is a unique collaboration between artist and printer: where the artist discovers direction but not restriction, where creative work speaks for itself.

The prevailing policy and goal set by Editions Press has been, and is, to produce works of art of the highest museum caliber. To achieve this end, an exhaustive search for new materials and methods is made during the initiation of each project or individual lithographic design. This application of industrial products, tools, and the designing of specialized equipment costs much in time and money, but the end result—a unique graphic work—justifies the means. A careful search is also made to find artists whose best expression comes out through graphics. Another criterion of the Press is to avoid being branded as belonging to one school or style. The only marks that identify work as that of Editions Press are those of uniqueness and high quality.

The Press strives to offer the artists whom it serves graphics that they will be proud of having designed. Editions Press strives to be a cultural center by giving tours and lectures to the artistic community.

Director: *Walter F. Maibaum*

Editions Press was founded in January 1967, under the direction of Ernest de Soto, a former recipient of a Tamarind Grant Fellowship. Until August 15, 1972, the workshop was known as Collectors Press; since then its name has been Editions Press. Since its inception, the workshop has attracted artists from all over the United States, Europe, and South America to come to San Francisco to create fine works of original graphic art on the workshop's six presses.

621 Minna Street
San Francisco, California

The following is a partial list of the artists who have worked at Editions Press: Garo Antreasian, Enrico Baj, Broderson, José Luis Cuevas, J. Davis, Richard Diebenkorn, Masuo Ikeda, Robert Natkin, Jules Olitski, Nathan Oliveira, Parker, A. Pomodoro, Mel Ramos, Scholder, Siqueiros, Tamayo, Peter Voulkos, Adja Yunkers, Francisco Zuñiga.

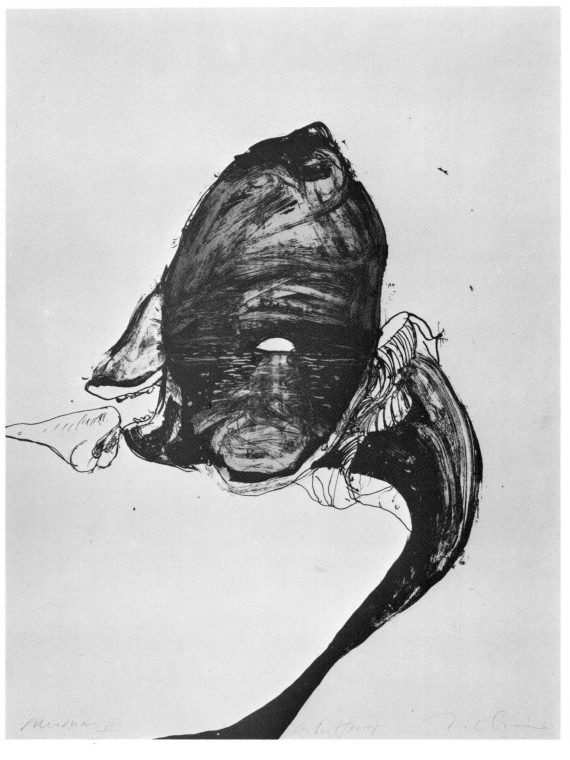

Miramar II (1969),
Nathan Olivera, 22 x 30 in.
(Courtesy of Editions Press)

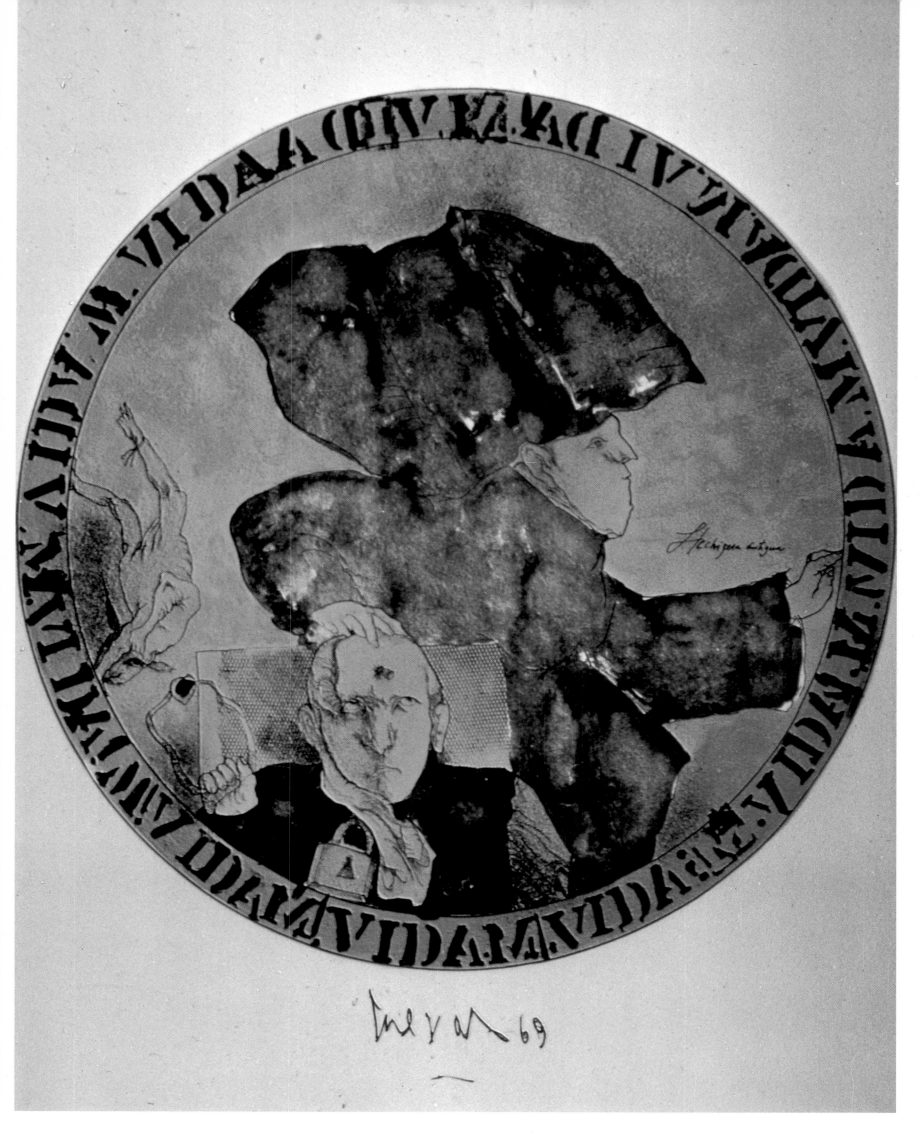

Hechizera Antigua (1969), José Luis Cuevas, 22 x 30 in.
From the suite, *Homage to Quevedo.* (Courtesy of Editions Press)

(Courtesy of Editions Press)

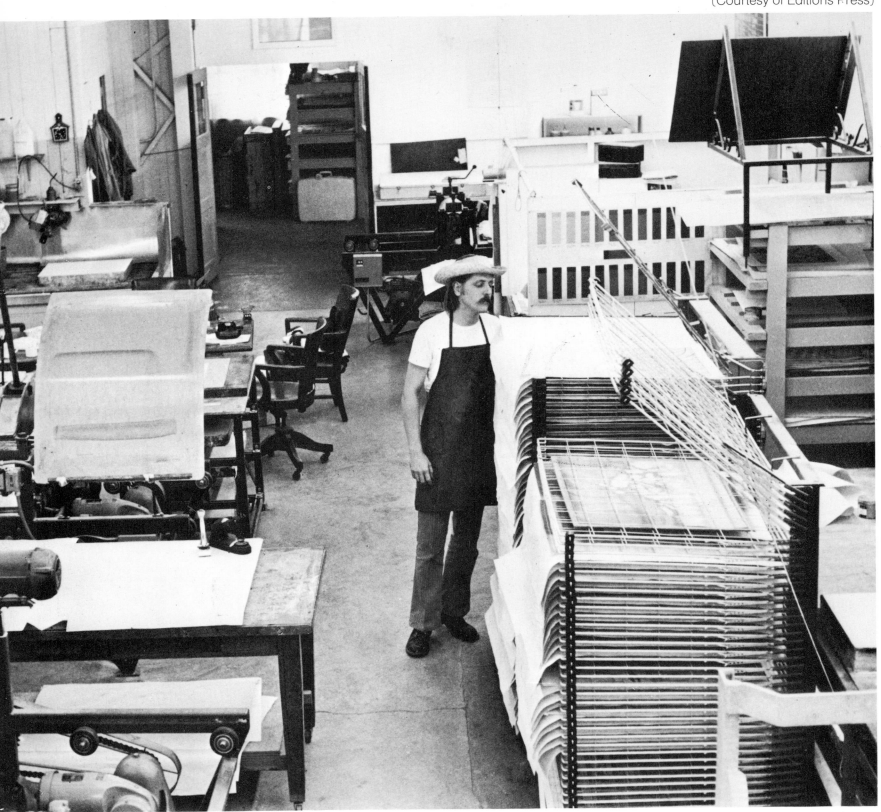

GEMINI G.E.L.
(GRAPHICS EDITIONS LIMITED)

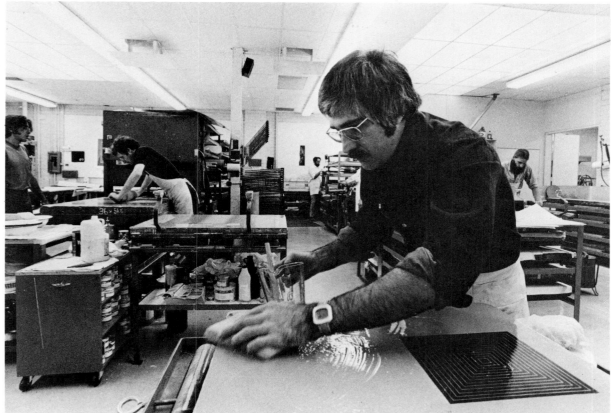

(Courtesy of Gemini, G.E.L. Photo, Malcolm Lubliner)

Since the purpose of Gemini is to commission, print, and publish major contemporary artists in depth in the areas of lithography and other print media and multi-dimensional objects, we collaborate directly with one artist at a time, using a wide base of research and technology augmented with a highly trained staff. Complete artistic freedom does not dictate a usual procedure. It is only possible to judge individual projects.

It is axiomatic that a technological society based on automation would not preserve hand crafts. This has become apparent to many concerned creative people over the last two decades. Unfortunately, some of these people tried to solve this contemporary problem by becoming hopeless craft romantics determined to restore craft to its original state. Like self-styled evangelists of the thirties, they thrived on the opportunity to add more rules and regulations to an already archaic tradition and to denounce anyone who disagreed. Rarely were the needs of the contemporary artist or craftsman taken seriously in this onslaught of craft revival. Few bothered to research and develop new techniques and systems for creative persons entering the crafts, either as workers or as creators.

By 1964 it became clear to me that most traditional methods, as well as some recent practices of the hand-printing crafts, were not compatible with the images of major contemporary artists. As a collaborator I left the ranks of this revival to aid the major artist in his search for new graphic expression and new work environments.

From the outset, the goals of Gemini were to expand the handcraft through the development of larger papers, new presses and printing elements, and new materials and techniques. These would also give the artist freedom to increase the scale and expression of his work. Each invited artist was encouraged to challenge the skills and inventiveness of his collaborator. Soon, what had begun as a hand-lithography workshop also became a workshop for dimensional object and screen printing. Believing that Gemini's total resources should be used for the realization of each artist's project, we developed a program of producing and publishing one artist's project at a time. The creative achievements and funds from one project contributed to the success of the next and provided a new freedom for both collaborators and creators.

Over the past six years Gemini has attempted to fulfill its goals by using technology and research to the fullest, while still remaining a hand-craft workshop flexible enough to serve the artist and his creativity.

Director: *Kenneth E. Tyler*

Formed in July 1965 by Kay and Ken Tyler under the name Gemini, Ltd., the shop's primary function was custom publishing. In 1966 Gemini G.E.L. (a California corporation) was formed, primarily as a publishing shop and retail gallery with some exceptional special printing jobs for museums or foundations.

The major innovations in lithography from this facility have been the largest hand-printed lithograph to date, a unique use of color, and specially designed equipment (four of the shop's seven lithographic presses are custom made from designs by the director).

8365 Melrose Avenue
Los Angeles, California 90069

The following is a partial list of the artists who have worked at Gemini: Anni Albers, Josef Albers, John Altoon, John Chamberlain, William Crutchfield, Alan D'Arcangelo, Ron Davis, Sam Francis, Joe Goode, Jasper Johns, Don Judd, Ellsworth Kelly, Edward Kienholz, Roy Lichtenstein, Claes Oldenburg, Ken Price, Joe Raffaele, Robert Rauschenberg, Man Ray, Ed Ruscha, Ben Shahn, Frank Stella, Wayne Thiebaud.

Frank Stella working on his *New Foundland* series at Gemini in 1970. (Courtesy of Gemini, G.E.L. Photo, Malcolm Lubliner)

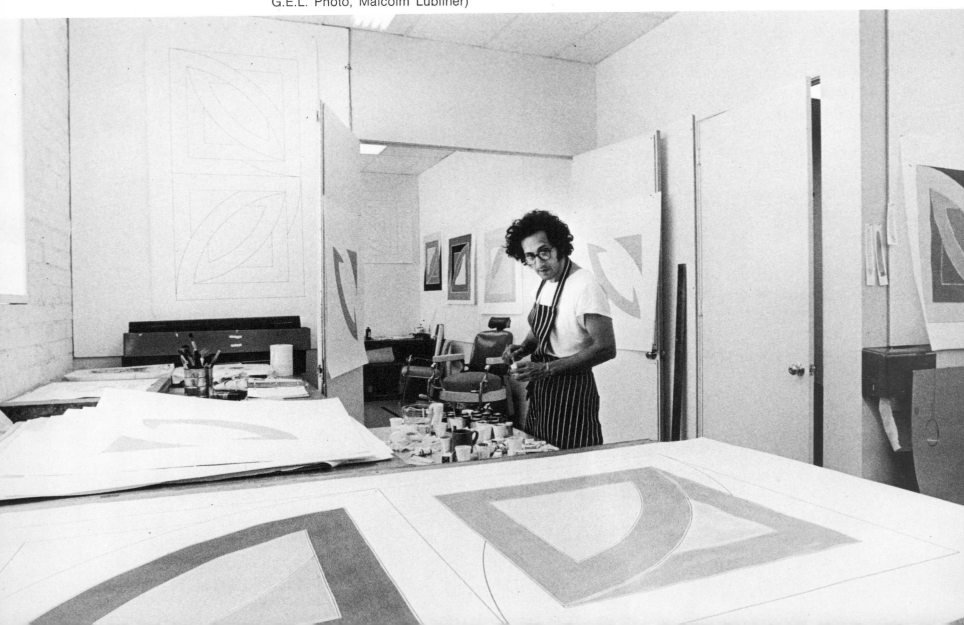

Fragment—According to What—Leg and Chair (1971), Jasper Johns, 35 x 30 in. (Courtesy of Gemini, G.E.L.)

Bonne Bay (1971), Frank Stella, 38 x 70 in. (Courtesy of Gemini, G.E.L.)

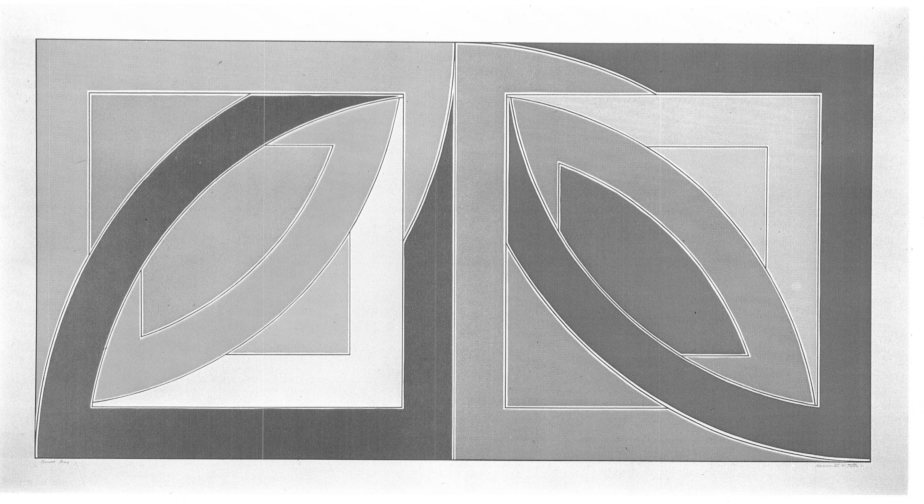

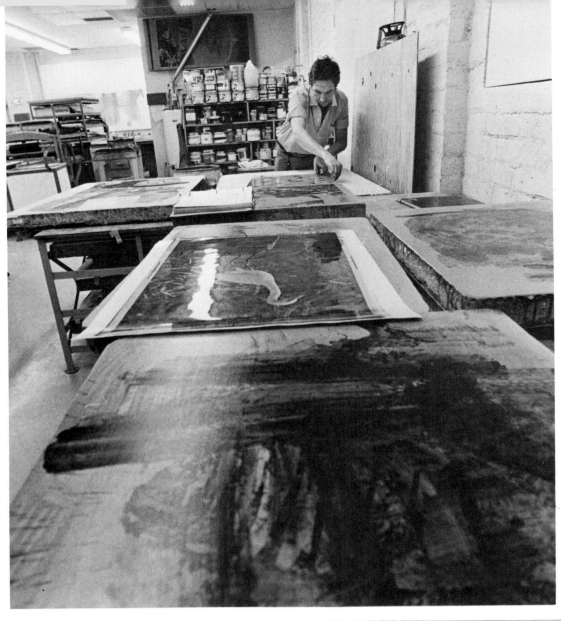

Robert Rauschenberg drawing on lithographic stones at Gemini in 1969. (Courtesy of Gemini, G.E.L. Photo, Malcolm Lubliner)

Gemini workshop during Robert Rauschenberg's *Stoned Moon* series in 1969. (Courtesy of Gemini, G.E.L. Photo, Malcolm Lubliner)

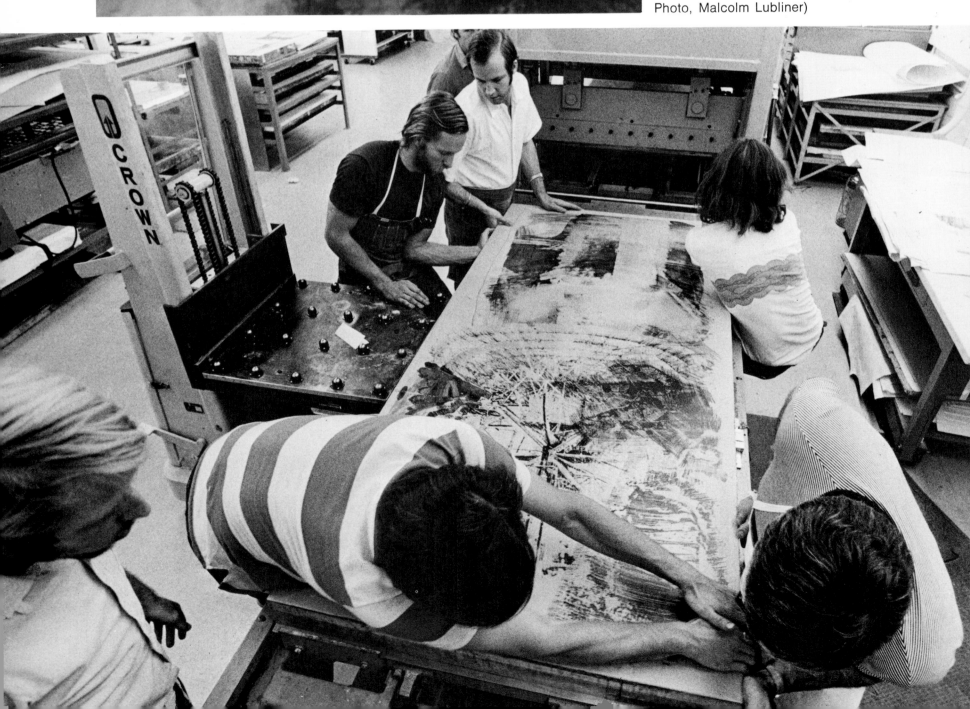

Sky Garden (1969),
Robert Rauschenberg,
89 x 42 in.
(Courtesy of Gemini, G.E.L.)

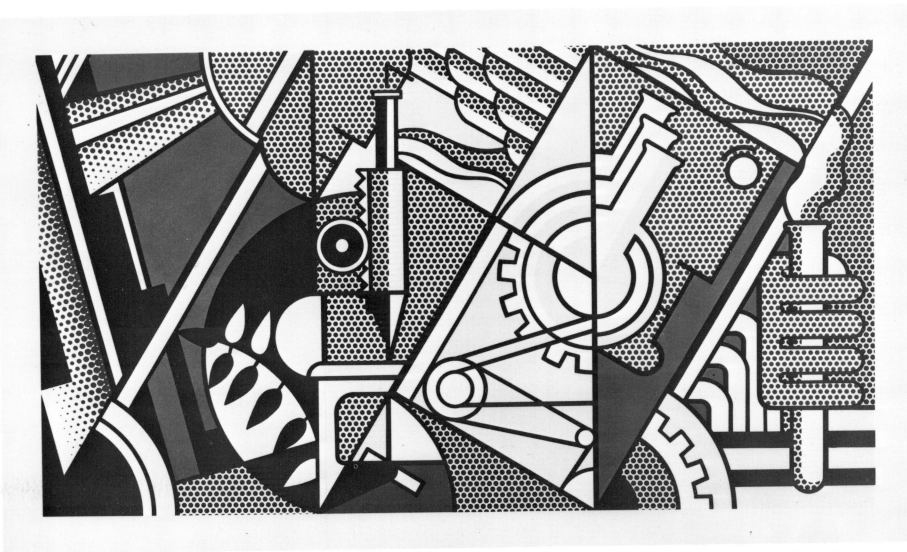

Peace Through Chemistry 1 (1970), Roy Lichtenstein, 37¾ x 63½ in.

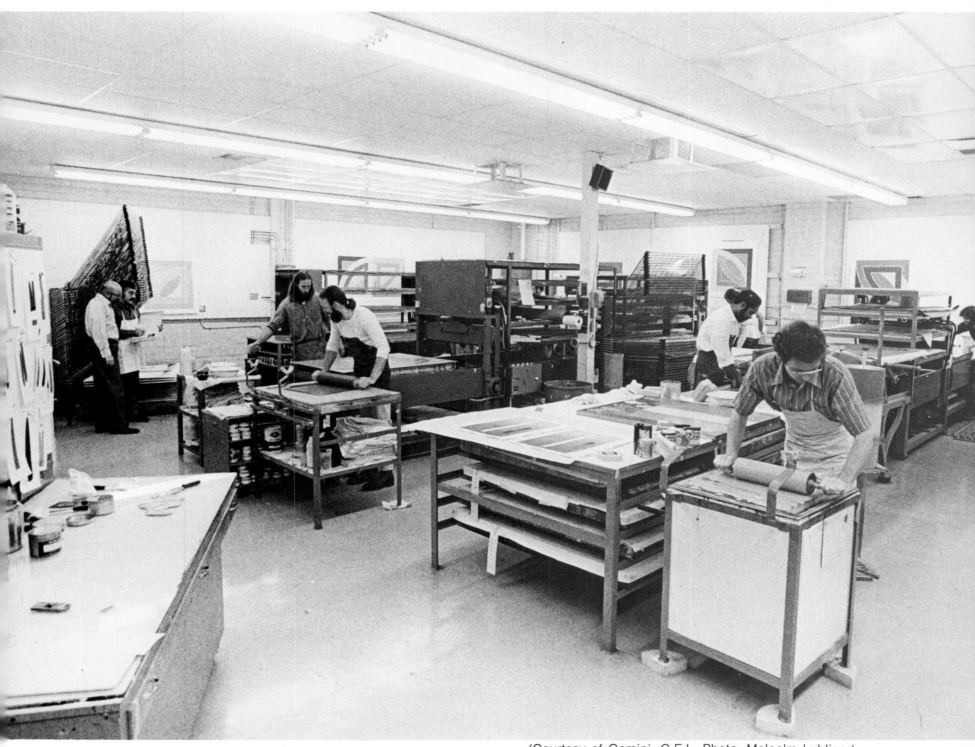

(Courtesy of Gemini, G.E.L. Photo, Malcolm Lubliner)

GRAPHICSTUDIO

(Courtesy of GRAPHICSTUDIO)

Five artists are usually invited and scheduled over a nine-month working period to collaborate with two full-time master printers. As a general rule, five editions are offered to each artist, encompassing an average of four press runs per edition. The printing of these editions commences when the entire proofing project is completed and the artist has left the GRAPHICSTUDIO. Upon completion of printing, curating, chopping, and documenting of the editions, a signing session with the artist is arranged. As an honorarium for his participation in the program, the artist receives most of the impressions produced, plus a limited number of trial proofs, color trial proofs, and artist proofs.

The GRAPHICSTUDIO at the University of South Florida was established to facilitate the production of prints in an atmosphere in which the artist is free from the pressures of a commercial atelier. Artists are invited to participate for a period of about six weeks for proofing and editioning of their work. They are assured of the complete attention of the GRAPHICSTUDIO staff during that time.

The workshop is devoted to technical excellence and experimentation within a framework flexible to the needs of the artist. It is a non-profit organization that prides itself on the multiplicity of activities that it serves. Besides being a resource to the artist, it serves as a vehicle through which students and the community can have the opportunity to communicate with some of the most formidable artists on the current scene. The dialog growing out of such a situation serves as an educational tool of prime quality. In addition, prints retained by the University are mounted in exhibitions for use on campus and are loaned without charge to other institutions in Florida.

The GRAPHICSTUDIO, in short, is devoted to the creative act and to affecting students and public through contact with artists and the eloquence of their art.

Director: *Dr. Donald J. Saff*

The GRAPHICSTUDIO was established in January 1969 by Dr. Saff as a cooperative program between the Department of Visual Arts and the Florida Center for the Arts at the University of South Florida. The first printer was Tony Stoeveken. Now Theo Wujcik and Chuck Ringness are the master printers who operate the shop's ten diversified presses. The development of the GRAPHICSTUDIO has been aided substantially by contributions from the National Endowment for the Arts, Washington, and the Syracuse China Corporation, New York.

University of South Florida
Tampa, Florida 33620

The following is a partial list of the artists who have worked at the GRAPHICSTUDIO: Charles Hinman, Nicholas Krushenick, Philip Pearlstein, Mel Ramos, James Rosenquist, Ed Ruscha, Richard Smith, Adja Yunkers.

83

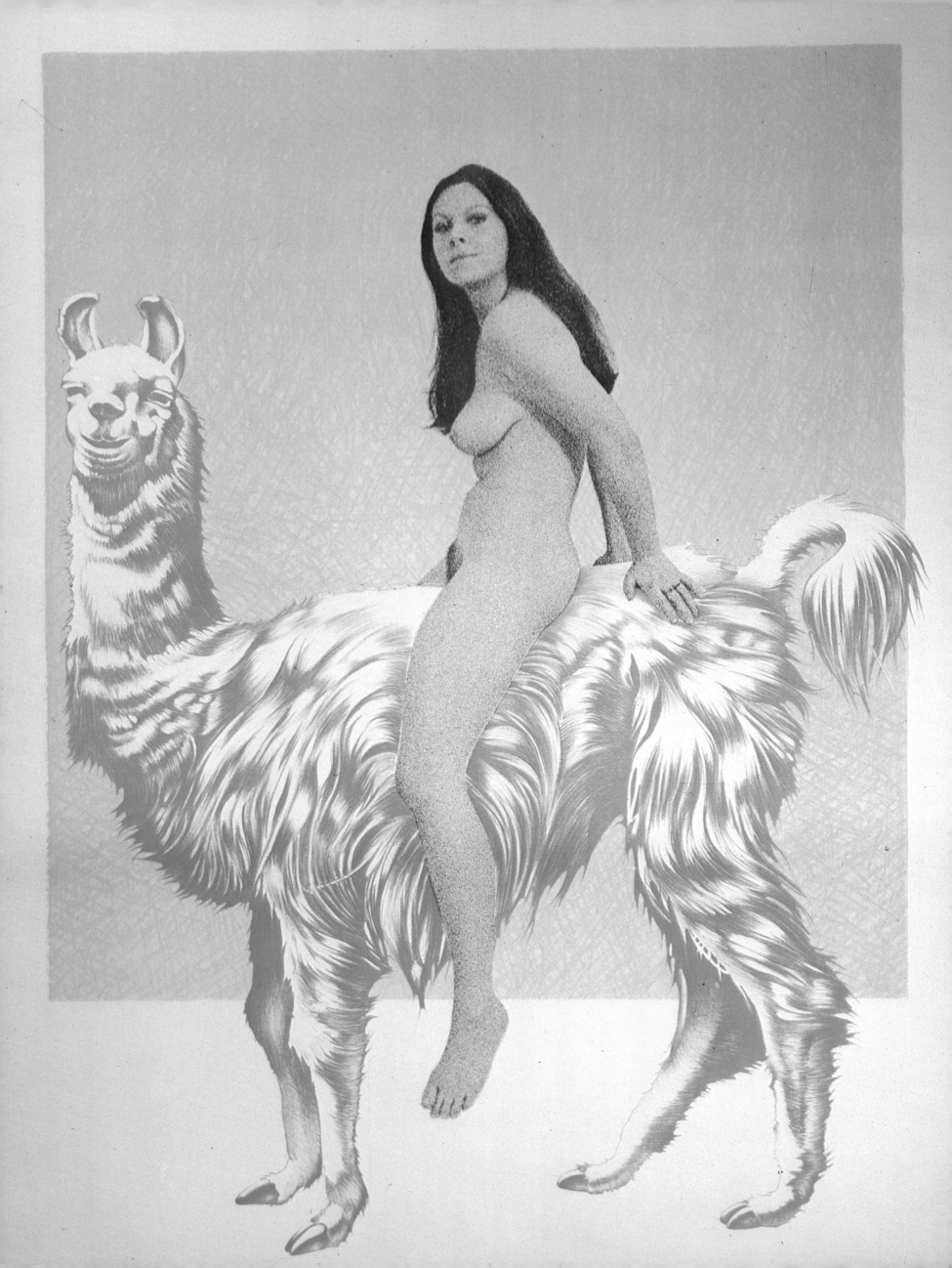

Llama (1970), Mel Ramos, 22 x 30 in.
(Courtesy of GRAPHICSTUDIO)

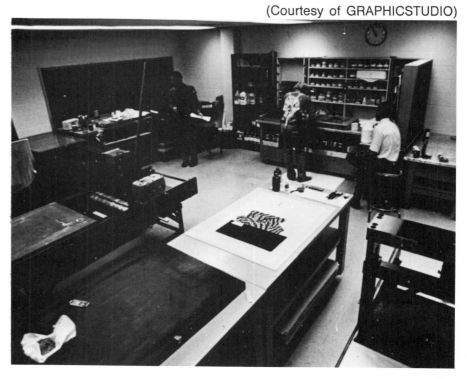

Mel Ramos at work on his lithograph *Llama*.
(Courtesy of GRAPHICSTUDIO)

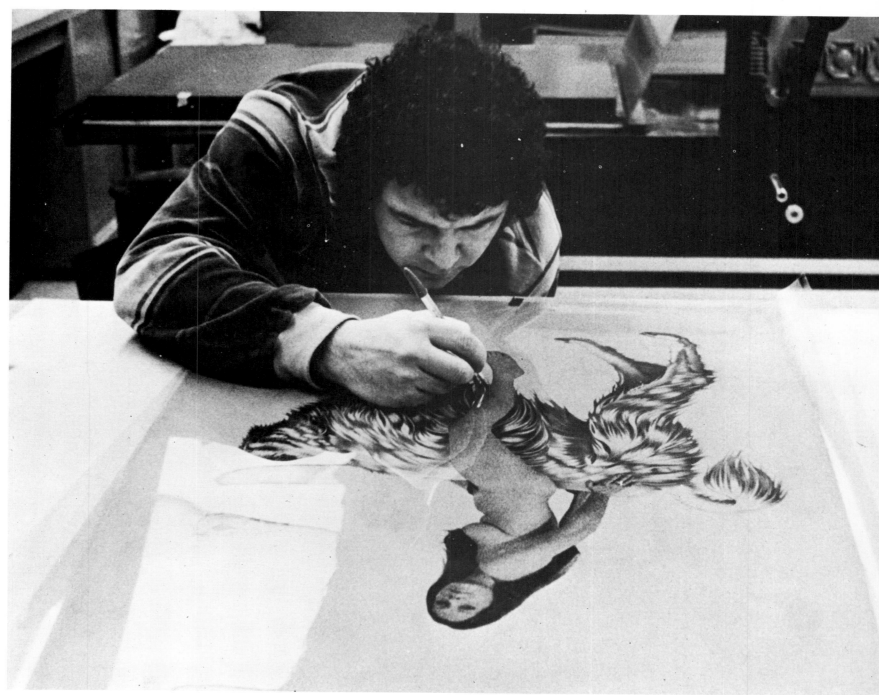

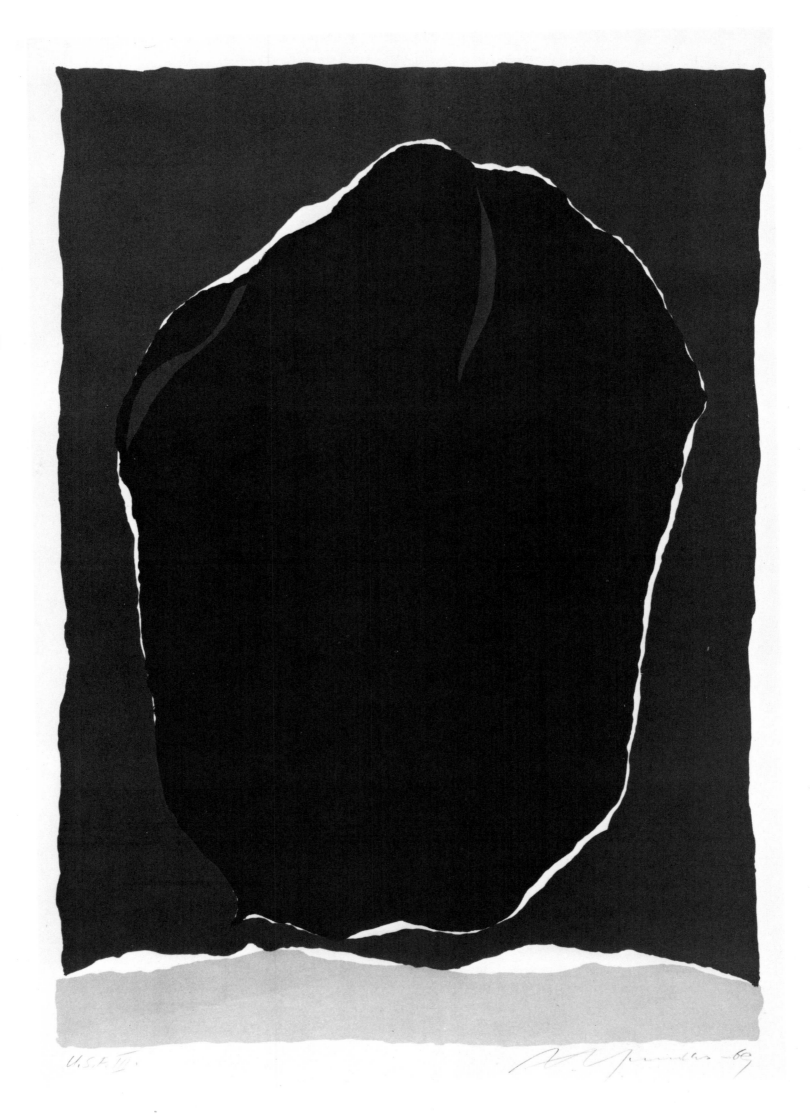

U.S.A. I. A. Upsuller 69

Untitled (1969), Adja Yunkers,
22 x 30 in.
(Courtesy of GRAPHICSTUDIO)

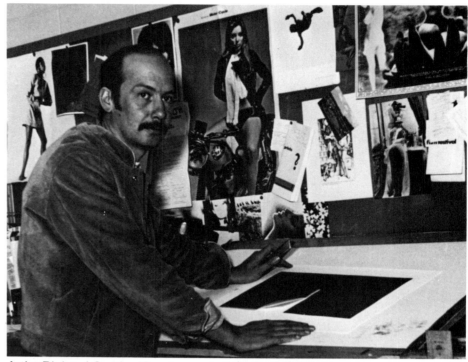

Artist Richard Smith. (Courtesy of GRAPHICSTUDIO)

Untitled (1969), Richard Smith, 12 x 15 in.
(Courtesy of GRAPHICSTUDIO)

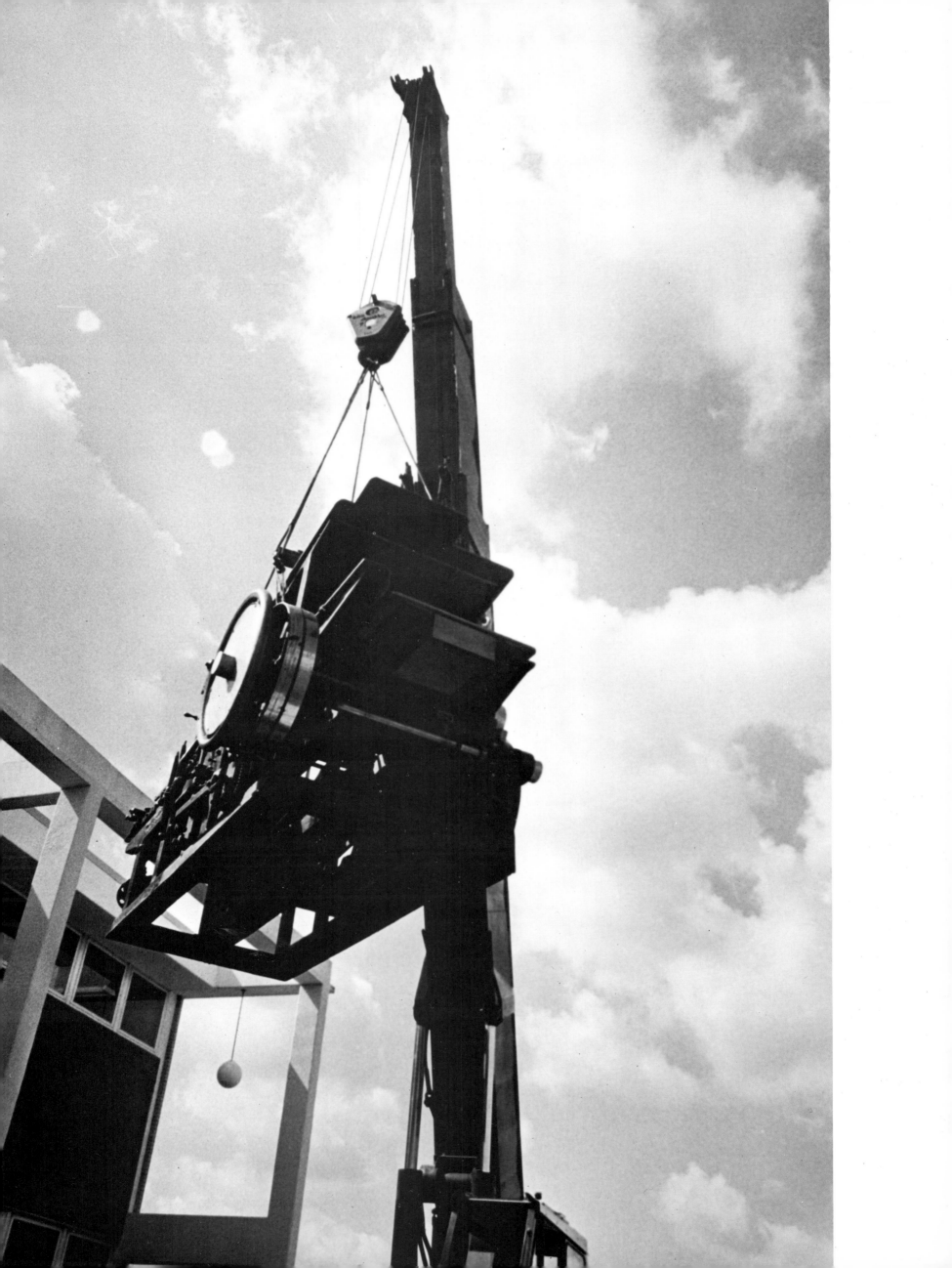

Installation of the studio's offset press.
(Courtesy of GRAPHICSTUDIO)

Offset printing of Nicholas Krushenick lithograph. (Courtesy of GRAPHICSTUDIO)

HOLLANDERS WORKSHOP

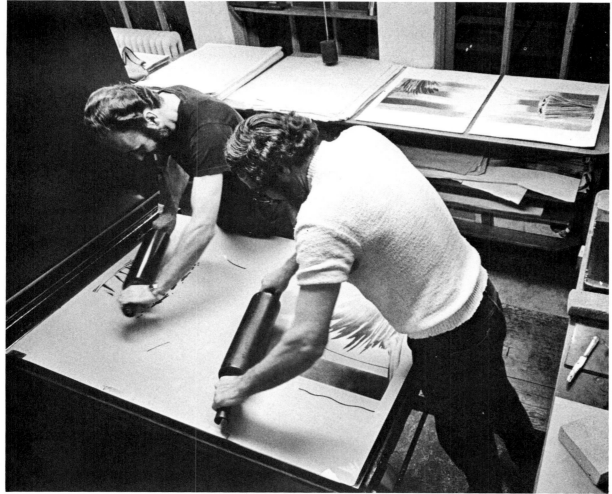

Since the intent of our workshop is to satisfy whatever technical quality level an artist desires, the right mode of collaboration develops uniquely with each artist. The opportunity to work with people who try to express visually through our collaboration allows us to see at first hand how varied and rich visions can be. From idea to finished product the process is satisfying and surprising since some prints develop and can be completed in hours and others take months.

Directors: *Irwin Hollander*
Fred Genis

Irwin Hollander, born in New York in 1927, studied at the Brooklyn Museum. He later studied at the Art Students League, as well as in Mexico. Hollander, a printer-fellow for two years at Tamarind Lithography Workshop, was technical director there from 1963 to 1964. In 1964 he moved to New York and set up the Hollander Workshop, a print shop that not only printed commissioned works but also published and sold through its gallery at 90 East 10th Street, New York City. He was joined by Fred Genis in June 1969.

Fred Genis was born in 1934 in the Netherlands. At the age of thirteen he had the opportunity to work with artists when he was enrolled in the Amsterdam Graphic School as a student stone-printer. Lithography proved to be the ideal field to combine his interests in art and printing. Working with artists and making fine prints is to this day what he happily thrives on.

He came to the United States in 1965 and worked for the Gemini Workshop in Los Angeles. He received a grant from Tamarind in 1967 and later took the position of master printer at Universal Limited Art Editions.

Hollander and Genis became partners in June 1969. Since Fred was a Hollander, the ''s'' was added to the existing name, making it plural. Hollanders Workshop is located on New York's Lower East Side. Prints published at Hollanders Workshop bear the distinctive mark of the combined chops of the two master printers.

195 Chrystie Street
New York, New York

The following is a partial list of the artists who have worked at Hollanders: Josef Albers, Pierre Alechinsky, Lee Bontecou, John Cage, Salvador Dali, Sam Francis, Helen Frankenthaler, Phillip Guston, Jasper Johns, Willem de Kooning, Jacques Lipchitz, Richard Lindner, Maryan, Robert Motherwell, Robert Morris, Louise Nevelson, Claes Oldenburg, Henry Pearson, Robert Rauschenberg, Larry Rivers, James Rosenquist, Saul Steinberg, Walasse Ting.

Silver Skies (1970), Jim Rosenquist, 34 x 29½ in. (Courtesy of Hollanders Workshop)

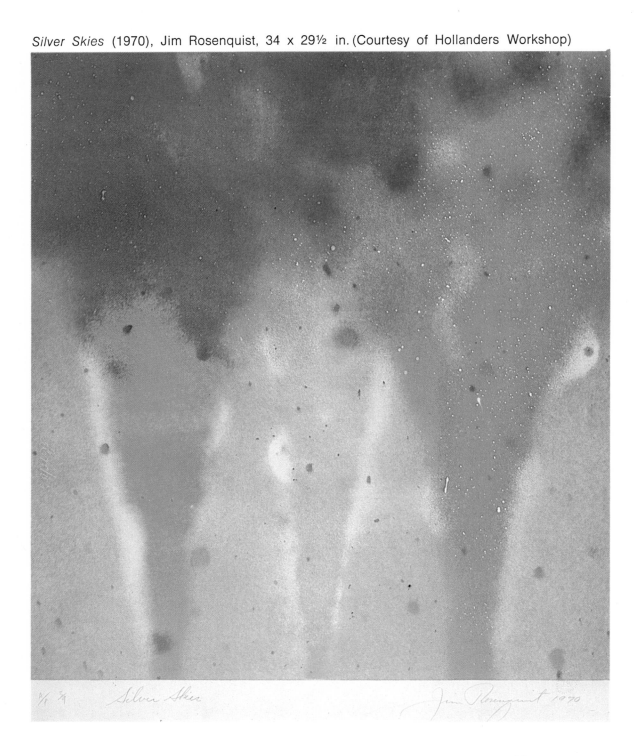

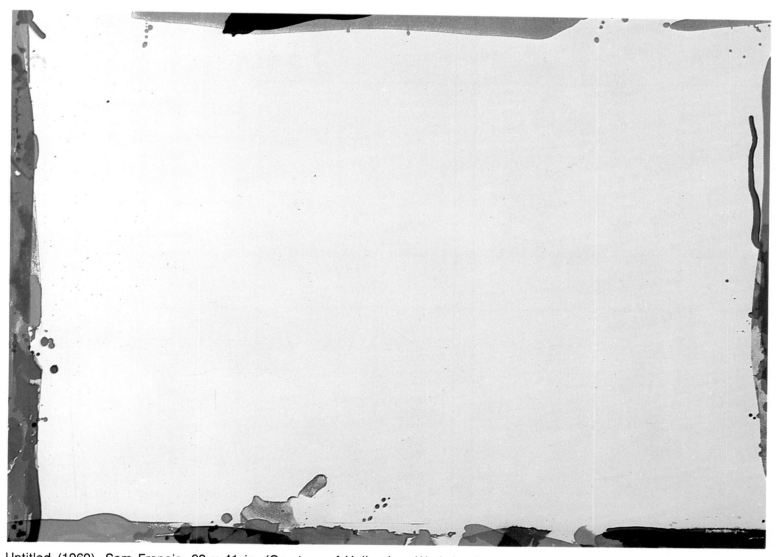

Untitled (1969), Sam Francis, 29 x 41 in. (Courtesy of Hollanders Workshop)

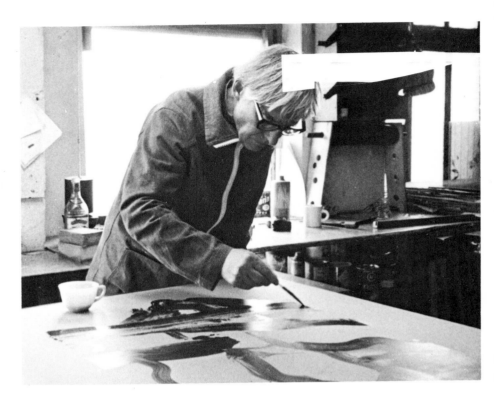

High School Desk (1970), Willem de Kooning,
40 x 28 in. (Courtesy of Hollanders Workshop)

Willem de Kooning drawing on a lithographic plate.
(Courtesy of Hollanders Workshop)

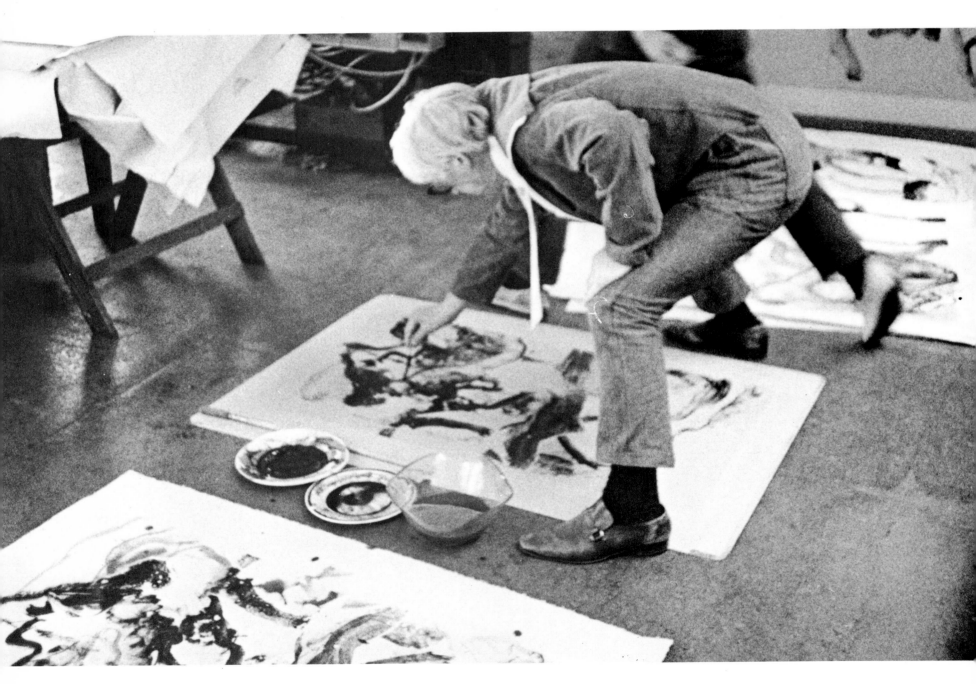

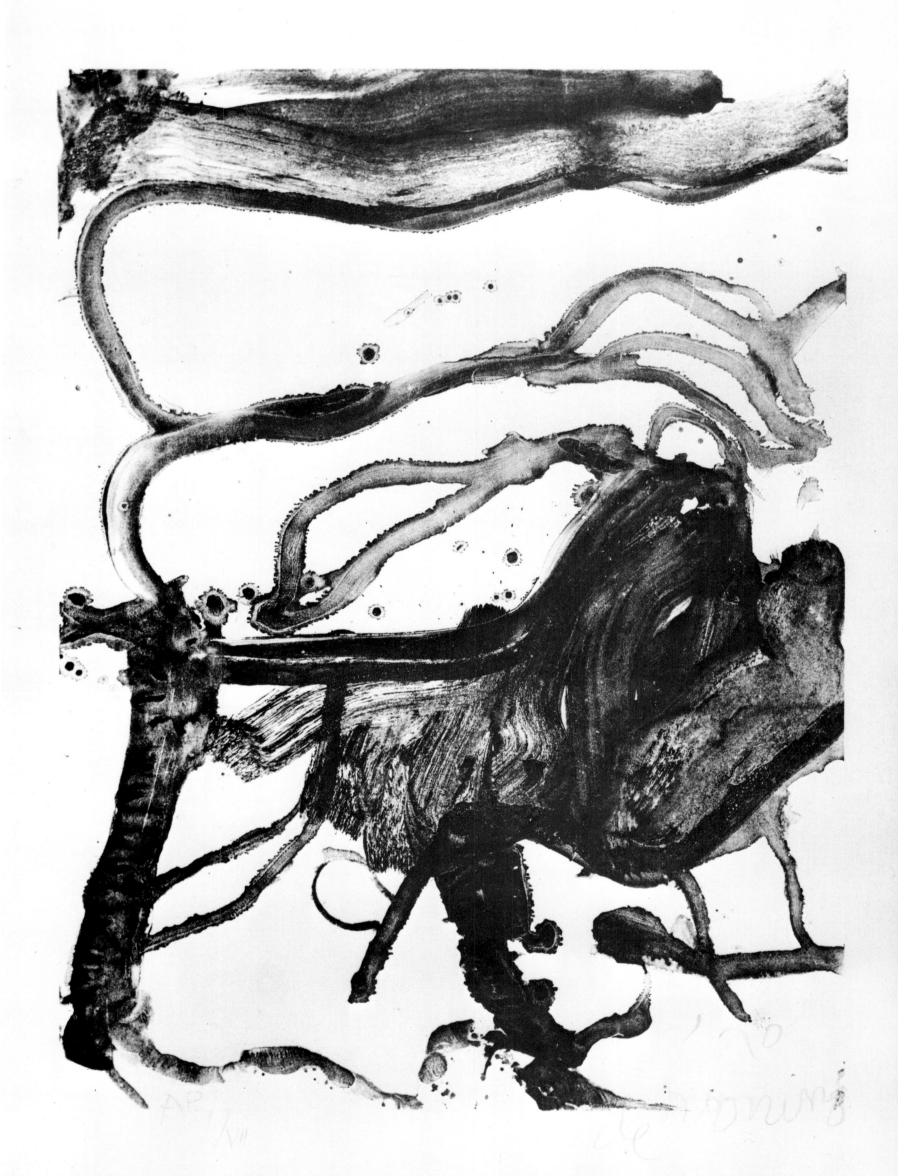

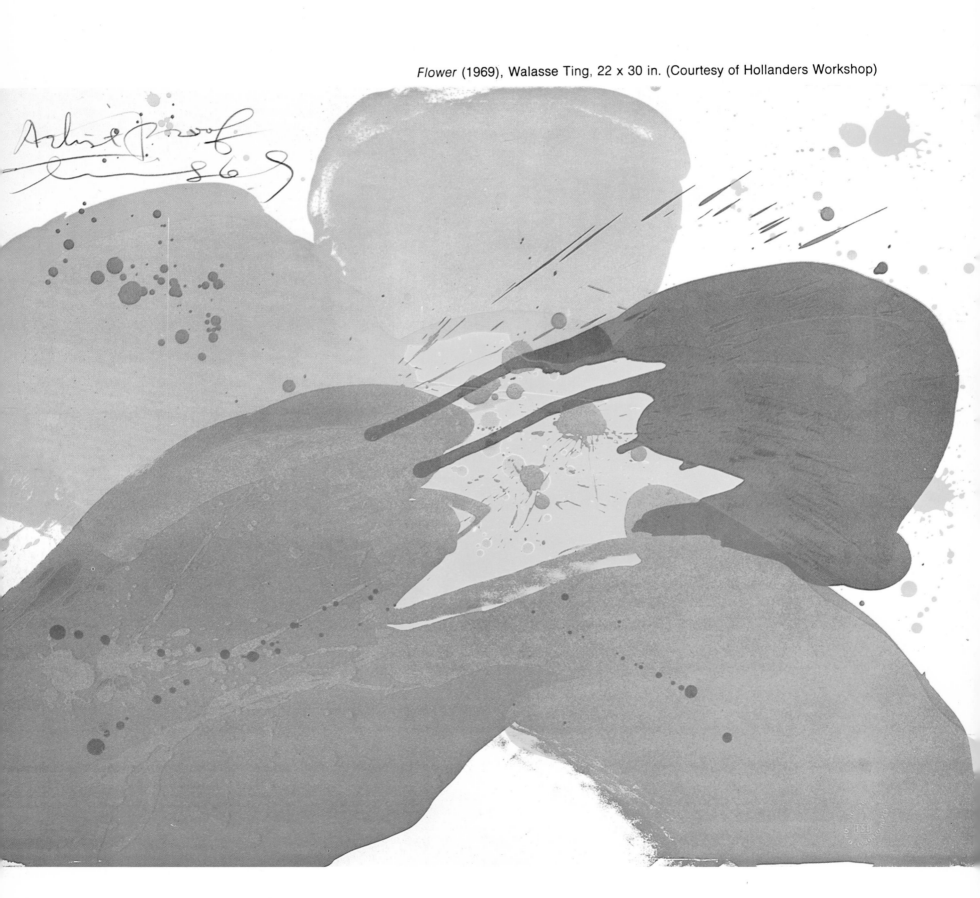

Flower (1969), Walasse Ting, 22 x 30 in. (Courtesy of Hollanders Workshop)

Not Wanting to Say Anything About Marcel—Litho A (1969), John Cage, 39½ x 27½ in. (Courtesy of Hollanders Workshop. Photo, Marvin Bolotsky)

Jim Rosenquist *(left)* at Hollanders Workshop with Fred Genis *(center)* and Irwin Hollander. (Courtesy of Hollanders Workshop)

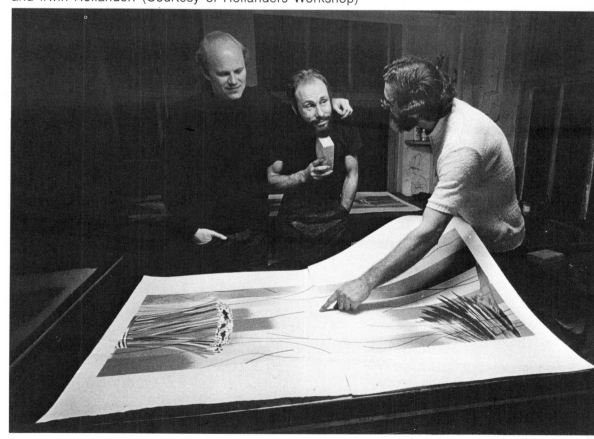

IMPRESSIONS WORKSHOP, INC.

I deally, we would like to divide our time about equally between custom printing for artists and other publishers, and our own publications. In past years we have sometimes approached this balance, but lately, for many reasons, our shop has been devoted primarily to custom printing for others. At present we are investigating and experimenting with a cooperative publication plan involving the workshop, a distribution organization, and an artist as partners in a series of specific ventures, and this type of co-publication arrangement seems to offer an ideal compromise.

It is difficult to set down in a general way a definite system that we use in working with artists, except to state certain principles that govern the way we try to relate to and serve the artists who work here. The first and most important of these is that the artist is treated very much according to his individual wishes, toward the end result that the artist be satisfied with the work of the shop and with his own work during the time that he is here. All of us who have direct dealings with the artist during his stay do whatever we can to encourage him to relax, experiment, ask for whatever he wants, and, in general, to feel free to create without pressure. We value the personal relationship that can grow between an artist and his printer to the point where each stimulates the other and the resultant print is a pleasure to both of them.

We maintain an apartment-studio in the workshop for artists who come to the shop from some distance. Most frequently and preferably an artist will come to the shop to work on the stones or plates here. If for some reason that is not feasible, however, we are prepared to send plates to the artist and conduct an entire printing job "long distance." The various stages of the work itself—proofing, arrival at a *bon a tirer,* and edition printing—are governed largely by the procedures and stages arrived at and recommended by the Tamarind publications. Our curating systems are also modeled on Tamarind's. Regarding curating, I should add that our standards are rigorous, and our curating is as meticulous as possible, but even so, the artist may at all times exercise absolute control over all the work. His choices, selections, and requests are followed, and he, of course, has the right to reject any prints or editions that do not meet his approval.

Generally we try not to have more than one artist working in the shop at any one time, largely in order to ensure that when an artist is working his printer will always be accessible and ready to answer any question or collaborate on any problem.

This workshop is committed to a fine, unique product, and while we deplore the mass production of our present-day culture and the loss of individual craftsmanship, we see nothing incompatible between artistic integrity and the imaginative use of any of the technologies of modern science. Thus, increasingly we find ourselves working with photographic techniques on both stone and plates, in lithography and etching. We have looked upon lithography as one of the most direct of the graphic media and one of the most versatile. Although this versatility lends the medium to direct reproduction, we have never involved ourselves in the purely reproductive capabilities (i.e., commercial aspects), and think of lithography purely as an original art form.

Historically, Impressions Workshop has been especially concerned with introducing the graphic arts to younger artists whose exposure to them has been limited and also to established artists in other media who have not previously involved themselves in printmaking. When working with an artist whose work we are publishing, we frequently invite experimentation. For example, the availability of a number of different graphic techniques within this one atelier greatly facilitates the achievement of prints of mixed media.

Though forced by reality to forego the luxury of the complete range of graphic media maintained in the past, we have established sound working relationships with other fine shops. Thus, for example, we still find a mixed-media print involving lithography and serigraphy entirely feasible. Combining the newer photographic techniques with the older classical methods, of course, greatly increases the range of possibilities.

Finally, we would like again to emphasize the importance of the relationship between the artist and the printer, since this is by far the most vital relationship within the atelier. Our goal is to give maximum freedom and flexibility to the artist. The only constraint that need enter the picture, as in the case of an artist unfamiliar with lithography, concerns the relatively few, yet important, technical limitations of the medium. Once the printer has transmitted this basic information to the artist, the relationship should flourish. Even in the instance where the printer is himself an artist, communication between him and the artist is maintained at the technical level, and no attempt is made to influence the artist's aesthetic.

Director: *Stephen B. Andrus*

Impressions Workshop was founded by the late George Lockwood in 1959. Incorporated in 1965 under its present name, it was the outgrowth of a one-man shop that had previously been located on Scotia Street in Boston. Several years later it was moved to its present and more spacious quarters on Stanhope Street, where it occupies the upper floors of two adjacent buildings.

This shop has always been devoted primarily to lithography, although under Lockwood's creative direction it made an increasing commitment to intaglio and relief printing and to typography and letterpress printing. The latter capabilities allowed the workshop to produce broadsides and books as well as portfolios in which the printed word was combined with the graphic image.

Following Lockwood's departure from the shop in 1967, there was a further expansion of services to include serigraphy, book binding, and restoration. The people involved in the workshop generally have been active as individuals in the political concerns of the country, and the political and social functions of art—and of the workshop itself—have always been a serious consideration. In recent years the shop has been involved in a great many efforts toward the advancement of civil rights and social change, including the contribution of its work to several publications designed to raise funds for specific causes.

There has been an increased emphasis on letterpress printing and the production of books containing original texts as well as graphics. These publications were the special concern of Robert Max who directed the workshop in 1969-70.

More recently, forced by economic pressures to simplify operations, the shop has had to restrict its services to lithography and intaglio printing, but it does continue to publish an occasional book.

The usual complement of staff in lithography is two printers and two apprentices, and in etching two printers and one apprentice. The printers at present are Paul Maguire and John Hutcheson in lithography, Robert Townsend and Gretchen Ewert in etching. The shop has three lithographic presses.

Impressions Workshop has for some time maintained a separate etching facility apart from the production shop. This experimental shop has an active teaching program and is open to local artists on a fee basis.

27 Stanhope Street
Boston, Massachusetts 02116

The following is a partial list of the artists who have worked at Impressions Workshop: David Aronson, Mirko Basaldella, David Berger, Harvey Braverman, Calvin Burnett, Paul Caponigro, Dana Chandler, Karl Fortes, Naum Gabo, Sam Gilliam, Sante Graziani, Edna Hibel, Gyorgy Kepes, Juliet Kepes, Karl Knaths, George Lockwood, Michael Mazur, Rick Meyerowitz, Maud Morgan, John Muench, Robert Newman, Arthur Polonsky, Aubrey Schwartz, Saul Steinberg, Barbara Swan, Harold Tovish, Steve Trefonides, Claire Van Vliet, Ruth Weisberg.

The Matisse Post Card (1970), Saul Steinberg,
22 x 30 in. From the portfolio
Six Drawing Tables, published by Abrams Original Editions.
(Courtesy of Impressions Workshop)

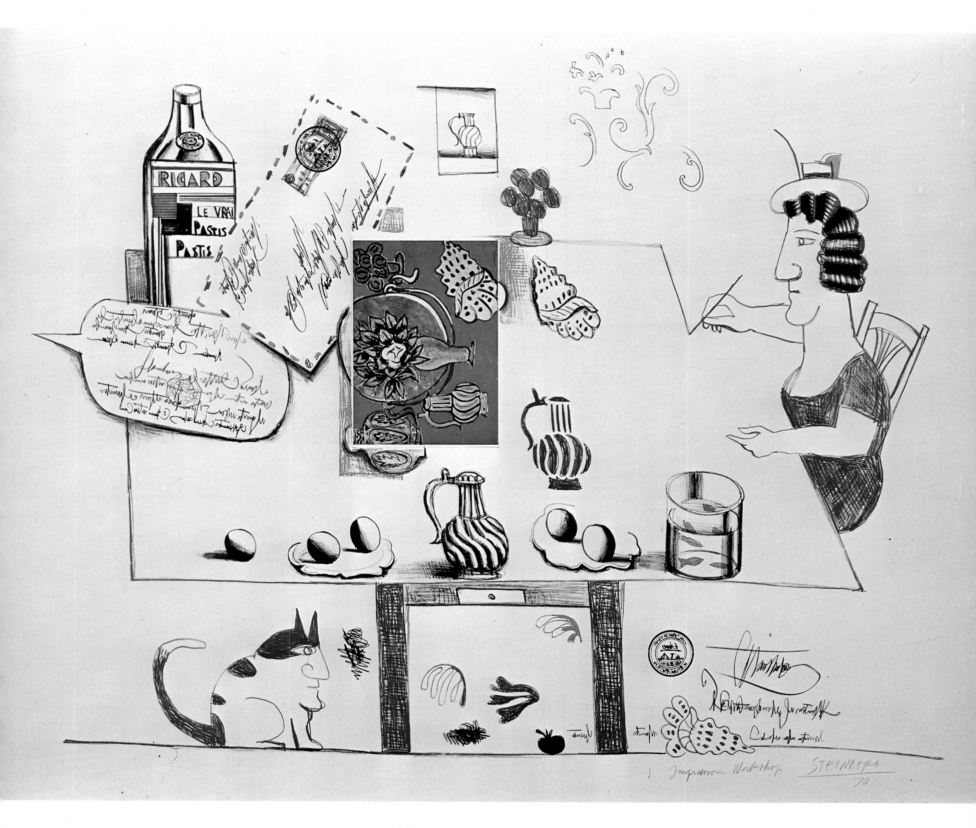

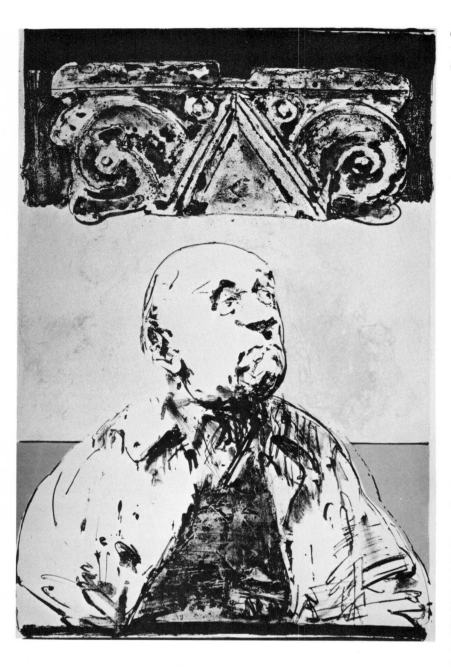

Cynic (1971), Harvey Breverman,
18½ x 26¾ in.
(Courtesy of Impressions Workshop)

Portrait of a Lady (1971),
George Lockwood, 26 x 17 in.
(Courtesy of Impressions Workshop)

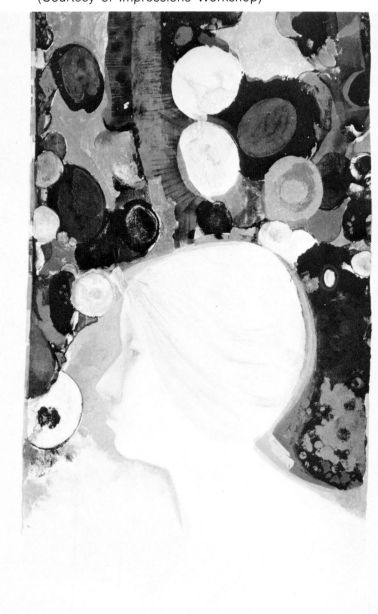

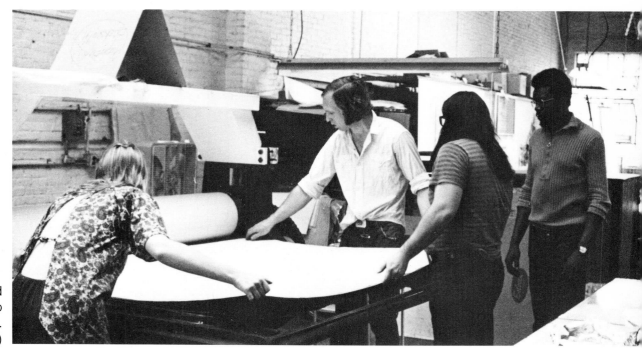

Artist Sam Gilliam *(right)* and printers adjusting large litho plate on press bed.
(Courtesy of Impressions Workshop)

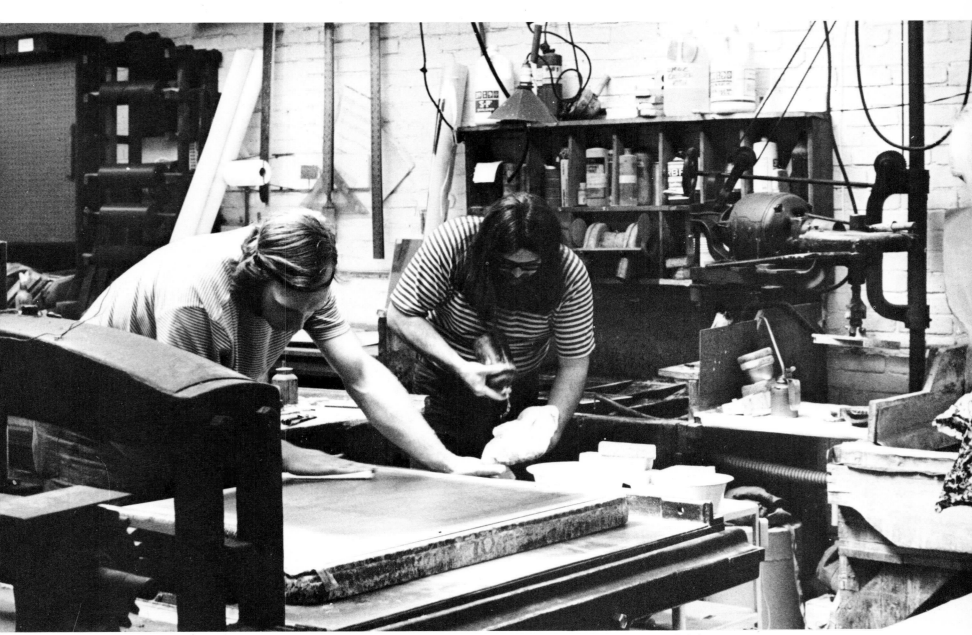

(Courtesy of Impressions Workshop)

THE LAKESIDE STUDIO

(Courtesy of Lakeside Studio)

The Lakeside Studio is actually an old hotel, situated on five acres of wooded land overlooking Lake Michigan. It was purchased in July 1968 to house the offices and workrooms of our national distributing business, which began in the fall of 1968. Prior to this, I was vice-president of the Ferdinand Roten Galleries of Baltimore, Maryland.

During the summer of 1969 Jack Lemon, who at the time was the director of the Nova Scotia College of Art and Design, came to Lakeside and completely renovated a large building into our lithography workshop. In December of that year Will Peterson put on the finishing touches. Peterson left in the spring and returned to teaching at the University of West Virginia. In the summer of 1970 Jack Lemon returned and, with the help of his assistant, Jerry Raidiger, printed five editions.

Our hope is to supply a place that will be a benefit to the arts, a shop where the artist can come and work with professional printers and produce meaningful work, not work that is mass produced and then signed and numbered and called original. On our three presses we print editions of fifty impressions, twenty-five of which go to university and museum collections, with the remainder retained by the artist.

Our hotel is non-profit, and no charge is made, We ask only that the people who come find our place a positive experience and, in return for being here, benefit the art world in some way.

Director: *John D. Wilson*

150 South Lakeshore Road
Lakeside, Michigan 49116

The following is a partial list of the artists who have worked at Lakeside: Harvey Breverman, Keith Hatcher, Richard Hunt, Misch Kohn, James McCormick, Winston McGee.

Misch Kohn at work. (Courtesy of Lakeside Studio)

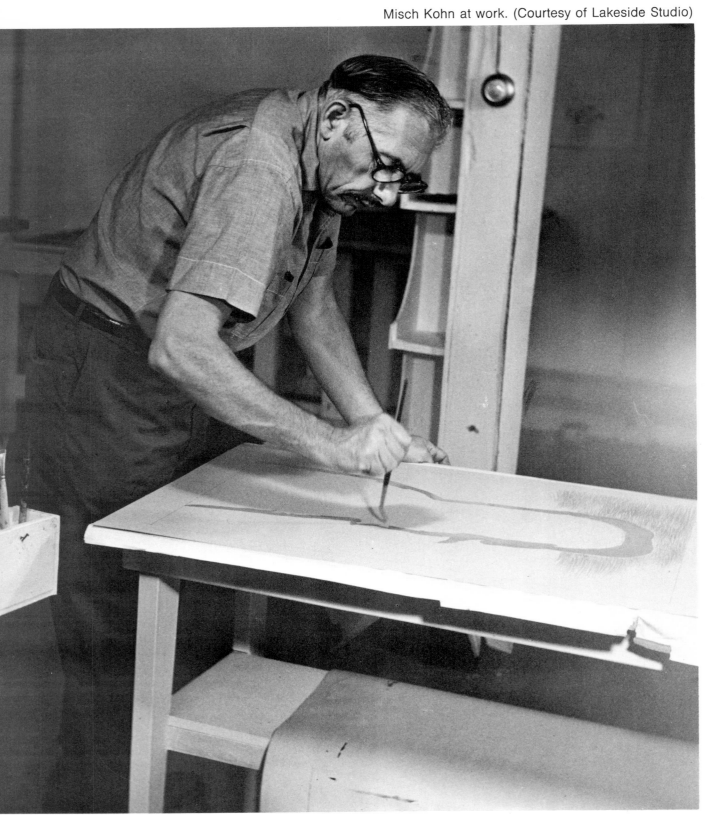

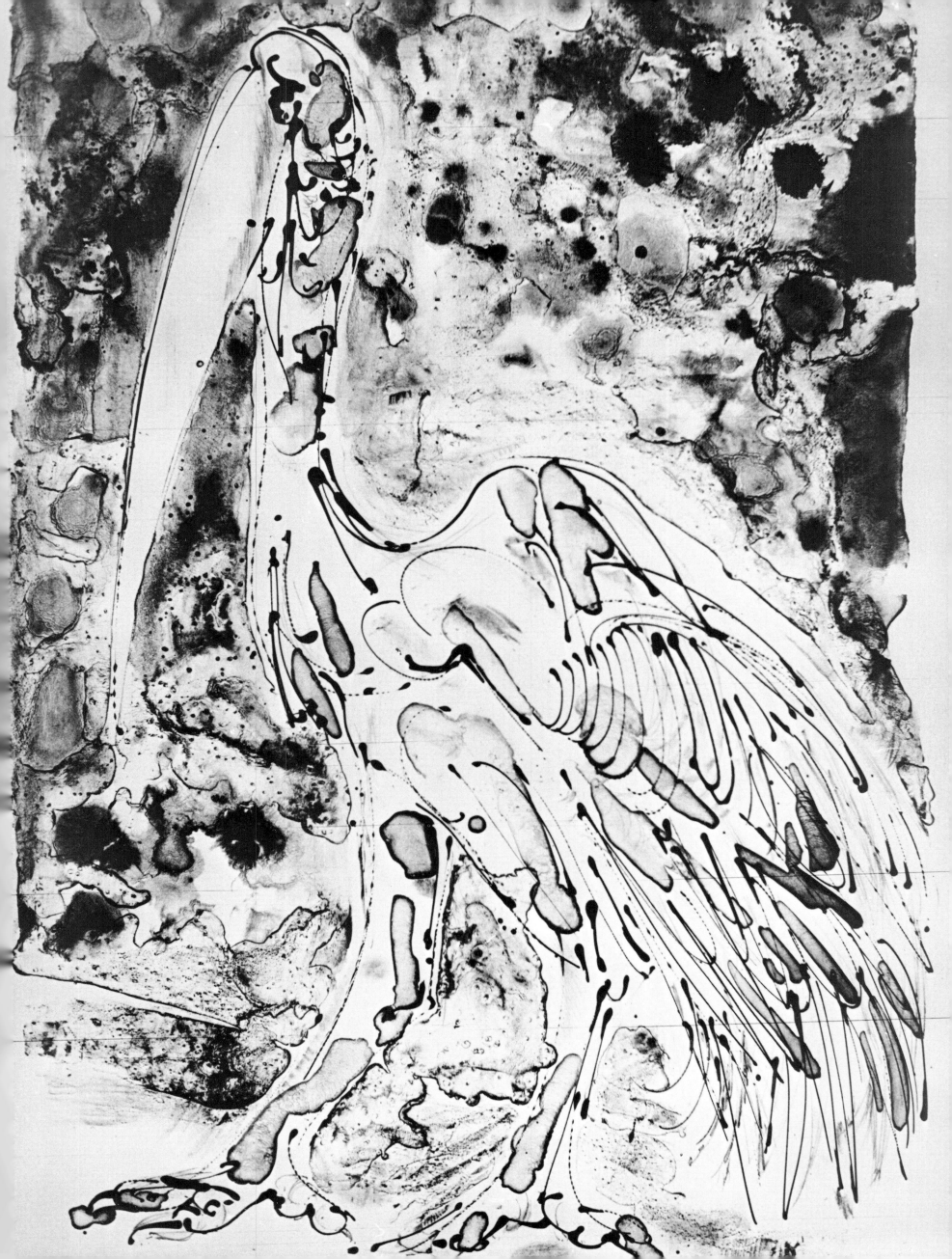

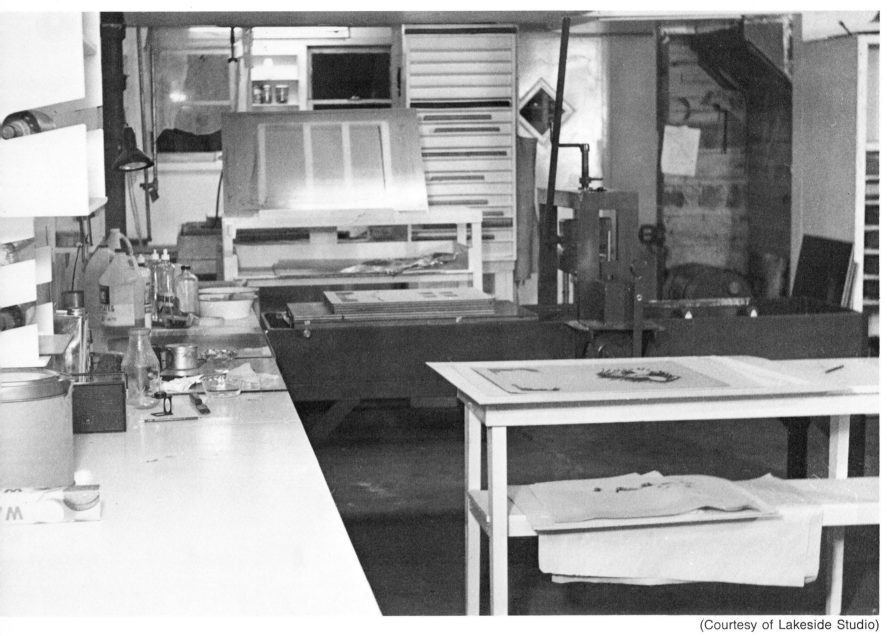

(Courtesy of Lakeside Studio)

Untitled #2 (1970), Richard Hunt, 19¾ x 26 in. (Courtesy of Lakeside Studio)

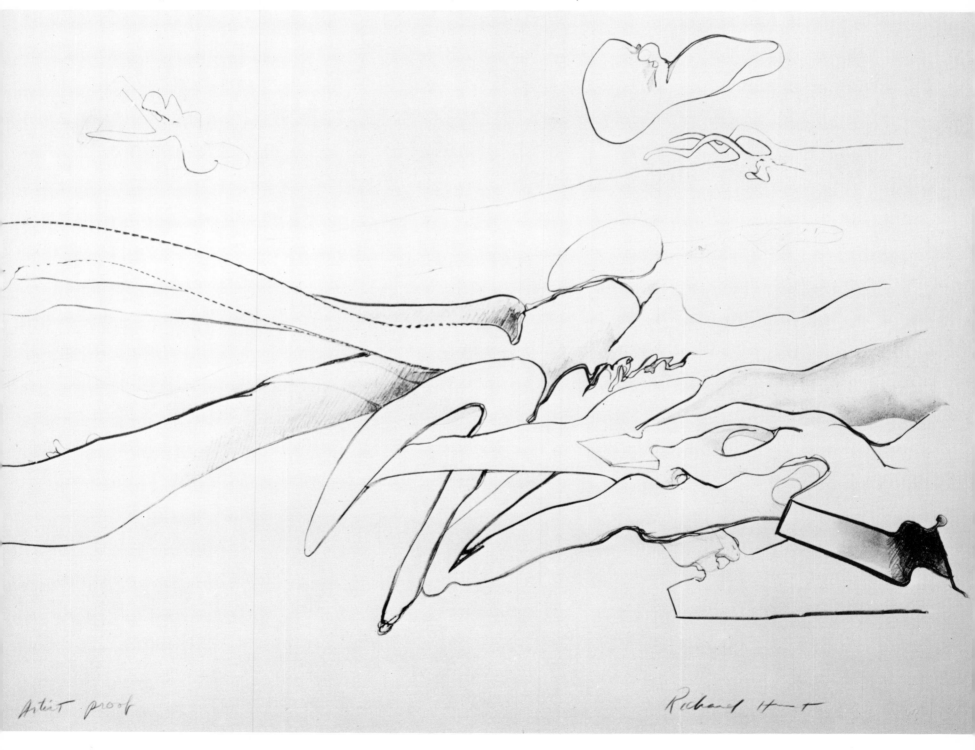

Artist proof Richard Hunt

LANDFALL PRESS, INC.

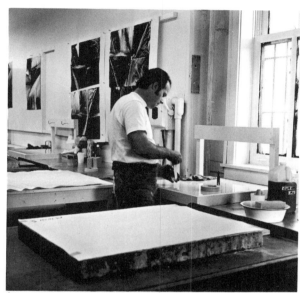

(Courtesy of Landfall Press)

Landfall Press came into existence in September 1971 to publish editions of important American artists as well as to offer a complete custom-printing program for artists, museums, and galleries. Since that time, we have dedicated ourselves to the art of hand-printed lithography. We perform a service through the creative collaboration between artist and printer-craftsman, a service that combines the aesthetic of the fine lithograph with the aesthetic of the artist, making a total greater than the sum of its parts.

By introducing many different artists to lithography as a medium, we ensure the continuity of what we feel is a great tradition. At the same time, this introduction of the medium to the fresh approaches of different artists challenges that tradition by making the printer-craftsman explore and expand the possibilities of lithographic techniques. This creative collaboration enables the artist to concentrate solely on his aesthetic, knowing that his ideas will be properly reproduced on our three presses, giving his work exposure to a wider public at a more reasonable cost. But, more importantly, through this collaboration the artist has an opportunity to expand his aesthetic.

Yet Landfall Press cannot work in a vacuum; we must be involved with the community. To this end we open our doors to all artists, not just a select few. We encourage art organizations and businesses to commission fine prints, and we have an educational program of exhibits, lectures, and demonstrations for the community. We at Landfall Press feel that we must become a part of the culture in which we live.

Director: *Jack Lemon*

63 West Ontario Street
Chicago, Illinois 60610

The following is a partial list of the artists who have worked at Landfall Press: William Allan, Christo, William Copley, Dan Christiansen, Robert Cottingham, Sol LeWitt, James McGarrell, Claes Oldenburg, Dennis Oppenheim, Philip Pearlstein, Kenneth Showell.

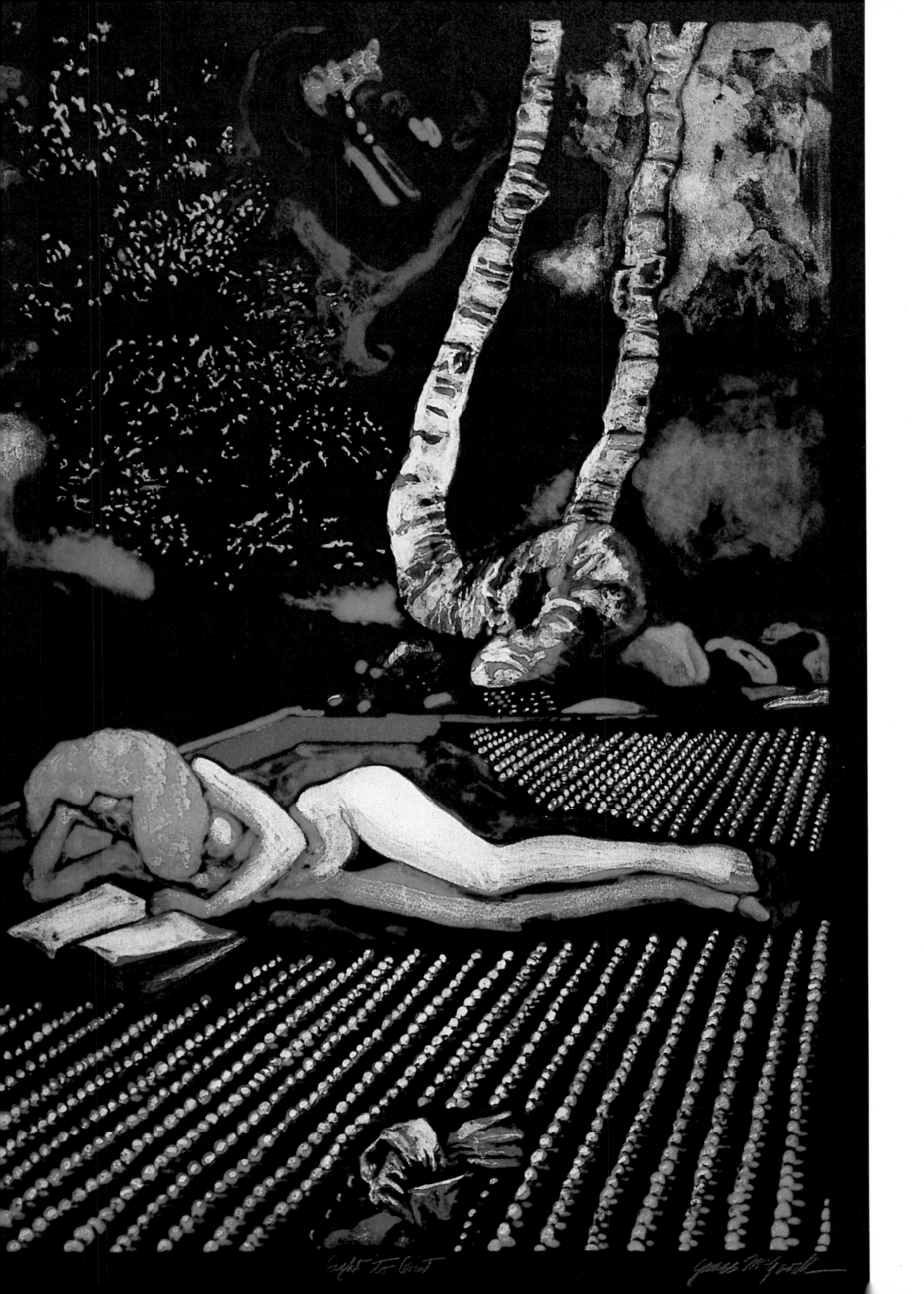

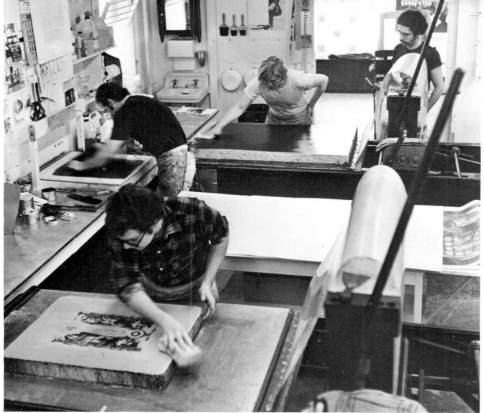

(Courtesy of Landfall Press)

Artist James McGarrel at Landfall.
(Courtesy of Landfall Press)

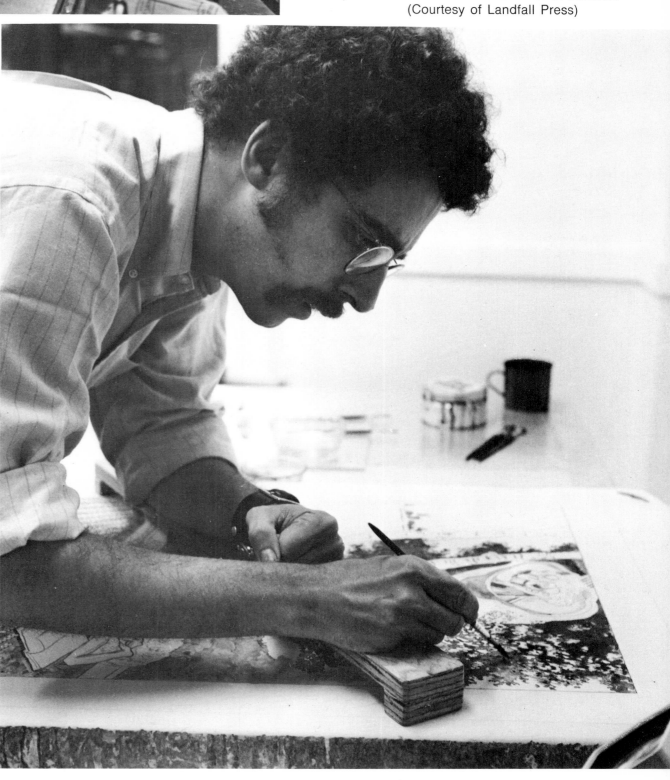

V (1970),
James McGarrel, 22 x 30 in.
(Courtesy of Landfall Press)

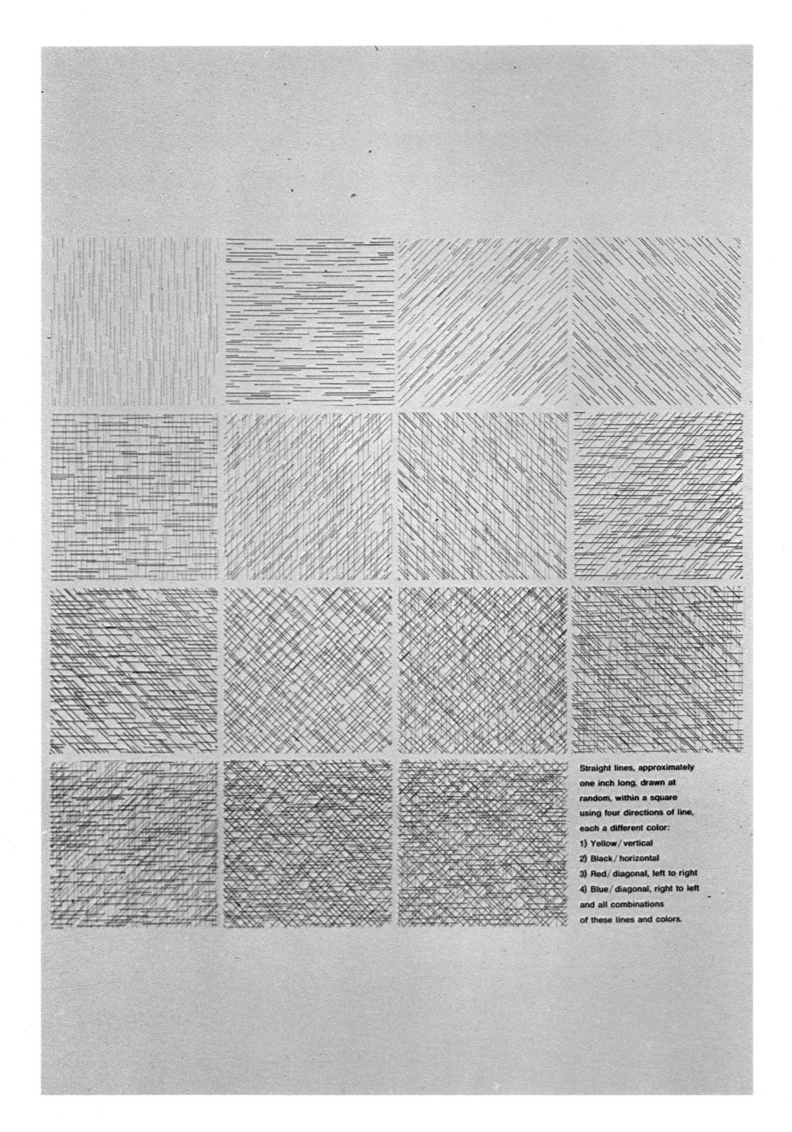

Straight lines, approximately
one inch long, drawn at
random, within a square
using four directions of line,
each a different color:
1) Yellow / vertical
2) Black / horizontal
3) Red / diagonal, left to right
4) Blue / diagonal, right to left
and all combinations
of these lines and colors.

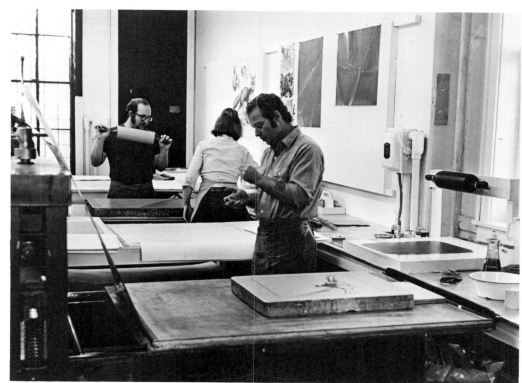

(Courtesy of Landfall Press)

Whitney Museum (1971), Christo,
22 x 28 in. (Courtesy of Landfall Press)

Sixteen Lithographs in Black and White
(1971), Sol Lewitt, 23 x 23 in.
(Courtesy of Landfall Press)

LITHOGRAPHY WORKSHOP

(Courtesy of Lithography Workshop)

Whether the Workshop acts as publisher or its services are contracted by another publisher, the artist determines shop procedure in accordance with his working habits and understanding of the medium. After preparation, the master printer determines production procedure.

When the Workshop acts as publisher, invitations to artists are based on their educational value to the institution and their market potential, as the shop was established on the basis of being an economically self-sufficient unit.

I regard lithography as an open circumstance with a rich historic tradition, but no more or no less valuable than any other medium for the demonstration of an idea by an artist.

The reason for a lithographic workshop is that it allows anyone to accomplish a print, regardless of his technical understanding of the medium. Obviously an understanding develops through the involvement, and varying levels of understanding surrounding the medium direct and affect the artist's idea.

We observe three principles in developing our workshop calendar. Primarily, as we are the only facility in Canada for this kind of work, we give preference to Canadian artists. Secondly, since we are established on an economically self-sufficient basis, the market potential of the artist and/or the decision to work with a publisher, are factors. Finally, the educational value of the shop is essential to the institution. The facility is open to students to observe, and we hire students as assistants and printer trainees in the shop. The artist's work becomes part of the college collection and is displayed in the school. A range of lithographic involvements is therefore important.

Our workshop is a "real world" demonstration to the student, made possible by its unique location within a professional art school. The shop keeps before the student what is involved in fine lithography from professional shop procedure in preparation and production through marketing and exhibition. Also, even to students who are not concentrating in lithography, the abstract benefit of a professional involvement taking place in their school generates a sense of professionalism.

The Lithography Workshop helps develop within the students a keen awareness of the medium in the broadest sense of the word which will ultimately reinforce the high standards of the medium both in Canada and around the world.

With economics playing a secondary role in the operating of the shop, we are able to engage in more experimental projects. For example, as far as I know, the Gene Davis print has the most colors—twenty-two—ever hand pulled in lithography in a professional circumstance.

The Lithography Workshop, in conjunction with the college's design production unit, has published two books. One is *Trans VSI Connection*, a 100-page book of Telex Telecopier demonstrations by Iain Baxter's N. E. Thing Company; and the other is *Flowed*, a thirty-two-page book by Lawrence Weiner. Our concern with publishing books is with those that are art rather than about art.

We published a print by Bob MacLean, a Halifax tattoo artist who had never heard of lithography. He brought a fresh perspective to the medium both technically and aesthetically.

A lithograph by Sol LeWitt is being printed completely with mailed instructions, leaving certain aesthetic decisions to art workers hired by the shop. LeWitt took full responsibility for the print.

Because we also have a professional design unit in the school and our own offset lithographic press, collaboration between lithographic production and graphic technology often occurs. An image by Dan Graham was laid out by one of our resident designers, and another production was run exclusively through that unit as a limited-edition lithograph designed for offset-press production.

The above experiments invariably cause us to rethink the nature of the medium and make us flexible in dealing with a range of artistic problems.

Director: *Gerald Ferguson*

When Garry Kennedy assumed the presidency of the college in 1967, one of his concerns was the establishment of a distinguished educational program in lithography. In keeping with his philosophy that a professional education is measured by professional deeds, Garry Kennedy recruited Jack Lemon, who was then operating a professional workshop in Kansas City. Lemon organized the printmaking program for the college and also began the professional workshop as an educational stimulus. Robert Rogers came to the workshop in April 1969 as master printer, after spending one and one-half years at Tamarind.

Workshop policy and operation is determined by the Workshop Committee. The original committee, chaired by Gerald Ferguson, included the director, master printer, the college president, and a business manager. In May 1970, when Jack Lemon went to the Landfall Press in Chicago, Gerald Ferguson became director.

Nova Scotia College of Art and Design
6152 Coburg Road
Halifax, Nova Scotia, Canada

The following is a partial list of the artists who have worked at the Lithography Workshop: Vito Acconci, Iain Baxter, Jack Chambers, Greg Curnoe, Francois Dallagret, Gene Davis, Jan Dibbets, Dan Graham, Sol LeWitt, Ken Lochhead, Bob MacLean, Art McKay, Guido Molinari, Robert Murray, Dennis Oppenheim, Philip Pearlstein, Christopher Pratt, Robert Ryman, Michael Snow, Joyce Weiland.

Artist Gene Davis. (Courtesy of Lithography Workshop)

Halifax (1970), Gene Davis, 30 x 36 in. (Courtesy of Lithography Workshop)

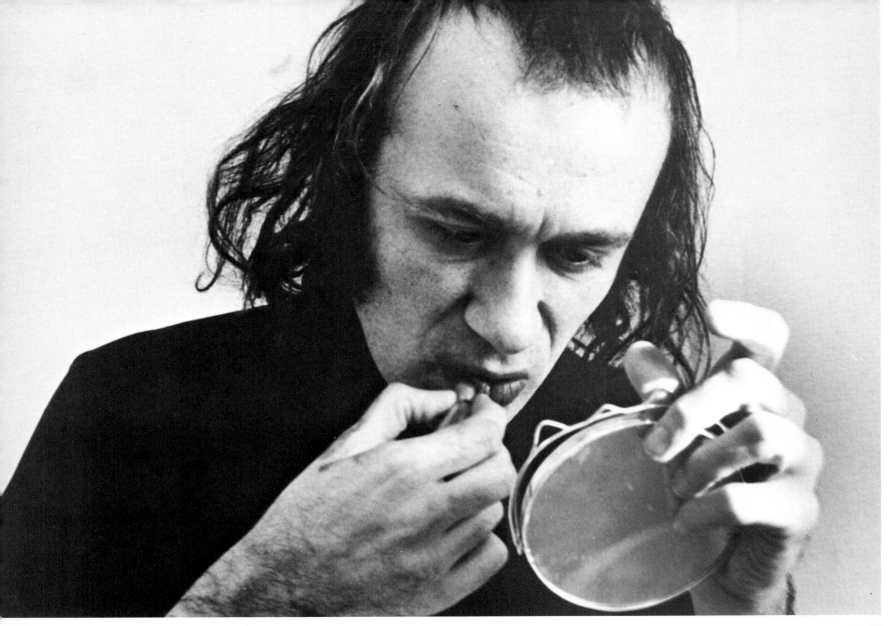

Vito Acconci in the process of making his print
Kiss Off. (Courtesy of Lithography Workshop)

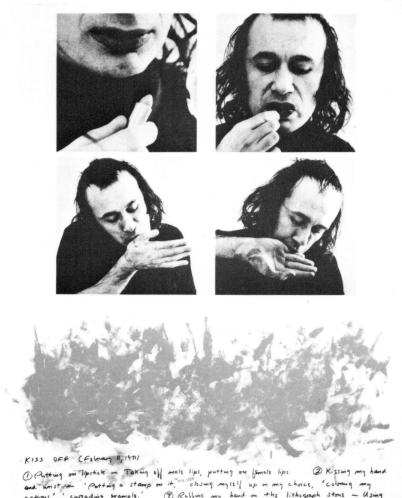

Kiss Off, Vito Acconci, 22 x 30 in. (Courtesy of
Lithography Workshop)

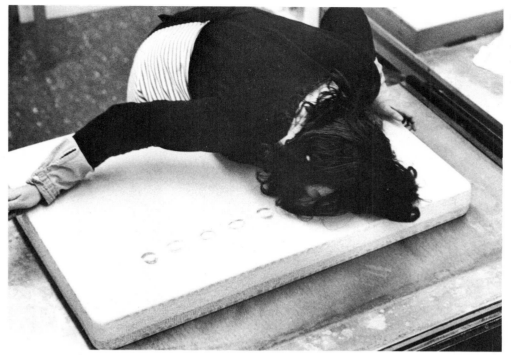

Joyce Wieland creating her print *O Canada.* She applies lipstick and kisses the stone, using a mouth configuration for each syllable of Canada's national anthem. (Courtesy of Lithography Workshop)

O Canada, Joyce Wieland, 22 x 30 in. (Courtesy of Lithography Workshop)

Stills from Projects, Dennis Oppenheim, 22 x 30 in.
(Courtesy of Lithography Workshop)

Dennis Oppenheim. (Courtesy of Lithography Workshop)

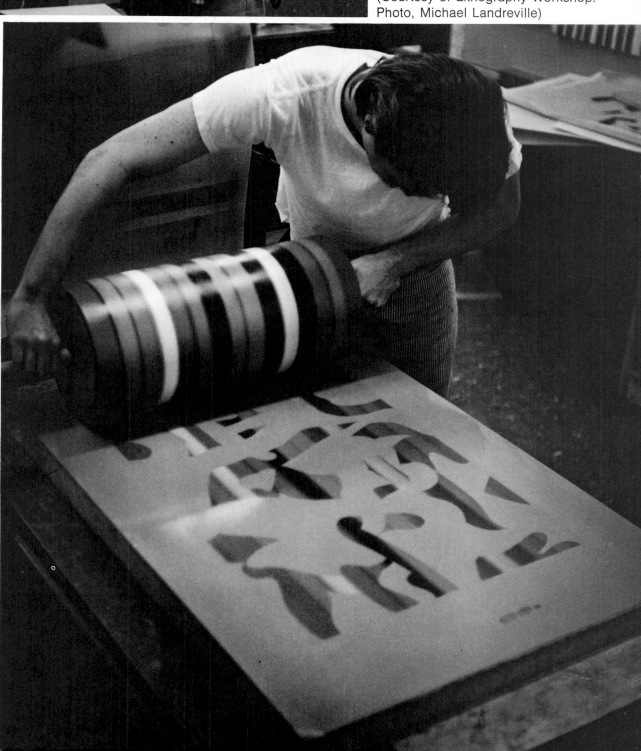

GEORGE C. MILLER & SON, INC.

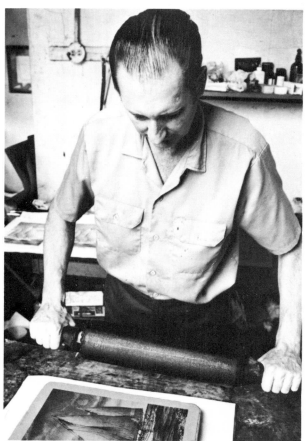

(Photo, M. Knigin)

We provide a stone for each artist. We retain ownership of the stone and the artist owns the design, which is executed either in our shop (no charge for working space) or in the artist's studio. We ship stones anywhere in the world. Proofs are pulled, corrections are made—by mail if the artist is out of town—and the editions are printed pursuant to the artist's instructions.

The versatility of the lithographic stone is probably one of the main attractions to artists. By presenting a surface that can be drawn, painted, brushed, stippled, splatted, scratched, scraped, picked, rubbed, and spit upon (saliva is fine for blocking out), and one that yields tones and values that range from a microscopic dot to dense solids, few surfaces can equal it.

To make a stone yield all these techniques requires not only years of training under expert guidance but day-in-day-out experience and continuous use of equipment and materials. An artist attempting to print his own lithographs not only finds his work in other media suffering because of the length of time and amount of energy used in trying to learn printing, but his lithography suffers as well, because he finds himself limiting his techniques to what only he can print. This is why the printer is so important to the artist. He gives him not only technical advice but broadens his range in printmaking and gives him precious time for other media.

However valuable the printer is to the artist, we are still just an extension of the fine line that runs from his mind to his fingertips. We advise, assist, and help him deliver his creation, much like a doctor delivering a baby.

However, we do not create, and because we do not, George C. Miller & Son has *never* signed an edition of prints, nor do we even have a chop mark. We have always felt that only the artist should receive full recognition for his or her work. We are not catering for public recognition, since we do not deal with the public. We deal with artists, and we want to be known by artists and have the artists be known by the public. By our craftsmanship, we believe we have accomplished this. This has been our biggest contribution to the medium of the past fifty years.

Director: *Burr G. Miller*

Early in 1917, George C. Miller was foreman of the stone-proving department at American Litho Company and was asked by a superior to help an artist friend who was having difficulty producing a good print. Through this association, he was called to the studios of George Bellows, Albert Sterner, and others, and he printed for them at night. Bellows and Sterner, who had just returned from Europe after "discovering lithography," had bought presses to do their own printing, but they failed to produce quality prints due to lack of technical knowledge. This George Miller provided.

With the demand for a professional printer growing, Miller opened up the first lithographic printing shop exclusively for artists in the United States. The shop was closed during World War I, while Miller was in the service. When he returned and

125

reopened his shop, it became a mecca for artists and has been in operation ever since.

The Miller shop is now operated by George Miller's son, Burr, who has been printing since 1948 and has been its director since his father's death in 1965.

An able assistant is the only other employee at the shop, since all the printing over all the years of its existence has been done by either George or Burr Miller. This means that only one stone is printed at a time, with a Miller handling it from beginning to end. The equipment consists of three hand presses and one offset press. By sacrificing volume for quality, the Millers believe they have set a standard in hand printing from stone in the United States. The fact that there is always a two-month or longer backlog of work bears this out.

George C. Miller wrote the article on "lithography" for the *Encyclopaedia Britannica* during the 1930s, which has not been changed or re-authored.

20 West 22nd Street
New York, New York 10010

The following is a partial list of the artists who have worked at George C. Miller & Son, Inc.: Sam Adler, O. Alkara, Irving Amen, C. W. Anderson, Benny Andrews, Vera Andrus, Peggy Bacon, Gifford Beal, George Beline, George Bellows, Thomas Hart Benton, Michael Biddle, Edward Bierly, Arnold Bilkin, Lawrence Blair, Jack Bookbinder, Paul Brach, Albert Bross, Jr., Robert Brown, Charles Burchfield, Federico Castellon, Castro-Sid, Maura Chabor, Anne Chapman, Chen-Che, William Cook, Lila Copeland, John Steuart Curry, Arthur B. Davies, Adolf Dehn, Sidney Delevante, Jan DeRuth, John Dobbs, Alexander Dobkin, Churchill Ettinger, Philip Evergood, Jerry Fairclough, Creekmore Fath, E. Favus, Lyonel Feininger, Tully Filmus, Richard Florsheim, Antonio Frasconi, Ada Gabriel, Wanda Gaǵ, Lloyd Goff, Sidney Goodman, Marion Greenwood, Leon Gregori, John Gregory, William Gropper, Chaim Gross, George Grosz, Robert Gwathmy, Marsden Hartley, Childe Hassam, Merle Higgison, Joseph Hirsch, Lucille Hobbie, Mel Hunter, Ron Jenkins, Joe Jones, H. Katzman, Nathaniel Kaz, James Kearns, Thomas Kenny, Rockwell Kent, Robert Kipness, Earl Klein, C. Klinghoffer, Leslie Kouba, Leon Kroll, Jacob Lawrence, William G. Lawrence, Alexander Liberman, Stanley Maltzman, I. Marantz, Joe Margullis, Reginald Marsh, Fletcher Martin, P. B. Maryan, John McClellan, Harry McCormick, William Meyerowitz, Agnes Mills, John Moll, Edward Morris, August Mosca, John Noble, Karen Novak, Tom O'Connor, Peter Paone, Joseph Penell, Joan Purcell, Albert Radoczy, Rapée, Maynard Reece, S. Regensdorg, Lionell Reiss, Lillie Rethi, Walter Richards, Robert Riggs, Noel Davis Rockmore, Seymour Rosenthal, Alex Ross, Helene Ross, Lewis Rubenstein, Elizabeth Saltonstall, Emilio Sanchez, Robert Sarsony, Greta Schreyer, Daniel Serra-Badue, Burt Silverman, William Smith, Joe Solomon, Raphael Soyer, Stanley Stearns, Albert Sterner, Prentiss Taylor, Sabrina Teichman, Barbara Teri, Fred Terna, Reynolds Thomas, S. Van Veen, Esteban Vicente, Lynd Ward, Walter A. Weber, Stow Wengenroth, Henry Wenzenreid, Raymond Whyte, Helen Wolf, Grant Wood.

Convention (1970),
William Gropper, 16 x 20 in.
(Photo, Malcolm Varon)

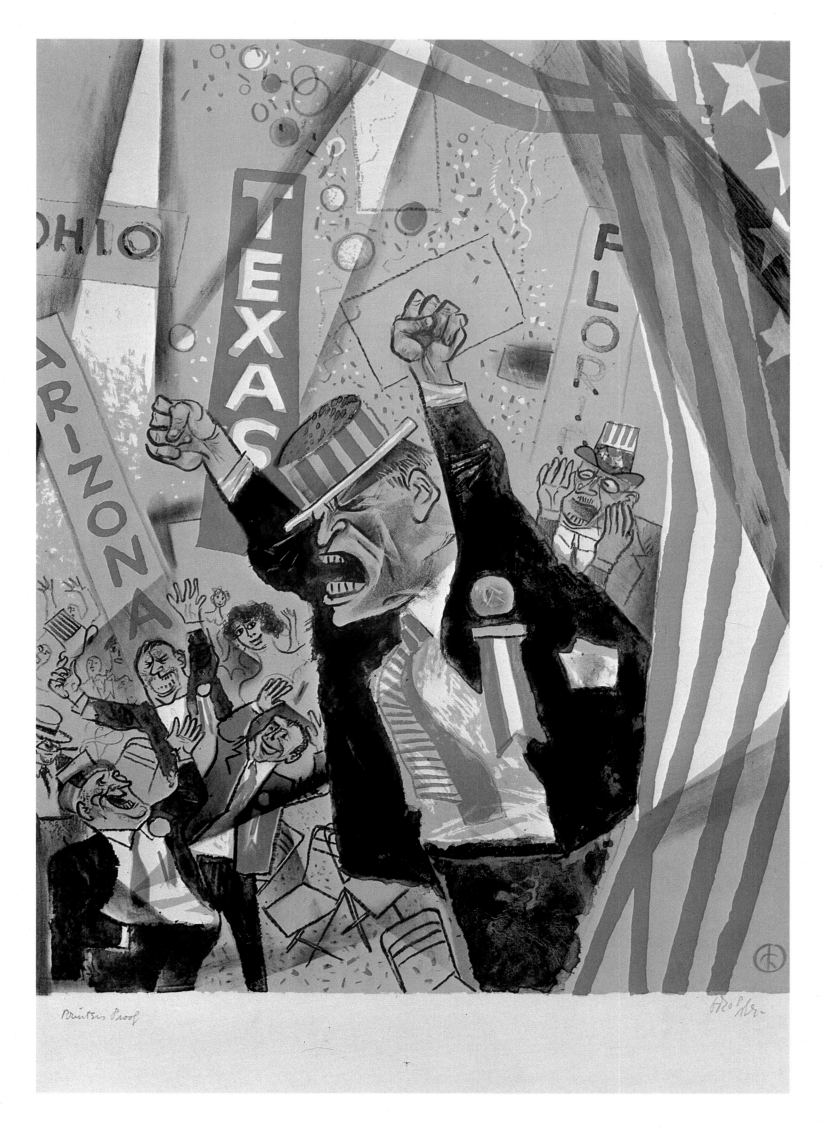

Printers Proof

The Window (1971),
Robert Kipness, 16¾ x 16 in.
(Courtesy of George Miller & Son)

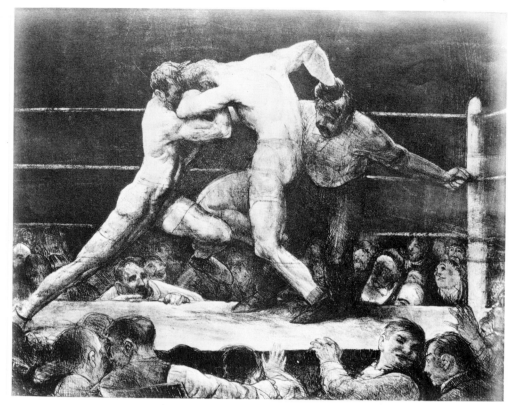

Stag at Sharky's (1923), George Bellows, 14 x 18 in. (Courtesy of George Miller & Son)

Jesse James (1936), Thomas Hart Benton, 16½ x 22⅛ in. (Courtesy of George Miller & Son. Photo, Malcolm Varon)

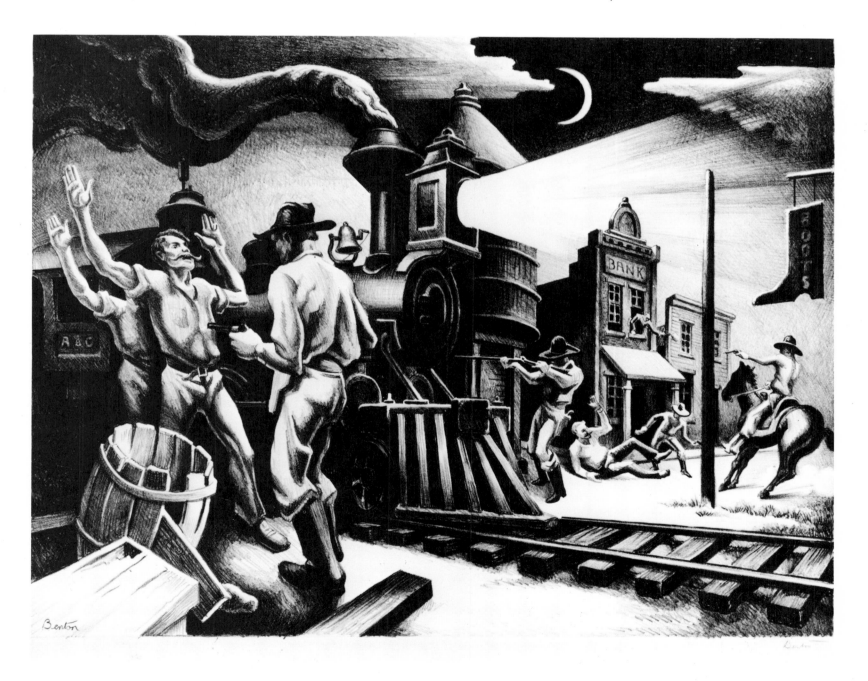

MOURLOT GRAPHICS, LTD.

mourlot
graphics ltd.

Jacques Mourlot, director of Mourlot Graphics, Ltd. (Photo, M. Knigin)

Representing the third generation of his family to be devoted to the finest works of the lithographic art, Jacques Mourlot personally directs Mourlot Graphics, New York, on a permanent, resident basis.

The son of Fernand Mourlot, director of the Paris atelier, and grandson of Jules Mourlot, who established the Paris atelier, Jacques Mourlot was born in Paris on October 28, 1933.

In the tradition of his family, he began his career as an artisan-printer—an *arpette*—the first step in learning the trade. He worked each step of the way, learning his craft and studying diligently, to acquire the skill and nuance of the art of lithography. Today he is recognized in the art world as an unrivaled master lithographer.

It was Jacques Mourlot himself who carefully dismantled the three flat-bed presses and five century-old hand-operated presses, had them shipped from Paris, and lovingly uncrated and assembled them at the New York atelier at the end of 1967.

First a partnership involving American interests was formed, with a workshop on Bank Street. After a few months of operation, however, Jacques Mourlot terminated this association, and the House of Mourlot went back to its original and traditional character: a family concern. Jacques Mourlot, sole owner of Mourlot Graphics in New York, moved his workshop to temporary quarters on Barrow Street while awaiting the completion of the new facility in Westbeth—the new artists' community on New York's West Street.

The young Mourlot noted that this workshop, which is comparable to the famous artists' facility in Paris, was established to encourage more artists in America to work in this medium and as a convenience for those artists who work both here and in France and whose lithographic works are identified with Mourlot craftsmanship. The New York branch of Mourlot Graphics, Ltd., closed in 1972.

The following is a partial list of the artists who have worked at Mourlot Graphics: José deCreeft, Sam Francis, Adolph Gottlieb, Paul Jenkins, Roy Lichtenstein, Claes Oldenburg, Abraham Rattner, Larry Rivers, James Rosenquist, Ben Shahn, Saul Steinberg, Jack Youngerman.

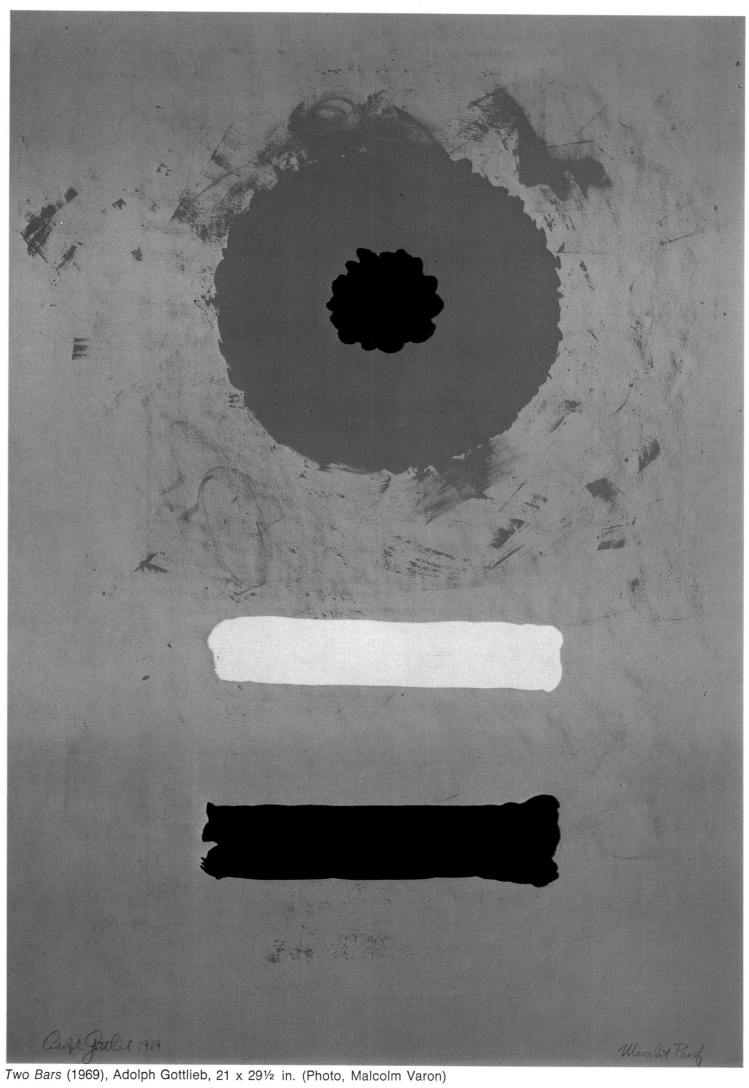

Two Bars (1969), Adolph Gottlieb, 21 x 29½ in. (Photo, Malcolm Varon)

The Swimmer (1969), Larry Rivers,
39½ x 26 in. (Photo, Malcolm Varon)

133

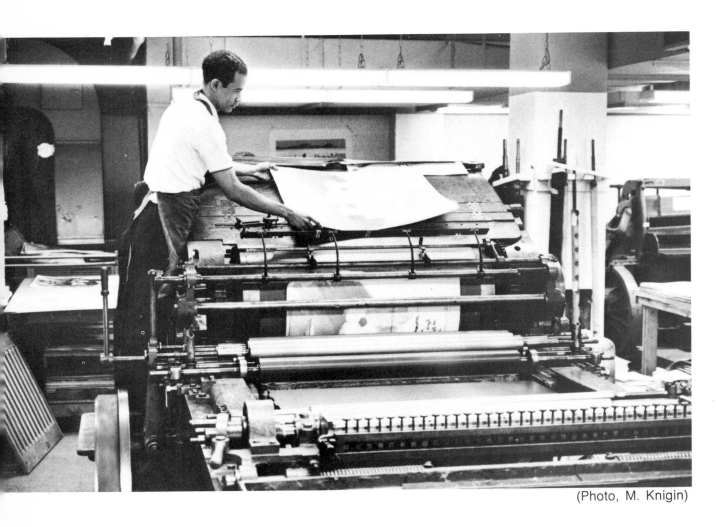

(Photo, M. Knigin)

(Photo, M. Knigin)

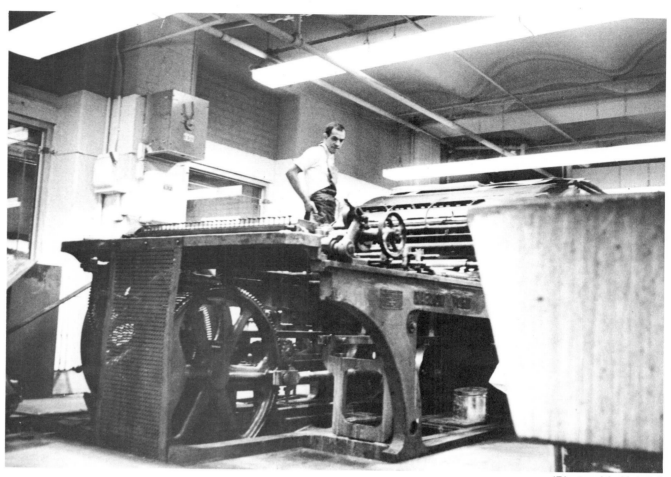

(Photo, M. Knigin)

(Photo, M. Knigin)

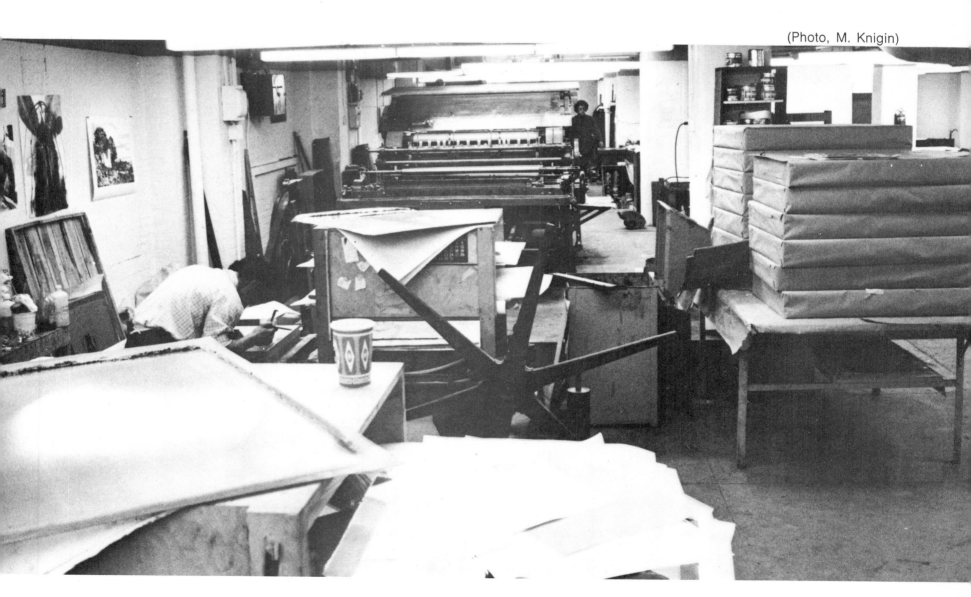

SHOREWOOD ATELIER, INC.

Primarily a lithographic workshop dedicated to the high-quality printing of fine-art prints, we also have facilities for screen printing and etching. We are presently expanding our facilities to include publishing a small select group of artists.

The artists usually work directly on the stone or zinc plate. After the plates and/or stones have been drawn and etched, the artist works closely with the proofing printer to obtain a *bon à tirer print.* The artist may also supervise the printing of his lithograph on the large flat-bed press and make corrections if he feels they are necessary. When the lithograph has been printed (usually in an edition of 100 to 120) and curated, it is ready for the artist's signature.

Lithography is not an art form; it exists between craft and technical process. In the hands of a creative artist it takes form. It is our function as fine-art lithographers to supply the artist with the materials, equipment, and technical ability that he needs to make a good print.

An artist's time is best spent making artistic decisions. In an effort to overcome the "printmaker's syndrome" (dry, stale, but technically proficient prints) we help the artist to arrive at a technique that his artistic direction indicates, and we perform mechanical functions for the artist which otherwise might divert his energies.

Our workshop is designed to provide a relaxed atmosphere in which each artist can stretch the medium by that dimension which is peculiar to him. We have made exciting prints by artists who had never done a lithograph before and were initially overcome by the technical obstacles. We are eager to see what other artists, previously strangers to lithography, might contribute, and we are anxious to develop and encourage a sustained interest in lithography whenever it occurs.

Director: *Jack Arnold*

The atelier was started in February 1969 under the name of Bank Street Atelier, Ltd. It became Shorewood Atelier in August 1971. Its staff usually consists of fifteen persons operating the two flat-bed and five hand presses.

115 Bank Street
New York, New York 10014

The following is a partial list of the artists who have worked at Shorewood: Leonard Baskin, Jack Beal, Albert Christ-Janer, Chryssa, Jane Freilicher, Lionel Gongora, Red Grooms, William Gropper, Philip Guston, Al Held, Al Hirshfield, Masuo Ikeda, Alex Katz, Jack Levine, Alexander Liberman, Richard Lindner, Malcolm Morely, Robert Munford, José Ortega, Robert Parker, Philip Pearlstein, Fairfield Porter, James Rosenquist, John Seery, George Segal, Raphael Soyer, Theodore Tobiasse.

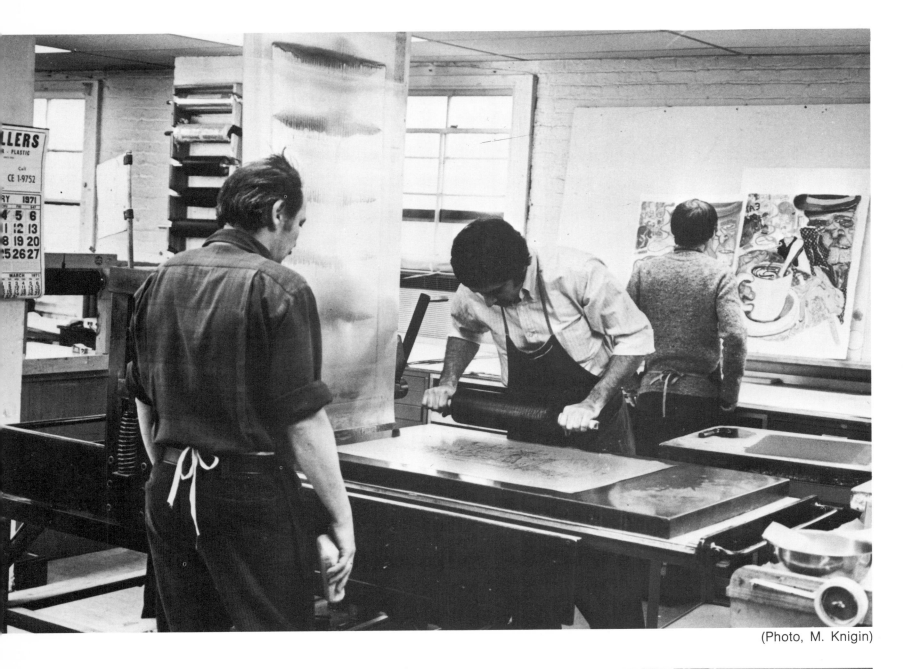

(Photo, M. Knigin)

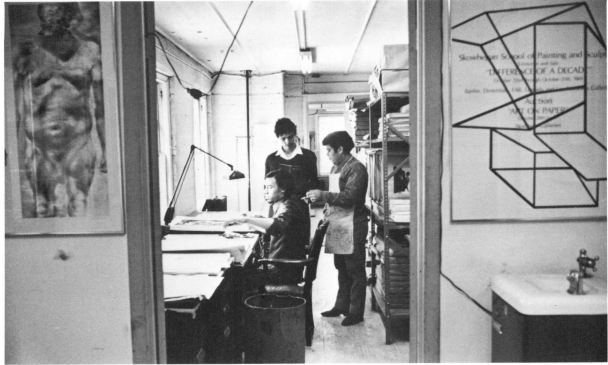

(Photo, M. Knigin)

The Dog at the Door (1971),
Fairfield Porter, 22 x 30 in.
(Courtesy of Shorewood Atelier, Inc.)

138

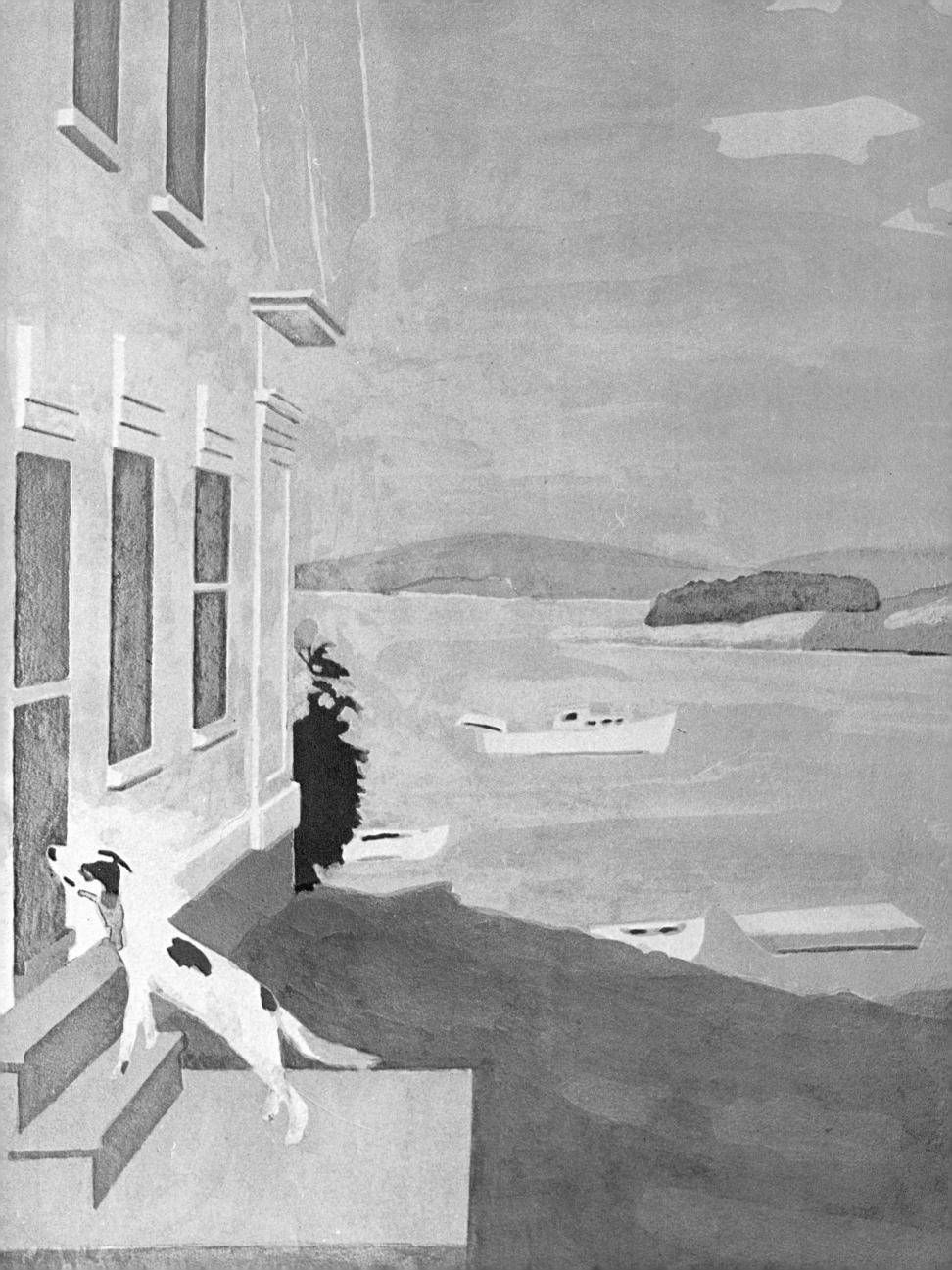

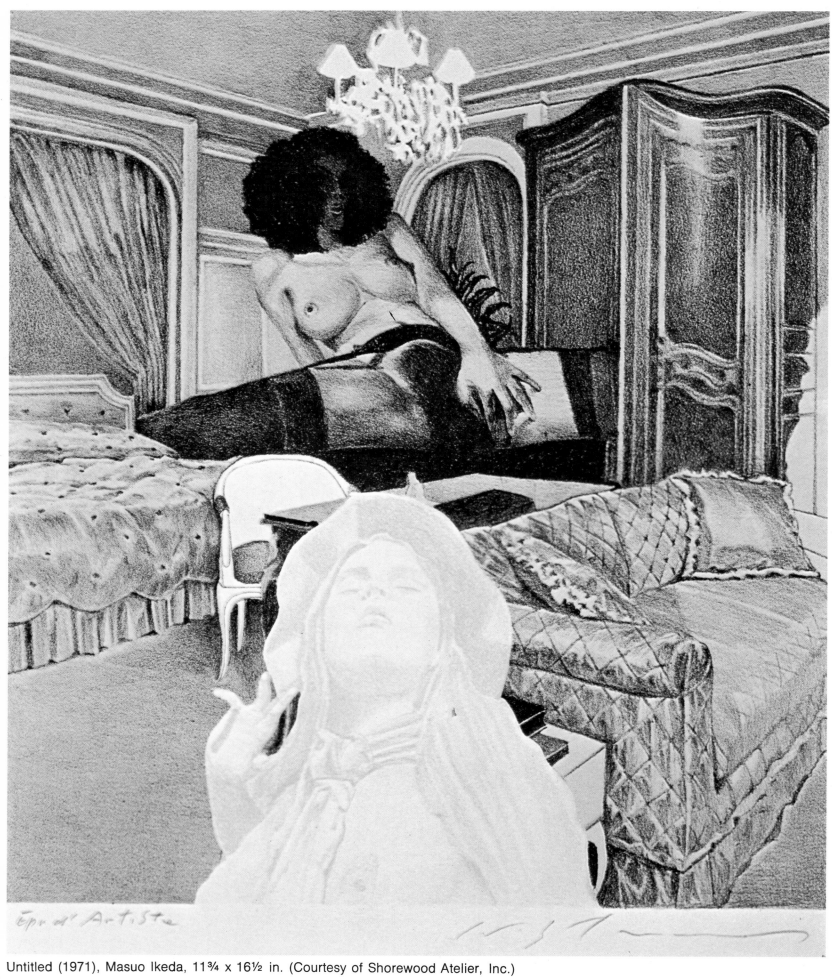

Untitled (1971), Masuo Ikeda, 11¾ x 16½ in. (Courtesy of Shorewood Atelier, Inc.)

Artist and Model (1971),
Bernard Pfriem, 30 x 40 in.
(Courtesy of Shorewood Atelier, Inc.)

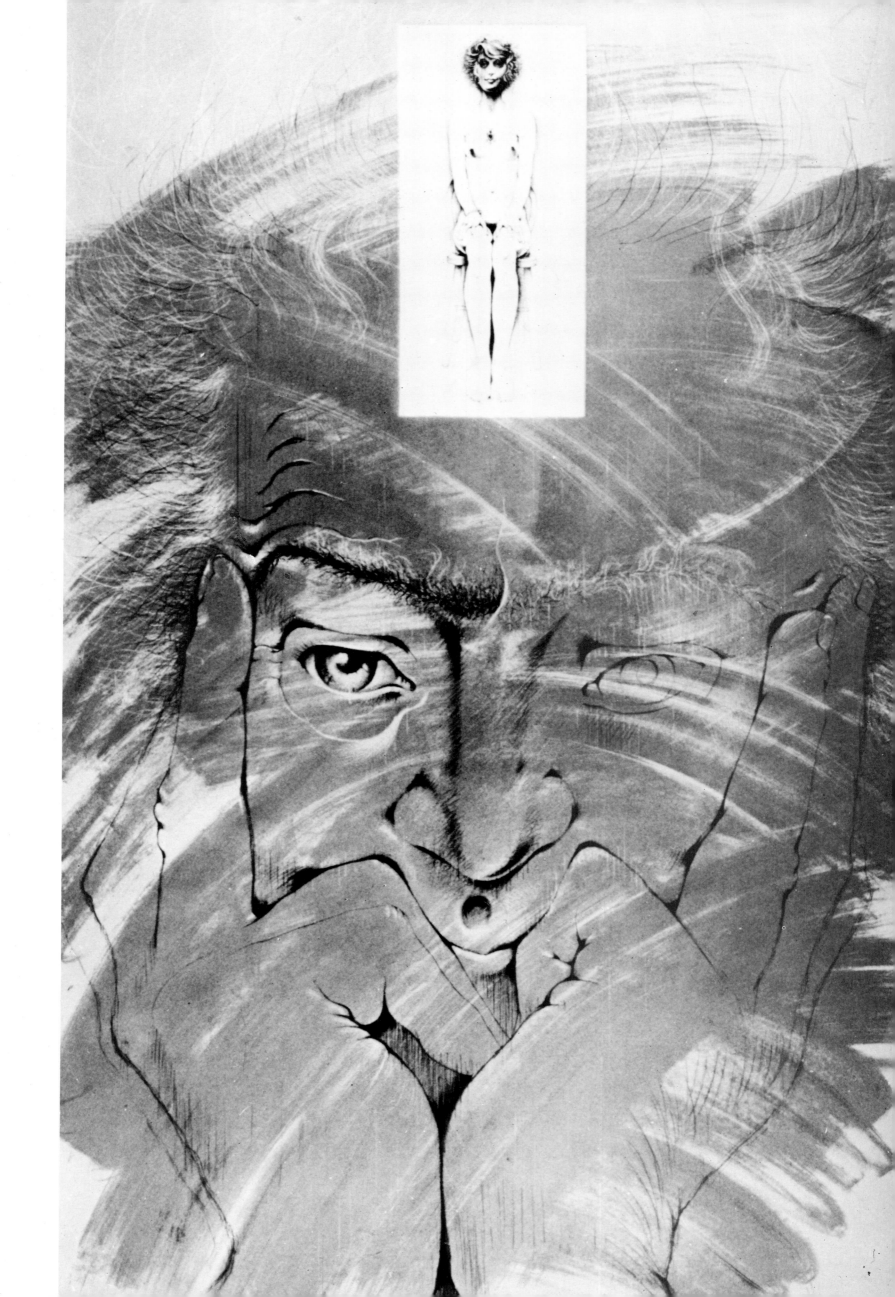

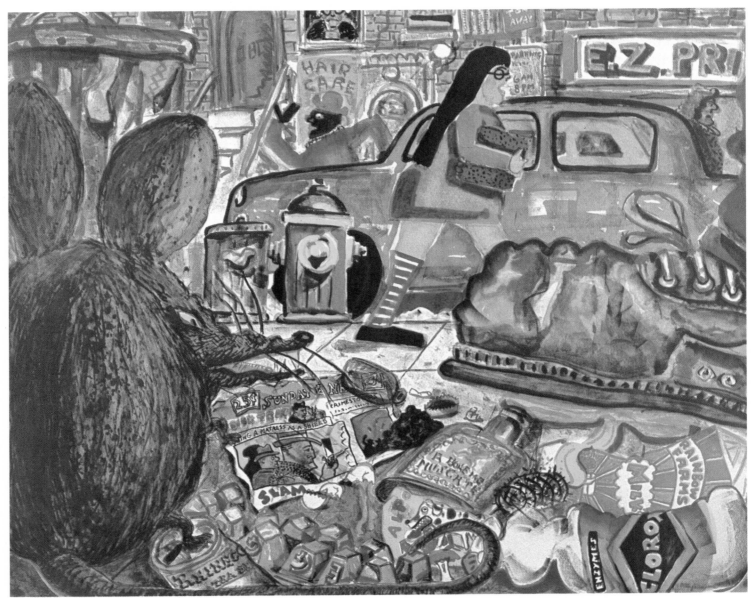

The Rat (1971), Red Grooms, 22 x 28 in. (Courtesy of Shorewood Atelier, Inc.)

Artist's studio with Grooms' lithographs. (Photo, M. Knigin)

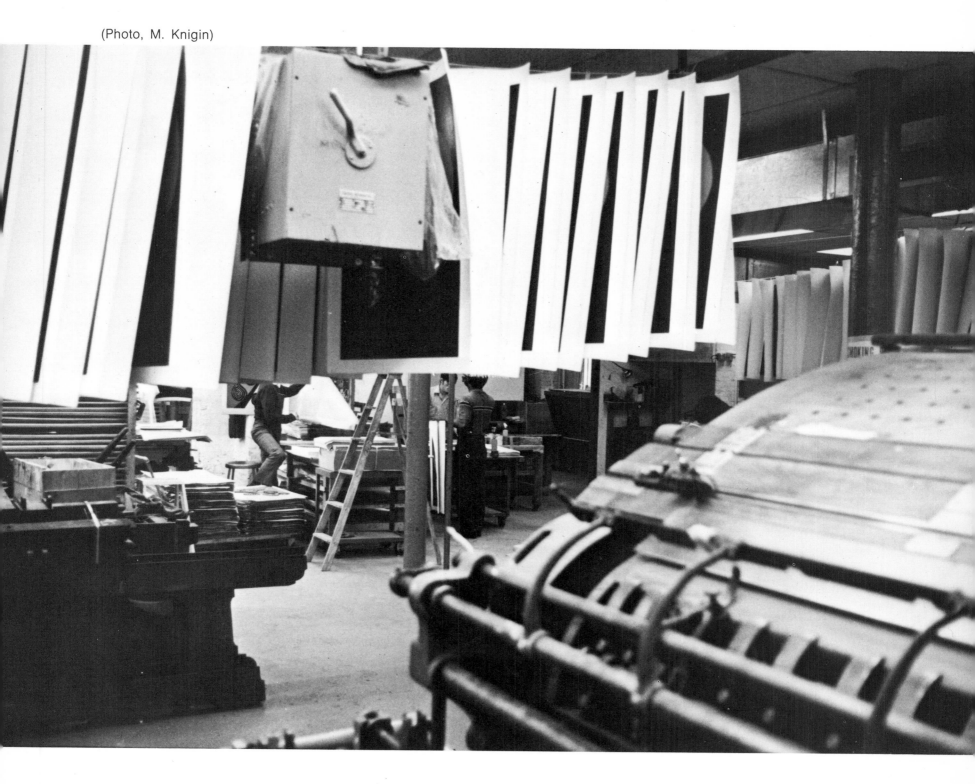

143

TAMARIND INSTITUTE

Clinton Adams *(left)*, director of Tamarind Institute, with Garo Antreasian, technical director. (Courtesy of Tamarind Institute)

The concepts and objectives of the Institute follow those already well established by Tamarind Lithography Workshop, Inc., in Los Angeles, California. These include the training and education of lithographic hand printers and print curators, the introduction of distinguished artists to the potential of lithography, and the technical and aesthetic extension of lithography as an art form. The Institute also continually updates materials, equipment, and processes related to the medium. It establishes technical and aesthetic standards of print documentation, preservation, and connoisseurship, and it provides economic studies related to the administration of hand-lithography workshops and the marketing of lithographs. Furthermore, Tamarind disseminates slides, films, publications, fact sheets, and other educational materials related to the above matters.

After an initial conference with the artist to identify aesthetic, technical, and practical matters related to a proposed project, shop policies, working procedures, and production schedules are described. Then, initial drawings, test stones, and proofing are undertaken with close collaboration between the artist and printer. In order to assess progress, the directors, the artist, and Institute personnel hold periodic conferences. The objective of maintaining the closest possible collaboration between all participants is fundamental to the precept of the Institute.

The following history of the atelier and statement by its director, Clinton Adams, are taken from a Tamarind Institute publication:

> During July and August of 1970, while its new building was under construction, Tamarind Institute began its work in the lithography studio of the University of New Mexico Art Department. In September, a second move was made, this time to a spacious new workshop immediately adjacent to the University campus. Much of the workshop's equipment, including three of its lithographic presses, was transferred to the new workshop from Los Angeles.
>
> Tamarind will gain in many ways from its association with the University. The Albuquerque workshop is far larger than was the one in Los Angeles, and the added space will permit expansion of many aspects of the program. University specialists from many fields will participate in the Institute's work. Stephen D. Takach, Senior Technician in the University's Department of Mechanical Engineering, has designed and constructed a much-improved machine for the graining of lithographic metal plates; Karl Christman, Associate Professor in the School of Business and Administrative Sciences, is offering classes in business systems for lithographic workshops; and Cleta Downey, Assistant Curator of Prints in the University Art Museum, is serving as curatorial consultant. Courses in the history of the graphic arts are offered by the faculty of the Department of Art. Artists, printers, and curators working at the Institute have full access to all resources of the University, including the Fine Arts Library and the Art Museum. The Library has considerable strength in the history and

practice of lithography, and the Museum has an extensive collection of original lithographs by major artists of the nineteenth and twentieth centuries.

The program of the Institute will differ in many ways from that of its parent organization in Los Angeles. Tamarind is now an 'open' workshop which will undertake printing on a custom basis, by contract with artists or their publishers. At the same time, Tamarind will continue to provide its services to a limited number of artists-in-residence. Some appointments will jointly be made in association with the UNM Department of Art.

University of New Mexico
108 Cornell Avenue, SE
Albuquerque, New Mexico 87106

The following is a partial list of the artists who have worked at Tamarind Institute: Clinton Adams, Keith Boyle, Anne Chapman, Dorothy Dehner, Charles Mattox, Mike Nevelson, George Rickey, Herman Rose, Fritz Scholder, Jack Sonenberg, Earl Stroh.

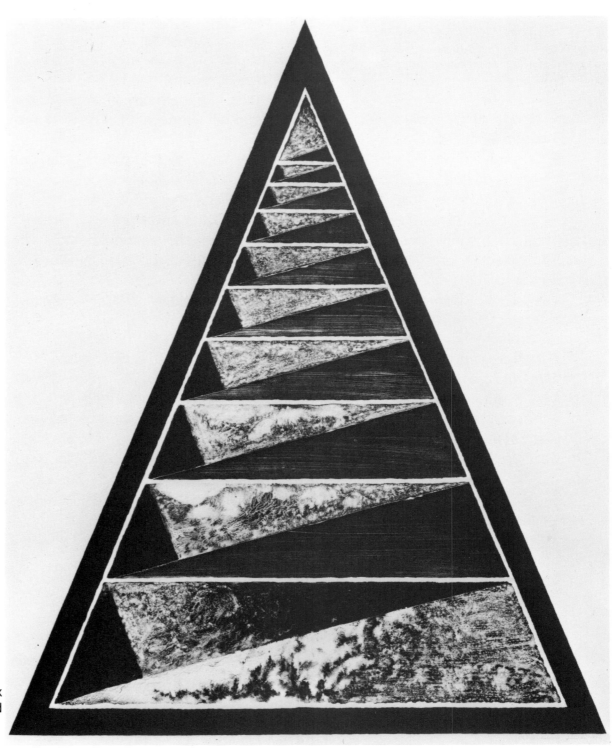

Strata (1970), Clinton Adams, 30 x 22¼ in. (Courtesy of Tamarind Institute)

Quadrate—Yellow (1970), Anne Chapman, 19½ x 19 in. (Courtesy of Tamarind Institute)

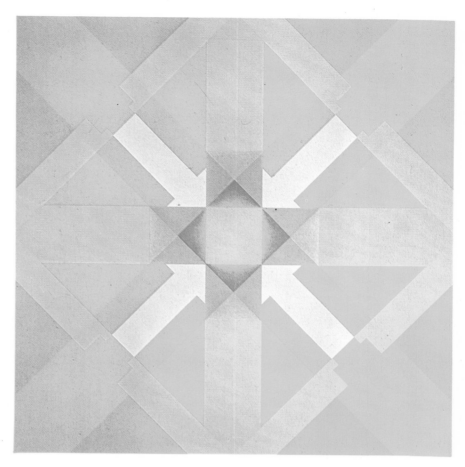

Variations on a Reauleau (1970), Charles Mattox, 20 x 26 in. (Courtesy of Tamarind Institute)

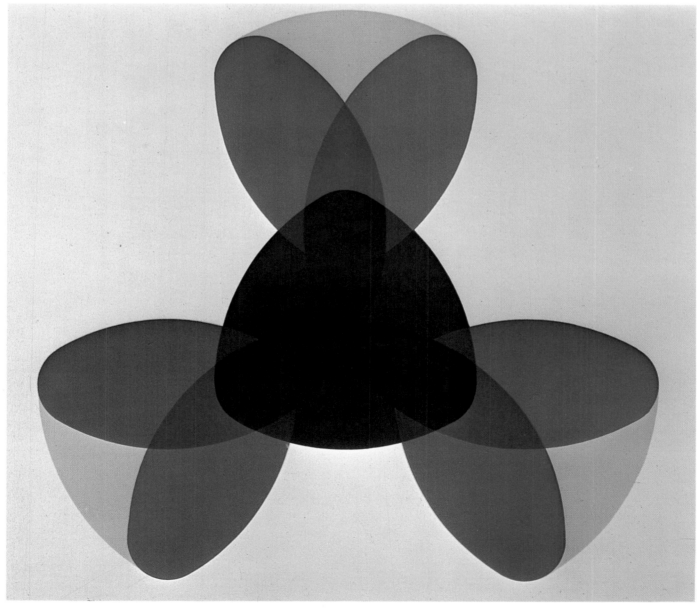

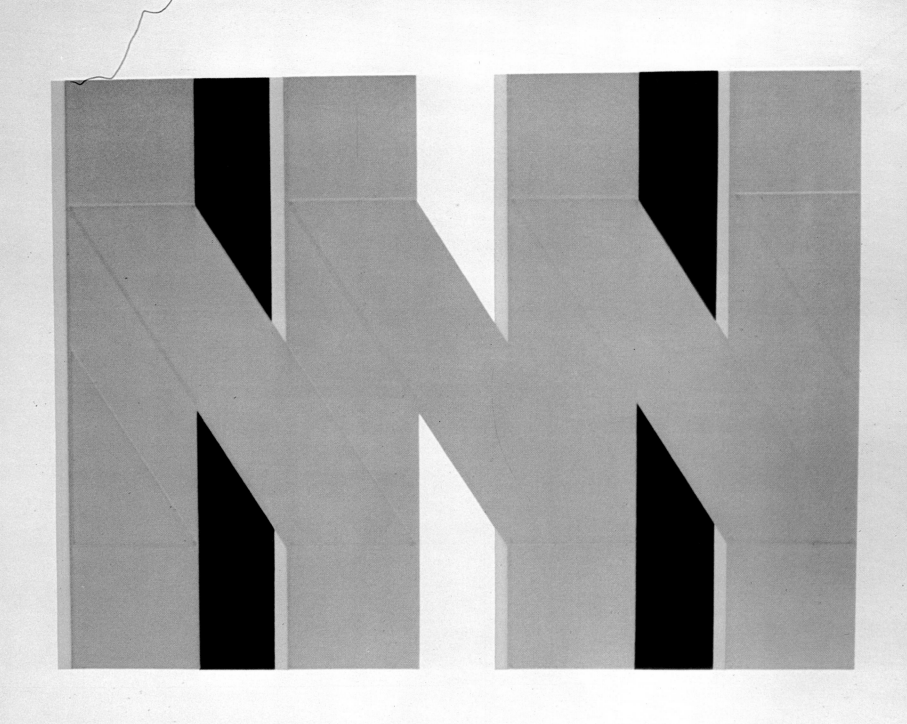

Terminal (1970), Jack Sonenberg, 33 x 27 in. (Courtesy of the Artist)

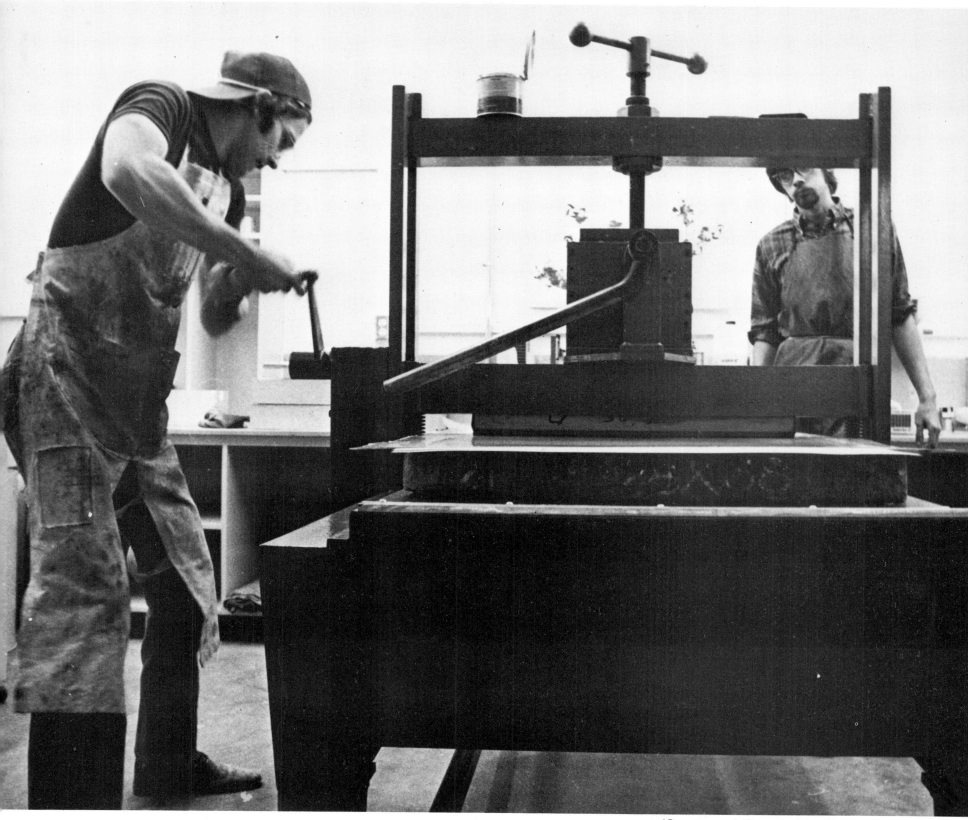

(Courtesy of Tamarind Institute)

149

TAMARIND
LITHOGRAPHY
WORKSHOP,
INC.

A national board selects artists for Tamarind and invites them for a two-month grant. Those chosen may produce whatever and as much as the shop can produce for them during their grant. The artists work with all the printer-fellows in training, and the master printer gives technical assistance and supervision. Lithographic materials are provided for the artists, who are given work areas in the shop in which to draw, convenient to the printing area where they can supervise the proofing and printing of their lithographs. All drawing is done by the artists; all printing is done by the printers on the shop's five presses. Editions of twenty numbered impressions are pulled for the artist, nine for Tamarind Collectors (museums, galleries, and universities), and a *bon à tirer* for the responsible printer as a standard of quality. All editions are cancelled. As editions are completed, they are again checked for quality by curator-trainees, signed by the artists, chopped with the shop and printer's chop, and documented. The artist sells his editions or distributes them to his dealers; Tamarind does not engage in marketing.

The following story of Tamarind—how it began, what its goals were, and how it operates —is excerpted from *About Tamarind*, a pamphlet written in 1969 by its director, June Wayne.

The Tamarind Lithography Workshop is a rescue operation.

It is still too early to tell whether the rescue attempt will succeed or fail. But if the effort had not begun when it did, the proposed rescue would by now be much more difficult—or even impossible. Tamarind, now in its tenth year, has trained some of the necessary people and created some of the necessary conditions to make the rescue endure. When Tamarind began, neither existed in America and both were vanishing in Europe.

What Tamarind set out to rescue was nothing less than the art of the lithograph.

To the person of average knowledge of the art scene of the 1950s, it may come as something of a surprise that art lithography was all but dead in that decade in the United States. He may not even have known it was sick. For there was, in fact, a vigorous print revival flourishing here, one which still continues. Peterdi and Lasansky were exploring and teaching others to explore the 'new ways of gravure' that Hayter had introduced here during World War II. Dean Meeker and others were raising the serigraph, that peculiarly American print form, to an achievement it had never attained before. Baskin and Frasconi were infusing with new life the most ancient print medium, the woodcut. And many young artists were in effect inventing their own print media for their own art purposes and doing so with considerable authority.

But in all this activity, little was said of the lithograph, little work was done in lithography, few lithographs appeared in the burgeoning exhibitions of prints. In that decade, the number of lithographic printers able and willing to work with artists and pull their prints dwindled to four, then two, and finally one. The reasons for this decline were complex, but they were rooted in the double nature—commercial and artistic—that lithography has had ever since its discovery. . . .

Any American artist who wished to make lithographs had two choices: to master the art of printing for himself, or to go to Europe. One such artist was June Wayne who, in 1957, left her studio in Los Angeles to make the 6,000-mile journey to Paris to work with a French master printer, Marcel Durassier. In 1958, she returned to Paris to make a livre de luxe *of John Donne's poems. Breaking the journey with a stop in New York, Miss Wayne met W. McNeil Lowry, director of the recently formed Program in Humanities and the Arts of the Ford Foundation.*

As it happened, at that time the Ford Foundation was seeking to be of decisive assistance to the arts as contrasted with awarding grants to individuals. Miss Wayne, in mid-journey, complained that her journey had to be made at all. Thus in response to the question Lowry was asking a great many people that year, she suggested that something be done to revive lithography and make its creative use available to the artists of the United States. Early the following year, when she returned from Paris with her Donne book in hand, Lowry asked Miss Wayne to suggest how the art might be rescued. She prepared a plan 'as a kind of intellectual exercise.' By late 1959 the Foundation decided to support her plan, and she directed the resulting workshop. Clinton Adams and Garo Antreasian came to Los Angeles to assist her, and, with the sensitive cooperation and funding from the Foundation, Tamarind became a reality, named for the street on which Miss Wayne's studio served as a home for the project.

To create the conditions in which—and only in which—a genuine flowering of lithography could take place, the Tamarind plan at inception set itself six goals:

(1) To create a pool of master printers in the United States;

(2) To develop American artists, working in many styles, into masters of the medium;

(3) To accustom artists and printers to intimate collaboration so that each becomes responsive to the other; to encourage both to experiment widely and extend the expressive potential of the medium;

(4) To stimulate new markets for the lithograph;

(5) To guide the printer to earn a living outside of subsidy or dependence on the artist as a source of income; and

(6) To restore the prestige of lithography by creating a collection of extraordinary lithographs.

The last of these goals, the collection, is the most visible to the art public. From 1962 on, exhibitions of Tamarind lithographs and especially one-man shows by Tamarind artists have been seen in art galleries, museums, and universities all over the Americas and abroad. In 1968, the Tamarind prints of Robert Cremean were part of the American pavilion at the Venice Biennale. In 1969, the Museum of Modern Art prepared a large Tamarind exhibition, showing lithographs by about half of the artists who have worked there and by some of the printers as well. This kind of visibility serves to cultivate appreciation and discrimination in the eye of the beholder. But in another sense such exhibitions are secondary to Tamarind's main purposes, restoration and extension of the art itself.

These have been more directly served by the continuing series of grants the Workshop has awarded from the beginning to apprentice printers, to artists, and, soon thereafter, to curators. These are the three principal art functions which have been enhanced at Tamarind, but there have been others, not least those of the art dealer and his assistants.

Central to the program has been the awarding of fellowships for the training of master printers, for it is upon the existence of master printers that the art of lithography depends. Grant candidates are selected after careful scrutiny of their talents and qualifications, which often include a master's degree in fine arts. On acceptance, they undergo an intensive preliminary course at the University of New Mexico given by Tamarind's Technical Consultant, Garo Antreasian. Then at Tamarind itself they receive a grant for maintenance during more advanced training. Their work and their progress are reviewed every three months and they are either promoted or dropped. After Tamarind, the trained

printer typically moves out into an existing free-enterprise workshop or a university art department, or opens a shop of his own.

While attention in the art world has inevitably focused on the artists, they are an important factor in the quality of education of the apprentice printers. It is essential to the good of the art that the printer trainee be able to work with artists of all styles. Hence, artists of every aesthetic persuasion have been invited to create at Tamarind. It was a considerable technical achievement for Josef Albers, working with printer Kenneth Tyler, to create hard-edge color lithographs in which two transparent colors made a third, the more so because lithography is traditionally considered less suitable for hard-edge images than other media. Yet the accomplishment in hard edge—continued, incidentally, by Tyler for Albers in the workshop (Gemini, G.E.L.) Tyler founded on leaving Tamarind— is but one of numerous directions newly explored by Tamarind printers and artists.

Artist grantees come to Tamarind for two months, a new one arriving each month when his predecessor is well acclimated and hard at work. Thus printers are provided a steady exposure to different aesthetic problems. An arriving artist is introduced to the Tamarind team and comes to feel at home with the materials and work practices of the shop. He is encouraged to create as many works as can be pulled for him; the art so produced belongs to him and reaches the public through his dealer. Many aesthetic innovations have resulted from this collaborative stimulation of artists and printers.

The printer grants and the artist grants were obvious necessities from the first. But it soon became clear that curatorial service was no luxury, but rather a necessity to proper quality control and documentation. Thus far, grants have been made to twenty-nine curatorial trainees who move out into museums, print workshops, and commercial galleries across the country when their training is complete.

Tamarind was conceived as an open-end project dedicated to achieve certain purposes rather than to repeat itself. When the achievement of those purposes has demanded new kinds of activity or new ways of relating the artist to his public, Tamarind has done what had to be done. "Ecology" is a word often used to describe Tamarind's approach. Ecological studies are exactly what guide the Workshop program. It has issued a substantial list of publications on all aspects of lithography. It has investigated and attempted to regularize the chaotic impermanence of lithographic inks available from various manufacturers. It has explored the quality of paper and, working closely with manufacturers, has subsidized development of great papers made to its own standards, two of which bear its own distinctive 'chop' as a watermark.

One significant 'failure,' so far at least, has been Tamarind's effort to get the government to salvage existing lithographic stones, inasmuch as the Bavarian quarry has exhausted the vein from which art lithography stones were taken. Tamarind has experimented with substitutes, including certain marbles and Mexican onyx, but so far all other stones are too brittle to survive the intense pressure of the hand presses.

Zinc has been extensively developed at Tamarind but is almost impossible for artists and printers to buy any more. Now that industrial lithography uses aluminum plates, zinc regrainers have vanished from the industrial scene and taken zinc plates with them. Tamarind has invented its own zinc-regraining machine, but none are yet available for its offspring printers to use in other parts of the nation. Even if zinc plates were still available, they would not replace the stone which has an aesthetic versatility no other material possesses.

Aluminum, which has its own characteristics, has succeeded zinc in commercial lithography and has been adopted into the art for certain limited application. But now industry is moving on to other alloys that art lithography may be utterly unable to use.

In the face of all this, Tamarind outlined a program for finding and stockpiling the thousands of high-quality Bavarian limestones that once were used by hundreds of commercial lithography shops in the United States and abroad. Many were dumped into convenient rivers and lakes. Some were used in building construction, but some still are lying about in the basements of printing plants. Many can be salvaged and returned to their lithographic function. Tamarind has done that with small batches, but an overall effort for stone conservation awaits the acceptance by government of the Tamarind plan, Operation Cornerstone. The existence of this plan in meticulous detail is an example of Tamarind's concern for any aspect of lithography's crisis that stands in need of resolution.

In the same spirit, Tamarind commissioned the design of household furniture with the dual purpose of providing print storage space. It has published instructions on how original prints can safely be framed. It has studied the art gallery business and published four studies on aspects of art marketing with particular attention to the handling and sales of original prints. The professional and economic data contained in these publications simply never existed before, and all of it is included in the course material to be mastered by printer and curatorial grantees to ensure their survival in free enterprise. Thus the printers learn to calculate the costs of materials, man-hours, and overhead; they can price their services accurately and allow for the necessary markups of distributors and dealers.

The Tamarind experiment moved a traditional medium toward new aesthetic and economic viability in an age that could no longer tolerate art and commerce as two sides of the same coin. At this time one sees the conscious separation of the two aspects. The art no longer shares the overtones of mass-production printing, nor the same equipment, nor the same technicians, nor the same economic base. In fact, in the main, only the word "lithograph" is the same, a reminder of another century.

There is no doubt that the art of the lithograph is thriving now. Its aesthetic importance is amply manifested by the number of artists now working in the medium with Tamarind graduates. Some of the methods used in our rescue program can, we suspect, be adapted to assist other art forms suffering from the pressures of these times. But finally, whether our gains endure depends on whether the nation, as an act of will, makes a firm commitment to the arts as integral to our way of life.

Tamarind ceased operation in 1970.

The following is a partial list of the artists who have worked at Tamarind: Rodolfo Abularach, Clinton Adams, Kenneth Adams, Josef Albers, Anni Albers, Glen Alps, Harold Altman, John Altoon, François Arnal, Ruth Asawa, Mario Avati, Edward Avedisian, Kenigro Azuma, Herbert Bayer, J. J. Beljon, Billy Al Bengston, André Bloc, James Boynton,. Paul Brach, William Brice, William Brown, David Budd, Louis Bunce, Fred Cain, Lawrence Calcagno, Rafael Canogar, Lee Chesney, Bruce Connor, William Copley, Robert Cremean, William Crutchfield, José Luis Cuevas, Andrew Dasburg, Richard Diebenkorn, Tadeusz Dominik, Seena Donneson, Lynne Drexler, Caroline Durieux, Kosso Eloul, Jules Engel, Conner Everts, Claire Falkenstein, Jan Forsberg, Sam Francis, Antonio Frasconi, Elias Friedensohn, Winifred Gaul, Sonia Gechtoff, Gego, James

Gill, Leon Golub, John Grillo, William Gropper, Ronald Grow, Philip Guston, Robert Hansen, Stanley Hayter, David Hockney, Robert Hughes, John Hultberg, Richard Hunt, John Hunter, Masuo Ikeda, Paul Jenkins, Alfred Jensen, Raymond Johnson, Ynez Johnston, Allen Jones, John Paul Jones, John Kacere, Reuben Kadish, Matsumi Kanemitsu, Jerome Kaplan, Karl Kasten, James Kelly, G. Ray Kerciu, Gabriel Kohn, Misch Kohn, Nicholas Krushenick, Gerald Laing, Jacob Landau, Rico Lebrun, Rita Letendre, Jacques Lipchitz, Frank Lobdell, Erle Loran, Sam Maitin, Robert Mallary, Maryan S. Maryan, Michael Mazur, James McGarrell, John McLaughlin, Eleanor Mikus, Enrique Montenegro, Carl Morris, Hilda Morris, Edward Moses, Lee Mullican, Robert Murray, Reginald Neal, Louise Nevelson, Tetsuo Ochikubo, Frederick O'Hara, Nathan Oliveira, George Ortman, Harold Paris, Raymond Parker, Robert Andrew Parker, Henry Pearson, Peter Phillips, Gio Pomodoro, Rudy Pozzatti, Kenneth Price, Krishna Reddy, Jesse Reichek, Bernard Rosenthal, Seymour Rosofsky, Richards Ruben, Ed Ruscha, Miriam Schapiro, Karl Schrag, Aubrey Schwartz, Antonio Scordia, Doris Seidler, Jun'ichiro Sekino, Artemio Sepulveda, Irene Siegel, Noemi Smilansky, Leon Polk Smith, Frederick Sommer, Benton Spruance, Hedda Sterne, James Strombotne, George Sugarman, Peter Takal, Rufino Tamayo, Prentiss Taylor, Walasse Ting, Joyce Treiman, William Turnbull, Reva Urban, Ernst Van Leyden, Esteban Vicente, Romas Viesulas, Hugo Weber, H. C. Westermann, Ulfert Wilke, Emerson Woelffer, Dick Wray, Alfred Young, Adja Yunkers, Norman Zammitt.

Untitled (1965), Nicholas Krushenick, 29 x 21 in. (Courtesy of Tamarind Lithography Workshop, Inc.)

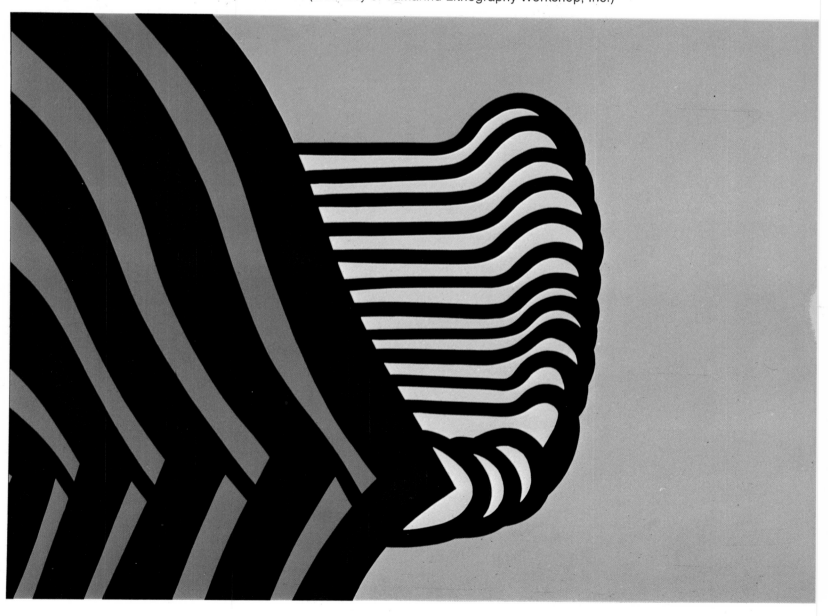

Big Red (1968), H. C. Westermann,
22 x 30 in. (Courtesy of
Tamarind Lithography Workshop, Inc.)

Untitled (1965), John Altoon, 22 x 30 in. (Courtesy of Tamarind Lithography Workshop, Inc.)

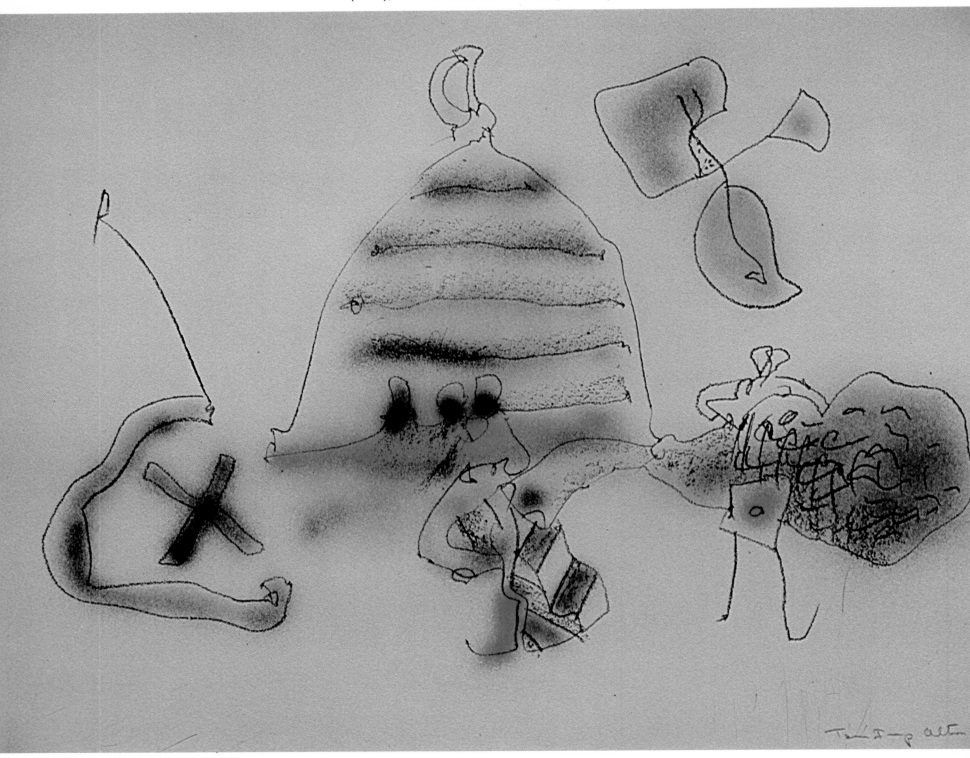

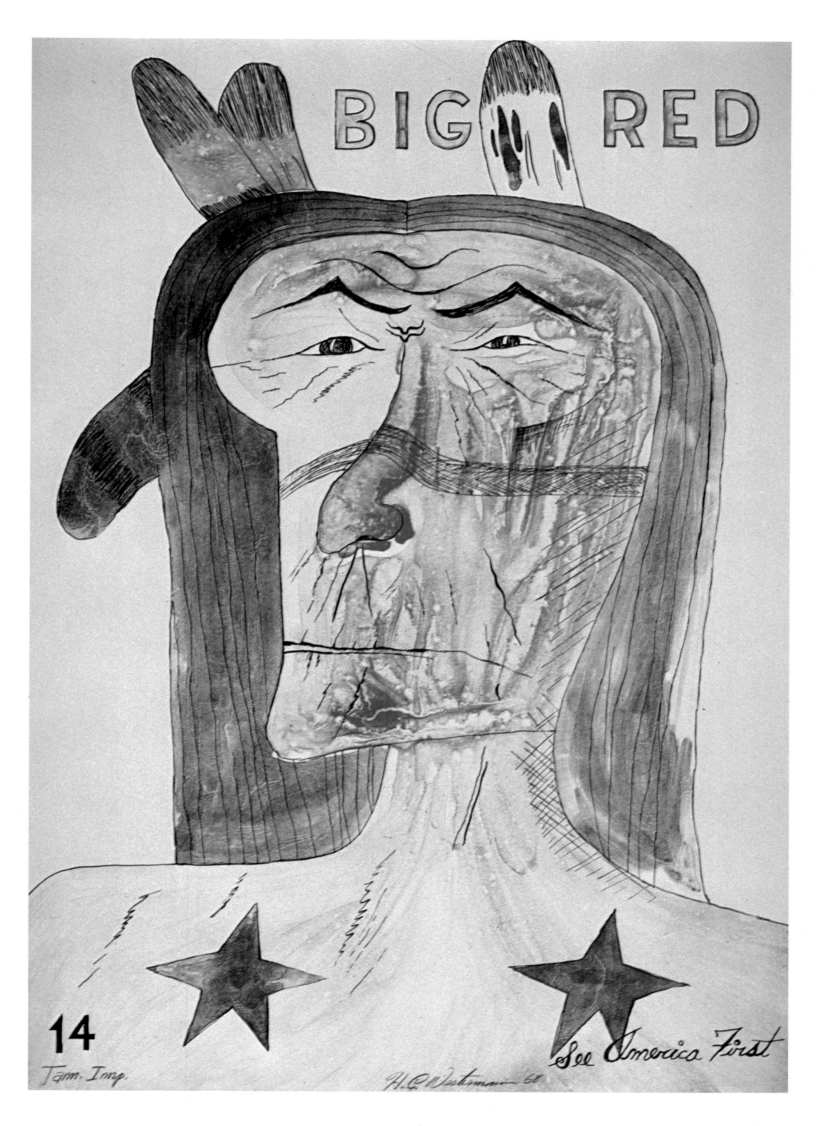

In and Over Mardi Gras (1969),
Otto Piene, 35 x 25 in. (Courtesy
of Tamarind Lithography Workshop, Inc.)

Untitled (1967), Louise Nevelson, 22½ x 42 in.
(Courtesy of Tamarind Lithography Workshop, Inc.)

Variations on a Man #1 (1964), Rufino Tamayo,
36½ x 26 in. (Courtesy of Tamarind Lithography
Workshop, Inc.)

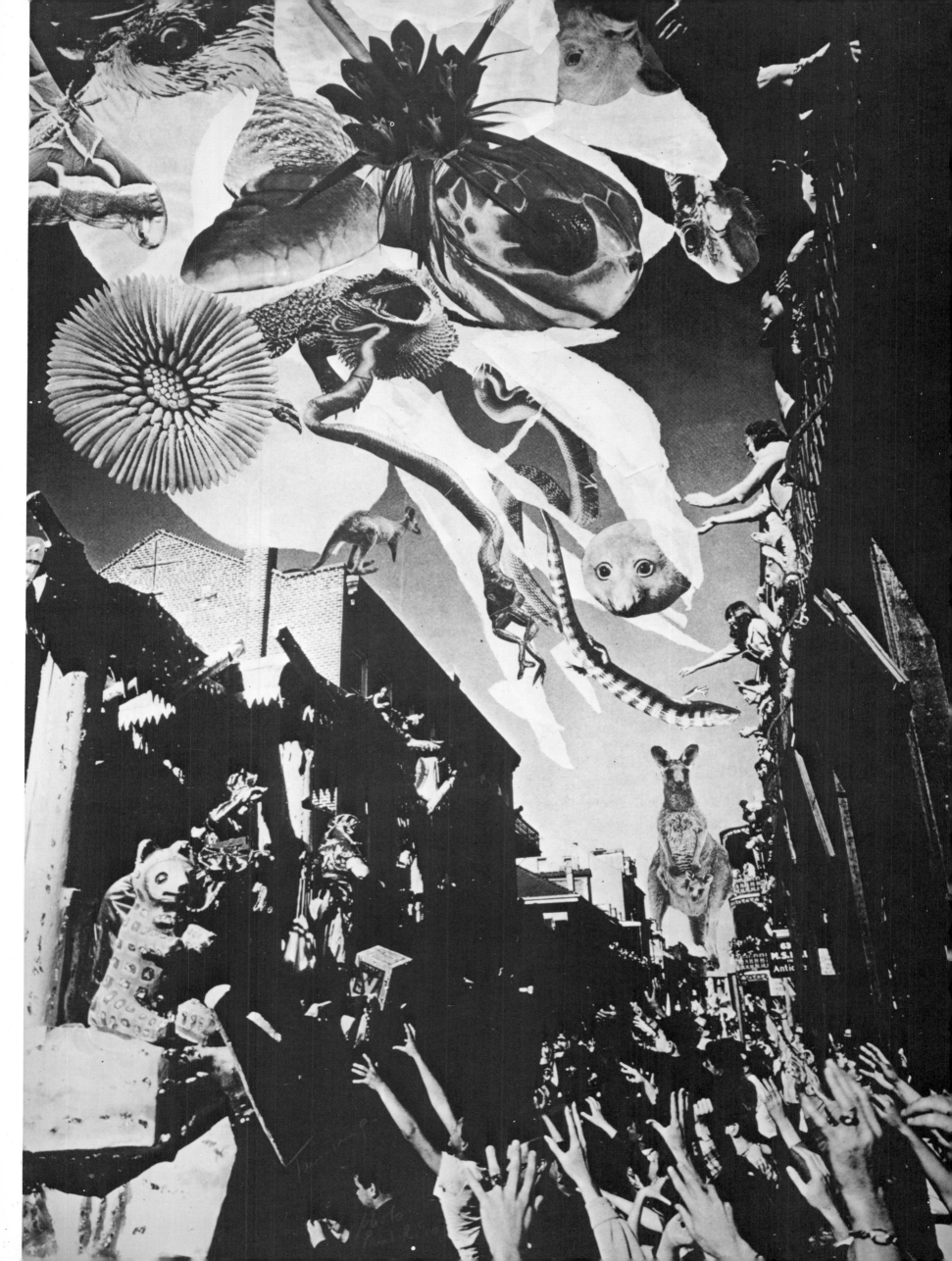

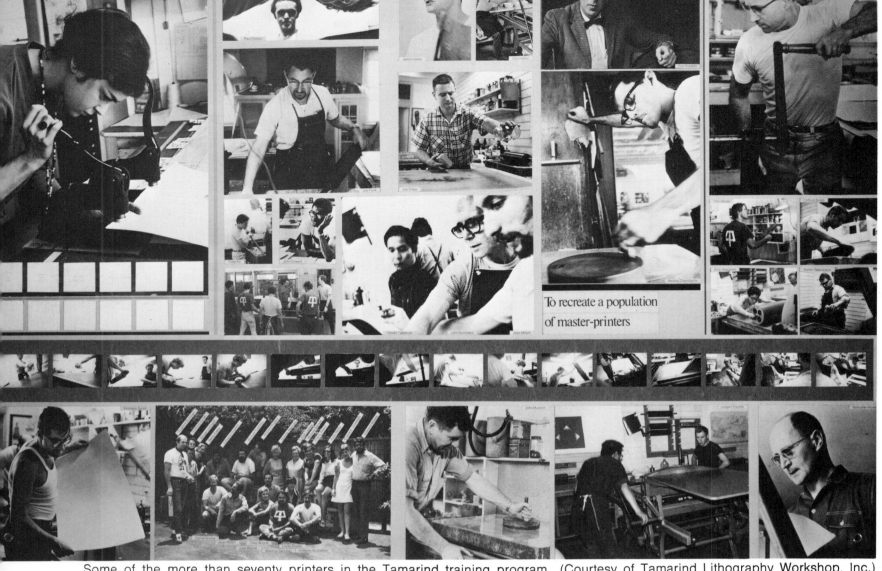

Some of the more than seventy printers in the Tamarind training program. (Courtesy of Tamarind Lithography Workshop, Inc.)

(Courtesy of Tamarind Lithography Workshop, Inc.)

Artists who have made lithographs at Tamarind.
(Courtesy of Tamarind Lithography Workshop, Inc.)

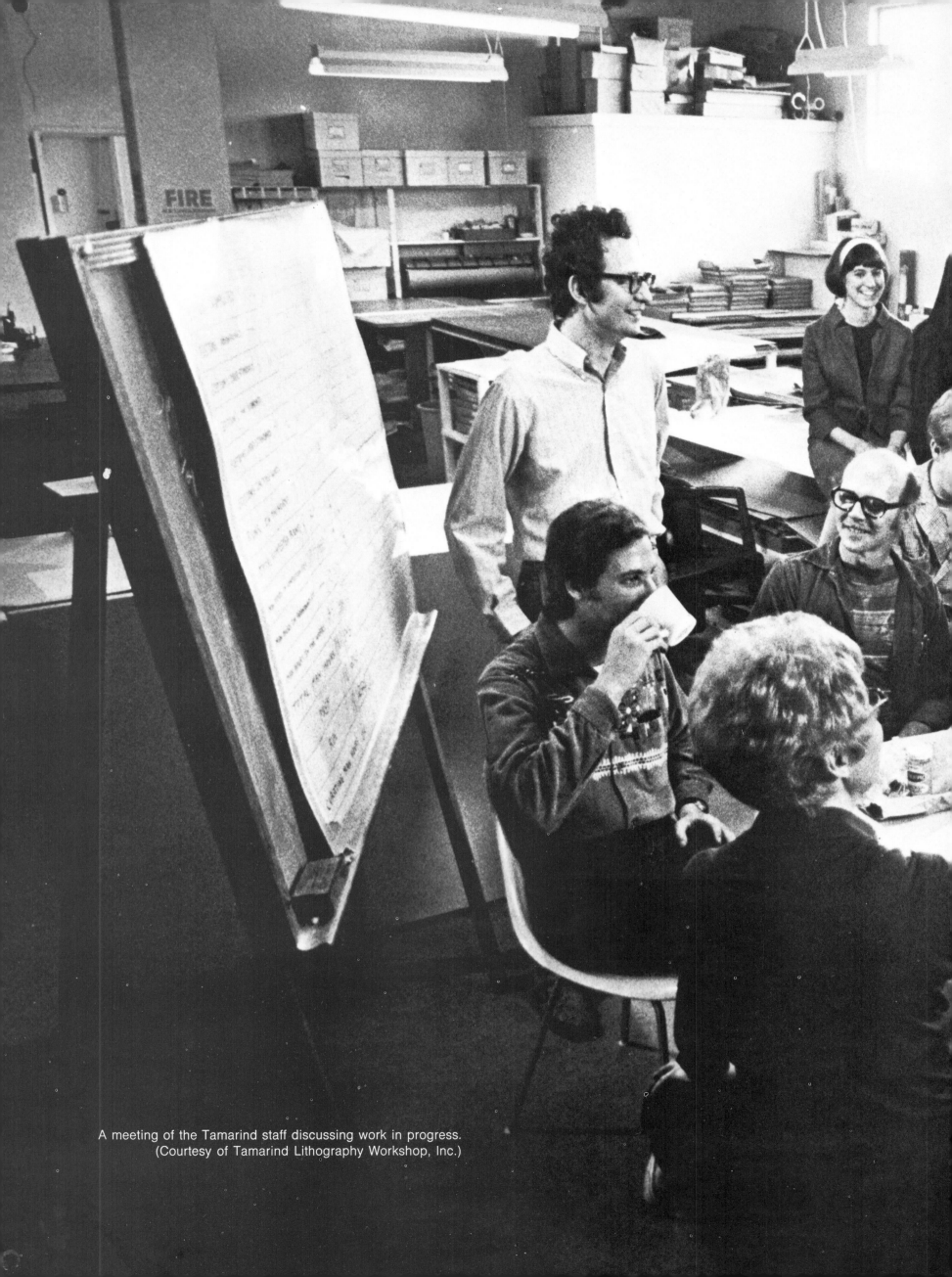

A meeting of the Tamarind staff discussing work in progress.
(Courtesy of Tamarind Lithography Workshop, Inc.)

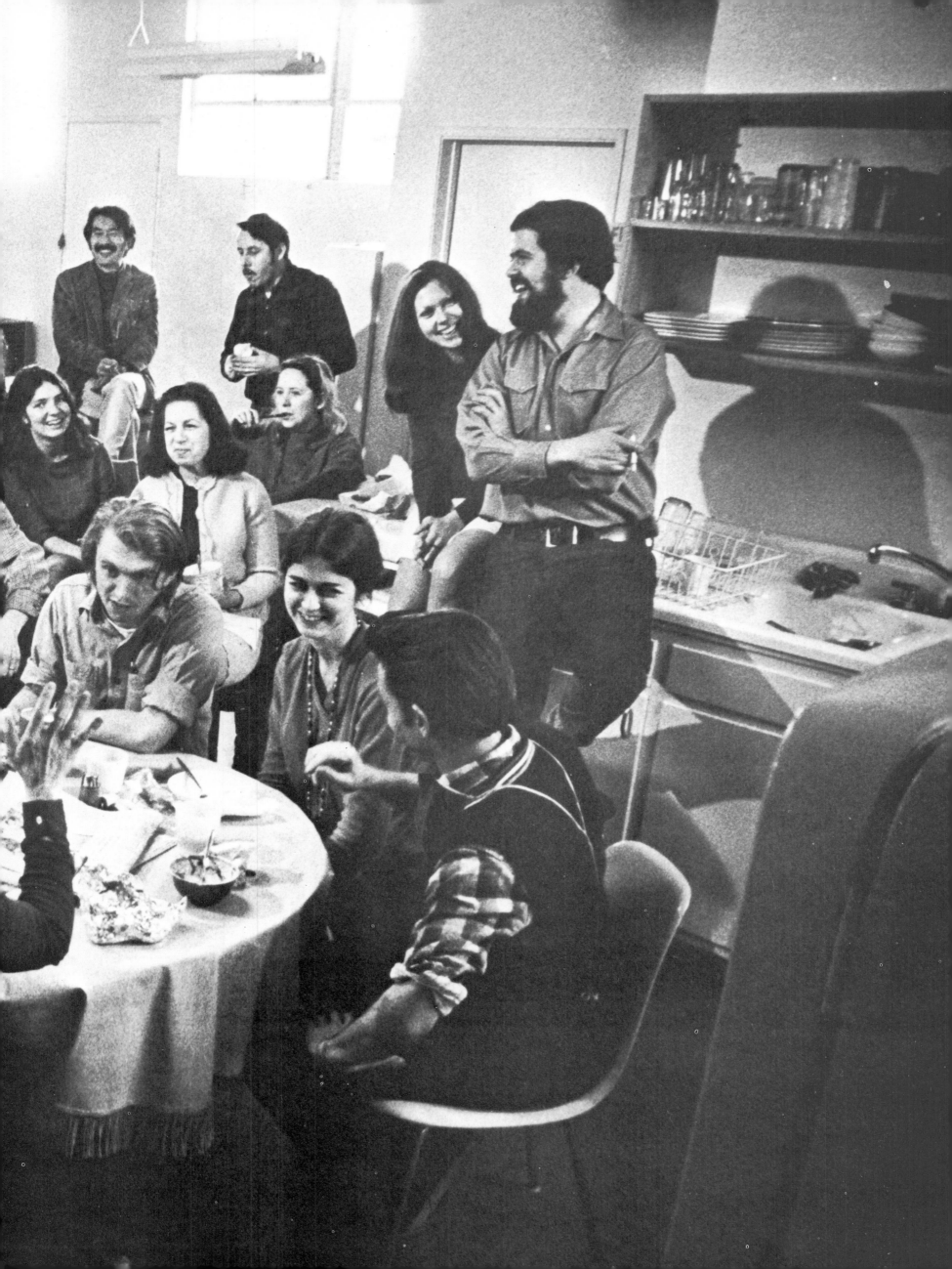

TAMSTONE GROUP

THE TAMSTONE GROUP, INC.

1110 N. TAMARIND AVENUE LOS ANGELES, CALIFORNIA 90038 213 464-6853

September 20, 1971

Mr. Michael Knigin
Knigin & Zimiles
831 Broadway
New York, New York 10003

Dear Mr. Knigin,

The attached brochure provides information about The Tamstone Group,
Inc. of which I am director. Our company was created in 1969.

Tamstone does not reveal the names of artists for whom it publishes
believing that the client relationship is confidential. The artists
do so when announcing their editions. This avoids the name-dropping
that is so misleading in the current art market. The Tamstone Group
is oriented to the welfare of its artists and the collectors who are
members only and are not distributed any other way. Naturally our
members know who our artists are and will be.

The Tamstone Group only uses hand presses and follows the ethical
standards formulated by the Tamarind Workshop. We do NOT provide
photos of our facility. However our members may visit our facility
by appointment. Our artists enjoy this creative privacy and we work
with only one artist at a time.

Our prints most often are pulled on our own all-rag, handmade paper
that carries our own watermark. We also use other well-known handmade
papers that meet our specs for stability, ph, and beauty. We pull
editions of fifty or less. The Tamstone Group cultivates the esthetic
spectrum. We publish artists we believe in, whether already world
famous or yet to become known.

The Tamstone Group does not provide photographs of the art it publishes
inasmuch as photos are misleading and cannot reveal the very qualities
that are intrinsic to the art of the original print. We believe that
art should be acquired for its esthetic; esthetic experience is exactly
what cannot be revealed in a photograph. Our collectors come in person
to see our publications in the flesh: or else they trust in our artist
panel of selection to assure that the print being published is worth
acquiring.

In view of what I write here, you can understand why I could not use
your questionnaire and why I request that you quote me verbatim in
including us in your book. Since our style of function is different
from current print marketing practices, we want our point of view to
be understood.

I will be pleased to answer any other questions you may pose.

Sincerely yours,

Peter Plone

PP:ljf
Encl.

TRITON PRESS

(Photo, M. Knigin)

Triton Press was organized after World War II by Joseph Verner Reed, Herman Weschler, and Harry H. Lerner. The specific aim was to establish a printing company that would compete with the old European pre-war standards of quality craftsmanship. By utilizing the most advanced scientific techniques then known in the graphic arts, it was possible to train new craftsmen in fine-art reproduction. Triton, for instance, was one of the first plants in the country to include complete control of temperature and humidity throughout every department. In 1949 Triton was using both transmission and reflection densitometers for greater control in art reproduction—a great departure from the hit-or-miss methods then in vogue. In 1954, on a contract from the U. S. Army Engineer and Research Laboratories, Triton developed the first successful plate for printing continuous tone on a high-speed press—referred to in the trade as offset collotype.

The principal form of printing now done at Triton is collotype, the traditional method since 1880 for reproducing fine-art subjects. After twenty years of pioneering effort and success in this field, the tables were reversed, and European printers came to America to study Triton's methods.

In 1968 a number of artists approached Triton with the idea of creating an original graphic using the collotype method for printing, but it was not until a year later that the first graphic was made by Paul Jenkins, while Triton was involved in producing a series of prints for *Art in America*. And it was Jenkins who named the method "light graphics." Since Jenkins is a highly skilled lithographic artist, he recognized in collotype a means for securing effects that were either very difficult or almost impossible to accomplish with lithographic stone. So instead of working on stone he took sheets of Mylar, which we normally use for making layouts, and drew his images on these translucent sheets. By contacting these sheets photographically, he could get either a negative or a positive image or a combination of the two. Suddenly enormous possibilities became apparent, and there seemed to be no end to what could be done creatively with this new method. What we thought was a new method, however, was simply a technique that artists used quite successfully before the turn of the century but had completely been forgotten with the advent of photography.

By studying what Jenkins had done, Albert Christ-Janer made a light graphic that was even more inventive. He used negative and positive images to create effects that were quite startling because he extended the technique by working directly on the press plate and making both additions and subtractions to suit his imagination.

At present, Triton operates with two collotype rotary presses and one offset press. The range of effects has been extended further with more experimentation, so that now the artists have almost unlimited possibilities. What is most interesting is that the artists became the stimuli for technical progress. Scientific advances in printing are usually governed by the parameters of speed, economy, or some labor-saving

device. Fortunately, the artist is less concerned with the marketplace and more with the images he wants to transpose onto a surface. It is, therefore, even more stimulating and more satisfying to be challenged technically by the artist because we then begin to wrestle with fundamental problems of improving quality in printing. By concentrating on quality we are fulfilling the aims of the original organizers of Triton Press, and we have not deviated from these aims for the past twenty-two years.

Director: *Harry Lerner*

263 Ninth Avenue
New York, New York

The following is a partial list of the artists who have worked at Triton: Richard Anuszkiewicz, Albert Christ-Janer, Charles Hinman, Bob Israel, Paul Jenkins, Michael Knigin, Ray Parker, Robert Rauschenberg, Frank Roth.

Noble Hope (1971), Michael Knigin, collotype, 35¼ x 27¾ in. (Photo, Malcolm Varon)

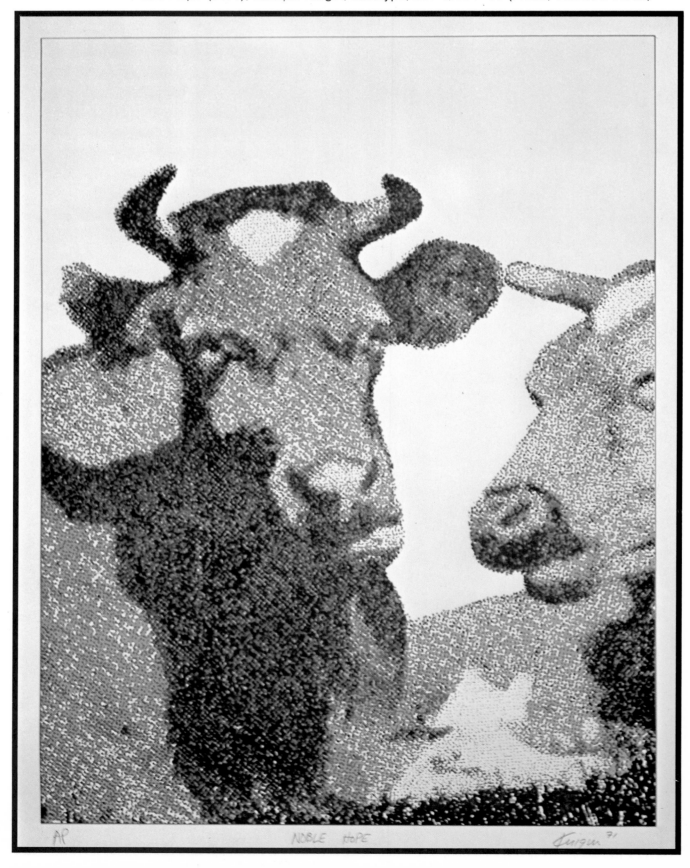

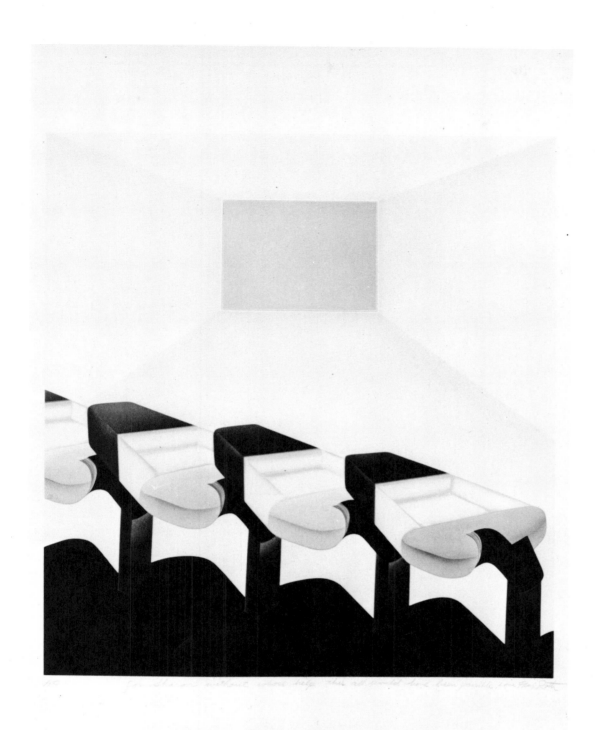

Untitled, Frank Roth, collotype, 17½ x 19 in. (Photo, Malcolm Varon)

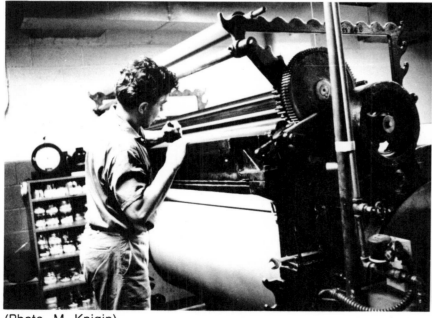

(Photo, M. Knigin) (Photo, M. Knigin)

UNIVERSAL LIMITED ART EDITIONS

Ever since I began Universal Limited Art Editions in 1957, I have tried to make the artist aware of the possibilities of paper. The paper is a completely integral part of the graphic work of art—as much as the material of which a sculpture is made, for example, determines the sculpture. I encourage the artist to experiment, with different papers, different inks, to see all the possibilities, until the artist reaches his final decision, and the edition is printed on our Brand lithographic press.

I always hope that the revelation, the encounter with the medium of graphics, will lead the artist to incorporate graphics as a part of his total *oeuvre;* it should become an expression as important and as original as painting or sculpture, collage or gouache Graphics is not a secondary medium, only a different one.

Director: *Mrs. Tatyana Grosman*

5 Skidmore Place
West Islip, New York

The following is a partial list of the artists who have worked at ULAE: Lee Bontecou, Jim Dine, Sam Francis, Helen Frankenthaler, Fritz Glarner, Grace Hartigan, Jasper Johns, Marisol, Robert Motherwell, Barnett Newman, Robert Rauschenberg, Larry Rivers, James Rosenquist, Cy Twombly.

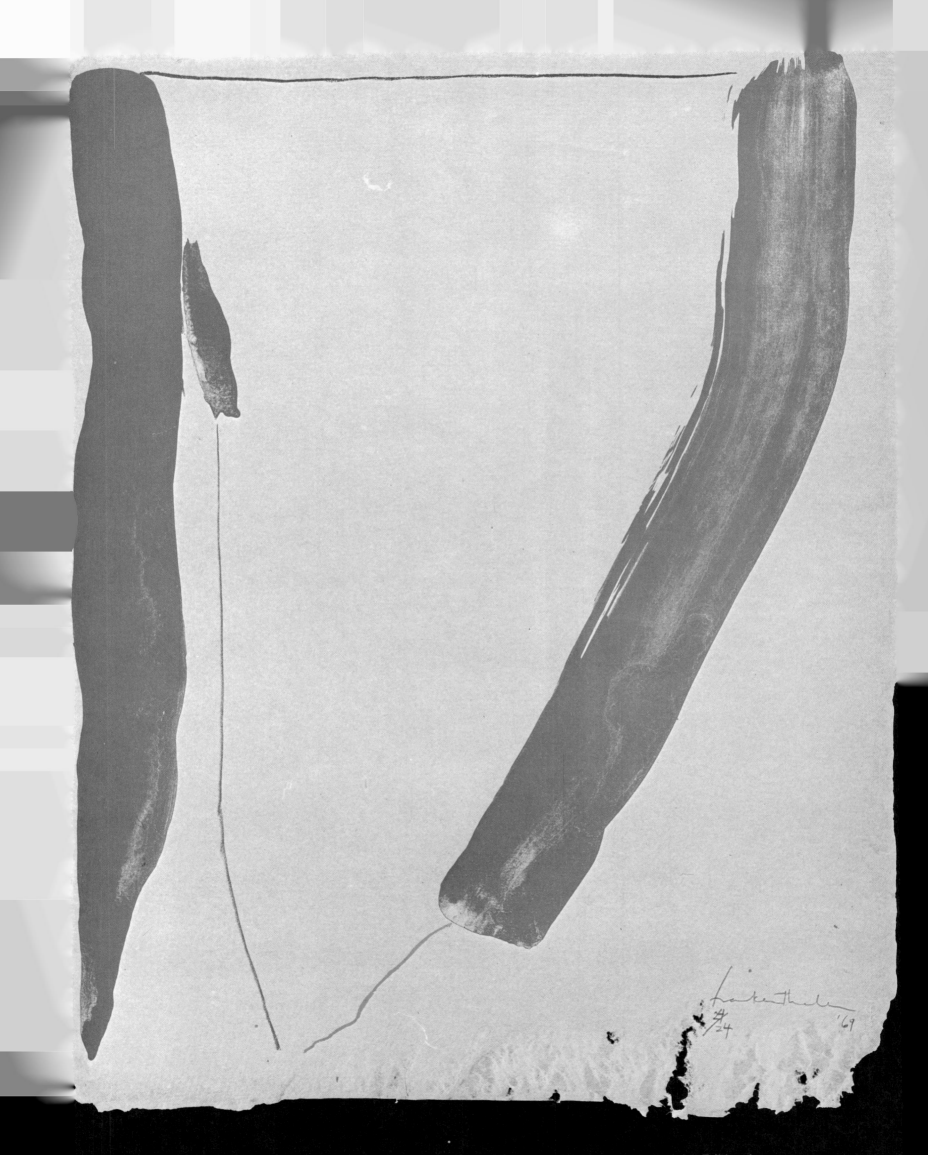

A Slice of the Stone Itself (1970), Helen Frankenthaler. 19 x 15 in. (Courtesy of Universal Limited Art Editions)

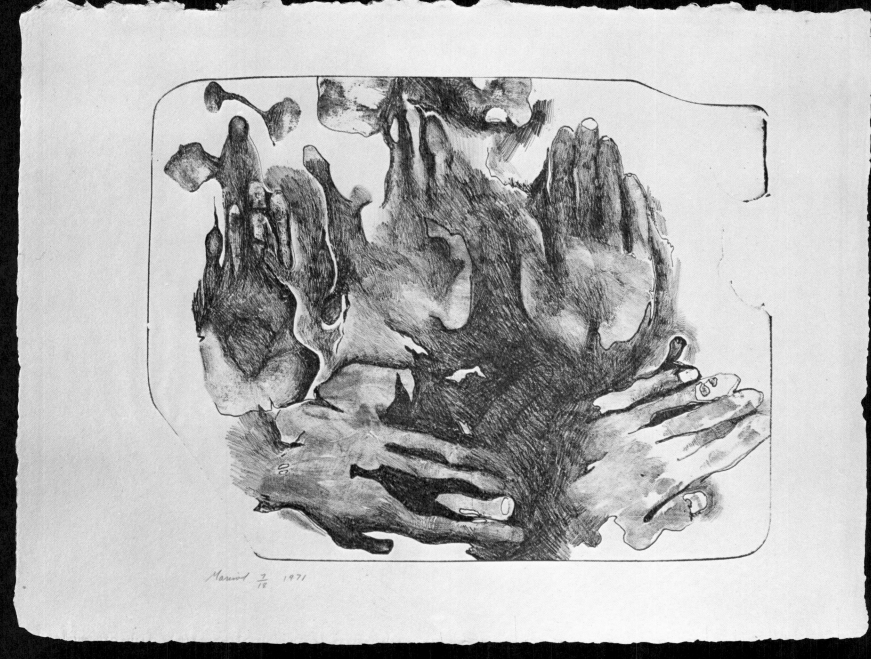

Five Hands and One Finger (1971), Marisol, 18 x 24½ in. (Courtesy of Universal Limited Art Editions)

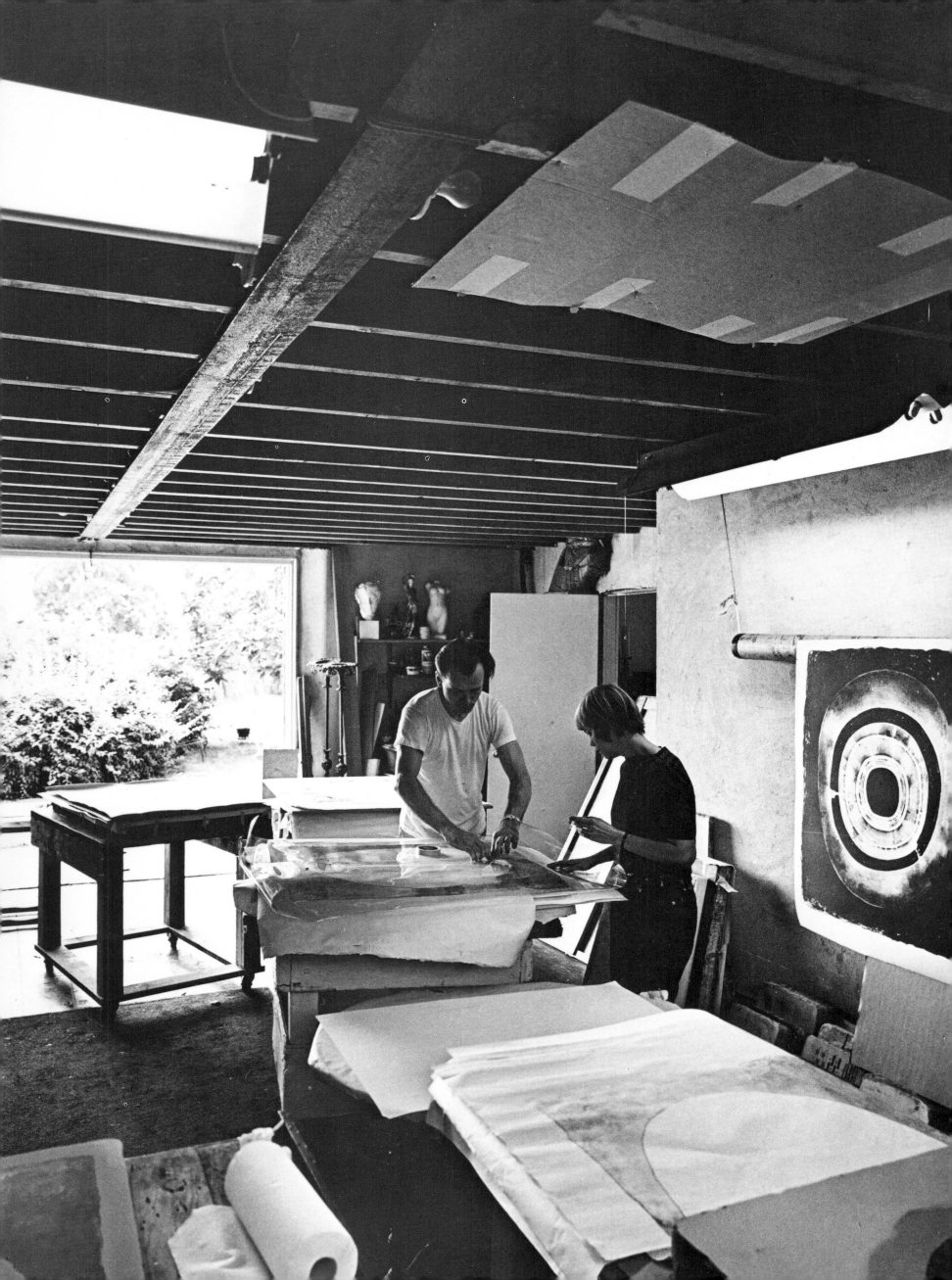

Artist Lee Bontecou *(right)*
working at Universal Art Editions
in 1964. (Photo, Hans Namuth)

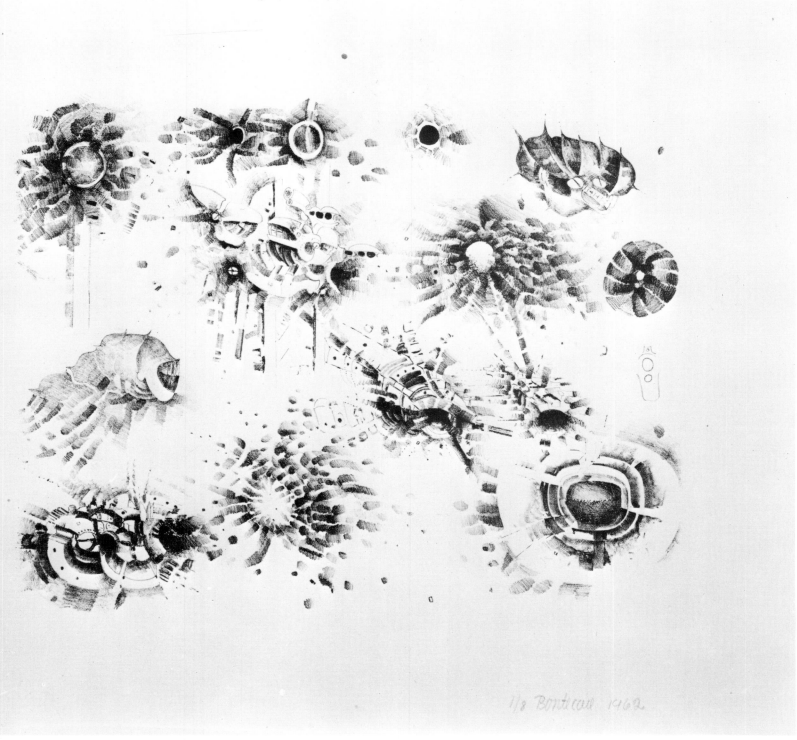

First Stone (1962), Lee Bontecou, 12 x 15⅝ in. (Collection, The Museum of Modern Art, New York. Gift of the Celeste and Armand Bartos Foundation.)

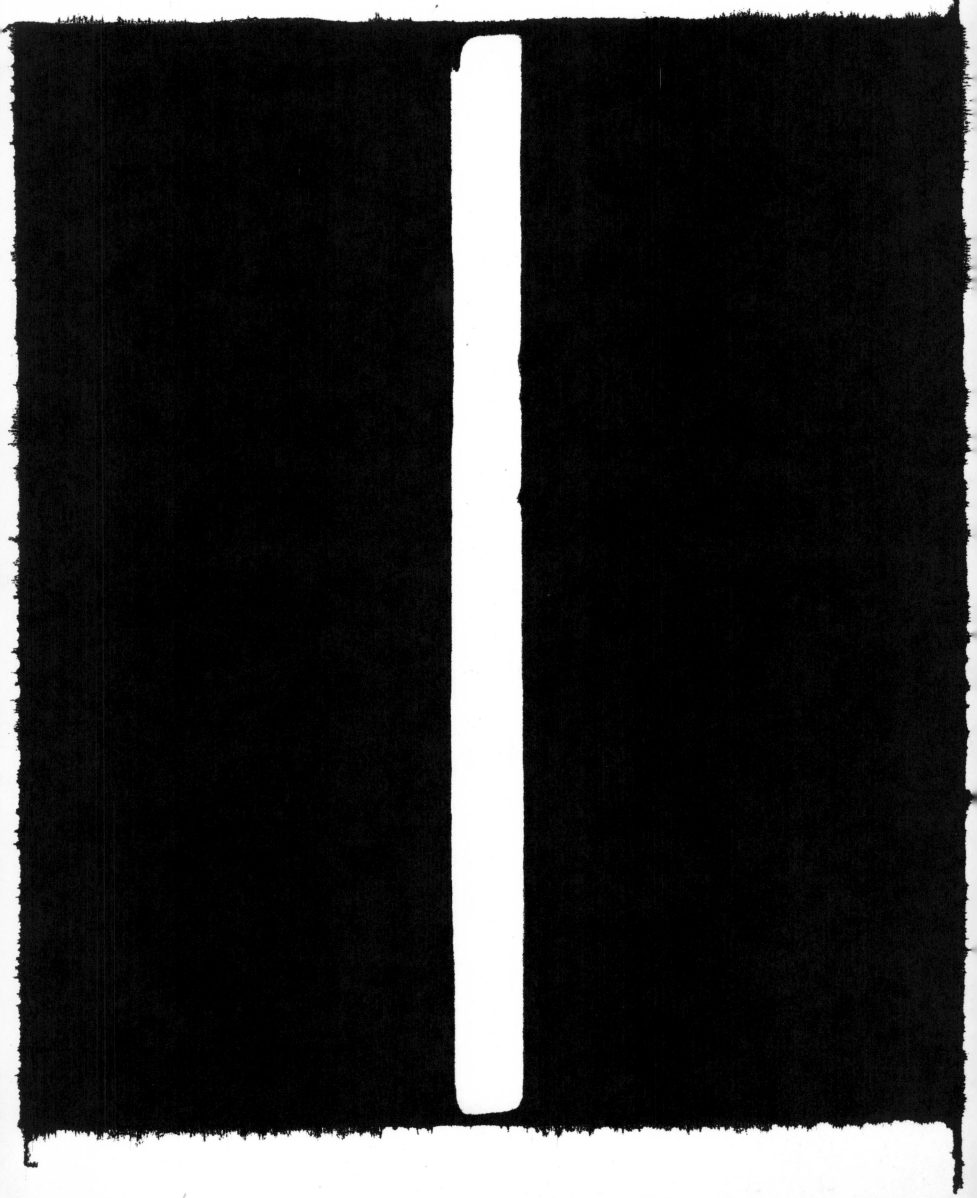

Canto III 1/18

Barnett Newman 9/63

Canto III (1963), Barnett Newman,
19⁹⁄₁₆ x 13¹¹⁄₁₆ in. (Collection, The Museum
of Modern Art, New York. Gift of
the Celeste and Armond Bartos Foundation.)

EUROPEAN LITHOGRAPHIC WORKSHOPS

IL BISONTE

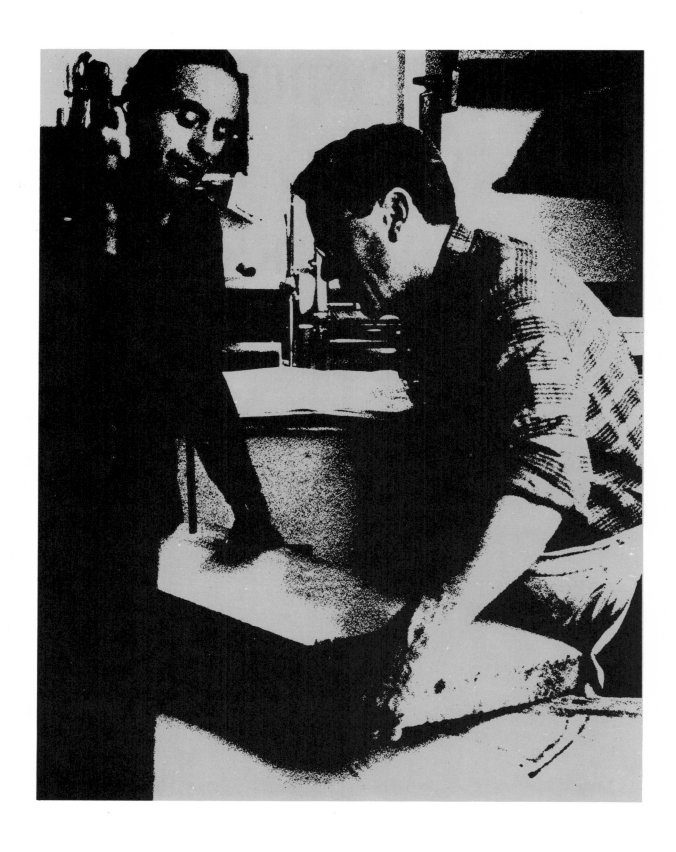

Generally the artists are invited by Il Bisonte to make a lithograph, an etching, or a series of lithographs to be presented in a portfolio. After establishing the extent and cost of the edition, the artists work side-by-side with the printers, up to the *bon à tirer*. Rarely, when artists cannot come to the workshop, they are sent transfer paper on which they execute their work with special lithographic ink. In this case, the printers transport it to the stone and send proofs to the artist for his corrections and final approval.

Personally, I see lithography as a true art form. While it offers outstanding technical guarantees, lithography provides great elasticity of graphic possibilities, sometimes opening to the artist the unexpected discovery of a new skill. Thus the paper often registers the fragrant sign of a just-revealed language modality, of a happy immediacy and enthusiasm. I feel I can state that a good lithograph shows the artist's highest capabilities.

Director: *Maria Luigia Guaita*

While journeying through Scotland in the late 1950s, Maria Luigia Guaita, a journalist and collector of graphics, happened to visit a lithographic atelier in Edinburgh directed by an enthusiastic elderly Scottish painter, Anna Redpatt. It was here that the idea for Il Bisonte was born. She returned to Florence and, with a friend, Professor Rodolfo Margheri, an engraving teacher at the local Academy of Fine Arts, she set out in search of antique radial hand presses, the kind used for the printing of lithographs on stone. Fortunately, they found antique Bollito hand presses and large lithograph stones stored at the Military Geographic Institute. Before the advent of offset printing, these presses had been used by the Institute to reproduce topographic maps for military use. They also found there a beautiful, old German copper-plate engraving hand press, which the Italian Army had confiscated after the defeat of the Austro-Hungarian Army in World War I.

The Military Geographic Institute also supplied skilled workers. Now that maps were being printed mechanically, two former printers, who had abandoned their craft, were glad to take it up again. So, in 1959 in a large room, named Il Bisonte after the engravings of bison found in ancient caves in Spain, the hand presses began revolving.

The first artist to make lithographs in the new-born workshop was the abstract sculptor, Arturo Carmassi. It was a new experience for all, even for the expert printers. Although highly skilled, they had been used to do a different kind of printing. It must be noted, however, that the military precision and exactness with which they executed their work has greatly contributed to the international repute that the artisan *équipe* of Il Bisonte has now received. During the past ten years many young people have arrived at the workshop as apprentices to become skilled printers, but only two have reached the excellence of the two master printers. Il Bisonte has found that a good printer, besides having a strict training, must have an innate gift for his craft.

Up to February 1967, the Bisonte workshop was fondly and strenuously directed by Professor Margheri. After his death, the technical direction of the workshop's four Bollito hand presses was taken up by his disciple, Professor Gustavo Giuletti, who also teaches at the Academy of Fine Arts in Florence.

Via San Niccolo, 28
50125 Florence, Italy

The following is a partial list of the artists who have worked at Il Bisonte: Cappochini, Carlo Carra, Carusco, Clerici, Cremonini, Emilio Greco, Renato Guttuso, Magnelli, Matta, Henry Moore, Pablo Picasso, Gio Pomodoro, Severini, Soffici, Graham Sutherland, Treccani, Lorenzo Vespignani.

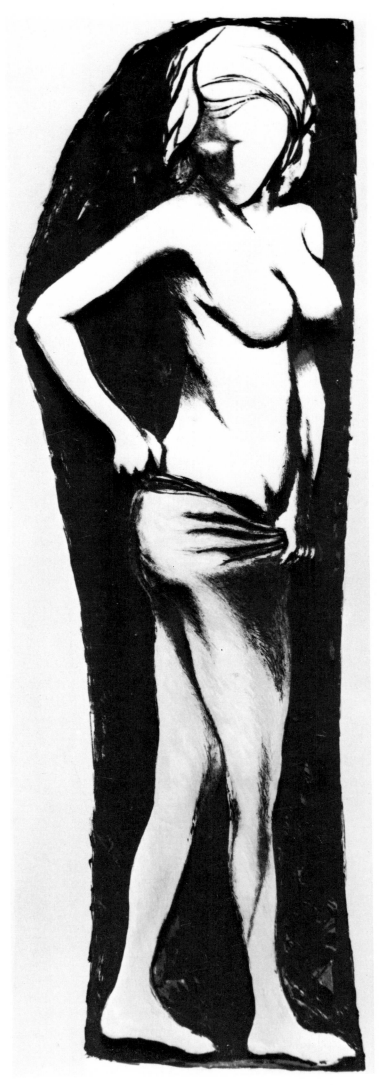

Girl in Leotards (1969),
Renato Guttuso, 47 x 18 in.
(Courtesy of Il Bisonte)

The Blind Fly (1968), Leonardo Cremonini, 20 x 29 in. (Courtesy of Il Bisonte)

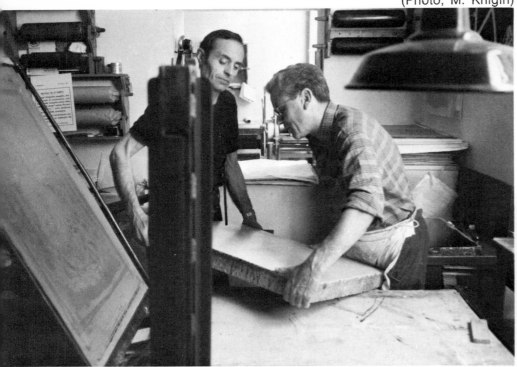

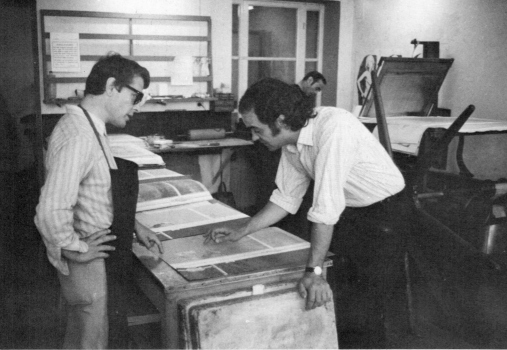

STABILIMENTO CROMO-LITOGRAFICO R.BULLA

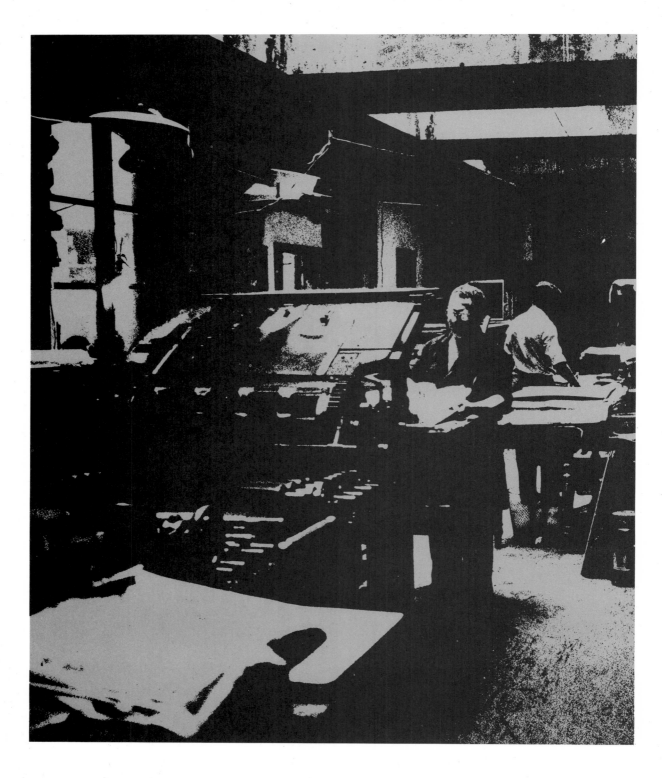

Just as Toulouse-Lautrec made a living contribution to the art of lithography, the best contemporary artists, in the same spirit of renewal, work directly on stone or zinc to round out their experience and to find, by way of the fascinating graphic medium, new expressive possibilities such as have brought iconographic enrichment and technical progress in every era.

The aim of our studio is to promote direct rapport between the printer and the artist in order to obtain results that are more valid, whether on a technical or an artistic level.

We study chemistry for lithographic compositions, using new chemical processes on stone and zinc, discovering the possibility of printing ballpoint pen on lithographic stone, and obtaining graphic results similar to dry-point. We are improving the process of etching on stone.

(Photo, M. Knigin)

Director: *Roberto Bulla*

In 1840 Anselmo Bulla founded a color lithographic firm in Via del Bufalo in Rome, inscribing his first stone with these words: "We execute artistic and commercial work, labels in black and white and in color, letterhead paper, bills of exchange and bank checks, graphics, numismatic work, advertising posters, wall posters, and any engraved or crayon work in black and white or color."

Skillfully and lovingly pursuing the still-young art of lithography, he achieved great fame and prestige for the perfection of his work. Bulla had an enormous and exceptional clientele, and his lithography was revered by personalities in the sciences and the arts, among them the famous astronomer Padre Secchi, for whom he designed the "physical picture of the solar constellations" in fourteen colors, now in Vatican City. For this he was awarded a gold medal and a certificate.

In 1897 the support and the growth of the clientele necessitated a move to larger quarters in Via della Consolazione, and additions to the equipment, namely two flat-bed machines with transmission, made by H. Voirin in Paris.

In 1899 the establishment came under the direction of Anselmo's son, Romolo, who moved to Via del Vantaggio, added an automatic flat-bed direct-printing machine, made by Albert Frankental in Germany, and put up a new building to house the press. He was among the first to print reproductions of paintings in oleography, using the lithographic technique. These prints were made by superimposing twelve or fourteen colors, and they imitated the perfection of the original paintings. Of them, the portraits of Victor Emmanuel III and Queen Elena achieved considerable success.

Romolo Bulla made calligraphy samples for the schools of the city of Rome; he reproduced designs by Professor Mola for schools of ornamental art; he engraved plates on architecture for Professor Borgogelli; he engraved and printed monumental, colored, bird's-eye-view plans of Rome and Naples. And on June 7, 1890, he received an honorable mention from the Associazione Commerciale Romana for the lithographic works he exhibited.

After the death of Romolo Bulla on May 23, 1943, the business was directed by

his son, Roberto, who modernized by applying direct-intake transmissions to the flat-bed machines. He made lithographic prints not only from stones, but also from zinc plates of his own design. He studied chemistry, looking for new lithographic compositions, and contributed new chemical processes for use on stone and zinc. He discovered the possibility of printing ball-point pen on stone, and he obtains graphic results similar to dry-point. Due to assiduous and strict instruction from his father, and following in the footsteps of his predecessors, he too is an engraver of rare ability, and an expert technical designer dedicated to the graphic arts. He has engraved and printed the coats of arms of the Heraldic Institute in color, and he has designed and engraved plates of calligraphy for the publishing house of Signorelli in Rome. His work is done on two Italian-made machines and his father's original German press, remodeled in 1965.

Via del Vantaggio, 2
Rome, Italy

The following is a partial list of the artists who have worked at Cromo-Litografico: Ugo Attardi, Afro Basaldella, Mirko Basaldella, Eugene Berman, George Biddle, Luigi Boille, Martin Bradlei, Paolo Buggiani, Alberto Burri, Corrado Cagli, Calcagnadore, Aldo Calò, Massimo Campigli, Domenico Cantatore, Giuseppe Capogrossi, Michele Cascella, Pietro Cascella, Giorgio Celiberti, Luigi Cheno, Arnoldo Ciarrocchi, Antonio Clavè, Ettore Colla, Cordio, Antonio Corpora, Giorgio de Chirico, Piero Dorazio, Gerardo Dottori, Gianni Dova, Fabio Failla, Pericle Fazzini, Carlo Fontana, Felicita Frai, Franco Gentilini, Emilio Greco, Renato Guttuso, Dimitri Hadzi, Marino Haupt, Giancarlo Isola, Leonardo Leoncillo, Raffaele Leonporri, Carlo Levi, Mino Maccari, Raphael Mafai, Giacomo Manzù, Antonio Marasco, Titina Maselli, Giuseppe Mazzulo, Mihailovič, Joan Miró, Sante Monachesi, Luigi Montanarini, Marcello Muccini, Gastone Novelli, Giovanni Omiccioli, Bernardino Palazzi, Achille Perilli, Pablo Picasso, Fausto Pirandello, Domenico Purificato, Righi, Pippo Rizzo, Mimmo Rotella, Mario Russo, Maglio Sarra, Alberto Savino, Toti Scialoya, Antonio Scordia, Mario Siniscalco Sinisca, Orfeo Tamburi, Phan Thang, Giulio Turcato, Aldo Turchiaro, Antonio Vangelli, Emilio Vedova, Lorenzo Vespignani, Romas Viesulas, Antonio Virduzzo, Alberto Ziveri.

Caffè Puerto Pueblo (ca. 1910),
37 x 28 in. (Courtesy of
Stabilimento Cromo Litografico R. Bulla.
Photo, Toni Sergio)

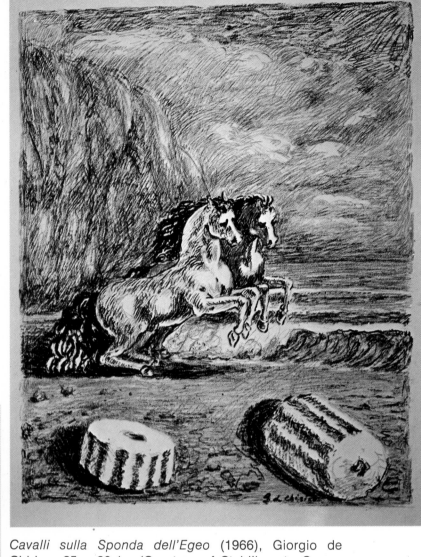

Cavalli sulla Sponda dell'Egeo (1966), Giorgio de Chirico, 25 x 20 in. (Courtesy of Stabilimento Cromo Litografico R. Bulla. Photo, Toni Sergio)

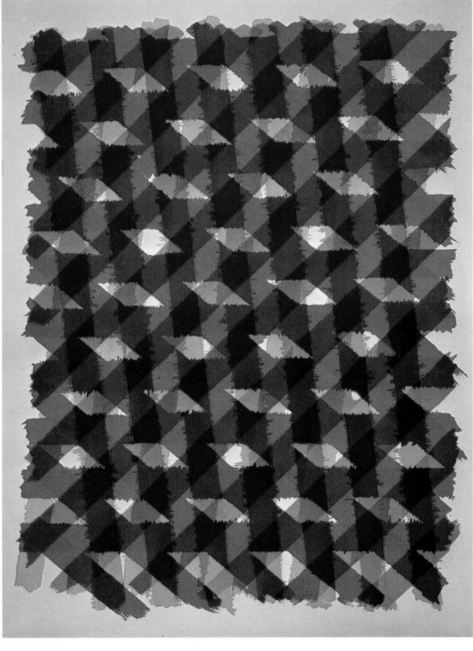

Untitled (1964), Piero Dorazio, 27 x 20 in. (Courtesy of Stabilimento Cromo Litografico R. Bulla. Photo, Toni Sergio)

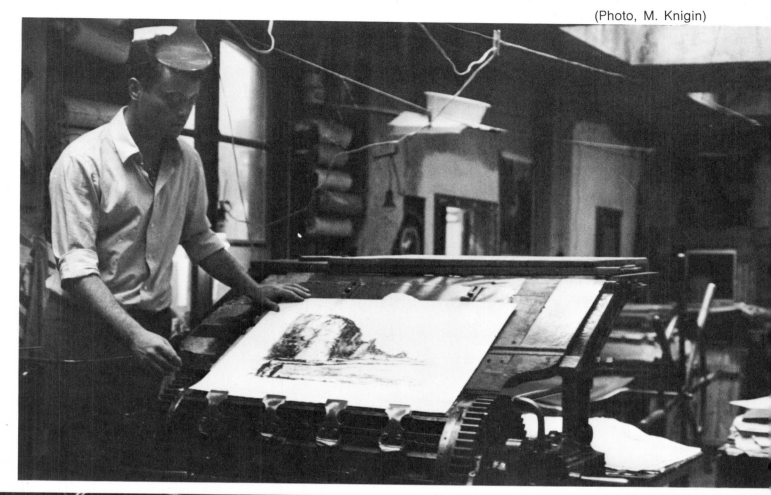

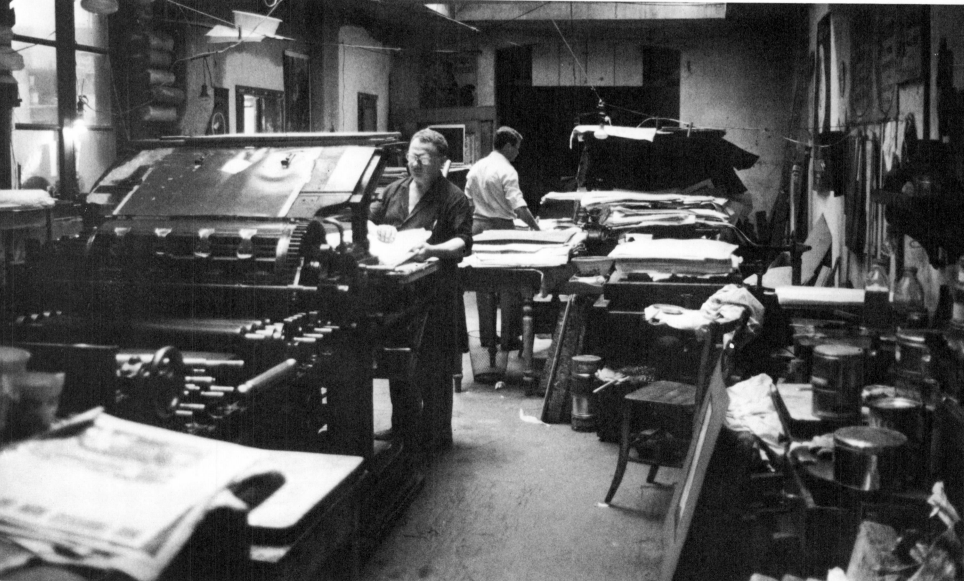

CURWEN PRINTS
LIMITED

Stanley Jones, director of Curwen Prints, Ltd. (Photo, M. Knigin)

In order to maintain its high standards for lithographic work, Curwen Prints offers its artists a great deal of help and advice at all stages of the process. Cooperation between artist, proofers, and machine operators provides the artist the utmost opportunity to develop his image lithographically within the limitations of the process and those imposed by publishers. Once the proof has been passed, the editioning is usually left to the Studio. The artist, however, can be present throughout if required.

The atelier was formed in 1958 by Timothy Simon, Hon. Robert Erskine, and Stanley Jones to continue a tradition started in 1910 by its parent company, the Curwen Press. In typography and graphic design, this policy had been to encourage artists in lithographic work of the highest standard. The Curwen Studio thus carried on an idea, specializing in lithography and drawing help in the form of men and machines for the Curwen Press.

For making proofs, the Studio uses two direct stone and two offset presses. For final editions it prints either on its flat-bed or its single-color rotary offset press. In addition to the conventional process, a great deal of experimental work has been done on zinc plate, where qualities formerly unique to stone have now become attainable. The workshop is directed by Stanley Jones and the gallery by Rosemary Simmons.

Studio
Midford Place
114 Tottenham Court Road
London W 1 P9HL, England

The following is a partial list of the artists who have worked at Curwen: Reg Butler, Lynn Chadwick, Harold Cohen, Alan Davie, Erté, Elizabeth Frink, Barbara Hepworth, David Hockney, Alan Jones, Henry Moore, Victor Pasmore, John Piper, Man Ray, Ceri Richards, James Rosenquist, Gerald Scarfe, Graham Sutherland, Ossip Zadkine.

17 Reclining Figures (1963), Henry Moore, 19¾ x 25¾ in. (Courtesy of Curwen Prints, Ltd.)

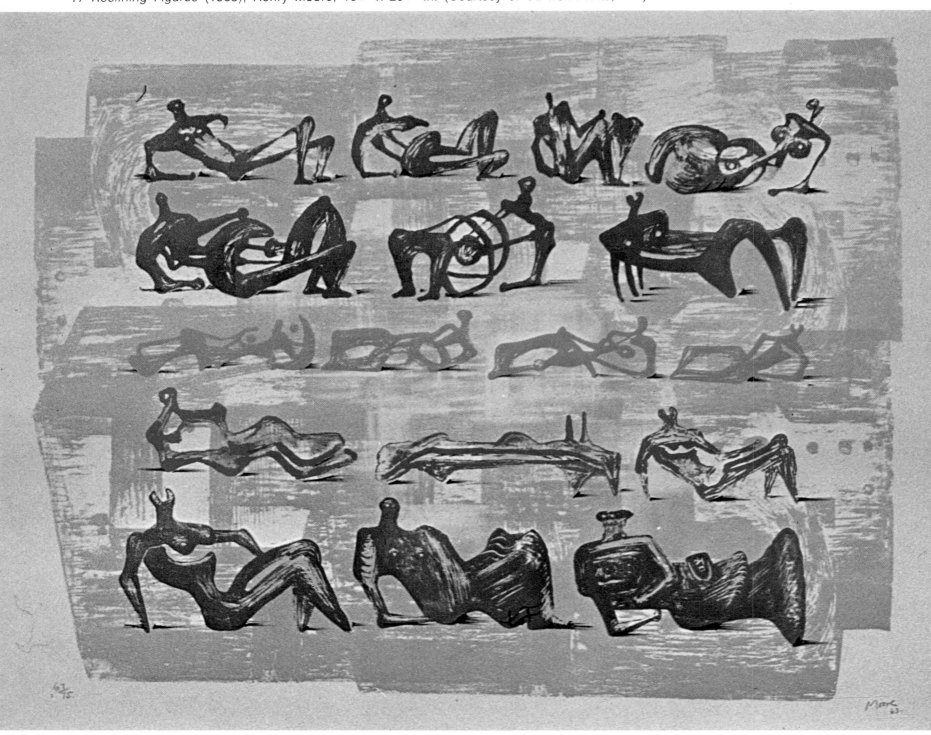

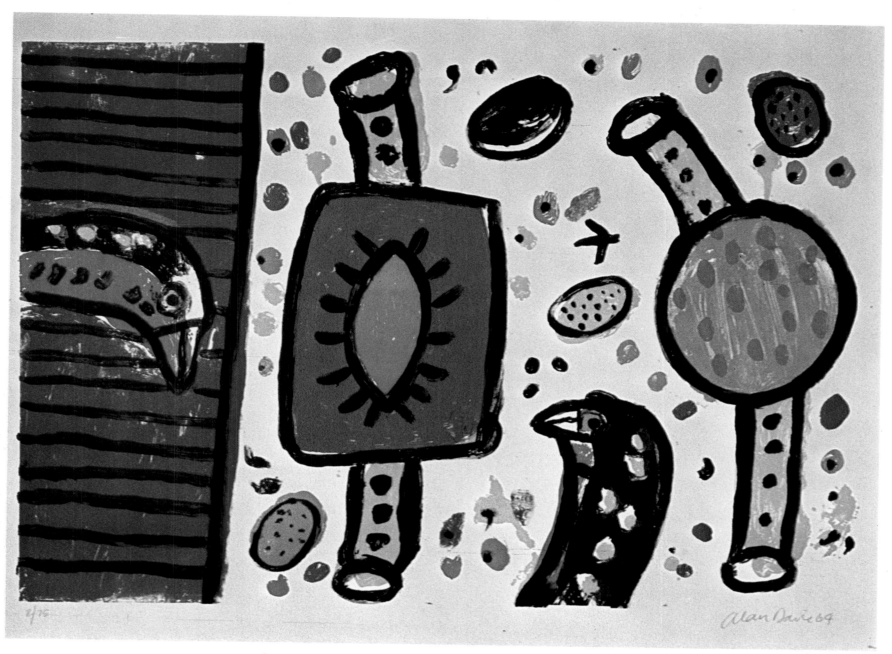

Bird Noises (1964), Allan Davie, 22 x 30 in. (Courtesy of Curwen Prints, Ltd.)

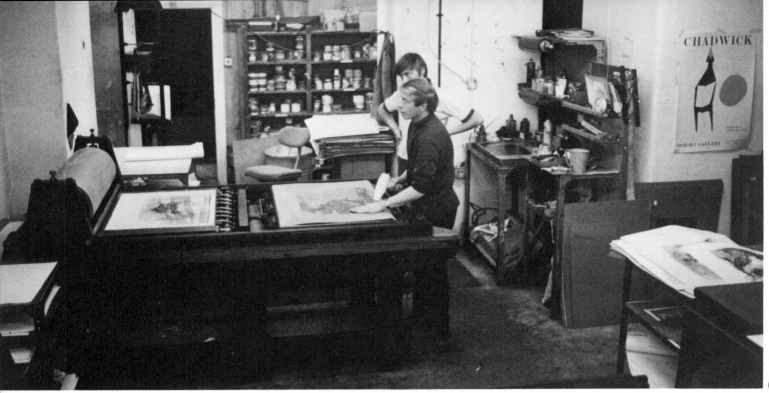

(Photo, M. Knigin)

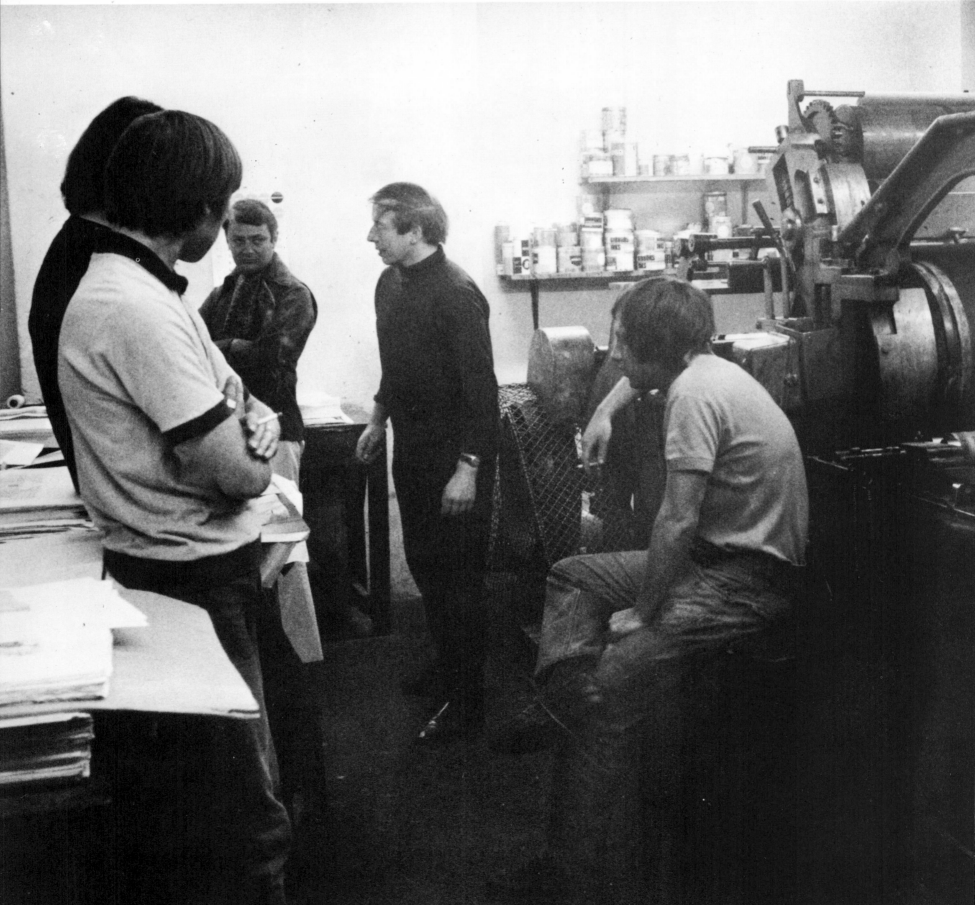

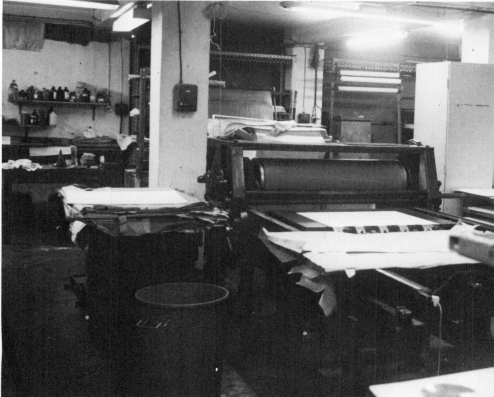

(Photo, M. Knigin)

(Photo, M. Knigin)

IMPRIMERIE CLOT
BRAMSEN ET GEORGES

(Photo, M. Knigin)

I n 1888 Auguste Clot, already known as an important *chromiste* (a man who determines color separation in lithography), decided to leave Lemercier and Cie, Lithographers, to install his own presses in the rue Cherche-Midi. He foresaw, perhaps, the work that the artists of his generation would be able to create from the invention of Senefelder, but he could not have foreseen that his own name would remain forever tied to the extraordinary creativity of color lithography at the turn of the century. Around 1890 lithography, though never abandoned by Fantin and Redon, suddenly became popular. The successive appearances of *L'Estampe Originale* and *Peintres Graveurs* of Vollard aided in this resurrection.

On this point Puvis and Manet can testify, as well as Lautrec or the younger artists Bonnard, Vuillard, Roussel, Denis, and Signac, who began to appear around 1895 in the atelier of Auguste Clot.

At first, existing prints, edited by Vollard, were lithographed into handsome facsimiles. The printer collaborated with such artists as Renoir *(la Baigneuse, les Petites Filles au Chapeau Épingle, les Enfants Jouant à la Balle, l'Enfant au Biscuit),* with Sisley *(les Oies),* with Cezanne *(les Grands et les Petits Baigneurs),* with Rodin *(le Jardin des Supplices),* and with Guillaumin. But very soon they created original works such as *Sulamite* and *Béatrice* by Redon, *Paysages et Interieurs* by Vuillard, *Quelques Aspects de la Vie de Paris* by Bonnard, and some suites by Roussel, Maurice Denis, Dulac, Signac, and Luce. Within two years Clot's presses produced *Paralellement* by Verlaine (1900) and then *Daphnis and Chloe* (1902); both were illustrated by Bonnard and considered by many the most beautifully illustrated books to appear since the eighteenth century.

By this time Degas, Cross, Forain, Munch, Puy, Raffaelli, Steinlin, Veber, Whistler and many others had come to work in rue Cherche-Midi, and with *Attelage* (1910), Rouault as well participated in the renaissance of color lithography.

In the years after World War I, Matisse also came to Clot and worked side-by-side with Bonnard, Vuillard, Roussel, and Denis and resurrected the work that the war had suppressed.

In 1929 *Physiologie de la Boxe* was soon followed by *Naissance du Jour* and *Chant Funèbre* for the death of Verdun (1936) by Luc Albert Moreau, who was, until his death, one of the most faithful friends of the "rat pack," as he jokingly named the atelier.

After the death of Auguste Clot in 1962, his grandson, Dr. Guy Georges, and Madame André Clot strove to keep alive this precious heritage. By chance they met the Danish lithographer Peter Bramsen, and in 1965 he became an associate, forming the Imprimerie Clot Bramsen et Georges.

Bramsen brought with him a host of young artists, many with international reputations: Pierre Alechinsky, Mogens Andersen, Karel Appel, Courtin, Jean Dewasne,

Dmitrienko, Engelman, Asger Jorn, Koenig, Wilfredo Lam, Vilhelm Lundstrøm, Mansouroff, Matta, Mihailovič, Postma, Man Ray, Reinhoud, Sonderborg, Tabuchi, Arthur Luiz de Toledo, Bram van Velde, Voss, Wyckaert.

Directors: *Dr. Guy Georges*
Peter Bramsen

19, rue Vieille-du-Temple
Paris IV^e, France

Pop's Story (1969), Erro, 40 x 26 in. (Courtesy of Imprimerie Clot-Bramsen et Georges)

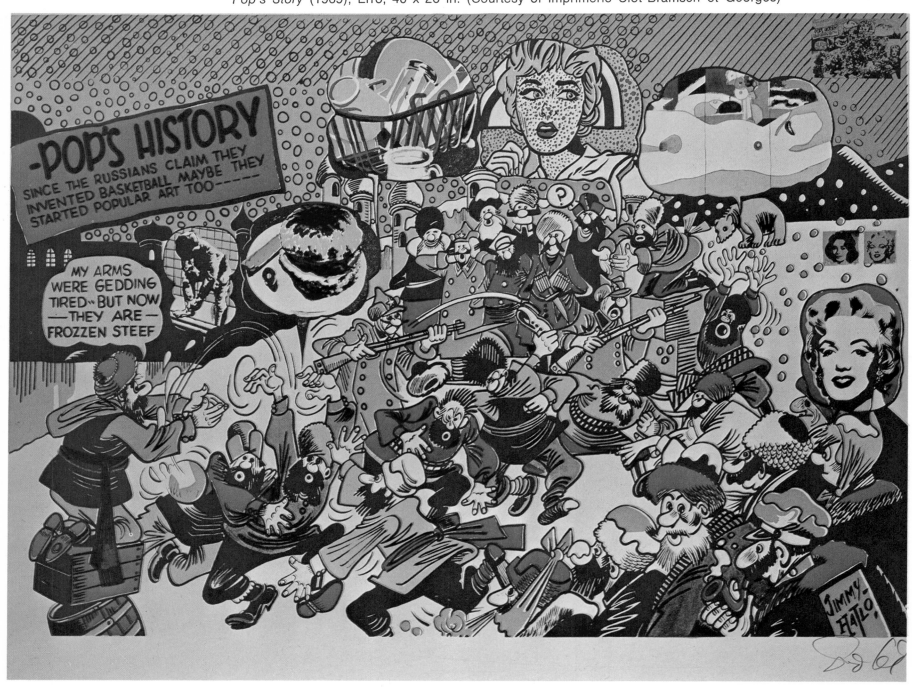

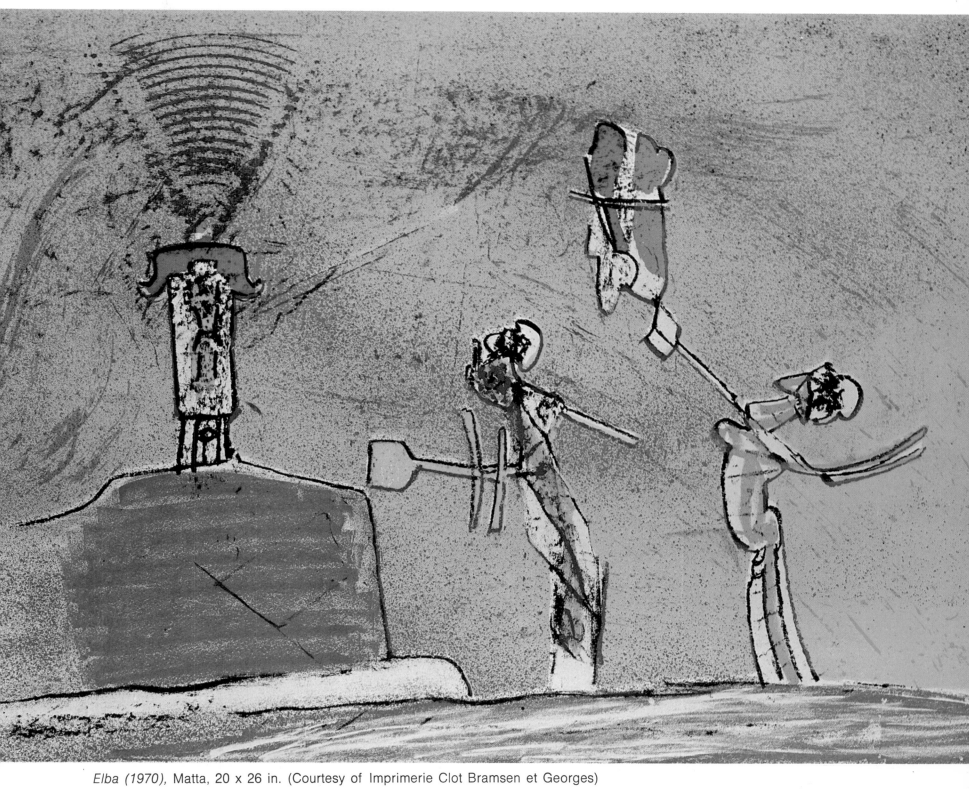

Elba (1970), Matta, 20 x 26 in. (Courtesy of Imprimerie Clot Bramsen et Georges)

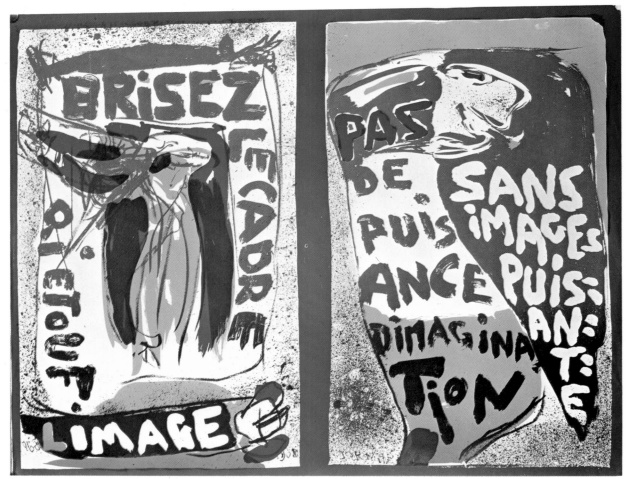

May Poster (1968), Asger Jorn, 40 x 26 in. (Courtesy of Imprimerie Clot Bramsen et Georges)

Sur les 12 Coups de Minuit (1970), Alechinsky, 22 x 30 in. (Courtesy of Imprimerie Clot Bramsen et Georges)

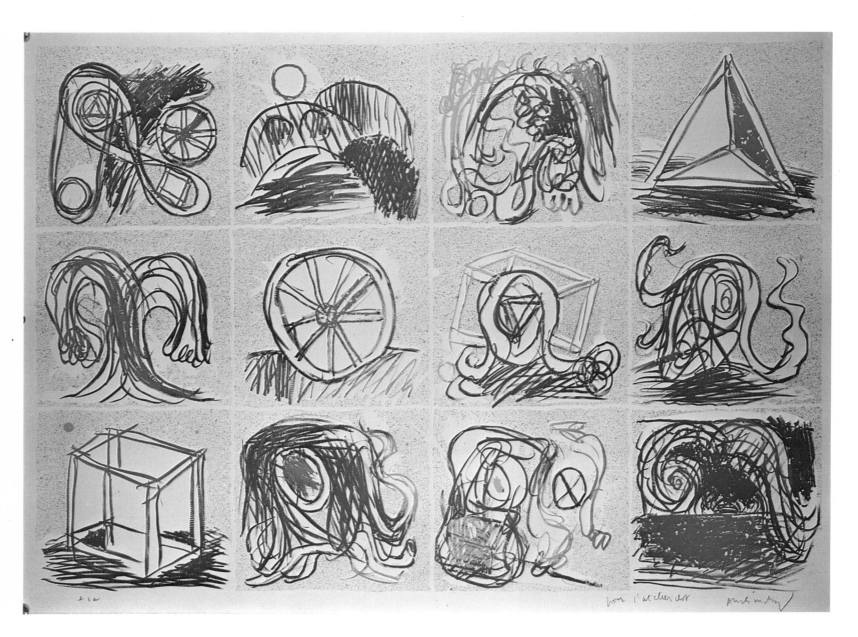

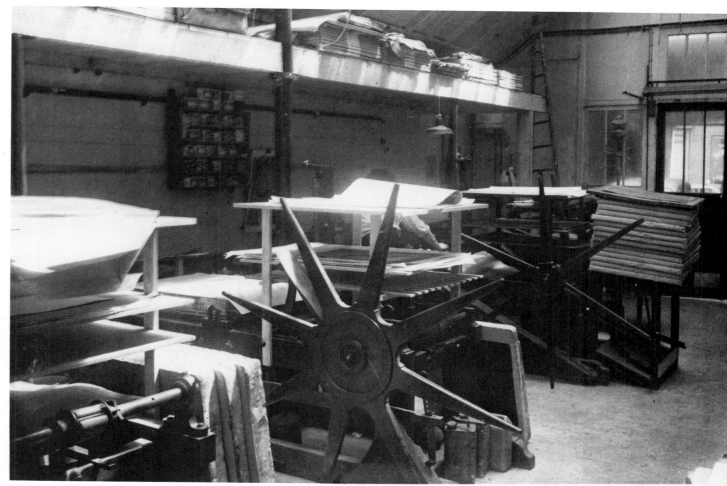

(Photo, M. Knigin)

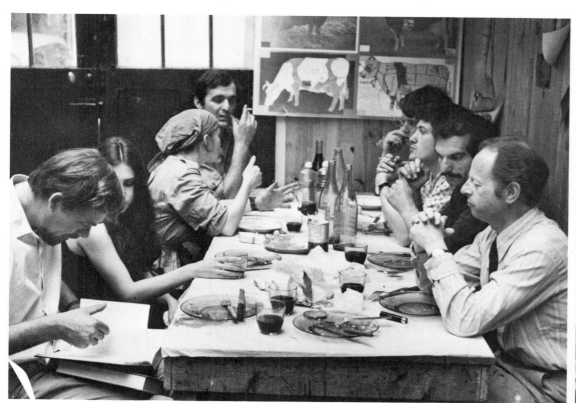

(Photo, M. Knigin)

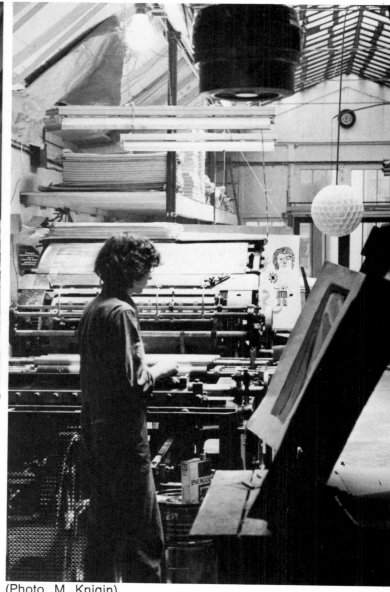

(Photo, M. Knigin)

203

MICHEL CASSE
LITHOGRAPHE

(Photo, M. Knigin)

The atelier of Michel Cassé prints lithographs for various national or international editors, as well as for individual artists. It also produces and directly distributes illustrated art books and separate limited editions of lithographs by selected artists.

Once the artists have drawn their lithographs on stone, they work closely with the director who has familiarized himself thoroughly with their work. Finally they collaborate on the *bon à tirer* and on all matters establishing or varying the colors.

Lithography is at its best and even fulfills a duty when it strives to have a magical quality. It must surprise and charm. It must rise above ordinary reality in order to have power over the mind. It matters little if all are aware of the ruse so long as success is complete and the effect always irresistible. The artists who have understood this well have received, in giving birth on the stone, a bit of the sacred fire with which to perform a new creative act of art.

Therefore lithography should not be used to the vulgar and inadmissible end of imitating and competing with painting.

Director: *Michel Cassé*

When the atelier was formed in 1955, Michel Cassé was associated with Gérard Patris. Patris withdrew in 1960, and in 1961 Cassé formed a new shop. For proofing and small editions the atelier utilizes four hand presses, and large editions are printed on its semi-automatic flat-bed press.

10, rue Malher
Paris IVᵉ, France

The following is a partial list of the artists who have worked at Michel Cassé Lithographe: Jean Arp, Arroyo, Enrico Baj, Bertholle, Bertollo, Bryen, Camacho, César, Charpentier, Corneille, Chu Teh Chun, Sonia Delaunay, Lucio Del Pezzo, Eppelé, Raquel Forner, Gillet, Gironella, Hans Hartung, Wilfredo Lam, Le Moal, Alfred Manessier, Etienne Martin, Matta, Messagier, Mihailovič, Antonio Music, Nallard, José Ortega, Luc Peire, Penalba, Peverelli, Pablo Picasso, Edouard Pignon, Man Ray, Ronald Searle, Segui, Severini, Sonderborg, Pierre Soulages, Kumi Sugai, Rufino Tamayo, Tatin, Bram van Velde, Marie-Hélène Vieira da Silva, Vielfaure, Voss.

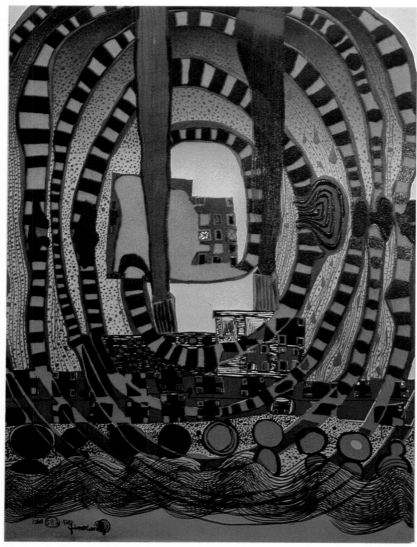

Untitled (1963), Underwasser, 22 x 30 in. (Courtesy of Michel Cassé Lithographe)

Untitled (1963),
Jean Arp, 22 x 30 in.
(Courtesy of Michel Cassé Lithographe)

L'Adieu aux Armes (1963), Segui, 22 x 30 in. (Courtesy of Michel Cassé Lithographe)

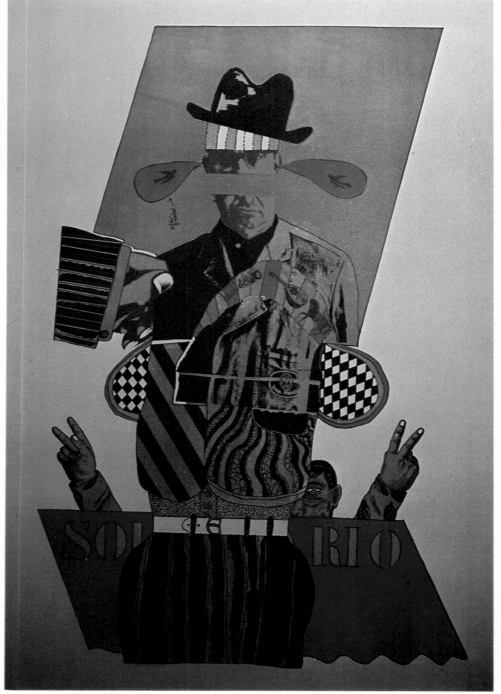

(Photo, M. Knigin)

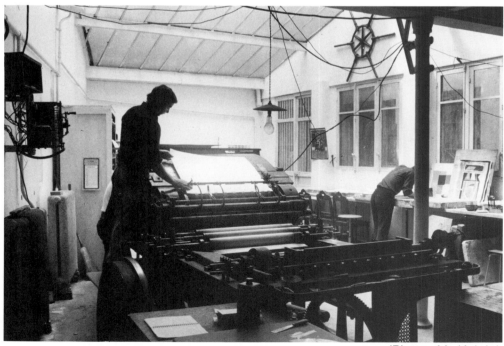

(Photo, M. Knigin)

LES IMPRESSIONS D'ART EDMOND ET JACQUES DESJOBERT

(Photo, M. Knigin)

Each artist is given an area to work where he executes the drawing on plates or stones. After the work has been etched the artist is assigned a printer with whom he works until a *bon à tirer* is pulled. If a large edition is desired, it is printed on the large motorized flat-bed press. Small editions are printed on one of the atelier's nine hand presses.

Director: *Jacques Desjobert*

The atelier was founded by Edmond Desjobert in 1920. It is now under the direction of his son, Jacques.

10 et 12 Villa Coeur de Vey
Paris 14ᵉ, France

The following is a partial list of the artists who have worked at Desjobert: Massimo Campigli, Cassigneul, Castellon, Antoni Clavé, Jean Cocteau, Salvador Dali, Jacquot, Landau, Laurencin, Fernand Léger, Henri Matisse, Pablo Picasso, Edouard Pignon, Gustav Singier, Kees Van Dongen, Vertes, Paul Wunderlich, Zao-Wou-Ki, Murray Zimiles.

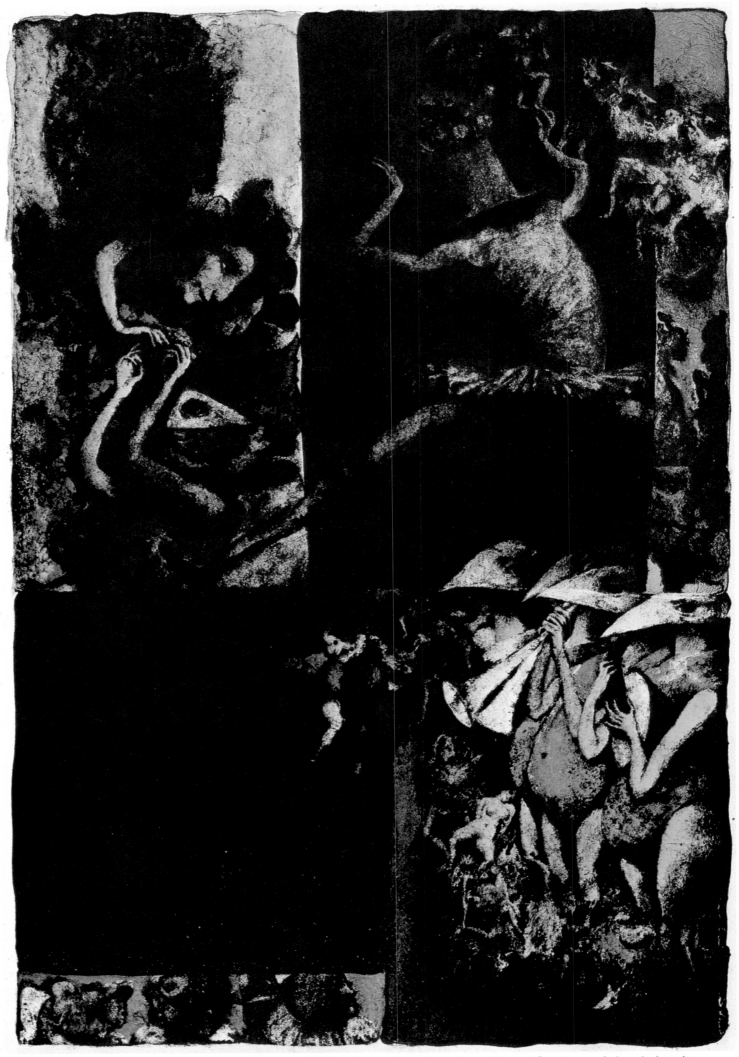

It Was a Voluptuous Scene, That Masquerade (1968), Fred Castellon, 15 x 11 in. (Courtesy of Jacob Landau. Photo, Malcolm Varon)

212

Title: 9 from portfolio *Song of Songs* (1970),
Paul Wunderlich, 25½ x 19¾ in.
(Courtesy of Jacob Landau. Photo, Malcolm Varon)

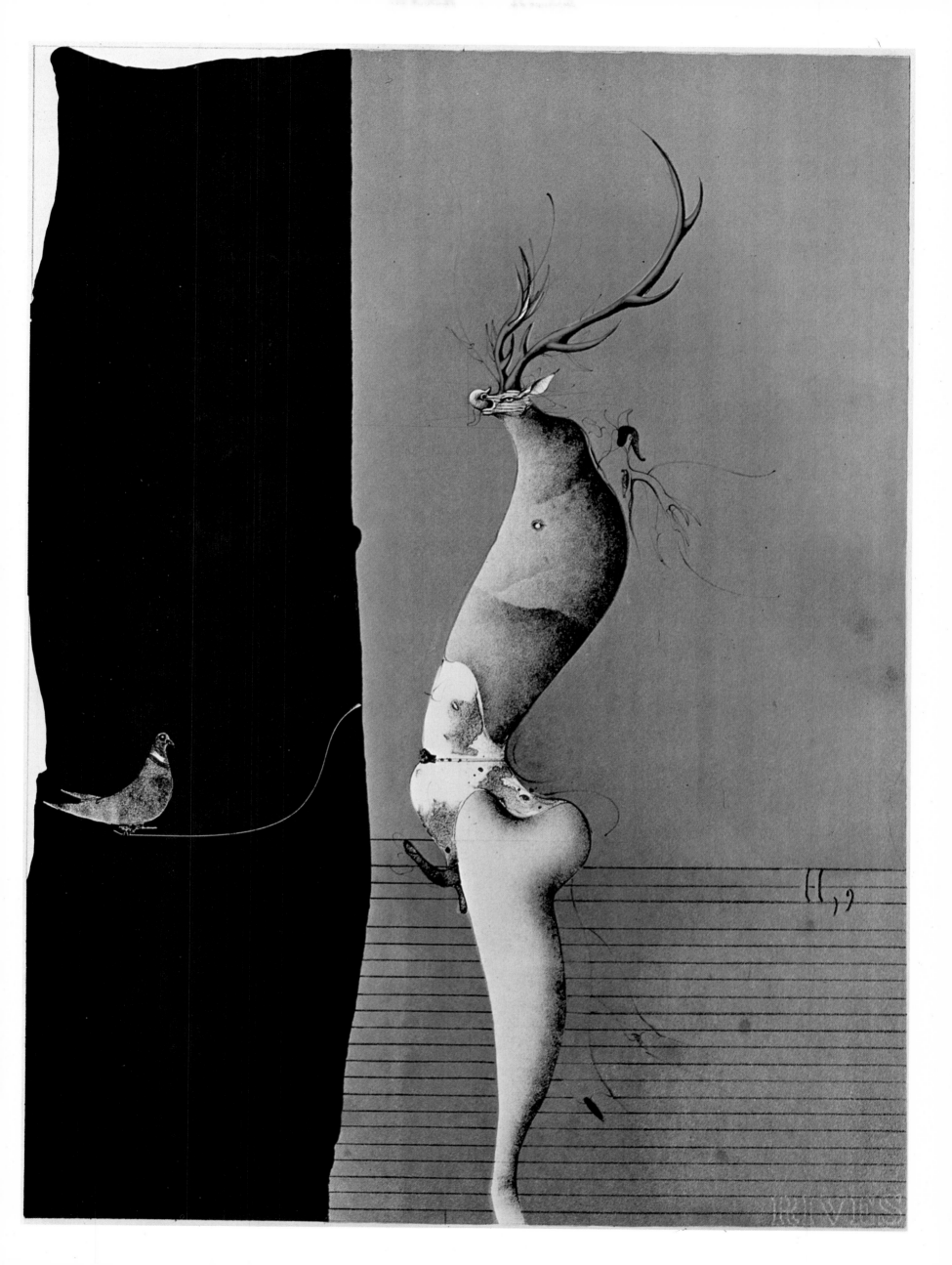

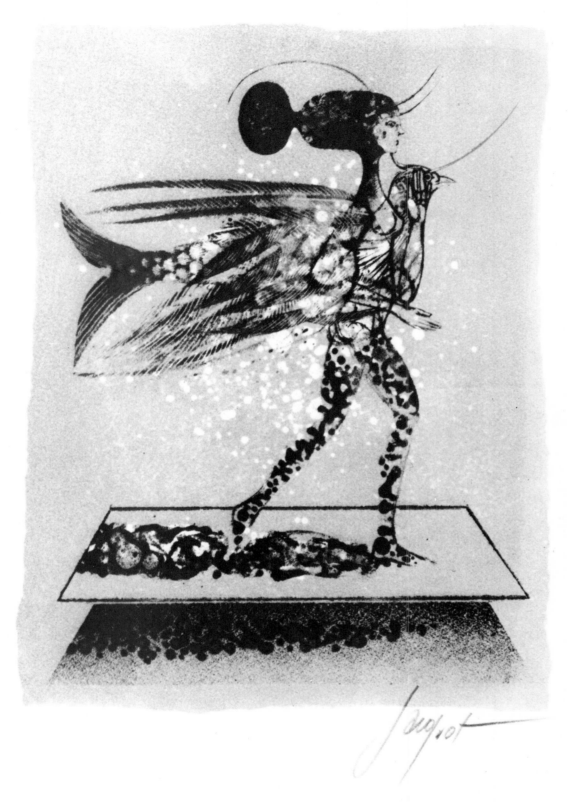

Voeux (1969), Jacquot, 11 x 15 in. (Photo, Malcolm Varon)

Earth Mother (1969), Jacob Landau, 11 x 15 in.
(Courtesy of Associated American Artists Gallery.
Photo, Russo Photographers)

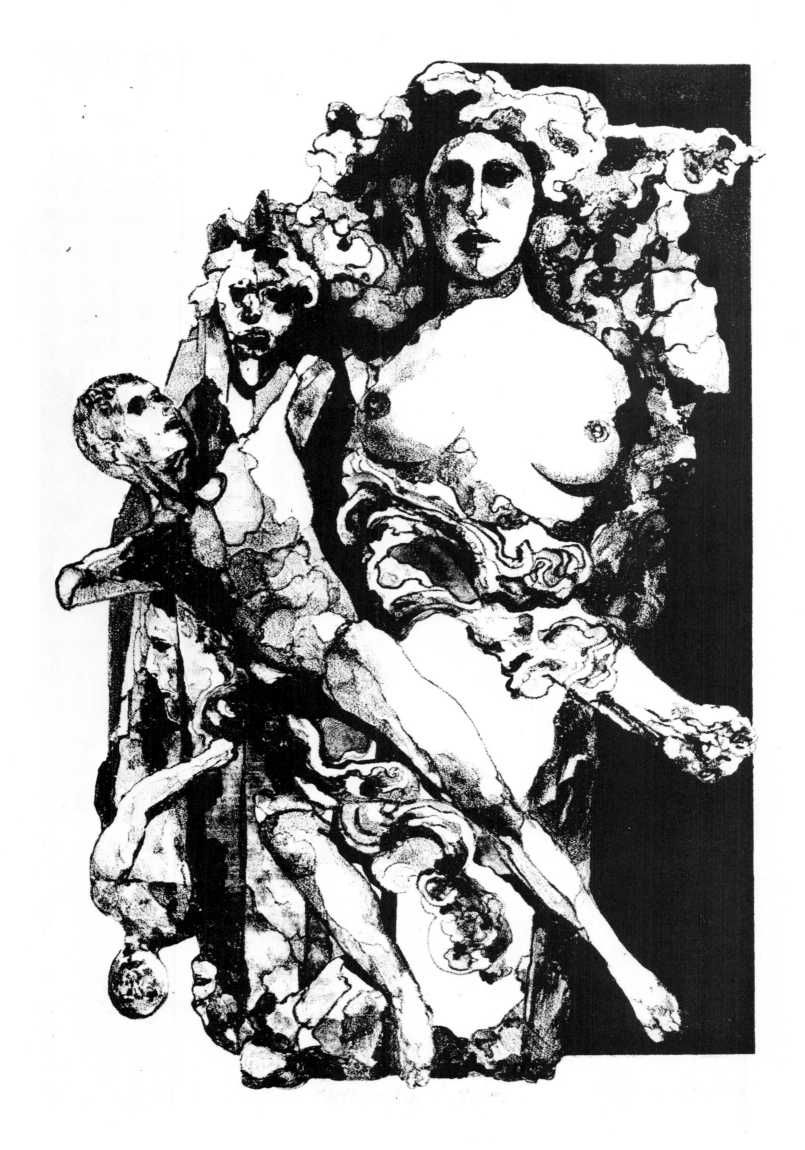

215

(Photo, M. Knigin)

216

(Photo, M. Knigin)

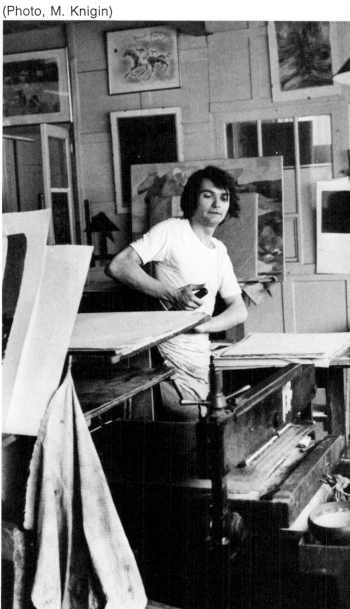

(Photo, M. Knigin)

(Photo, M. Knigin)

(Photo, M. Knigin)

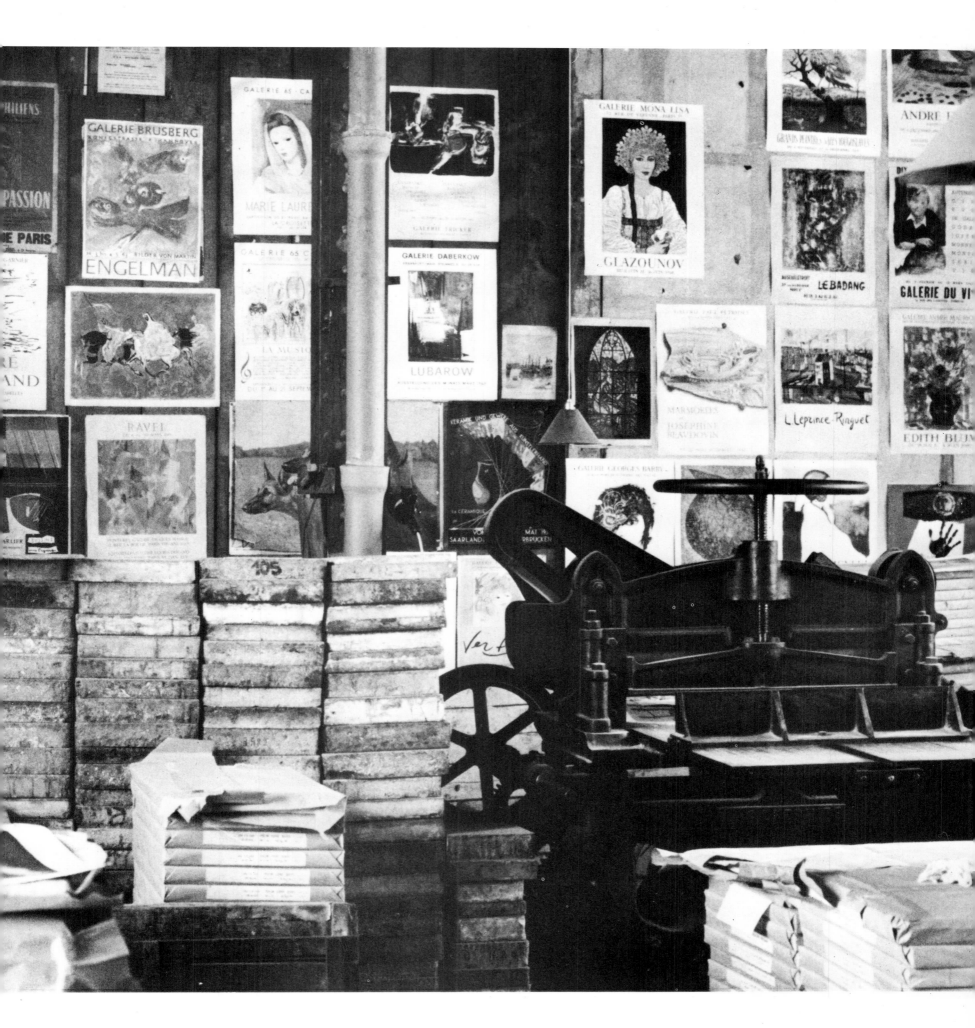

HENRI DEPREST

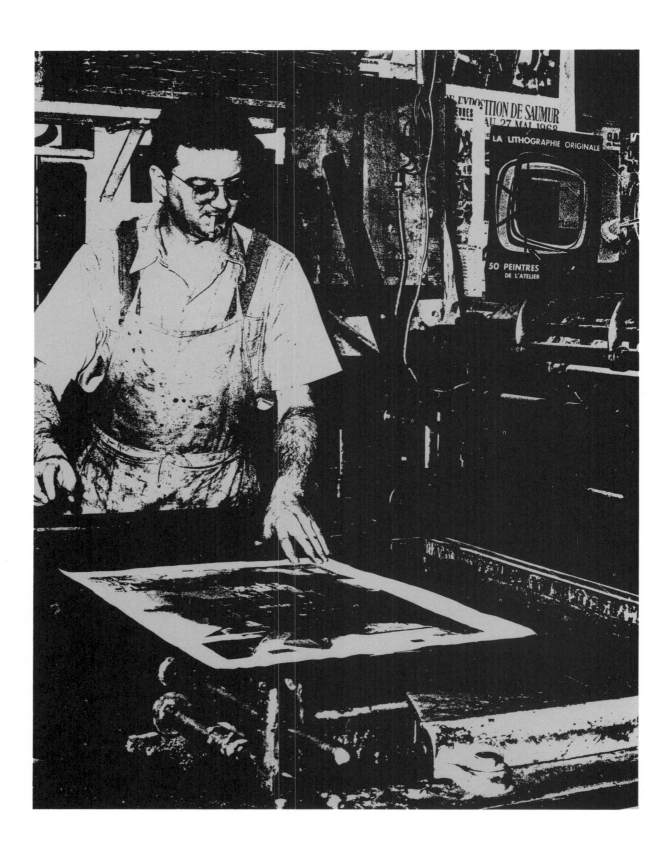

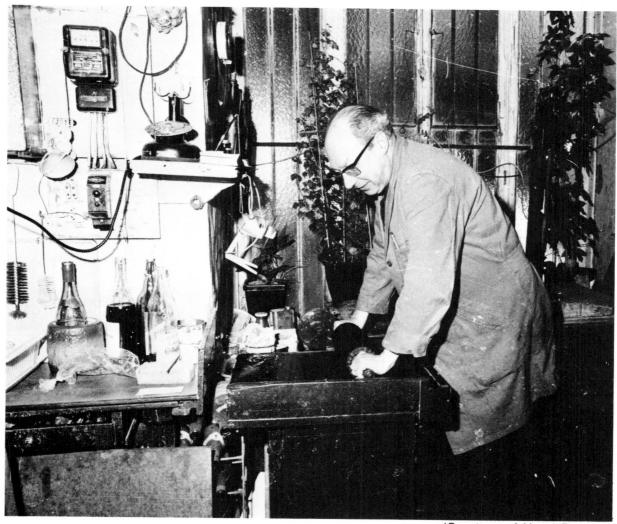

The atelier exists to produce original lithographs, and to this end the artists work closely with the printer in choosing both paper and inks.

An original lithograph is a creation directly on the stone, and it is necessarily realized by the artist himself from his first sketch to his signature. The artist is the sole judge of his work and is responsible for the distribution of his edition.

Director: *Henri Deprest*

Henri Deprest started studying this art in 1926 in the famous *École Étienne.* He improved his knowledge in various Parisian ateliers, and, since 1950, he has devoted himself entirely to original lithography. His studio operates with one flat-bed and one hand press.

208, rue St. Maur
Paris 10ᵉ, France

The following is a partial list of the artists who have worked at Henri Deprest: Acosta, J. P. Alaux, Ambille, Aslanian, Bachelet, Bazire, Blumberg, Boitel, Maurice Buffet, Charmat, Clamagirand, Clero, Colomer, Cruzat, Darot, Delaveau, Dessirier, Douking, Esmein, Flaure, Foucher, A. A. Fournier, Fuchs, Garcia Fons, Gleiny, Grollet, Guanse, M. Halter, Hayden, Pierre Henry, Hirakawa, Jouenne, Joyet, Leo Khan, King, Lafarge, Lamour, Le Colas, Légendre, Alexander Liberman, M. Marceau, Menguy, Mori, Morvan, Edvard Munch, Palmeri, Pedoussant, Perron, A. Petitjean, O. Petit-Jean, Petre, Pophillat, Quilici, Quillivic, Saint-Criq, Tanaka, Thiollier, Vacher, Van-Hout, Van-Moe, Vidalens, Viko, Viot, Vives, Weintraub, Worms, Zenderoudi.

Atlas (1970), Légendre,
24½ x 17 in.
(Courtesy of Henri Deprest)

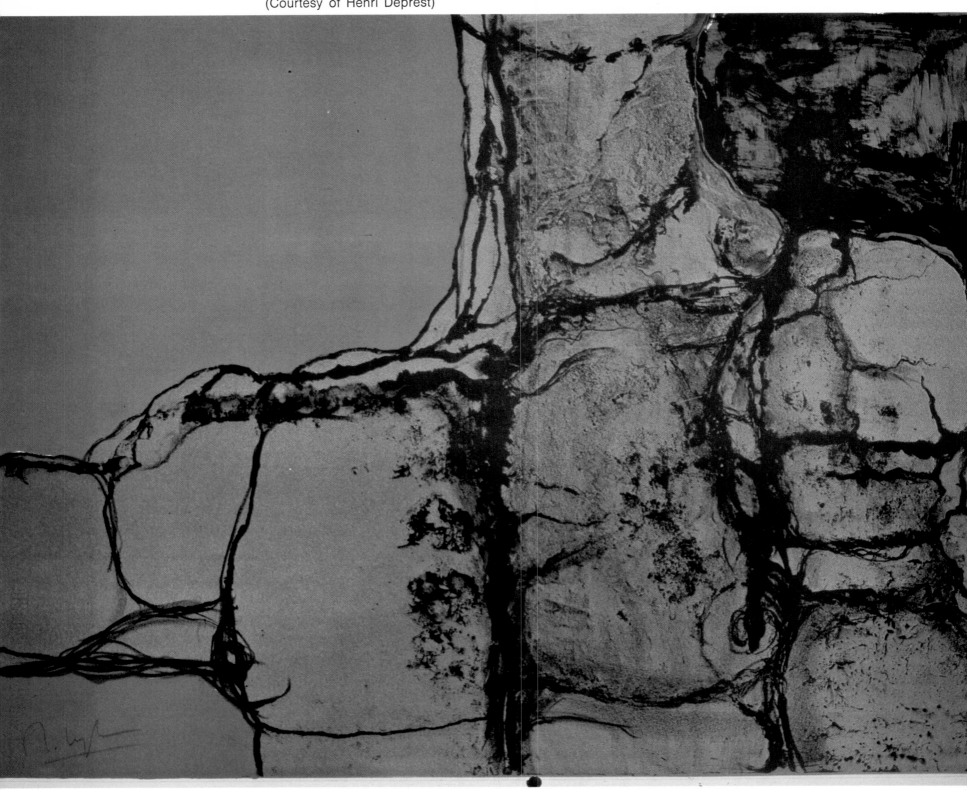

Épreuve d'artiste

Guy Perron

Accords (1970), Perron, 15 x 19 in. (Courtesy of Henri Deprest)

Fauteuil (1868), J. P. Alaux, 14 x 19 in. (Courtesy of Henri Deprest)

Soleil Red (1969), Guansé, 14½ x 19½ in.
(Courtesy of Henri Deprest)

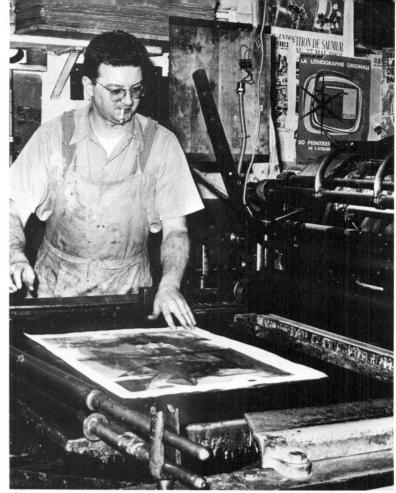

(Courtesy of Henri Deprest)

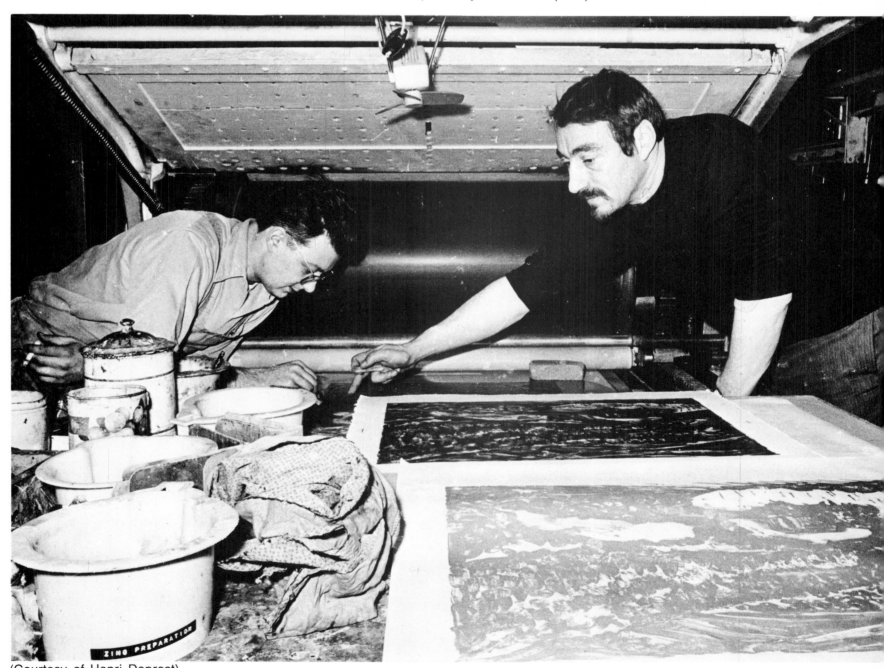

(Courtesy of Henri Deprest)

225

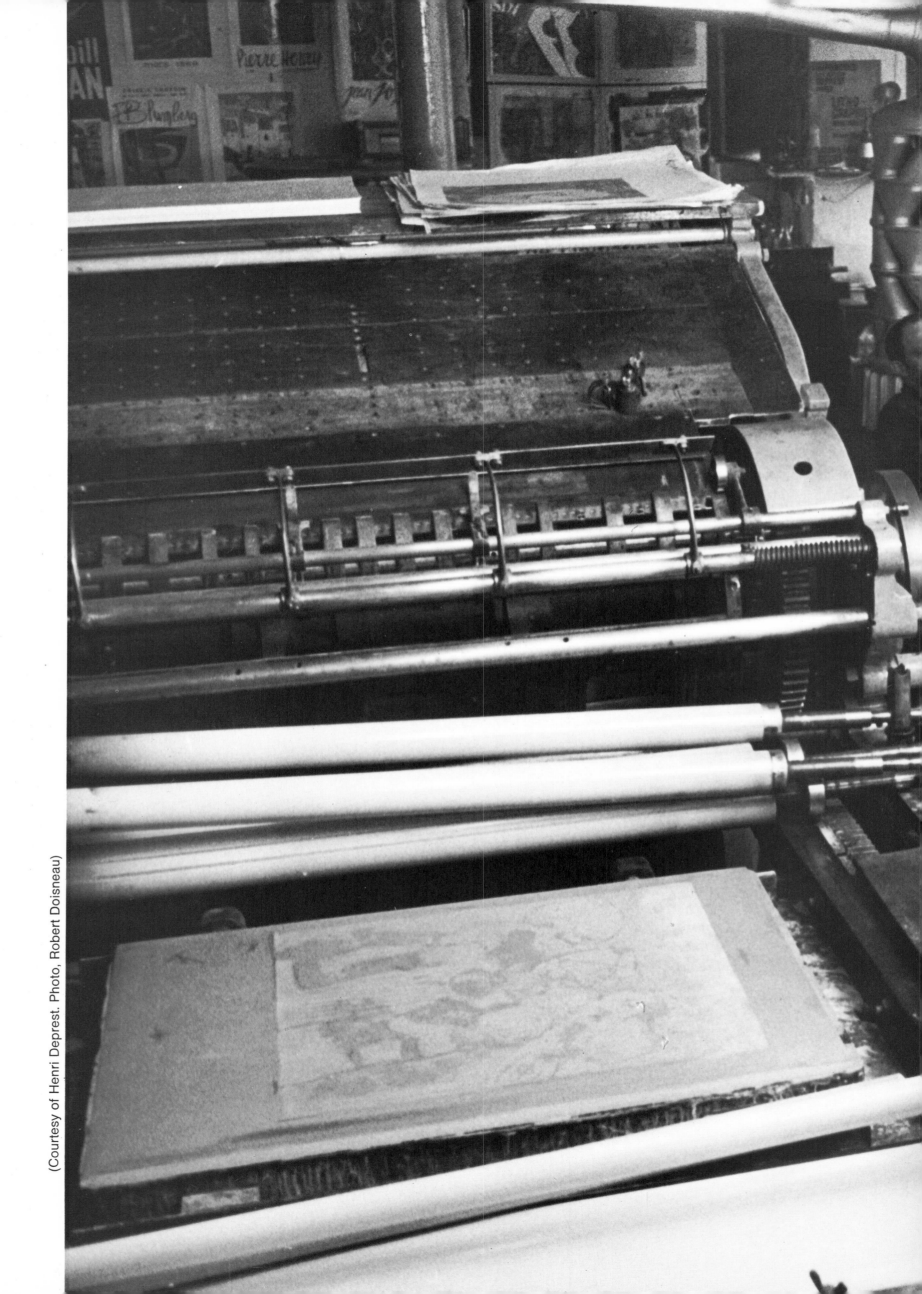

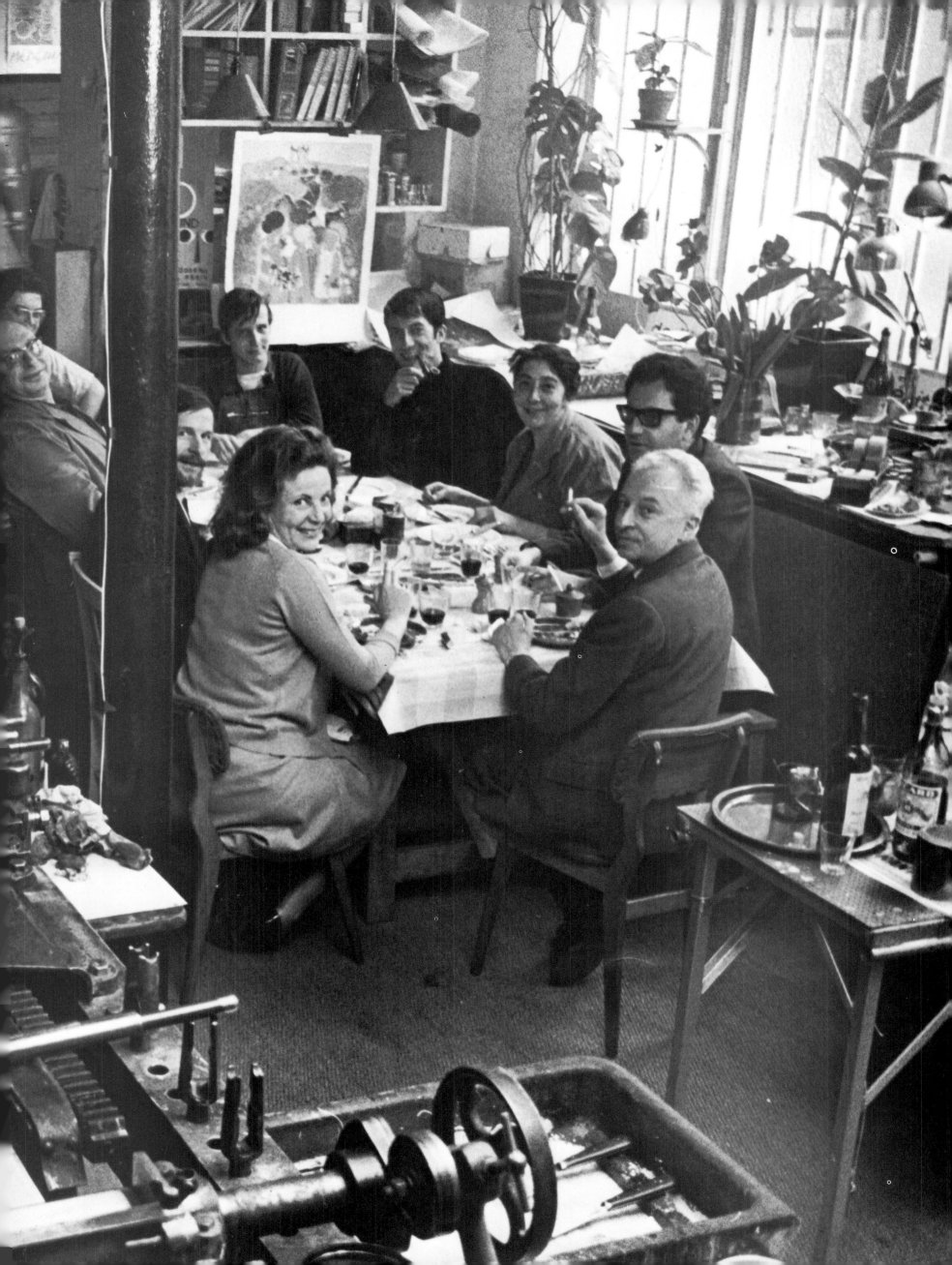

GRAFIK

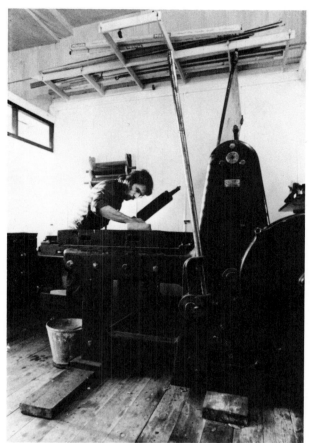

(Courtesy of Grafik)

Artists normally work on the premises, so there is cooperation between artist and printer from the very beginning of the process. Plates are then processed and proofed with the artist in the studio, until the finished-proof stage. The artist may also desire to be present as editioning begins on each plate. A close liaison is preferred throughout the whole process.

With the advent of screen printing as a "fine-printing" medium and the revival of interest in etching, encompassing greater experimentation and advanced techniques, lithography, particularly in this country, appears to have suffered a temporary loss of favor. This has been emphasized by the fact that art schools are expanding their printmaking departments and adding silk-screen machinery. There is now increased interest in the possibilities of graphic techniques, a leveling out in the use of media, and a greater willingness by artists to explore techniques and media that may not be familiar to them. The help of a professional printer and workshop will enable the artist to work confidently in the medium of his choice.

The working relationship between artist and workshop is, of course, one of great importance to both artist and printer. There is an obvious need for the artist to understand the medium, and for the printer to understand the artist's ideas and intentions. This is vital if the artist's intentions are to be realized through the printer. Since the production of a limited-edition print is a somewhat more personal process than that of a mass-produced object, this understanding is normally reflected in the atmosphere of the workshop.

These criteria will establish the attitude of the workshop, which should be to reduce the number of procedures and processes that the artist and idea have to go through. Consequently, the working arrangement has to be one that is both personal and direct. As a result of this, Grafik has developed its studio on a scale most sympathetic to this way of working, by limiting the number of presses and printers so that the studio is concerned with only one project at a time and it is carried through to completion.

Director: *Alan Cox*

Formed in 1967 by Alan Cox in the East End of London, primarily as a means of printing his own work, Grafik soon developed as a facility for other artists working in the medium to the point of becoming a self-supporting workshop. It moved to new premises in June 1970, taking its Mann Broadway direct transfer press.

Grafik
28 Thornhill Road
Islington
London N. 1, England

The following is a partial list of the artists who have worked at Grafik: Warrington Colescott, Uzo Egonu, Richard Smith, Philip Sutton.

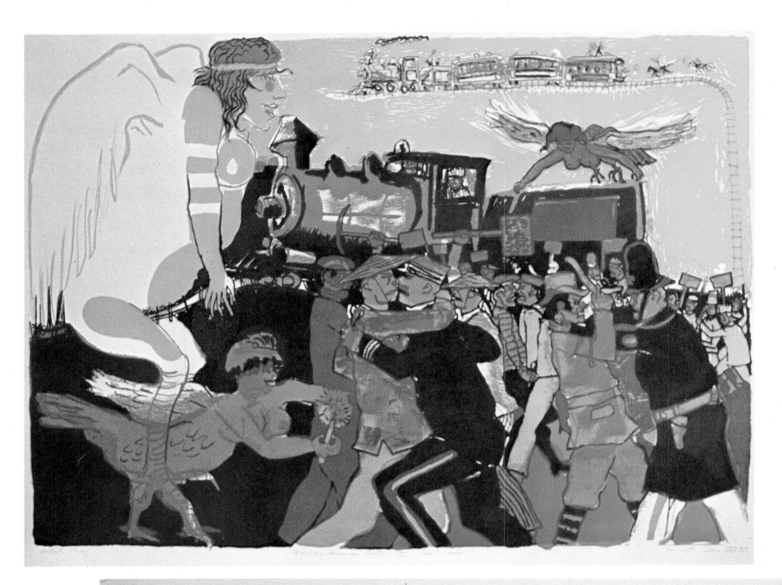

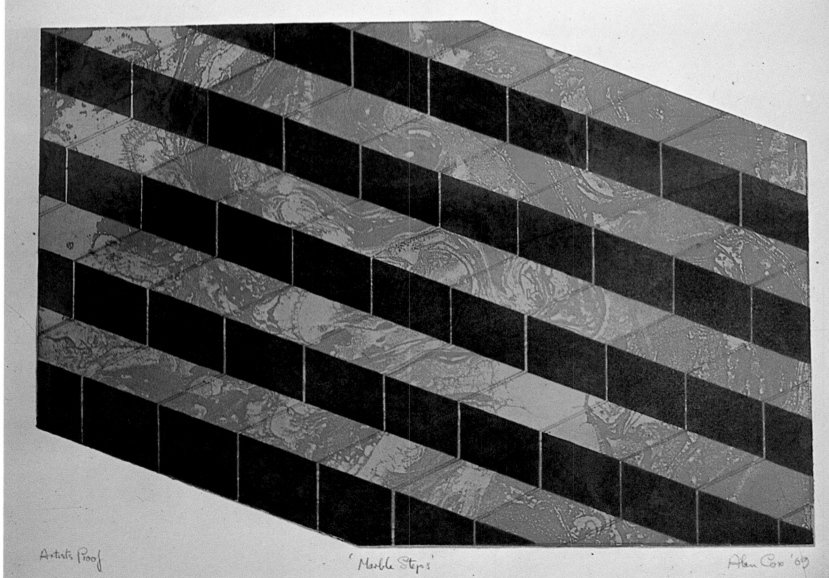

Artist's Proof 'Marble Steps' Alan Cox '69

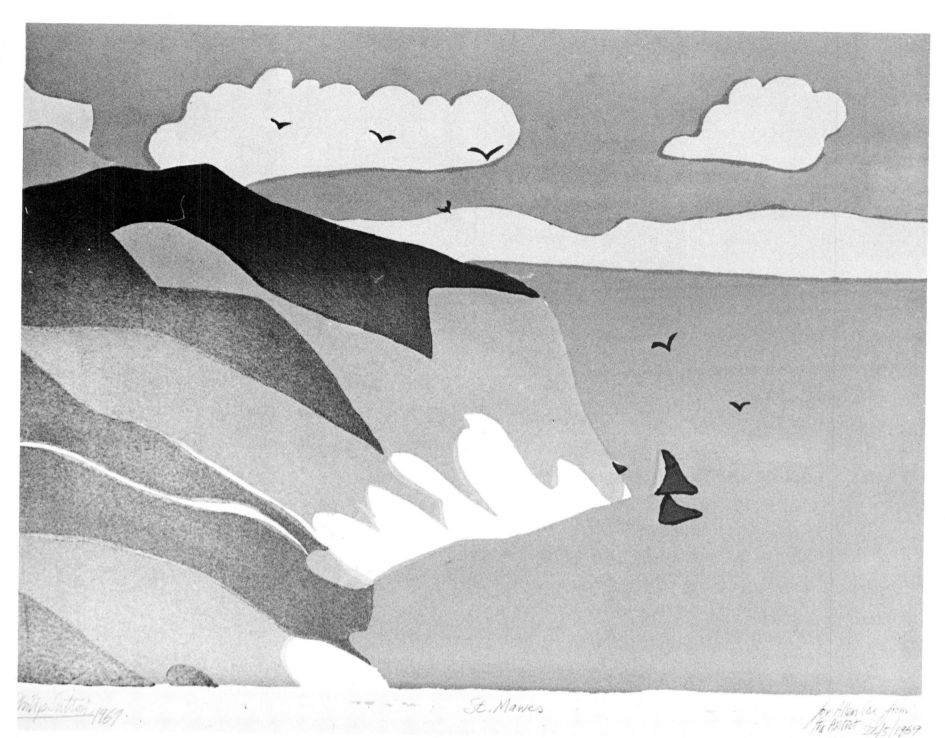

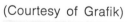

St. Mawes (1969), Philip Sutton, 12 x 9 in. (Courtesy of Grafik)

(Courtesy of Grafik)

Famous American Riots II Railroad (1969),
Colescott, 12 x 9 in.
(Courtesy of Grafik)

Marble Steps (1969),
Alan Cox, 12 x 9 in.
(Courtesy of Grafik)

GRAFICA UNO S.A.S.

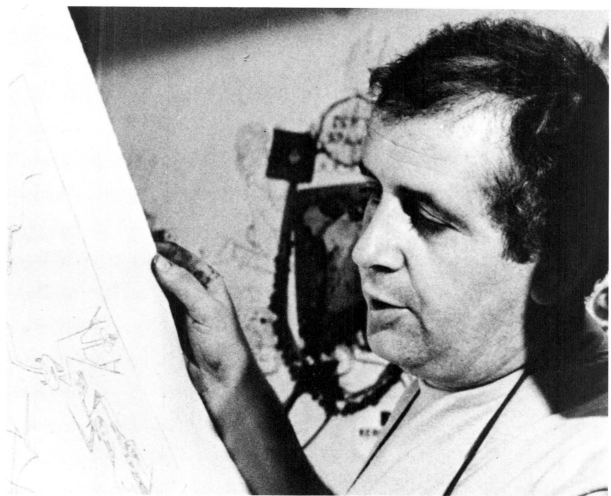

(Courtesy of Grafica Uno. Photo, Walter Mori)

The artists find in our workshop all the assistance and materials necessary for their works, be they lithographs, etchings, or woodcuts. They usually prepare their work in the workshop and assist in preparing the first proofs.
What counts is the final result of the print; all the rest is secondary.

Director: *Giorgio Upiglio*

The workshop itself was established in 1960, after Giorgio Upiglio had worked with his father for many years. The workshop is wholly owned by Upiglio, and he has always run it himself. He established the workshop because he enjoyed printing, and because he had many artist friends who could not proceed because of the lack of such a workshop. Printing is done on two hand presses.

Via G. Fara, 9
20124—Milan, Italy

The following is a partial list of the artists who have worked at Grafica Uno: Pierre Alechinsky, Enrico Baj, Hsiao Chin, Giorgio de Chirico, Jim Dine, Gianni Dova, Marcel Duchamp, Agenore Fabbri, Claire Falkenstein, Lucio Fontana, Alberto Giacometti, Giuseppe Guerreschi, Richard Hamilton, Masuo Ikeda, Wilfredo Lam, Gio Pomodoro, Giancarlo Pozzi, Man Ray, Sergio Saroni, Kumi Sugai, Graham Sutherland.

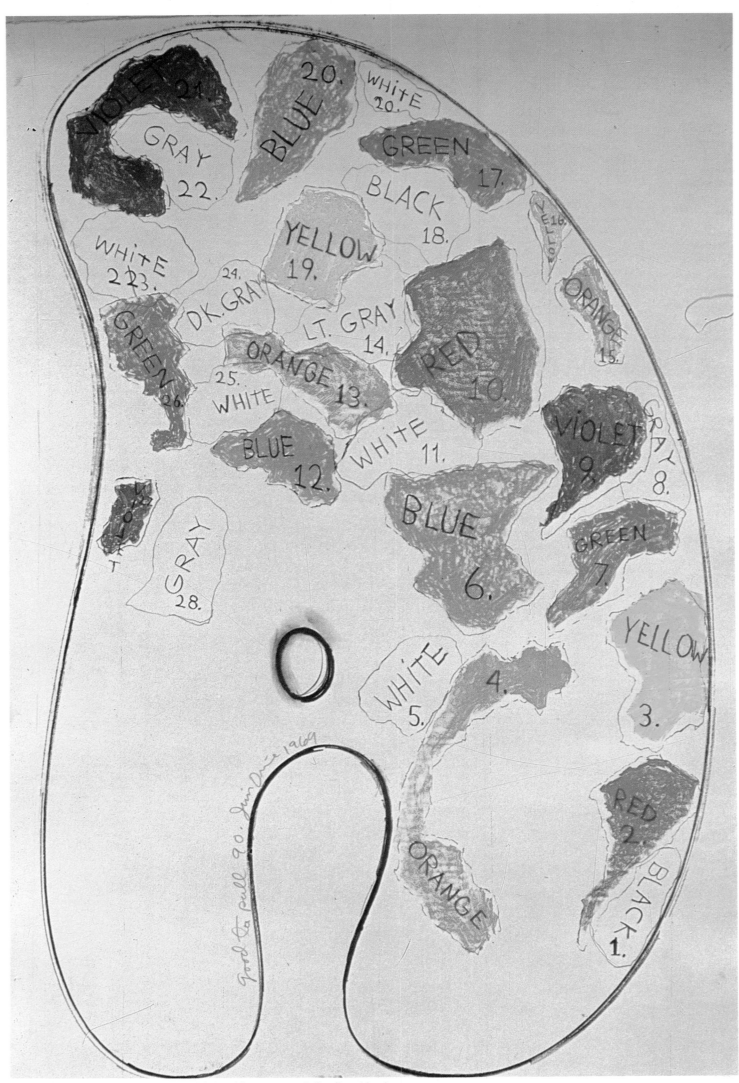

Pallate (1970), Jim Dine, 28 x 20 in. (Courtesy of Grafica Uno)

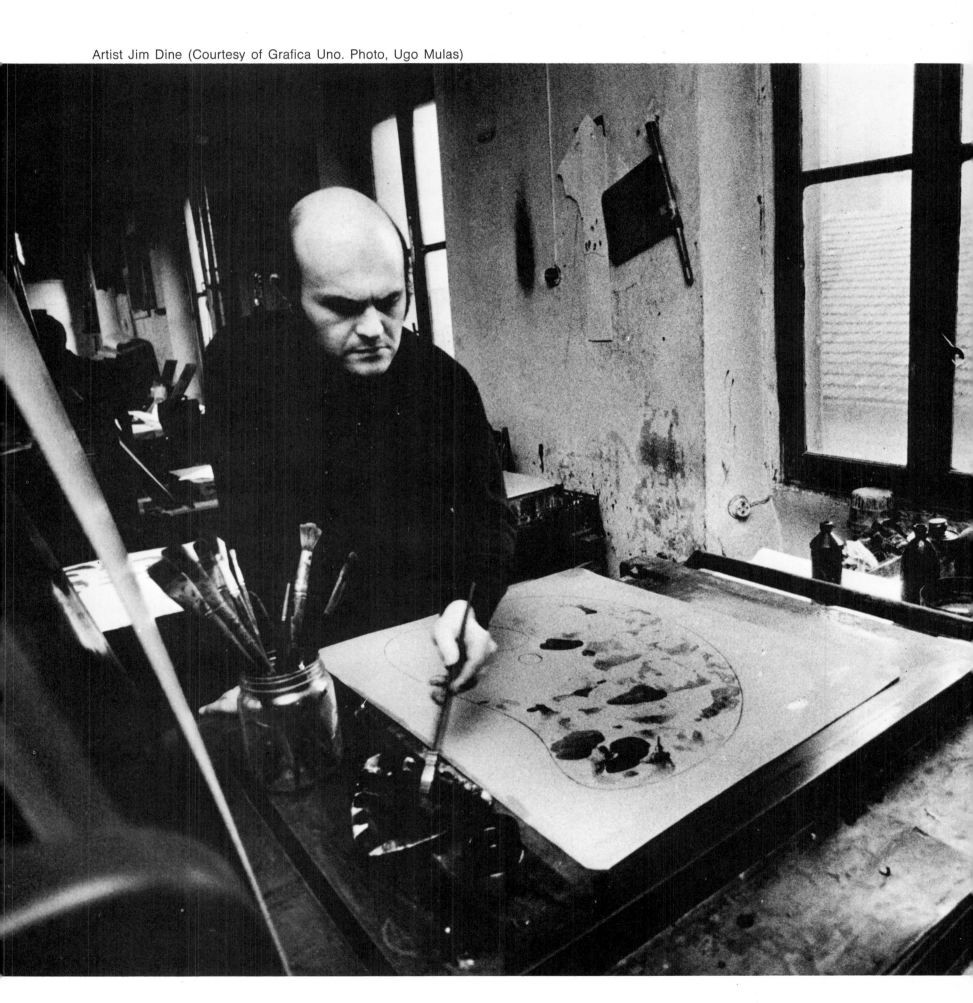

Artist Jim Dine (Courtesy of Grafica Uno. Photo, Ugo Mulas)

Artist Wifredo Lam (Courtesy of Grafica Uno. Photo, Walter Mori)

Untitled (1970), Wifredo Lam, 22 x 18 in.
(Courtesy of Grafica Uno)

237

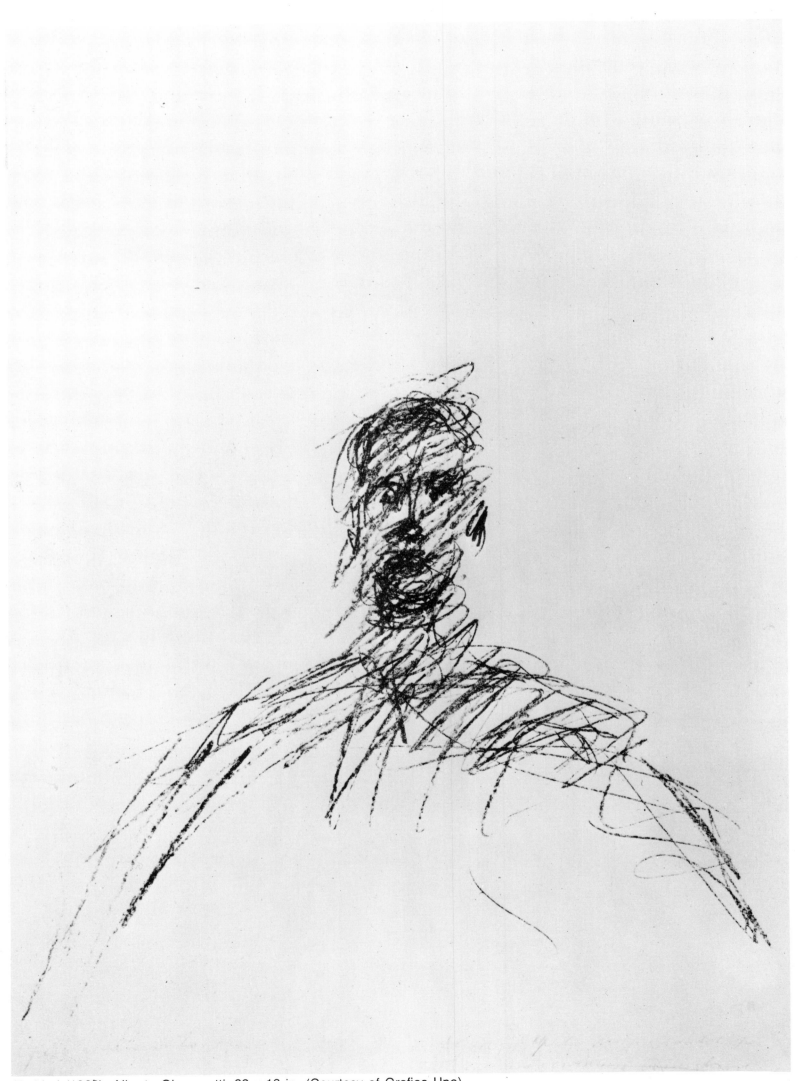

Untitled (1962), Alberto Giacometti, 22 x 16 in. (Courtesy of Grafica Uno)

(Photo, M. Knigin)

(Photo, M. Knigin)

EDITIONS LAFRANCA

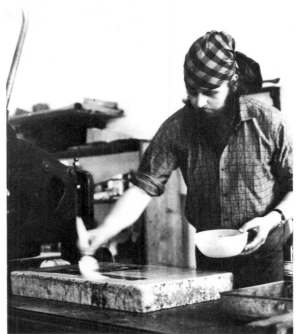
(Courtesy of Lafranca. Photo, Foto Volontario)

Editions Lafranca prints and publishes original graphics in limited editions in close collaboration with the artist, generally on paper of its own manufacture. The artist comes to the workshop at a prearranged time with his concept already in mind, or with finished sketches, and he lives there during the creation of the edition, generally two to three weeks. I alone do the etching in the presence of the artist, who is also on hand during the printing and usually takes part in the process. Every aspect is discussed in common, and through this collaboration the final work takes shape.

Very exceptionally, I may go to the artist with a small hand press, familiarly known to us as "the flying press."

What we aim for is an especially close, creative relationship between the artist and the workshop. The artist collaborates in, and supervises, every step of the process, and every effort is made to suit his individual requirements. Inasmuch as I do all the printing myself, I must give close attention to the choice of the artist. It is not enough that his work should please me. Of equal importance is my ability to be of service to him in its expression. In this way we hope to achieve a certain unity of outlook which can make our prints look as though they were the work of one man.

In general we plan all our work a long time in advance. The paper is created according to the needs of the technique to be employed. The artist comes to live with us for the time it takes to create an edition. Usually he arrives with definite projects which we then discuss from the technical standpoint before beginning work. I believe strongly in the necessity of a deep understanding between the artist and the printer, and perhaps for this reason our prints all bear a certain family resemblance: the hand of the craftsman can be sensed.

It is very important that the artist himself draw on the stone or engrave the plate. I have never yet made use of transfer paper, nor have I made a reproduction on stone of an artist's design. Our editions are limited to a maximum of fifty. In larger editions there is the risk of losing the sensitivity and quality of the print. The artist assists not only at the pulling of the proofs but also during the making of the final print, which is important, particularly for lithographs in color. If the artist is young and in good health, he aids in turning the press.

Even though our shop is fairly large (ten rooms), and we have a number of presses, our personnel is very limited: two people to manufacture the paper and to help with the printing; my wife to deal with office work and distribution; and myself as printer. Since we take only one artist at a time, he is free to concentrate on his work in complete tranquility.

Our chief interest is to assist young, little-known artists; many of them have never even tried lithography or engraving. But to maintain a certain balance, it is also desirable to have some well-known names, which explains our fairly variegated list.

For the future my intention is to expand somewhat our circle of artists and to raise the level of craftsmanship and of selection but not to increase production.

Director: *François Lafranca*

Years ago, François Lafranca came to Locarno as a young artist and began to make prints on a small bookbinder's press. Soon afterward, Ben Nicholson asked Lafranca to make proofs of his first etchings, which was the occasion for acquiring his first copperplate press. With the help of various books, Lafranca learned the necessary techniques. Nicholson became his first client, and since 1965 Lafranca has printed all his etchings.

Thus encouraged, Lafranca set about expanding his shop, and when the press was no longer adequate for the increasing size of the copperplates, he had a large press made to his own design and satisfaction in Locarno.

In the spring of 1966, he had the good fortune to acquire the lithographic workshop of Felix Brunner, the author of *Graphic Reproduction Processes*, which made it possible for Lafranca to teach himself the techniques of lithography.

In August 1966 he began to publish prints in his own editions, and today more than twenty artists have had their work published by Éditions Lafranca.

Since 1969 the workshop has manufactured its own handmade rag linen paper, "Carta Lafranca."

The atelier has been housed since 1969 in a fine old building that has room for seven hand presses and the papermaking equipment, in addition to a small attic apartment.

Via Angelo Nessi 7
CVc-6600 Locarno, Switzerland

The following is a partial list of the artists who have worked at Lafranca: Jean Arp, Jean-Edouard Augsburger, Bruno Baeriswyl, George Ball, Julius Bissier, Arturo Bonfanti, Gianfredo Camesi, Piero Dorazio, André Evrard, Gottfried Honegger, Ben Nicholson, Hans Richter, Horst Scheffler, Peter Stein, Mark Tobey, Italo Valenti, Danilo Wyss, Marcel Wyss, Léon Zack.

Untitled (1970), Italo Valenti, 21½ x 17 in. (Courtesy of Lafranca. Photo, Alberto Flammer)

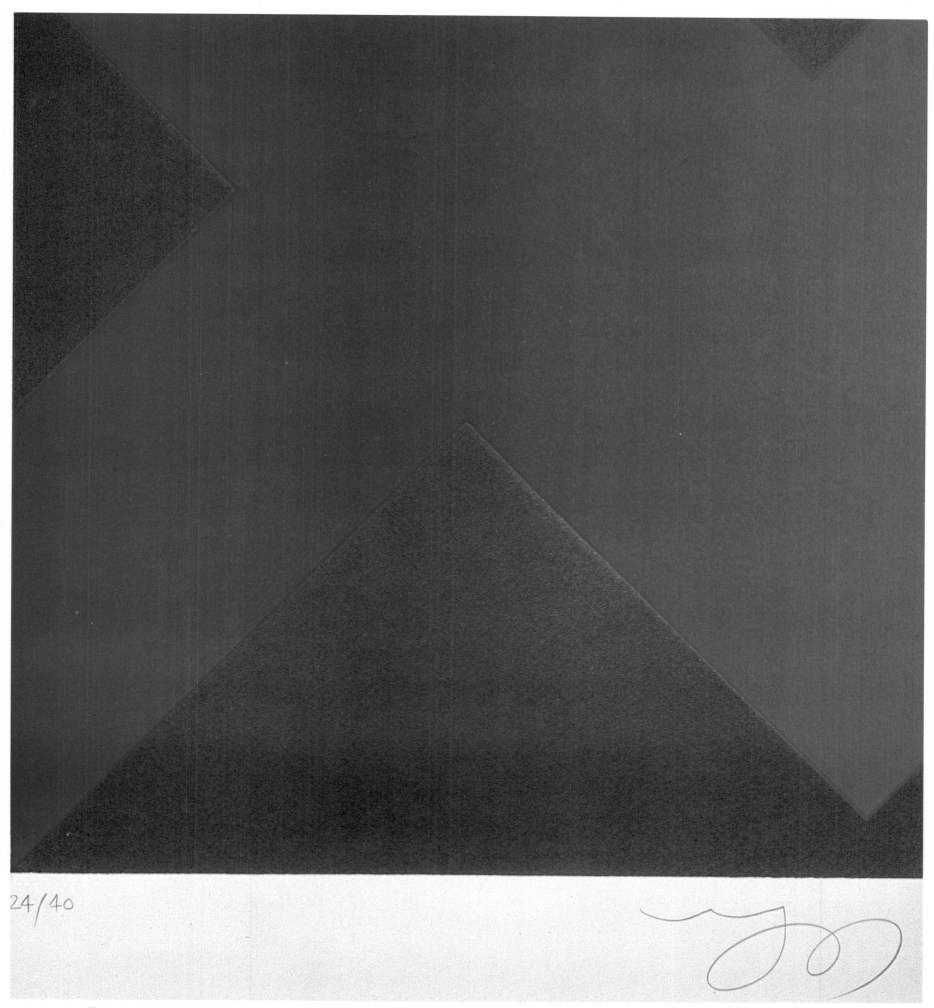

24/40

Trilogie (1967), Marcel Wyss, 18 x 22 in. (Courtesy of Lafranca)

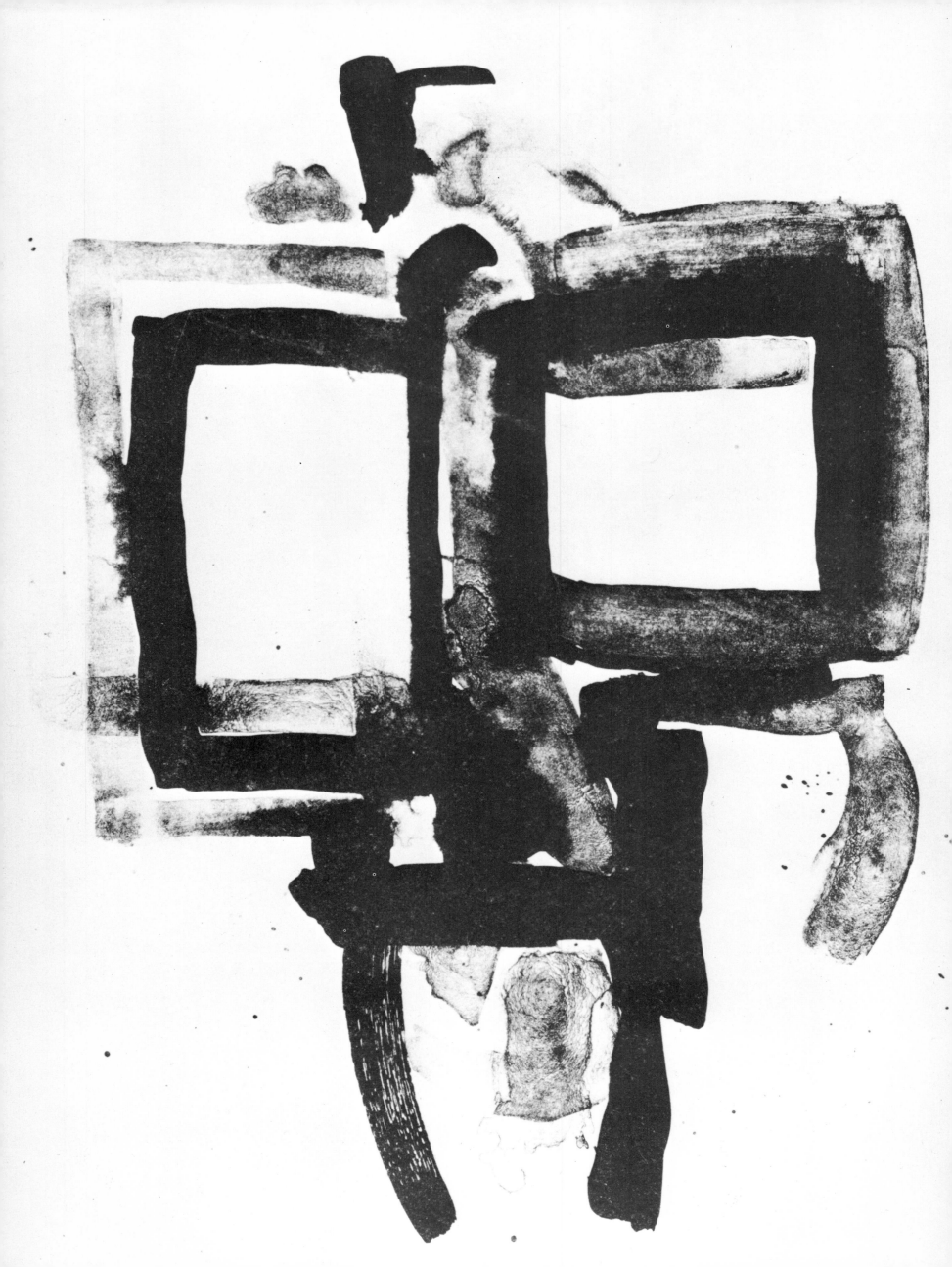

Untitled (1970), Bruno Baeriswyl,
11½ x 8 in. (Courtesy of Lafranca.
Photo, Alberto Flammer)

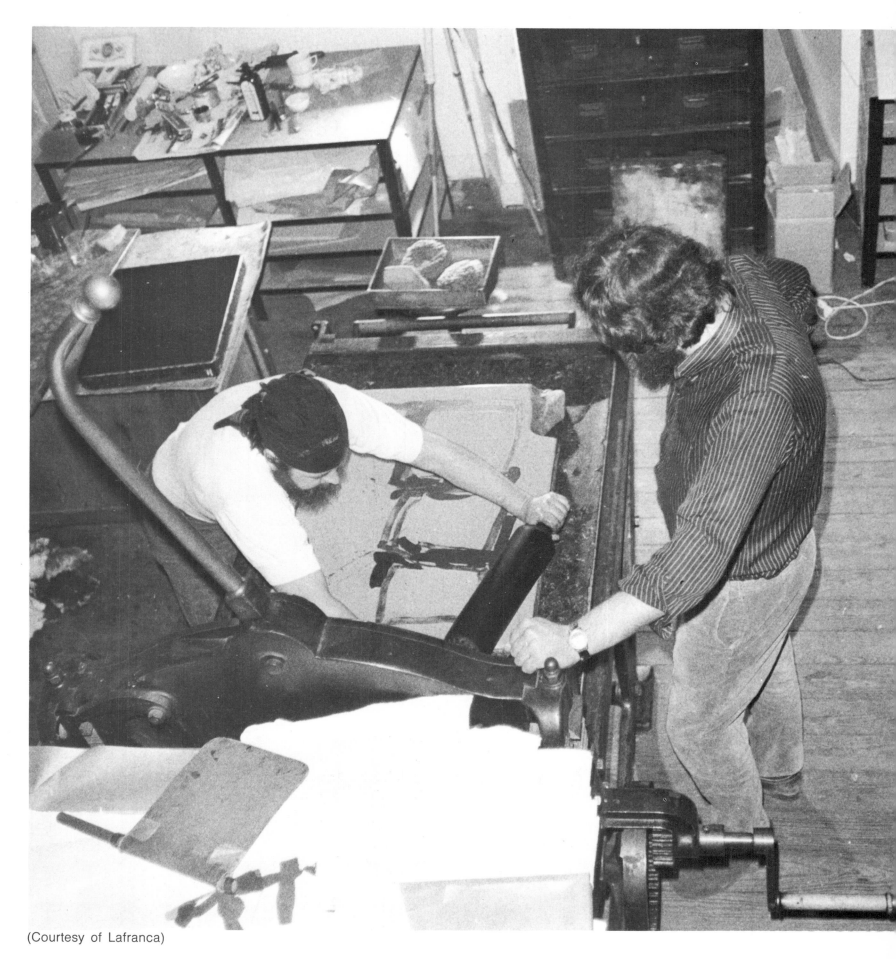

(Courtesy of Lafranca)

L'ATELIER ARTE
(MAEGHT)

In its attempts to allow artists to work in complete freedom and to engage in technical and artistic experiments, L'Atelier Arte has found that there are as many ways to work with artists as there are artists. In general and to simplify: Arte's procedure is to give the artist a workspace of his own where he draws either on zinc or stone. He then works with the printer at the press until they together achieve the *bon à tirer*. The artist chooses the paper and determines the size of the edition, and then the edition is printed.

The original Gallery Maeght had to share workspace and presses with the Atelier Levallois, where artists represented by the gallery worked side-by-side with those printing the review *Derrière le Miroir,* as well as other lithographs and copper and zinc etchings. Quarters became too small by 1966. The current director, Aimé Maeght, formerly a lithographer himself, formed the present L'Atelier Arte to permit his artists to work free from commercial dictates and financial worries. In their new workshop, they can develop their imaginations and partake in experiments. Many artists from the best known to the younger ones have since worked there.

13, rue Daguerre
Paris 14ᵉ, France

The following is a partial list of the artists who have worked at Maeght: Pierre Alechinsky, Jean Bazaine, Georges Braque, Pol Bury, Alexander Calder, Eduardo Chillida, Dmitrienko, Fielder, Alberto Giacometti, Ellsworth Kelly, Joan Miró, Palazuelo, Paul Rebeyrolle, Rispelle, Saul Steinberg, Antoni Tàpies, Raoul Ubac, Zao-Wuo-Ki.

Préparatifs d'Oiseau #1 (1964), Joan Miró, 19 x 23 in. (Courtesy of Galérie Maeght)

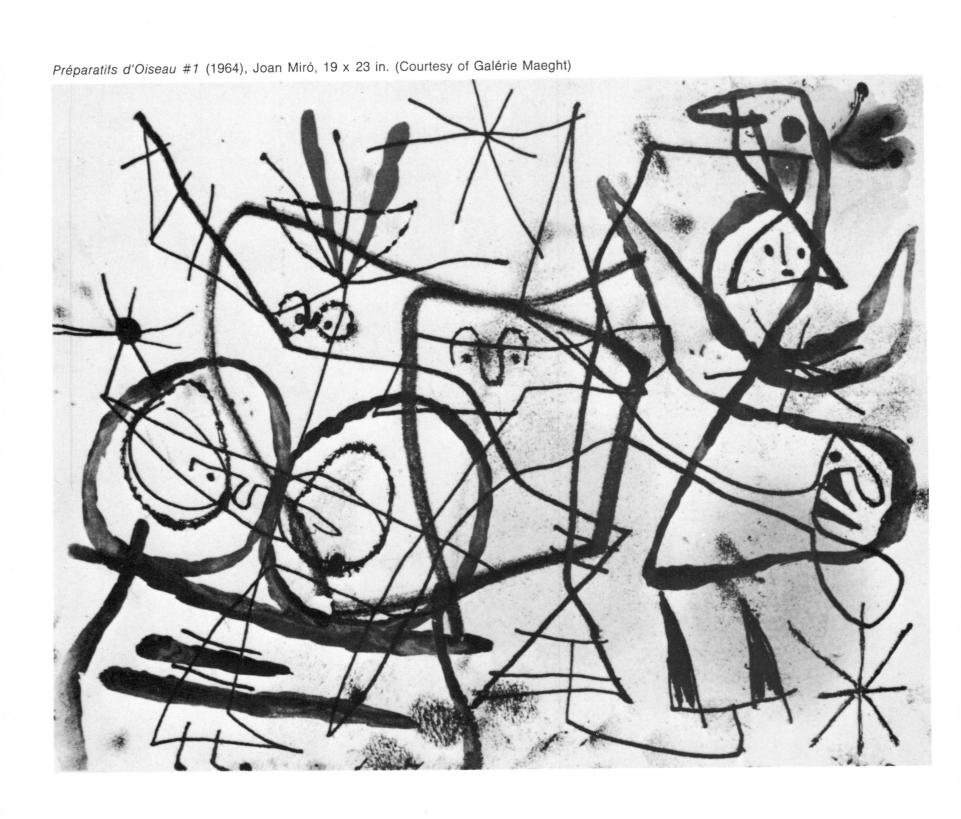

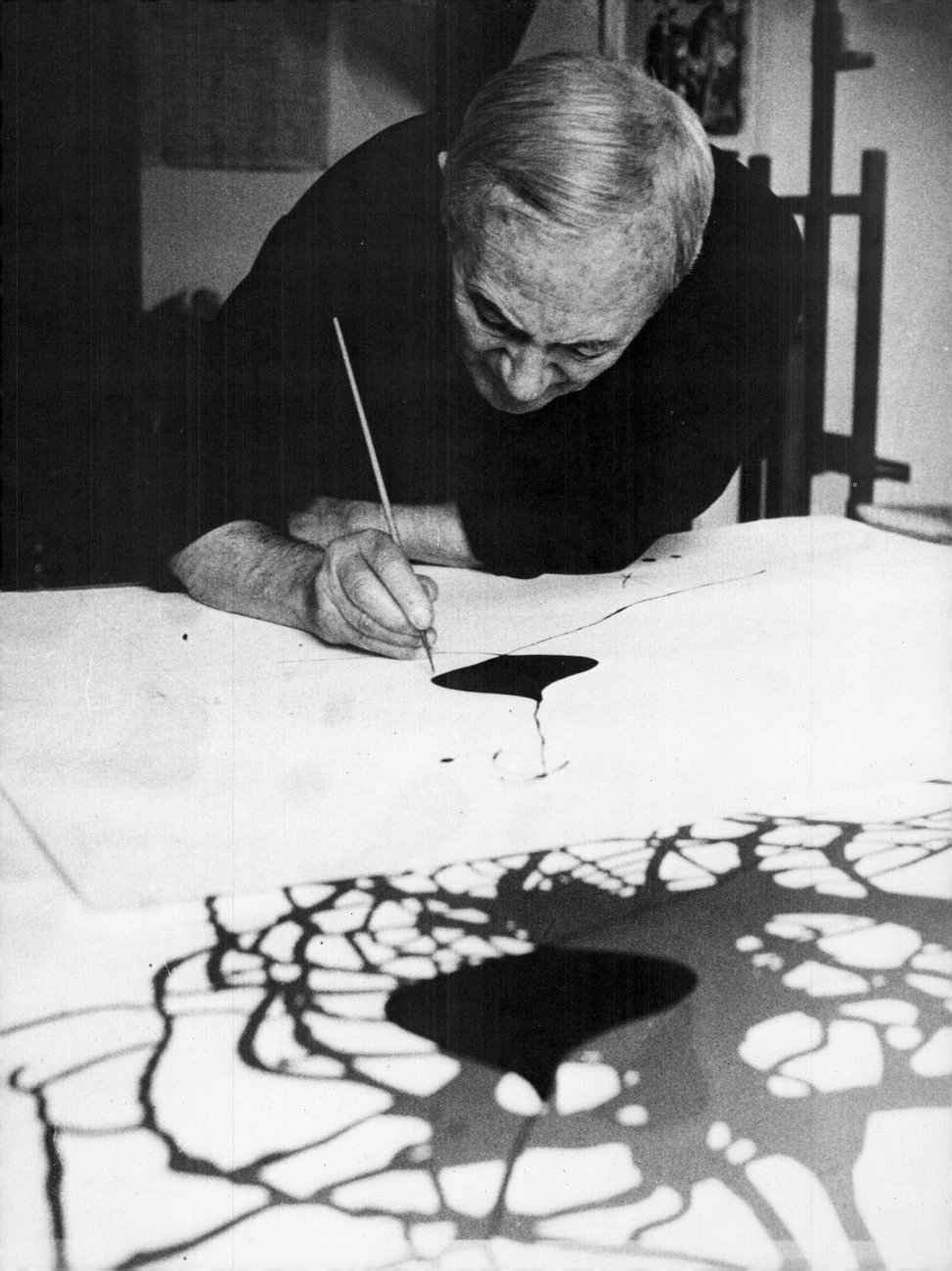

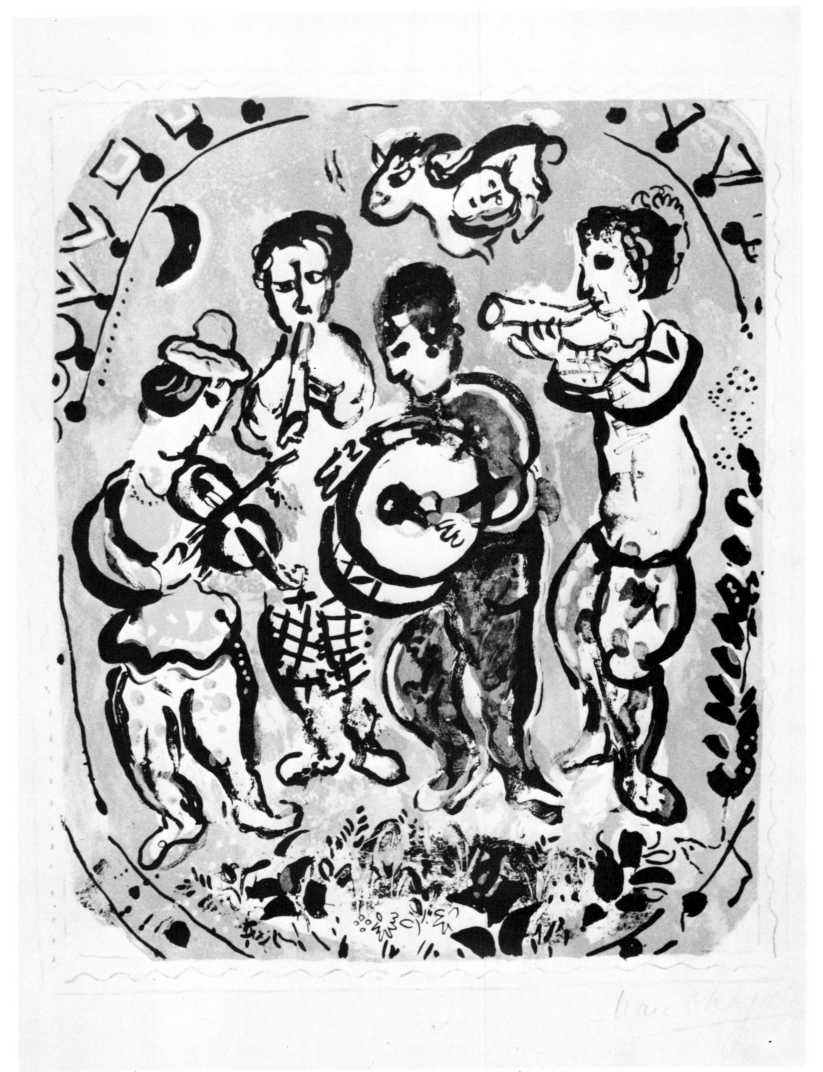

Musiciens sur Fond Vert (1964), Marc Chagall, 21½ x 17 in. (Courtesy of Galérie Maeght)

Le Mousson (1965), Alexander Calder, 30 x 22 in. (Courtesy of Galérie Maeght)

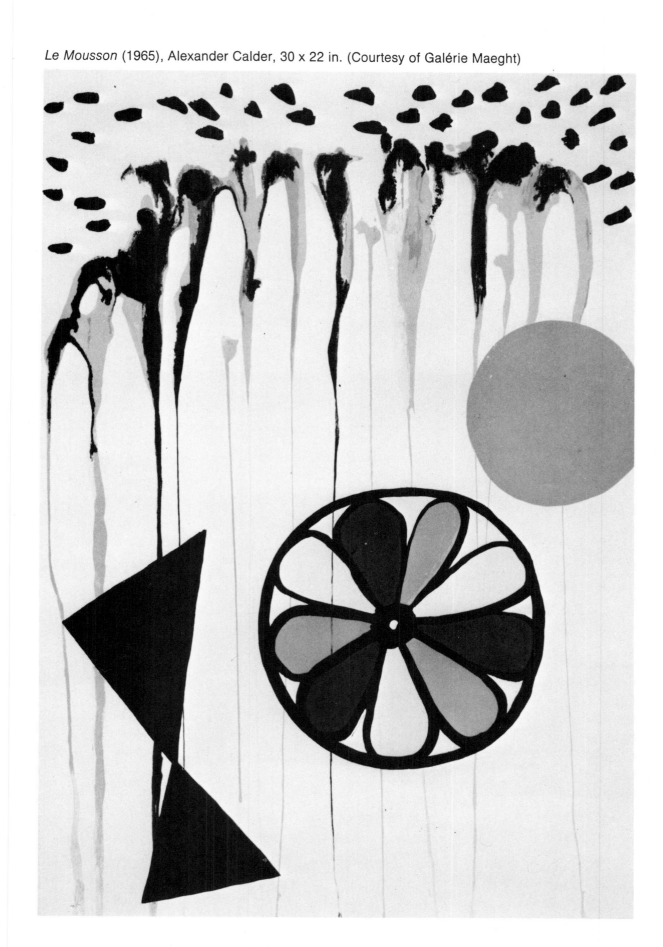

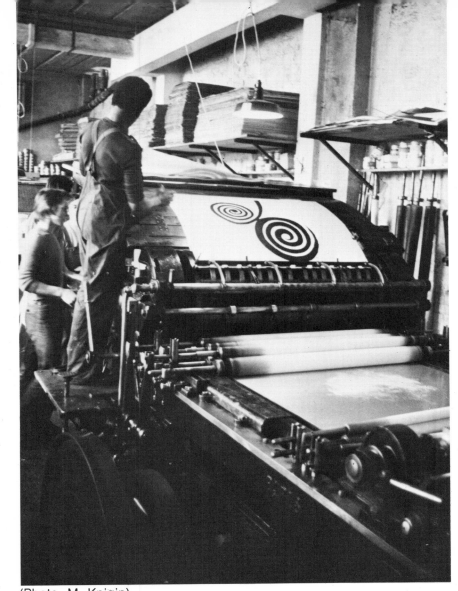

(Photo, M. Knigin)

(Photo, M. Knigin)

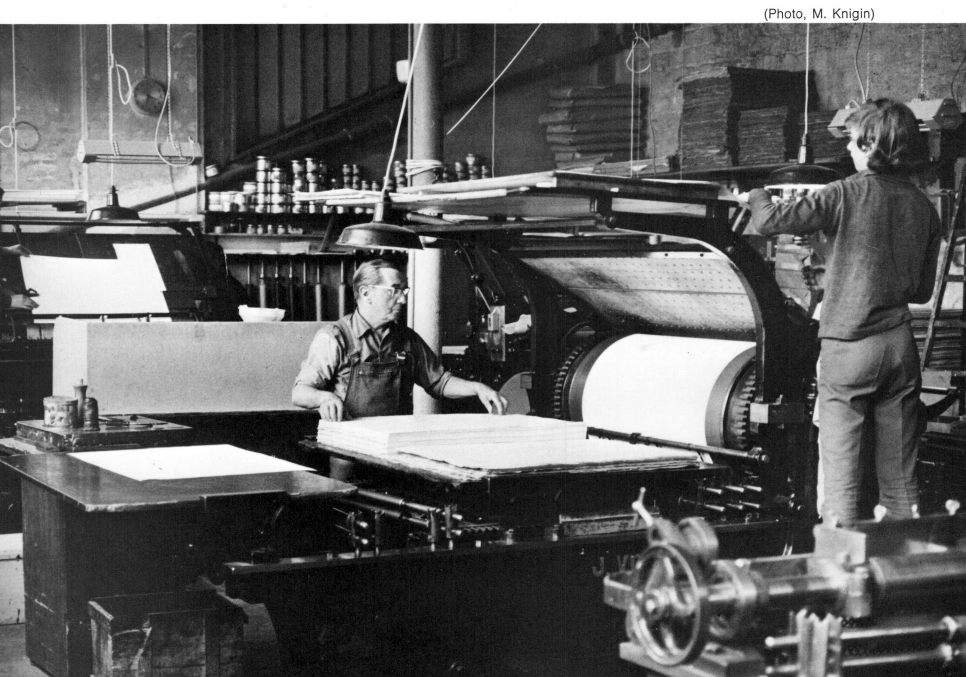

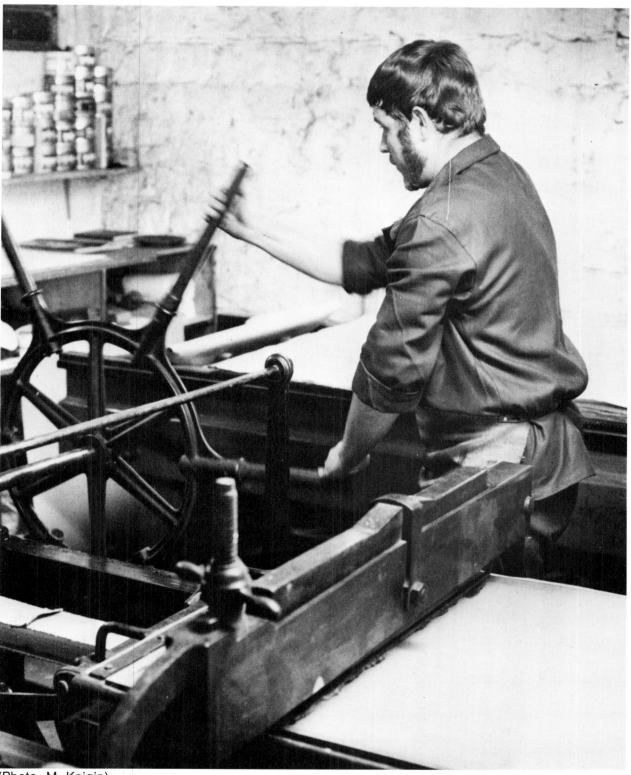

MATTHIEU AG
ATELIER FUR
KUNSTLITHOGRAPHIEN

In its attempts to print original lithographs, the atelier cooperates in various ways with the artists. Some artists work directly on the material in the shop, while others request stones or plates so that they can work at home. At times an artist may draw and paint on Berlin transfer paper, which the atelier then transfers to the stones. And finally, some artists send in originals from which the workshop then produces the lithograph without a screen.

Our proven workers, who have been with us for many years, have developed a method that precisely preserves the finest works, such as washes and drawings, whether they are worked directly from the stone or from transfer paper.

Director: *Hans E. Müller*

The atelier was originally known as Frey & Kratz from 1894 to 1958 and was directed by Frey. Emil Matthieu took over the director's chair in 1959, and the atelier took his name. Since 1969, under the direction of Mr. Müller, the atelier has been known as Matthieu AG. The company of Matthieu AG erected a new building next to the world-famous printers Lichtdruck AG in Zurich-Dielsdorf. The workrooms and artists' studios, formulated from plans by Max Bill, enjoy the best possible lighting conditions. The atelier operates nine presses.

Schulstrasse 6
CH-8157 Dielsdorf, Switzerland

The following is a partial list of the artists who have worked at Matthieu: Alcoplay, Horst Antes, Otto Bachman, Serge Brignoni, Alois Carigiet, Chadwick, Alan Davie, A. W. Diggelmann, Piero Dorazio, Hans Erni, Hans Falk, Franz Fedier, Forissier, Sam Francis, Ferruccio Garopesani, Nanette Genould, Alberto Giacometti, Girard, Max Günther, Renato Guttuso, Willi Hartung, Erich Heckel, Hoflehner, Hopkins, J. Hugentobler, Karl Iten, Allen Jones, Kemeny, Oskar Kokoschka, Wilfredo Lam, Arnold Leissler, Lurcat, Michele Mainoli, Marino Marini, Ivan Mosca, Antonio Music, Ossi, Celestino Piatti, Hans Potthof, Purmann, Ludwig Sander, Henri Schmid, Gustav Singier, Sonderborg, Graham Sutherland, Joaquin Vaquero, Gérold Veraguth, Bernd Völkle.

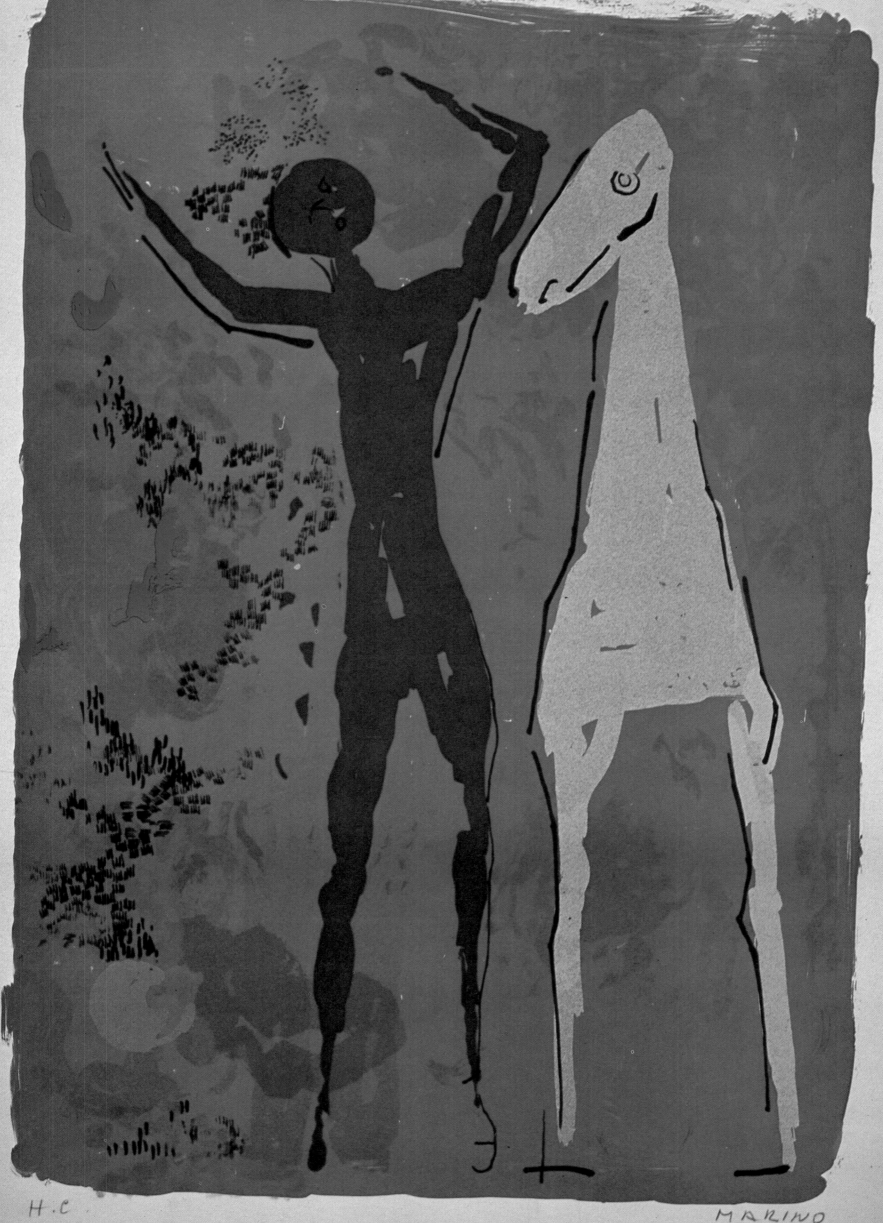

H.C. MARINO

Olympic Games in Munich 1972 (1971), Horst Ántes, 25 x 35 in. (Courtesy of Matthieu AG)

Untitled (1967), Allen Jones, 22 x 30 in. (Courtesy of Matthieu AG)

Green Man—Pink Horse (1969),
Marino Marini, 20 x 26 in.
(Courtesy of Matthieu AG)

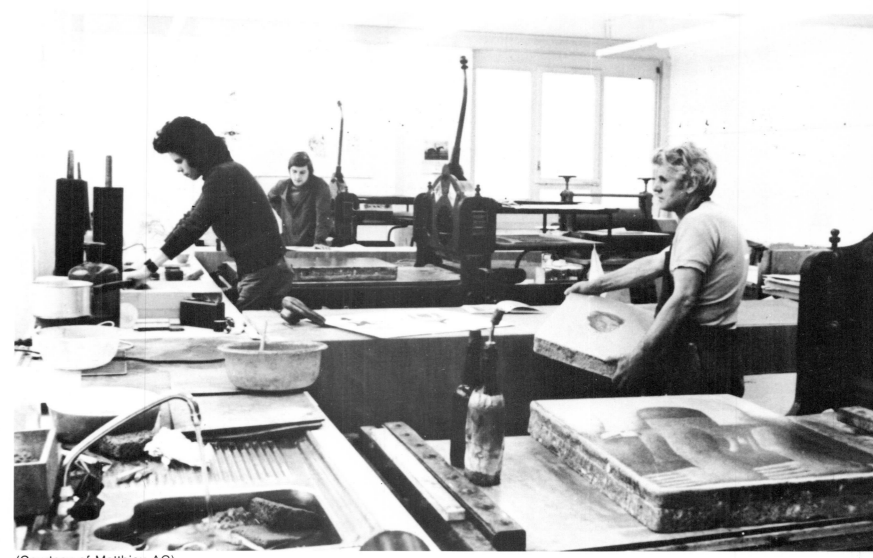

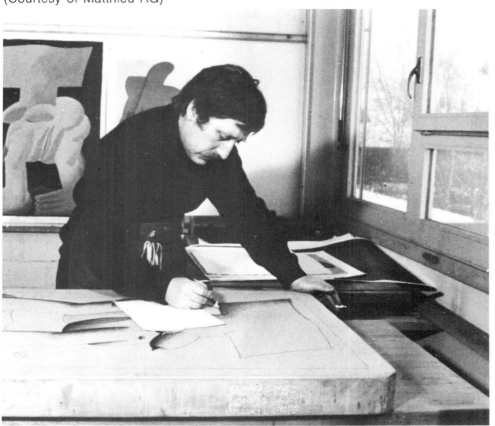

Untitled (1963), Graham Sutherland,
22 x 30 in.

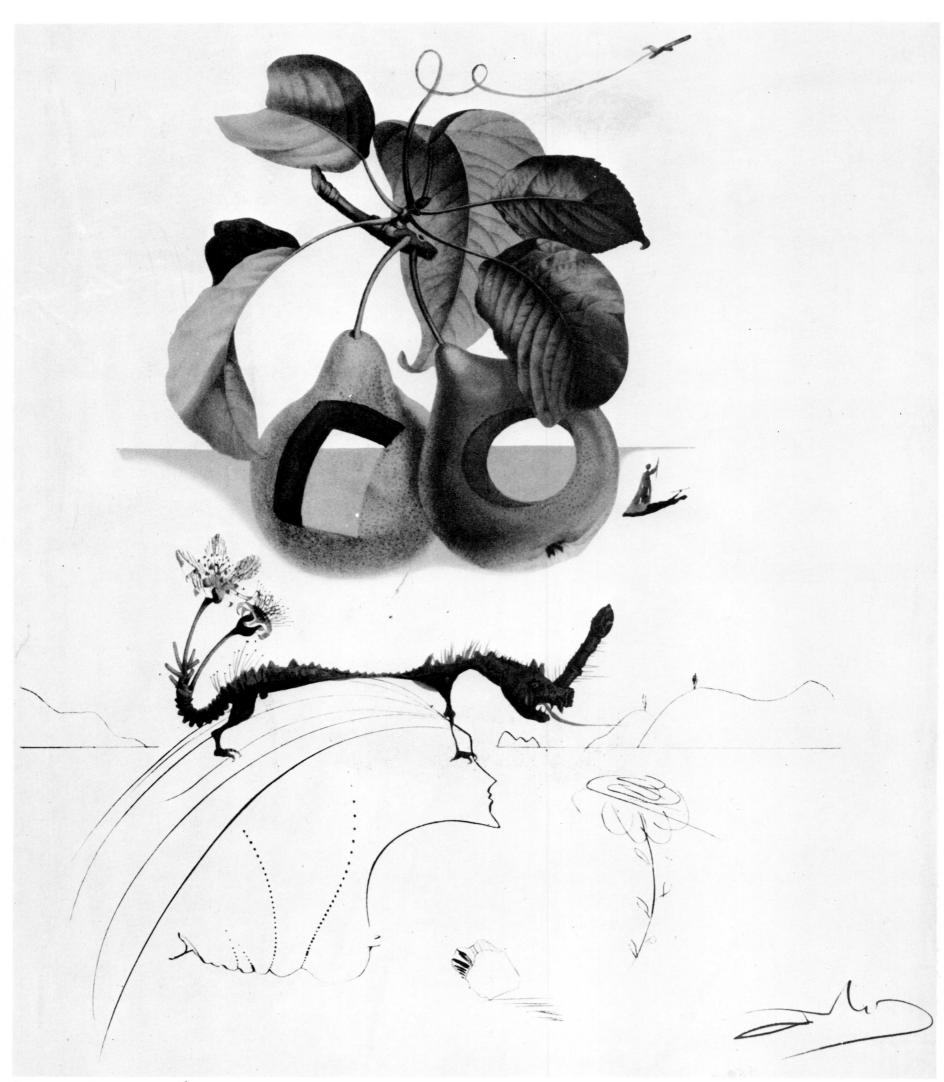

Dragon and Pears (1970), Sàlvador Dali, 22 x 30 in. (Courtesy of Matthieu AG)

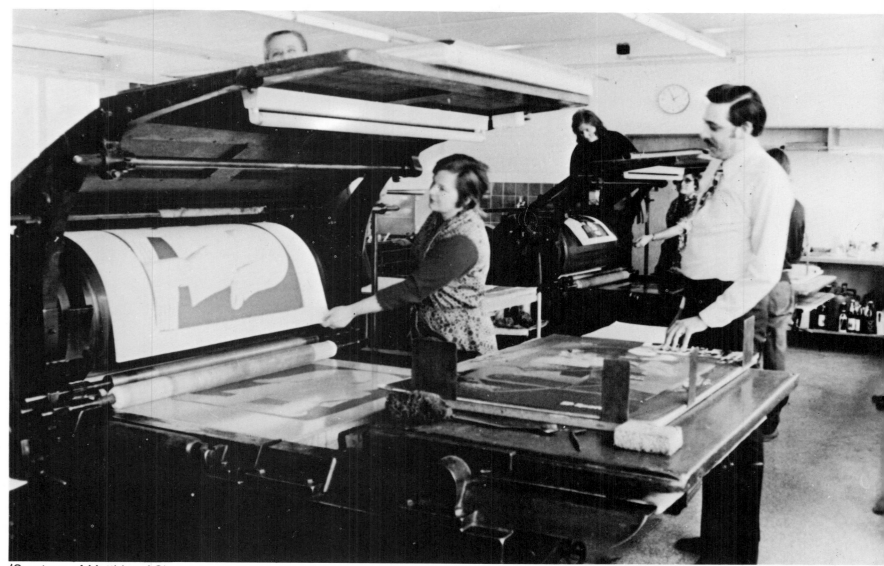

(Courtesy of Matthieu AG)

(Courtesy of Matthieu AG)

MOURLOT IMPRIMEURS

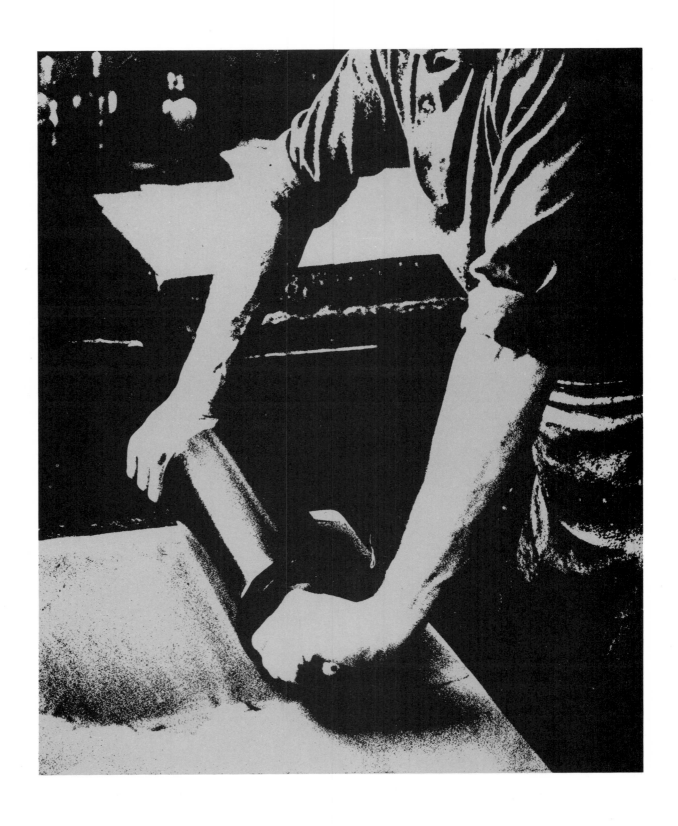

Fernand Mourlot, director of Mourlot Imprimeurs. (Photo, M. Knigin)

Founded in 1852 by Honoré Bataille, the workshop was bought in 1914 by Jules Mourlot, who had been directing his own atelier since 1880. Since then the shop has grown to the extent that it employs fifty printers to operate its twenty presses. The following statement about the atelier originally appeared in *The Hudson River Museum News.*

The Imprimerie Mourlot is over one hundred years old. Jules Mourlot, a Paris printer, founded what is today the Imprimerie Mourlot Frères at 43 rue Barrault under the direction of his son, Fernand Mourlot. Artists flocked there, coming to prepare their stones and seek advice. Among the first to come were Utrillo and Vlaminck. In 1935, Braque and Matisse arrived, in 1937, Bonnard wrote to Mourlot 'I entrust myself to your skill.' Since 1927, the National Museums, the Bibliothèque Nationale, and the important publishers of fine editions have all given their work to Mourlot.

Artistic activity subsided during World War II and Mourlot engaged in the Resistance utilizing his printing skills. After the Liberation, artists again came to Mourlot. The list of those who have worked with Mourlot is lengthy and impressive. It includes, among others: Buffet, Chagall, Cocteau, Dali, Dufy, Léger, Magritte, Miró, Moore, Shahn, de Stael, Villon, and, of course, Picasso. Picasso said he spent many of the best moments of his life working at Mourlot. At first, he claimed to be a student there to learn, but soon he became so excited by the lithographic possibilities that he would work with Fernand Mourlot from nine in the morning until eight at night. He was delighted by the ambience of Mourlot's atmosphere. Villon's faith and feelings for the House of Mourlot were also strong. Shortly before his death, he insisted upon being carried to sit and drink in the atmosphere of Mourlot that he had loved to work in.

Today, as then, the activities of the House of Mourlot represent the ideal collaboration between the artist and artisan. Stanley Hayter has written on the training of Mourlot printers: 'The training of these men takes many years and requires a very exceptional capacity.' This capacity lies as much in their talent for creative collaboration with the artist as in their magic-like craftsmanship.

The following is a partial list of the artists who have worked at Mourlot: Beaudin, Pierre Bonnard, Georges Braque, Brianchon, Bernard Buffet, Alexander Calder, Marc Chagall, Jean Cocteau, Salvador Dali, Max Ernst, Estere, Estève, Alberto Giacometti, Laurens, Le Corbusier, Fernand Léger, René Magritte, Marino Marini, André Masson, Henri Matisse, Minaux, Joan Miró, Henry Moore, Pablo Picasso, Richier, Ben Shahn, Surrage, Maurice Utrillo, Kees Van Dongen, Victor Vasarely, Villon, Maurice Vlaminck, Paul Wunderlich.

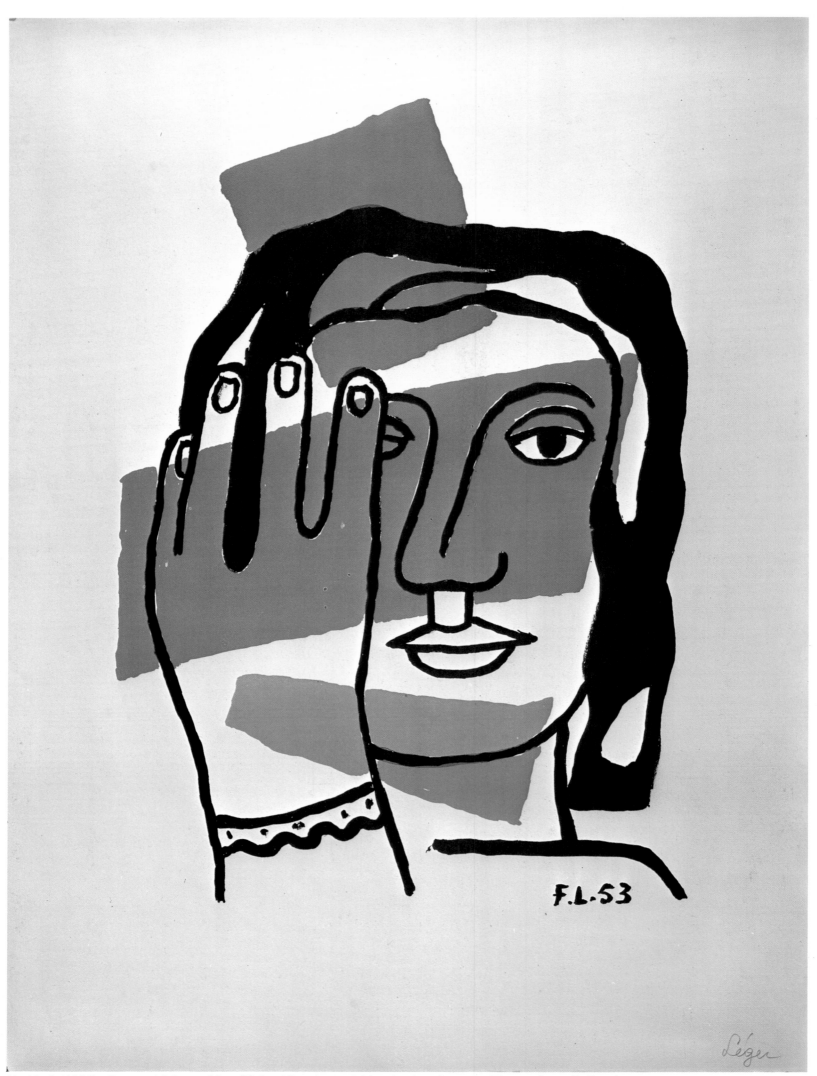

Untitled (1953), Fernand Léger, 20 x 26 in. (Courtesy of Mourlot Imprimeurs. Photo, Jean DuBout)

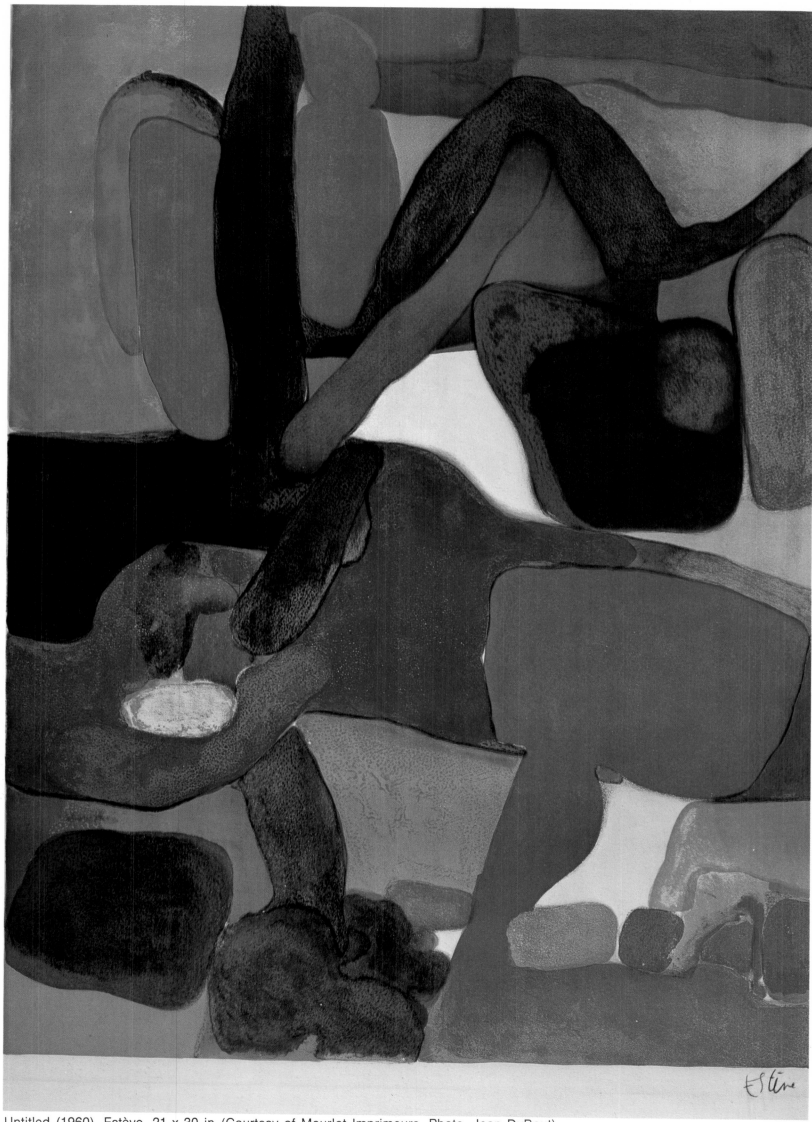

Untitled (1960), Estève, 21 x 30 in. (Courtesy of Mourlot Imprimeurs. Photo, Jean DuBout)

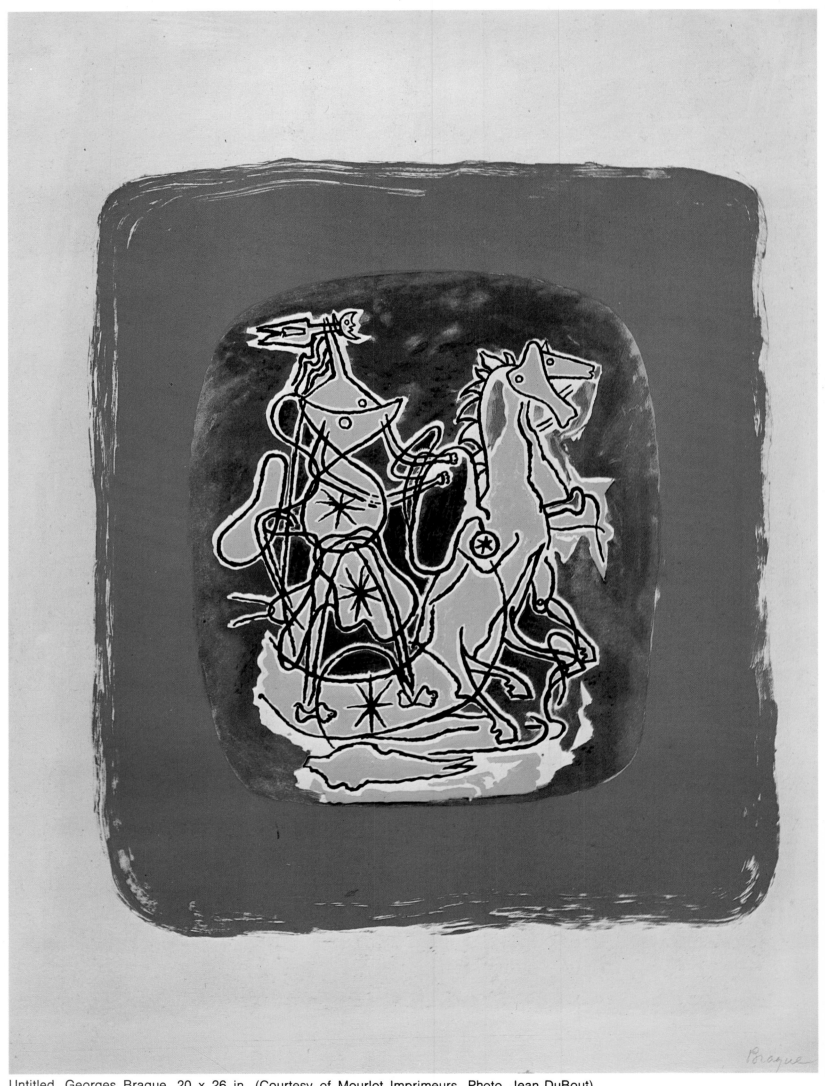

Untitled, Georges Braque, 20 x 26 in. (Courtesy of Mourlot Imprimeurs. Photo, Jean DuBout)

Jacqueline au Mouchoir Noir (1958), Pablo Picasso, 20 x 26 in. (Courtesy of Mourlot Imprimeurs. Photo, Jean DuBout)

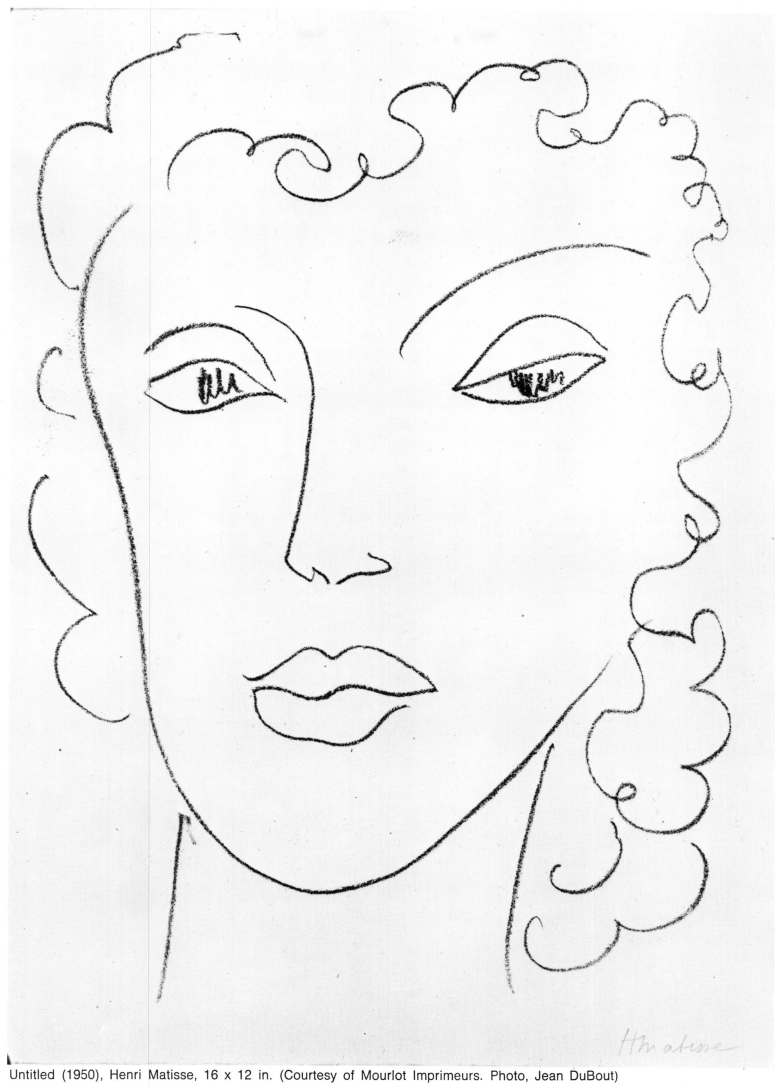

Untitled (1950), Henri Matisse, 16 x 12 in. (Courtesy of Mourlot Imprimeurs. Photo, Jean DuBout)

269

Untitled (1966), Paul Delvaux, 25¼ x 19¾ in.
(Courtesy of Mourlot Imprimeurs. Photo, Jean DuBout)

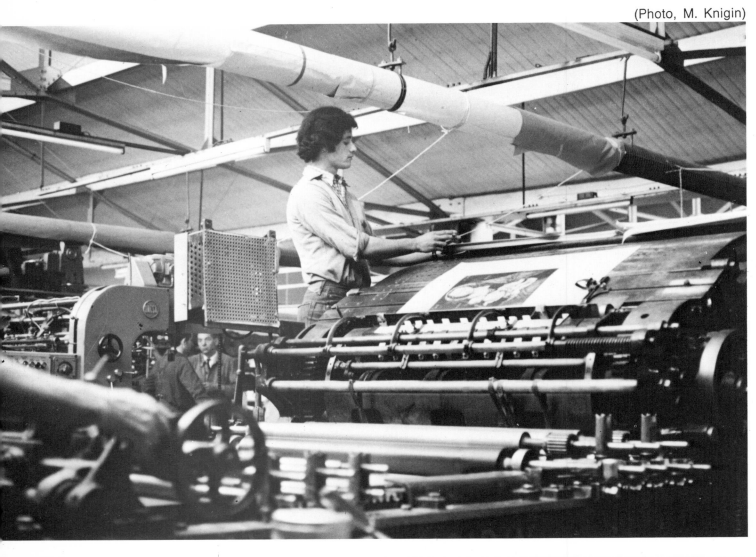

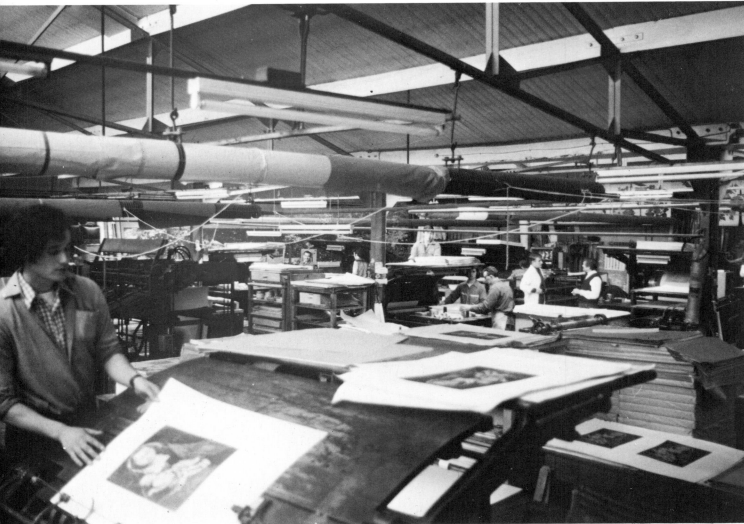

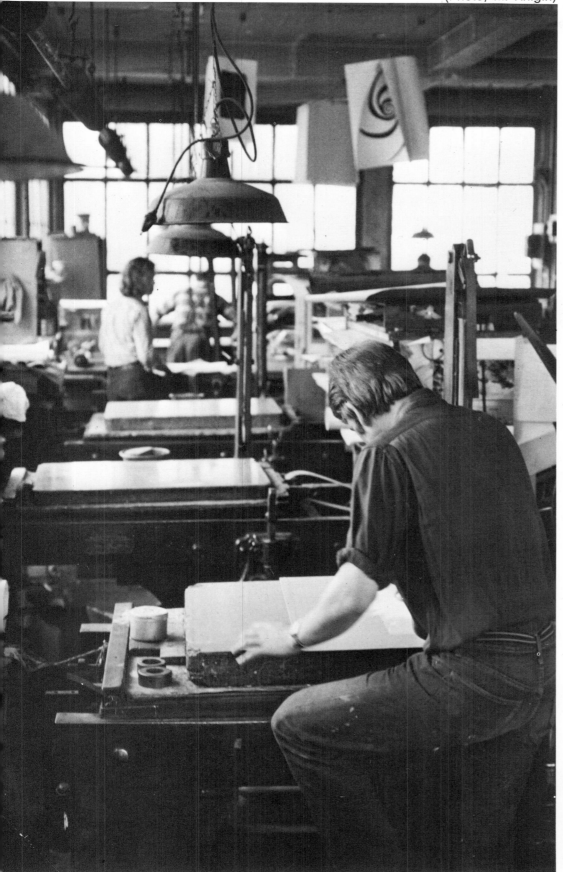

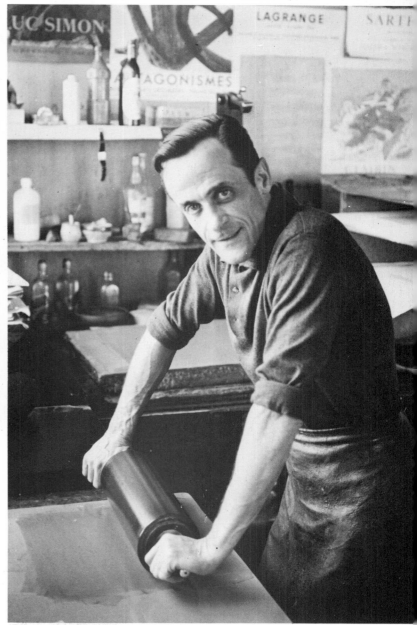

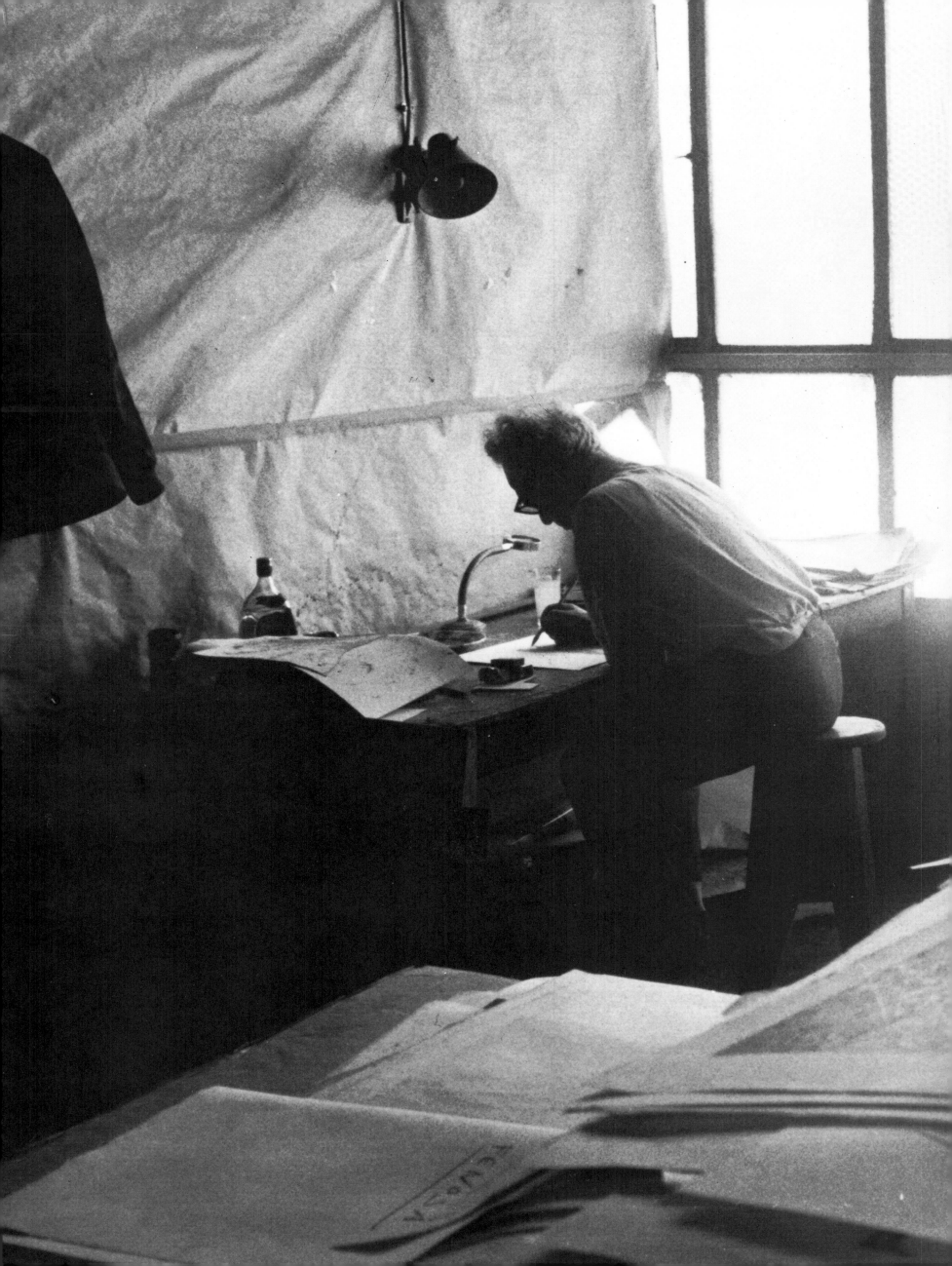

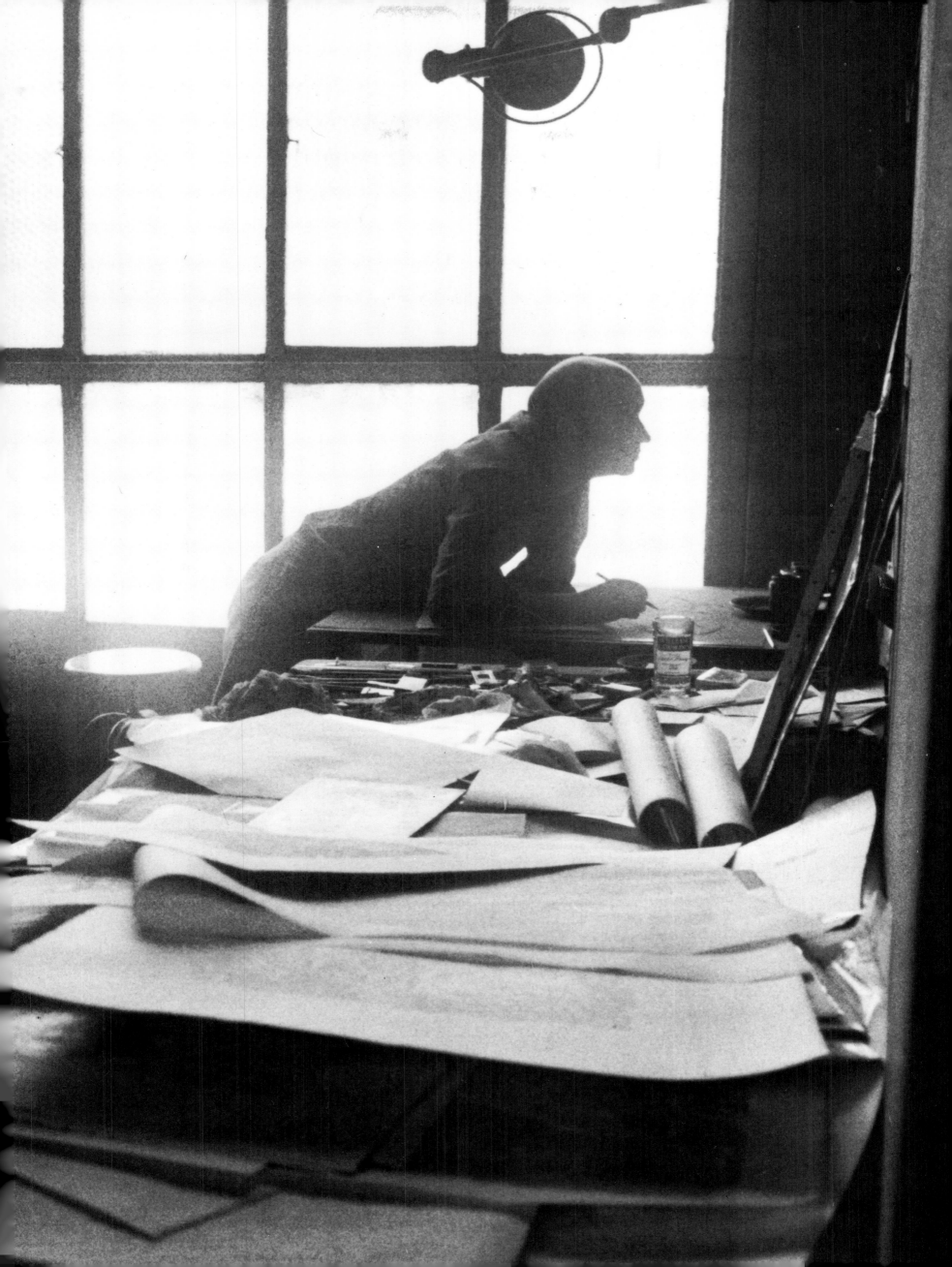

PRINTSHOP

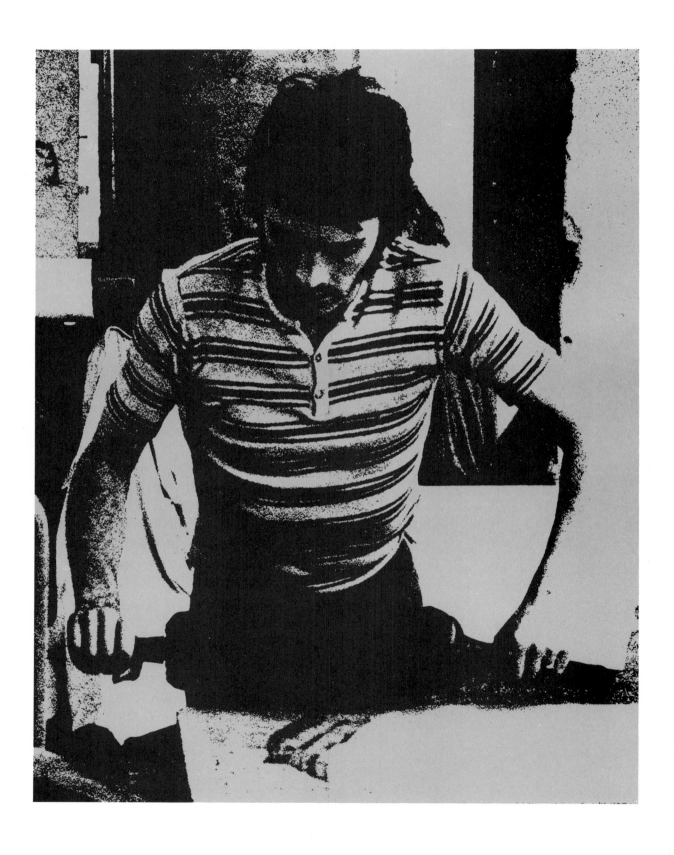

(Photo, M. Knigin)

Printshop exists primarily to publish the lithographs of Dutch artists and to fill what it sees as a growing need of the public for inexpensive original art instead of reproductions. To achieve this end, the artists work one at a time with the artisans at the workshop.

In March 1958, when I began printing lithographs for artists, there was hardly any work at all, as Holland had no existing graphic workshop. Through working with the artists there, an interest developed for graphic art that enabled me to begin printing etchings and woodcuts. Ten years later, we opened our new, larger screen-studio, completing our graphic workshop. I think that my desire to make a workshop where artists could work in all the techniques was inspired by my training as a commercial printer, which I began when I was fifteen, without any artistic aspirations. I have decided not to enlarge our workshop anymore, since I have noticed that when working with too many printers I must withdraw myself from the actual printing due to the enormous amount of organization required.

Director: *Piet Clement*

In 1968, a decade after its small beginnings in a single room, Printshop opened a new workshop with two large studios. Three etching printers, three litho printers and one screen printer operate its six hand presses. All work is done in daylight and in adequate space, and the artists have a separate room in which to make the stones. The average yearly output is four portfolios and various loose prints in editions of one hundred.

In 1969 the atelier opened a print gallery, which has had a great success selling the work of about 100 artists.

Prinsengracht 845
Amsterdam, Netherlands

The following is a partial list of the artists who have worked at Printshop: Horst Antes, Constant, Corneille, Wessel Couzijn, Jan Cremer, Jim Dine, David Hockney, Ger Lataster, Lucassen, Lucebert, Paolizzi, Roger Raveel, Vazerelij.

To Signal with a Mirror (1970), Hannes Postma, 20 x 26 in. (Courtesy of Printshop)

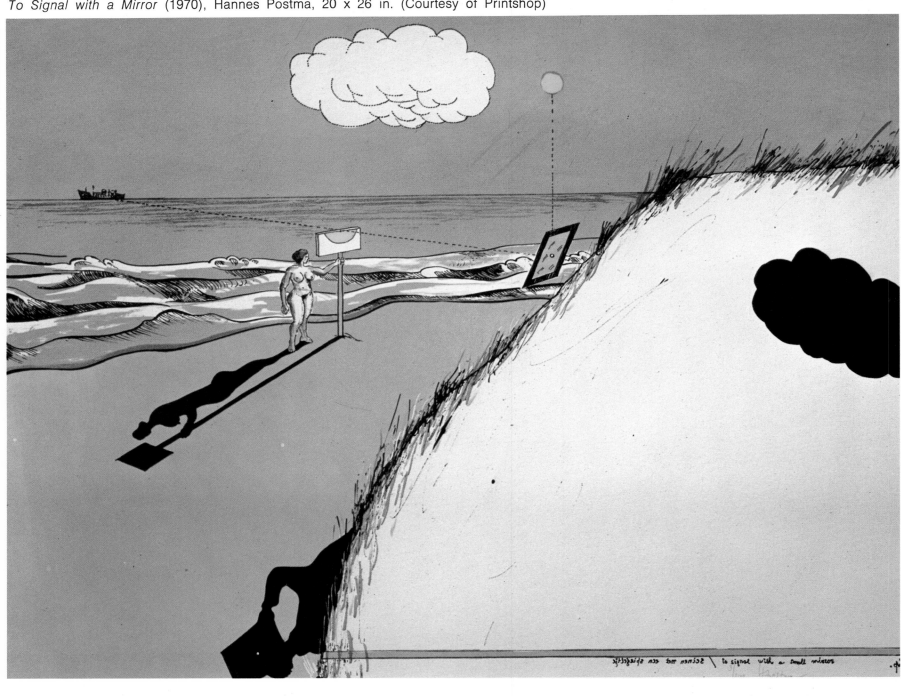

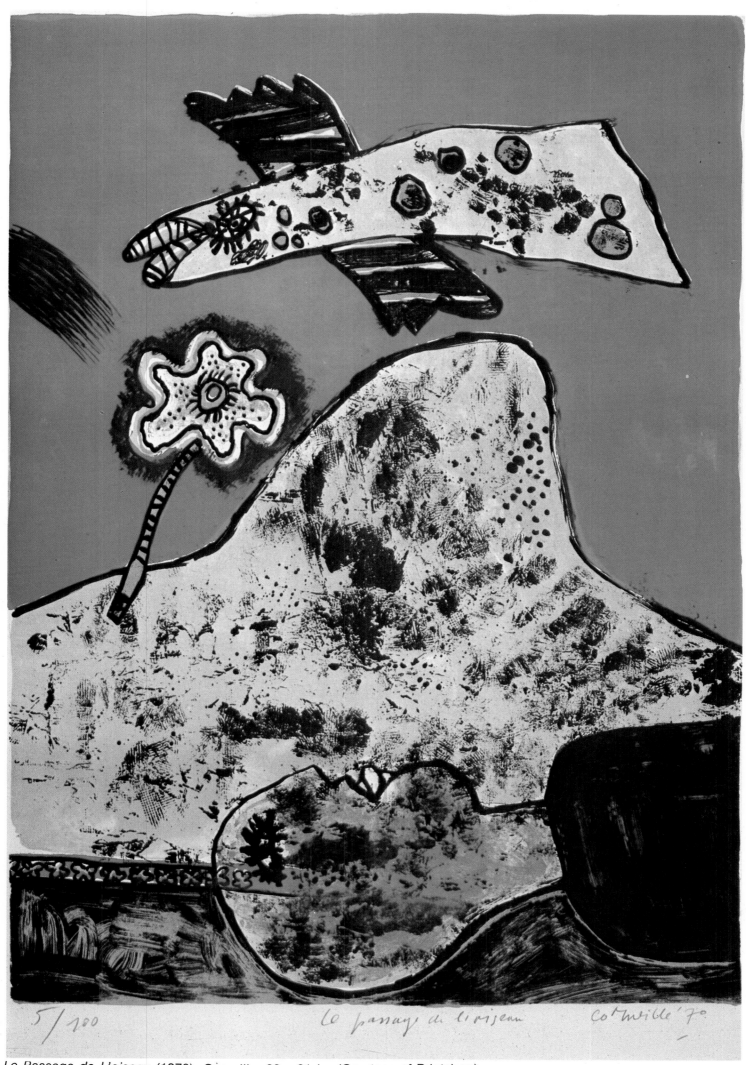

5/100 Le passage de l'oiseau Corneille '70

Le Passage de L'oiseau (1970), Corneille, 22 x 31 in. (Courtesy of Printshop)

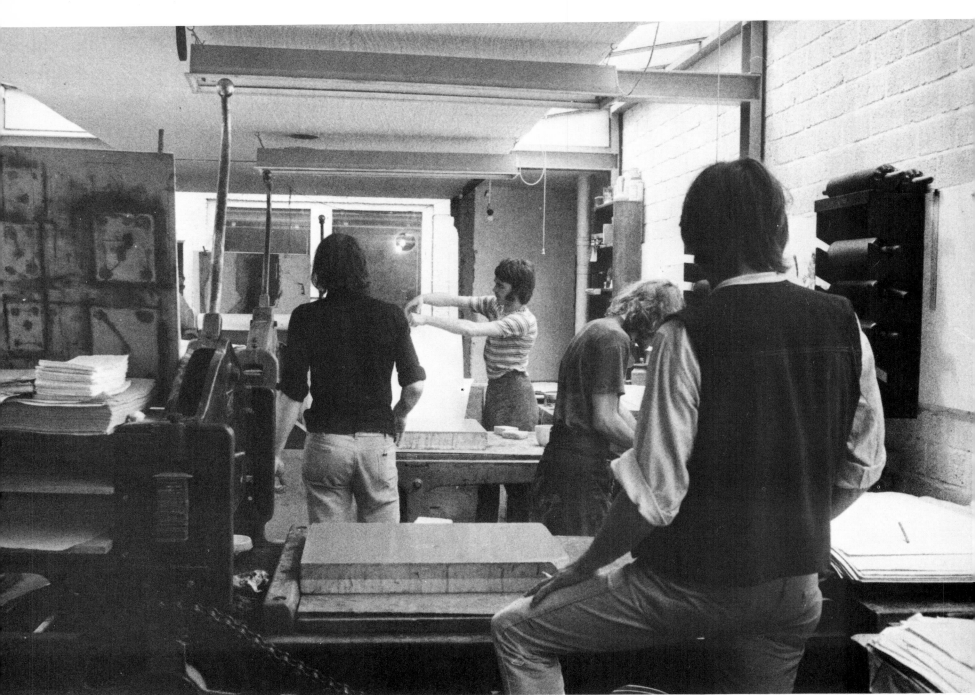

(Photo, M. Knigin)

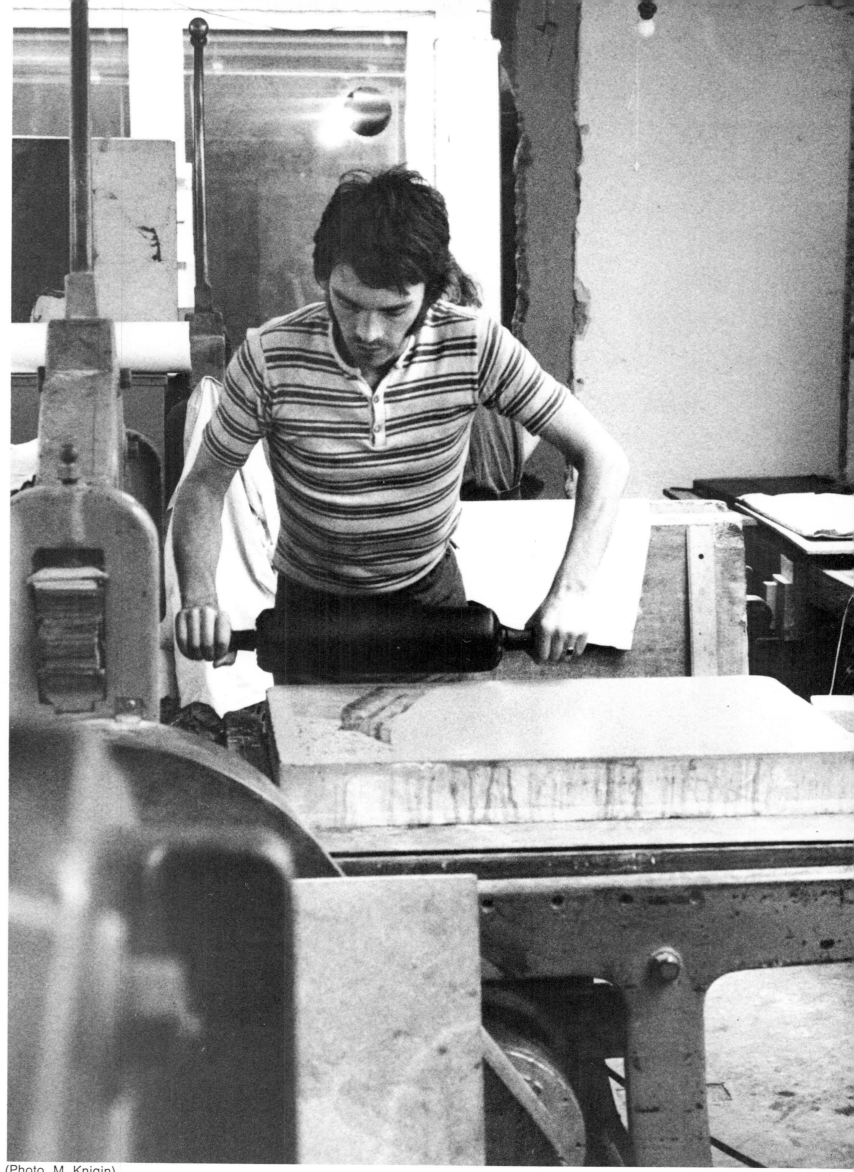

(Photo, M. Knigin)

279

G. QUINCE

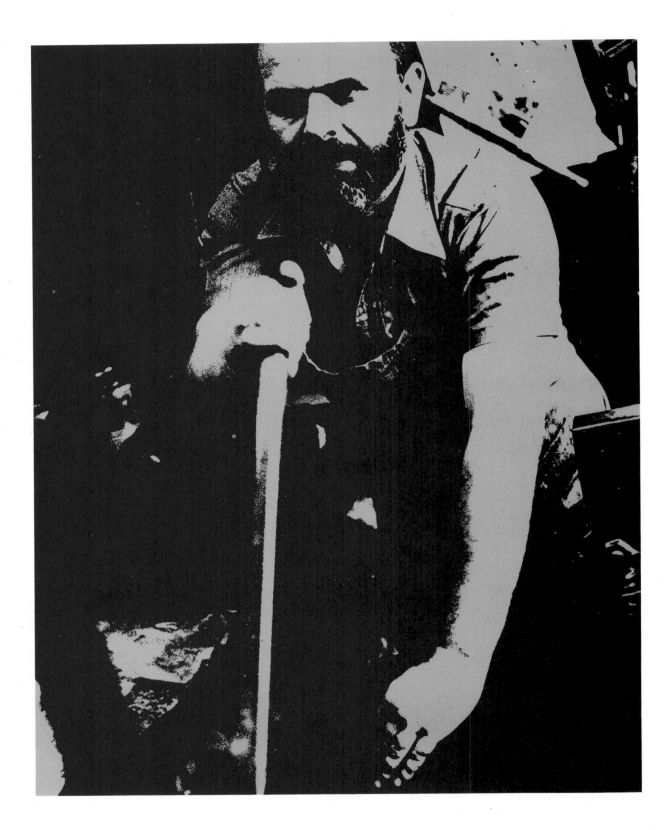

Close cooperation is established between the artist, director, and the printer at the start, and it continues throughout the drawing process, even to the choice of color and best medium. Thus far, all work has been done directly on the stone by the artist, without the mediation of photolithography.

After twelve years of running this shop, I have found that painters learn the technique of lithography quickly, through their long experience using inks, pencils, brushes, colors. A good painter will always make good lithographs. I believe the medium's main contribution lies in the cultural field. Today, there are a great number of people who feel a need for art, and, thanks to the reasonable price of graphic work, they can afford to possess pieces by their favorite artists, whose work in other media may be beyond their means.

Summing it up, this is the end of my workshop: letting artists find out about lithography and helping spread art appreciation as much as I can.

Director: *Dimitri (Papagueorguiu)*

Founded in 1958, by Dimitri and painter Manuel Alcorlo, the workshop, called Estudio BOJ, was located at Illustracion 12, Madrid. In 1960 Alcorlo went to Rome on a scholarship, leaving the workshop under Dimitri's direction and ownership. That same year, the workshop was moved to Modeste La Fuente 78, Madrid, in collaboration with the widow of painter C. Pascual de Lara, Margarita Pérez Sánchez. A collection of twelve lithographs a year (one a month) by figurative artists was edited under the name "Colección BOJ. Artistas Grabadores" and distributed to subscribers. Publication, which was very successful, lasted for three years. Since its founding, the workshop has printed lithographs done by a very large number of artists, and its files contain upwards of 7,000 prints encompassing various forms of graphic work. In September 1971 a new gallery-workshop, with the new name, opened at Fortuny 7, Madrid, exclusively for invited artists, and the former workshop remains available to general customers. Each shop has its own Voirin press.

Fortuny 7
Madrid 4, Spain

The following is a partial list of the artists who have worked at G. Quince: Cossío, Farreras, Raúl Fernández, Antonio López, García, Luis García-Ochoa, José Guerrero, José Hernández, Manolo Millares, Maribel Quintanilla, Manuel Rivera, Antonio Saura, Antonio Suárez, Vásquez Díaz, Salvador Victoria, Villaseñor.

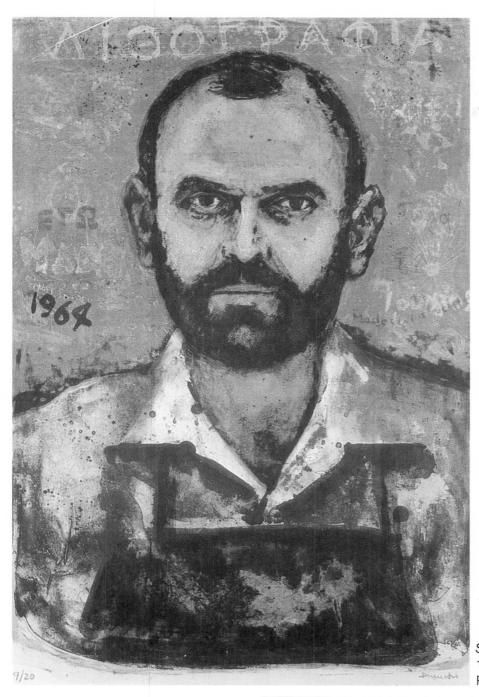

Self-Portrait (1964), Dimitri (Papagueorguiu),
14 x 20 in. (Courtesy of G. Quince.
Photo, Arnaiz)

Personnage (1964),
Antonio Saura, 16 x 20 in.
(Courtesy of G. Quince. Photo, Arnaiz)

The Circus (1962), Jorge Castillo,
14½ x 20 in. (Courtesy of G. Quince)

STAMPERIA D'ARTE
"IL TORCHIO"

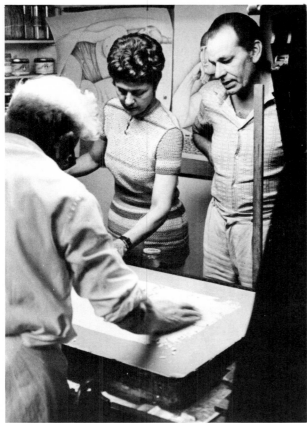

(Photo, M. Knigin)

Once we have made contact with an artist and agreed to work with him, it is often months, sometimes years, before the lithograph is executed. We talk to the artists, making them aware of our point of view as printers, and we invite them to our workshop so that they can understand the lithographic method and the work done in our shop. We also go to their studios to understand, in turn, their possibilities as graphic artists, and to see which procedures would be most congenial to them.

In short, the print is discussed, examined, and studied long before it is executed. From the artist, we ask a maximum sense of involvement, and, in return, we offer him the possibility of extended periods for proofs so that he can achieve results that are, if not always excellent, at least commensurate with his possibilities as a graphic artist.

In collaborating with an artist, we also think it is necessary to know his work as a painter or sculptor in sufficient depth. Without this knowledge, we feel at a disadvantage, as if a certain support, or rather a point of reference, were missing. For these reasons we prefer to be the ones to contact or invite the artist.

As far as types of matrices are concerned, we scrupulously follow the concept of original printing, and we insist that the artist personally draw on the matrix without ever seeking recourse to more convenient processes of reproduction such as photomechanical engraving.

Given the difficulty of supplying, storing, and, above all, of managing large stones, the workshop now uses zinc plates. These are patterned with four different kinds of grains to suit the characteristics of each artist's style. Sometimes, if the artist is working directly from the subject and wants to avoid the reversal of the image that is required when working directly on zinc, he draws on transfer paper.

Among the many forms of art, lithography, because of its technical particulars and its consequent graphic results, occupies a well-defined, independent, and autonomous position. Born as a craftsmanly means of reproduction, lithography, after the discovery of photography, established and asserted itself as an original artistic medium.

The type of lithograph, however, that results from the faithful, photomechanical reproduction of a preexisting work, has neither artistic nor commercial value and is considered purely and simply a reproduction. It sometimes happens that such a reproduction is sold to the inexpert buyer as an original graphic work by an unscrupulous printer through galleries and resale agents who are not always qualified or acting in good faith. This is done, unfortunately, with the consent of the artist, who backs up the reproduction with his signature. Only an "original work" lithograph can be regarded as one of the legitimate vehicles for the diffusion and assertion of artistic taste.

A good lithograph, though not always destined for the true print collector, accomplishes one of its cultural functions even when it is bought in place of an artistically worthless painting.

In this context, let us remember our slogan, which, about a dozen years ago, in the beginning of Torchio's activity, caused not a little perplexity, and provoked varying and opposing opinions:

Better a good lithograph than a mediocre painting. It is not possible to buy an excellent painting with a modest sum.
On the other hand, it is possible to buy an excellent lithograph with a modest sum.

Together with a few other colleagues, we struggled for more than ten years to diffuse artistic taste in Italy; to assert the autonomy of lithography and its right to be regarded as an art form; to defend the fundamental principle of originality; and to inject principles into a market that was relatively young and thus susceptible to possible side-slipping.

As printers, we have tried a number of times to demonstrate that it is possible to modernize art printing by bringing to it the innovations resulting from the creative needs of the artists and the evolution of graphic art, all the while respecting the basic canons of lithography as an original art.

Director: *Mrs. Franca Menotti*

Il Torchio first opened at Via Brera 10, in the heart of the Milanese artistic community. It was a single large, octagonal room with a vaulted ceiling, which was previously the carriage-house of the titled proprietor of a beautiful eighteenth-century palazzo, now considered a national monument by the Soprintendenza della Belle Arti.

A few years before World War II, the director, Franca Menotti, and her husband, Libero Formenti, who had always been friendly with artists, struck up a special friendship with a painter who was in time to become one of the most important dealers of Italian art: Enzo Pagani. In 1957 Pagani opened a gallery in the same courtyard with the atelier, a Milanese branch of the one he had founded in Legnano immediately after the war. The Milanese gallery soon became one of the liveliest and most interesting centers of the Italian artistic and cultural world by virtue of its anti-conformist activity. Il Torchio, working side-by-side with Pagani, experienced during these years a fundamental evolution toward a liberated artistic frame of mind that, in Italy, had been politically channeled and pigeonholed for too many decades in a false climate of pseudonationalistic cultural vindication.

Apart from rare exceptions, even immediately after the war, Italian "official painting" almost completely ignored the artistic evolution in other countries and was strictly and psychologically tied to the so-called "Italian tradition." The Galleria Pagani thus aroused much dissent and little agreement by exhibiting Vasarely and the whole group of Denise René, who were considered controversial even in Paris at that time. Pagani also exhibited Mauro Reggiani and Luigi Veronesi, who, together with a few others are considered the Italian leaders of the "Concretist" or "Abstract Geometric" movement.

Alternating in shows with this stylistically unified and well-defined group were artists who, although in an aesthetic sense part of the opposing "Figurative Movement," tended openly to oppose the official post-war movement. Among the artists belonging to this figurative avant-garde was Remo Brindisi.

Although aesthetically opposed to one another, two of these artists shared a strong common interest in a branch of art that was largely ignored and neglected at that time, graphics. They were Luigi Veronesi, one of the first signers of the Italian abstract manifesto of 1935, and Remo Brindisi, the proponent of the neofigurative movement in 1955, which followed in the footsteps of Bacon and Giacometti and

286 *Personaggio* (1968), Enrico Baj, 27½ x 20 in.
(Courtesy of Il Torchio. Photo, Titti Marchese)

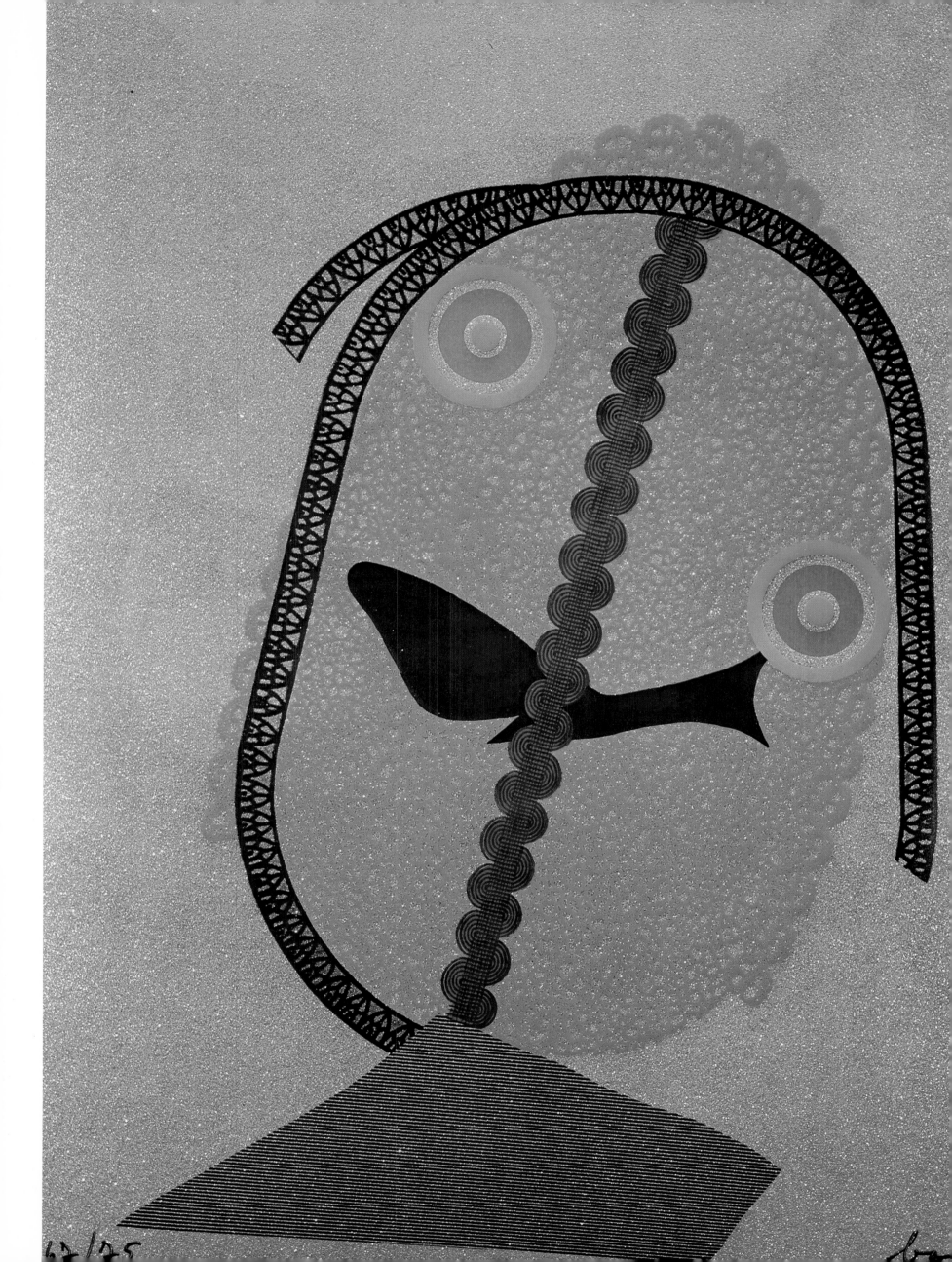

reproposed for Italy a profound investigation into the destiny of man, viewed in his humanity and interiority rather than as a social fact.

For some time, both Brindisi and Veronesi had been trying to expand their dialog, which had been restricted to a very limited circle of initiates, the few collectors or lovers of graphic art, and, more specifically, of prints. These two voices, although stylistically opposed, were able, in unison, to awaken sufficient enthusiasm and interest at Il Torchio to convince them to face the great adventure of graphic art.

Thus it was the mandate to expand the graphic dialog in Italy that provided the incentive to begin an activity so little appreciated by collectors of painting, completely ignored by the public, and consequently neglected by the majority of artists. The beginnings were anything but simple and encouraging.

It was easy to rent a little place, equally easy to unearth an antique, but where to find the pressman, the technical man? The old craftsmen had disappeared, or changed profession, and the young understandably preferred a more up-to-date occupation that did not require such long apprenticeship and hand labor.

One day Mrs. Menotti happened to be at a lithographic establishment composing the cover of a catalog for Pagani's gallery. In her conversation with the director, she happened to mention the problem of running a workshop without a pressman.

"Are you looking for a pressman?" asked the director. "There's one right here; I keep him on only because his son is a friend of mine. He was out of work for two years!" He indicated a man with white hair who was standing nearby to work on the catalog. He was an old man, apparently older than he looked, taciturn, a little cantankerous, and obviously uncomfortable and unprepared as a photolithographic composer. She was disappointed and at first refused to consider him. Then, more as a courtesy to the typographer than out of conviction, she agreed to try him.

In a short time that amorphous, absent man was transformed into a passionate, able craftsman. Returning to the tiring work of the hand press, according to him, even made his rheumatism go away. Now he could turn around and see the taillight on the bicycle he rode to work. He had to be pushed out the door in the evenings, and he would go reluctantly, but not before carefully cleaning all his tools and stopping a moment to look at "his" press again with the look of someone who had found an old friend he had thought lost forever. The experiences of almost a half century spent with a similar press were revived and integrated with the new experiences put in his head by his new directors who, although younger, understood that his craft, in its artistic essence, was still important and should not die.

In this same spirit, even the equipment of the shop is kept to the basic tools of this old craft. Avoiding the temptation to modernize and install machines for photo and offset techniques, Il Torchio maintains only two antique direct-printing presses. One is a century-old Bollito made in Turin; the other is a Borgo-Caratti from Milan that dates from the turn of the century.

Via Solferino 24
20121 Milano, Italy

The following is a partial list of the artists who have worked at Il Torchio: Nobuya Abe, Valerio Adami, Pietro Annigoni, Enrico Baj, André Bloc, Pompeo Borra, Remo Brindisi, Domenico Cantatore, Carmelo Cappello, Giuseppe Cesetti, Gaston Chaissac, Roberto Crippa, Sonja Delaunay, Lucio Del Pezzo, Gianni Dova, Salvatore Fiume, Lucio Fontana, Achille Funi, Giuseppe Guerreschi, Renato Guttuso, Guy Harloff, Wilfredo Lam, Francesco Messina, Giuseppe Migneco, Nando, Domenico Purificato, Amilcare Rambelli, Mauro Reggiani, Hans Richter, Aligi Sassu, Angelo Savelli, Tomonori Toyofuku, Luigi Veronesi.

Concetto Spaziale #5 (1961), Lucio Fontana, 27½ x 20 in.
(Courtesy of Il Torchio. Photo, Titti Marchese)

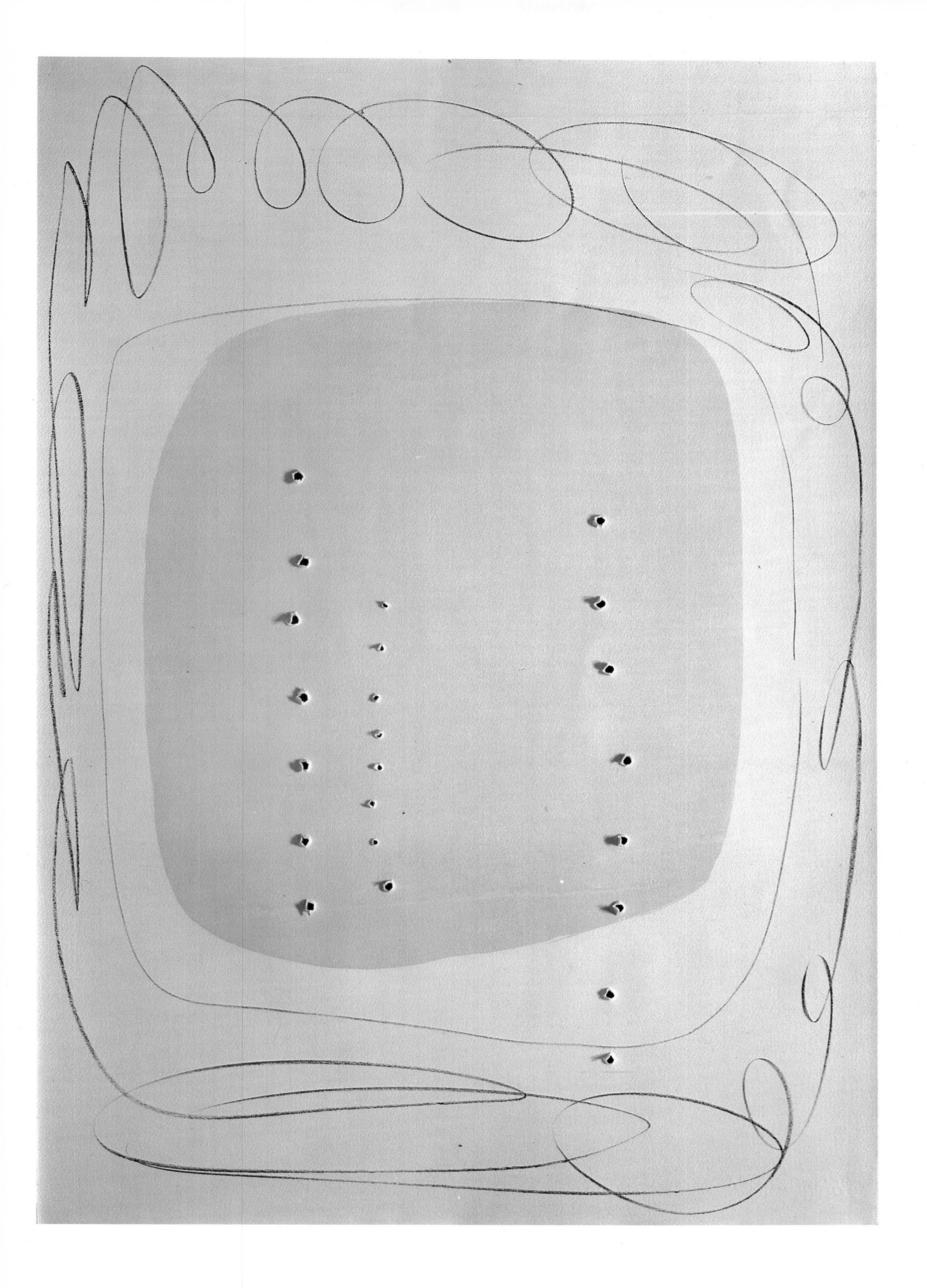

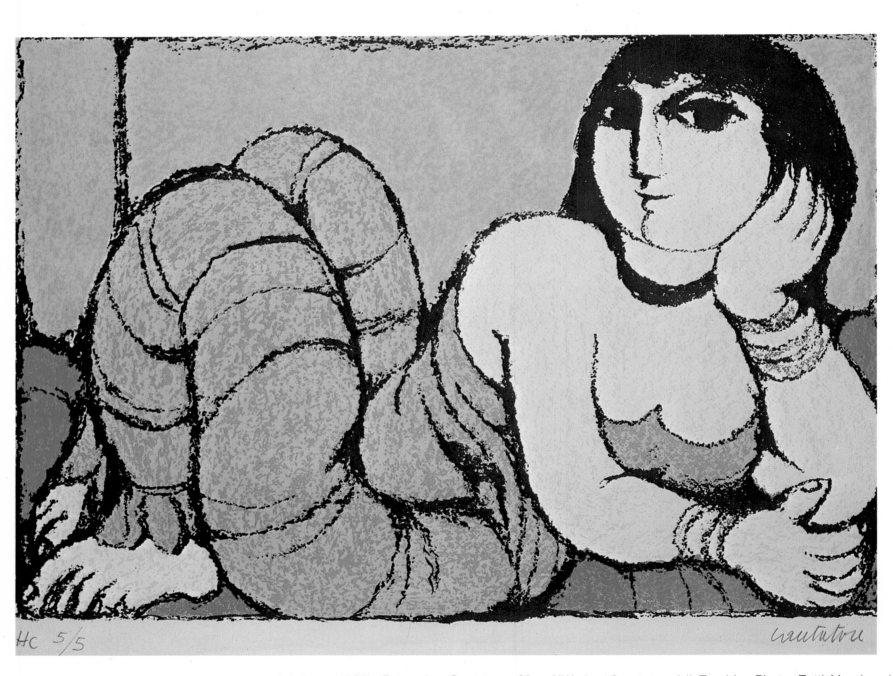

HC 5/5

Odalisca (1968); Domenico Cantatore, 20 x 27½ in. (Courtesy of Il Torchio. Photo, Tutti Marchese)

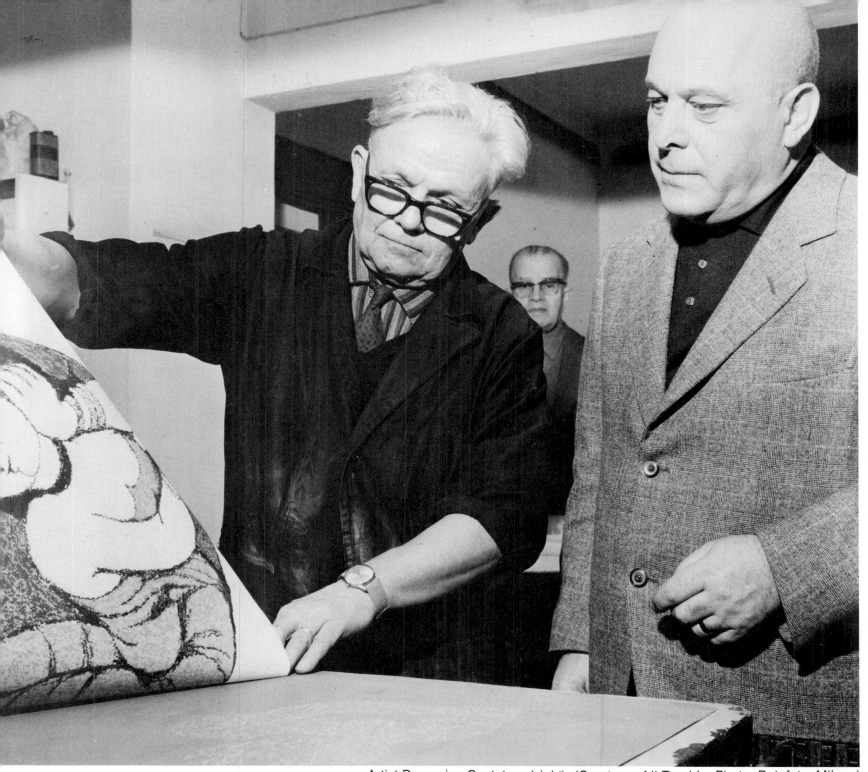

Artist Domenico Cantatore (*right*). (Courtesy of Il Torchio. Photo, Rotofoto; Milano)

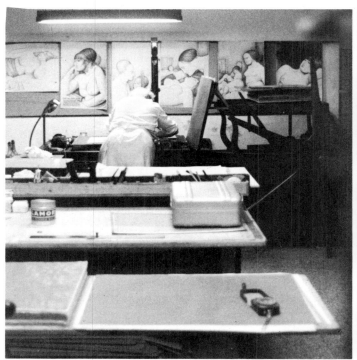

(Photo, M. Knigin)

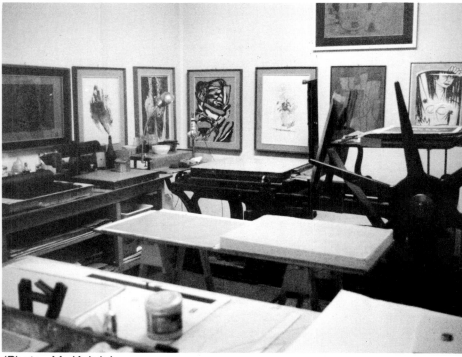

(Photo, M. Knigin)

JOAN TORRENTS

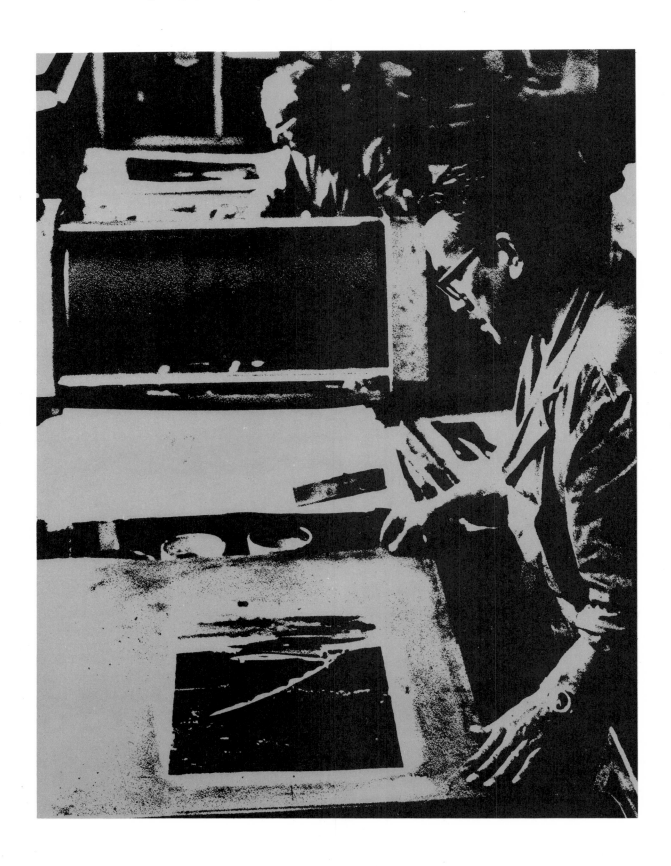

Joan Torrents *(right)*, director of Joan Torrents, with artist Norman Narotzky. (Photo, M. Knigin)

Although some artists merely follow an idea and create their lithograph in the process of producing it, the more orthodox procedure is first to make a maquette of form and color, then, using the maquette as a basis, to work on the plates, printing the colors until satisfied.

Every day lithography assumes a more important place in the life of the plastic arts. Yet it is very difficult to give a valid critical summary of the art of lithography in one's own time, for the variables of style, spirit of the proof, and personal preferences dazzle us. While the greatest painters of our time have interpreted the graphic qualities of their art through lithography, it is difficult to list all the names of those who honor it without forgetting some who have dedicated to it the best of themselves. These artists have summed up in a knowing line or a brief play of colors their essential concerns.

On the other hand, there are modest or introverted artists whose work remains temporarily unknown. I wish that these many undeniably talented artists, who disinterestedly work only for the jewel of creating a new image, would come to enrich the art of lithography and perpetuate its glorious name.

The relation that should exist between the artist and the lithographic workshop is one of mutual understanding and collaboration, with a total fusion of values. When the artist works freely and is introduced into the art of lithography, knowing the results of the workshop where he works and the techniques used, there is no problem; the moment comes when the creation of a final, printed impression is a total symbiosis, and the consequence is beneficial to the fine worth of the art.

I dedicate my attentions to the benefit of lithography, in order to promote it, perfect it, and enrich it. Despite the funereal predictions of some able men and specialists in art, lithography at this point is vital, certain of its future, and proud of its past.

Director: *Joan Torrents*

The shop was founded in 1924 by Joan Torrents' father, who was a great promoter of the graphic arts. In 1933 Joan joined the shop and began his introduction to graphic art, while at the same time taking drawing classes at the School of Fine Arts (Escuela de Bellas Artes) in Barcelona. Later, between 1950 and 1955, he took advanced courses in France and Belgium. His workshop now does all its work on zinc plates with two hand presses and one Aleuzet press.

Calle Belén, 20
Barcelona 12, Spain

The following is a partial list of the artists who have worked at Torrents: Marcos Aleu, Jim Amaral, Morató Aragonés, Arenys, Artigua, Bacqués, Barnardas, Cabané, Caraltó, Jesús Casaus, M. J. Colom, Xavier Corberó, Crespo, Curós, Salvador Dali, D'Arquer, Pla Domenech, Dubischar, Duran, Florit, Prim Fullá, Grau Garriga, Hinterreiter, Hurtuna, Icaza, Hank Laventhol, Lloveras, Ramón Llovet, Aguilar Moré, Pla Narbona, Yago Pericot, Joan Ponc, Gabriel Portolés, Sanjuan, Subirats, Alvar Suñol, Tarrassó, Tharrats, Todó, E. Torruella.

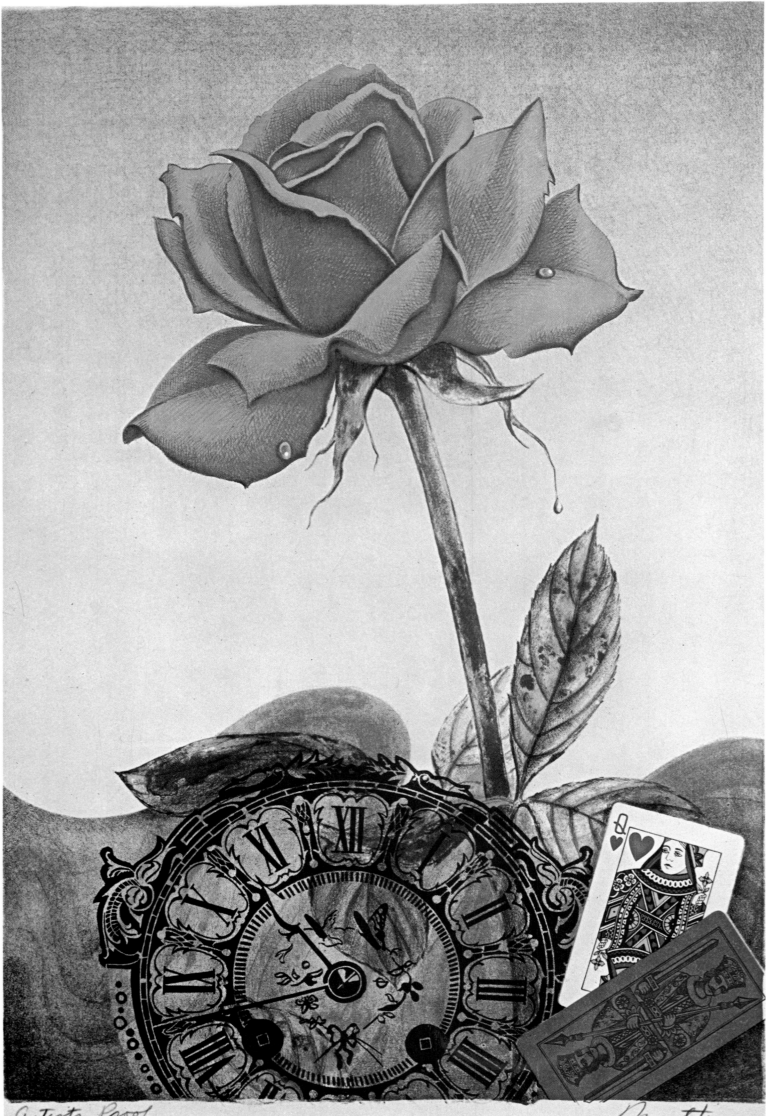

Marstey

El Juego, la Rosa y el Tiempo (1969),
Norman Narotzky, 13 x 18½.
(Courtesy of Joan Torrents)

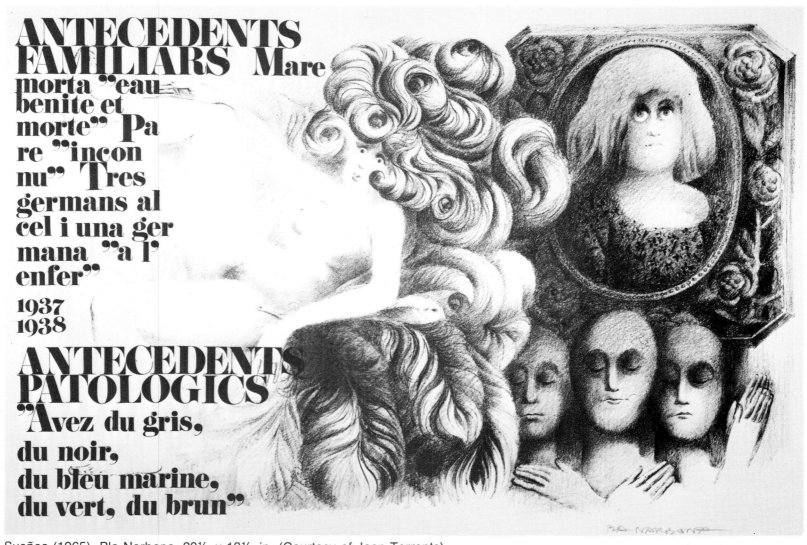

Sueños (1965), Pla Narbona, 20½ x 13½ in. (Courtesy of Joan Torrents)

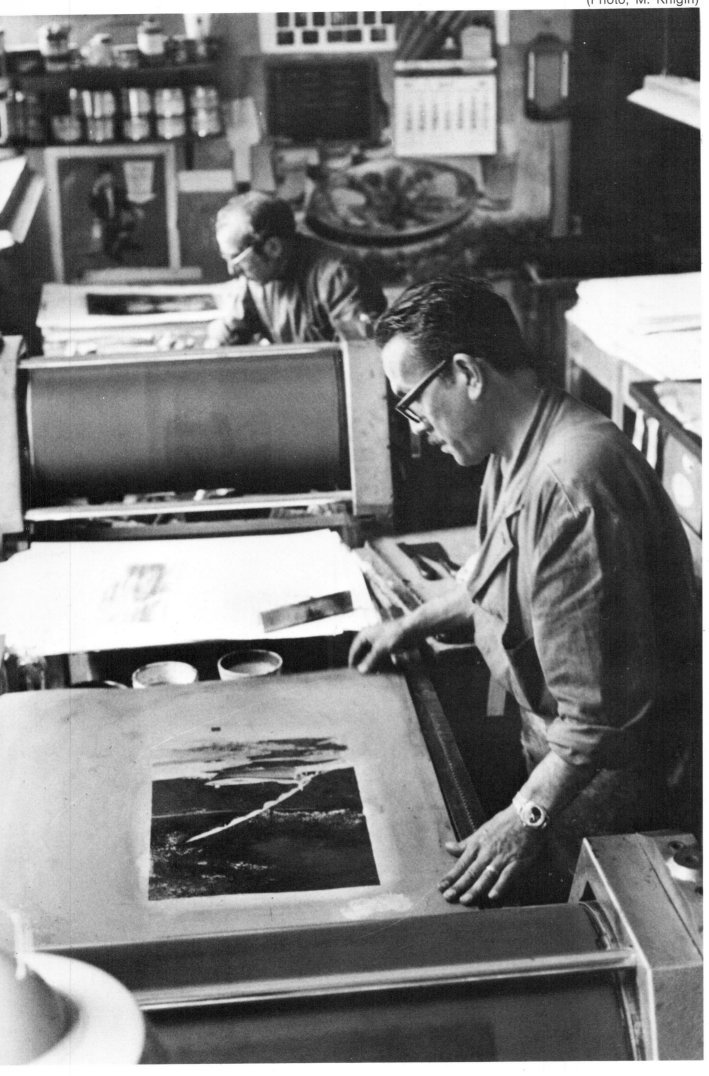

(Photo, M. Knigin)

Madona (1968), Baques, 10 x 13½ in.
(Courtesy of Joan Torrents)

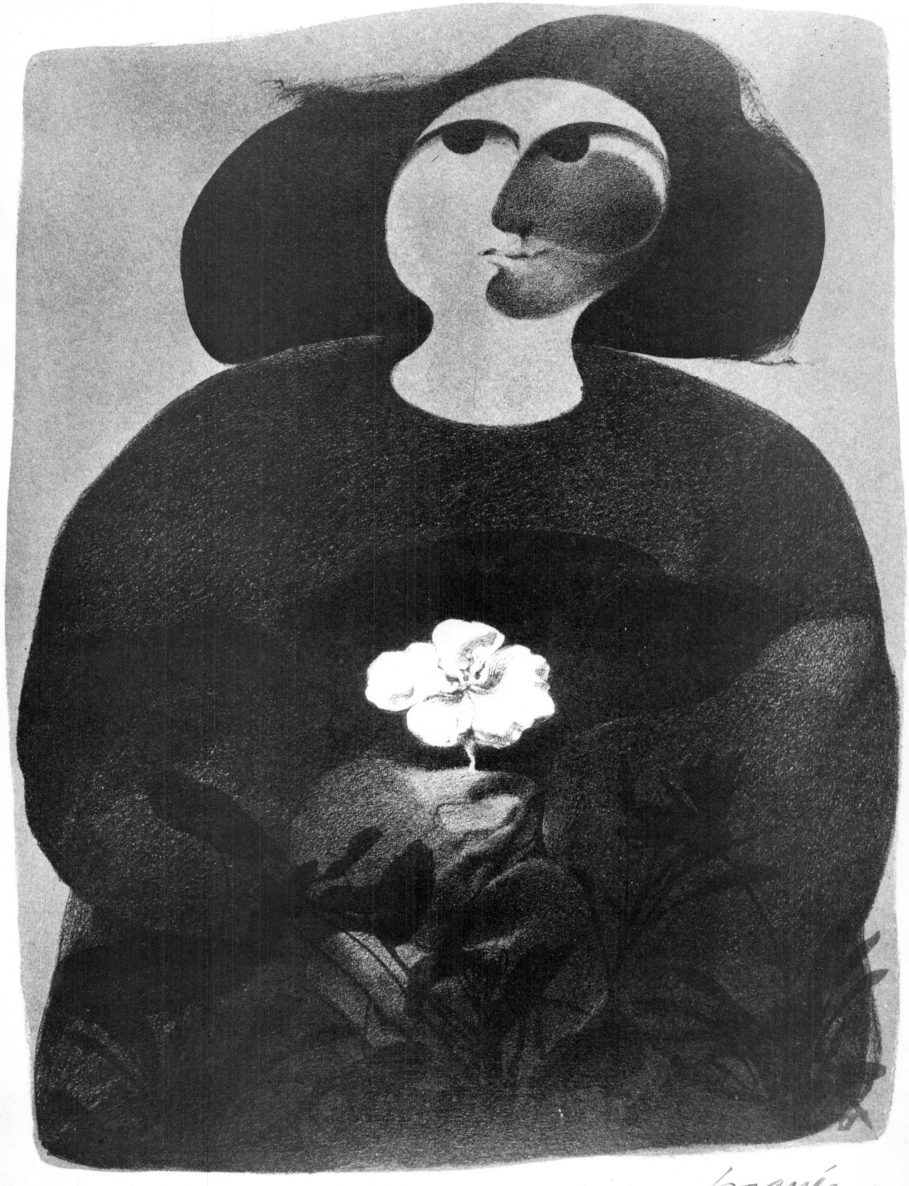

11/80 Braque

VAERKSTED FOR GRAFISK KUNST

(Courtesy of J. C. Sørensen. Photo, Ayoe)

The atelier exists to help artists create original lithographs in an atmosphere totally free from commercial pressure. The artist draws his motif partly in nature and partly in the workshop directly on the lithographic plate, and he then works together with the artisans to achieve the graphic expression. The special quality of our work, which does not employ any phototechnical methods, is due to the old craftsmanlike principles used and the practice of working directly on the plate.

I always have looked upon the graphic art as the naked art through which it has been possible for me to obtain a greater and more intense experience of an artistic personality. By my publications, I have tried to share with others this experience. It is unfortunately a fact that picture appreciation by the public is so rudely exploited by reproductions that the artistic experience is getting more and more destroyed. For me it is a matter of only one experience, the living power in things, that one clearly feels when confronted with the experience of graphic artworks.

In a recent interview with the art-historian Knud Voss, one of the best artists making lithographs in my workshop right now, Jens Nielsen, said: "It is my personal opinion that everything alive is a proclaiming reality. Life in all its colors and nuances proclaims, man proclaims, we all do it, but mostly in that moment perhaps when we do not know of it and do not want it to be known. I have tried to paint and have painted much, I have tried to draw and have drawn little, and now I am at the point where I shall draw and paint and make it a graphic artwork. Drawing is one branch of art, painting another, and lithographing a third. It is like standing on three different steps, and every time you leave one to get over on the other, you face a new experience and find completely new things, having relations to the main theme though, and so you obtain another great new joy."

Director: *J. Chr. Sørensen*

After some years in France, Sørensen began lithographic printing in Copenhagen, taking up again a forgotten tradition in Denmark. He contacted the Cobra-group, which in Denmark consisted of the painters Asger Jorn, Carl-Henning Petersen, Else Ahlfelt, Henry Heerup, Egon Mathiesen, and Egil Jacobsen, for whom he made several prints during World War II. After the war a number of French artists with relations to the Cobra-group came to Copenhagen, where they explored the graphic possibilities of both the traditional lithographic technique and the offset printing method. In 1946 the undertaking was enlarged, and until 1970 a great number of artists from all over Europe came to the workshop in Copenhagen. Among the best pupils was Peter Bramsen, who is now the head of Bramsen et Clot in Paris. In 1970 Sørensen renounced all his commercial doings and started an establishment in Hjørring dedicated exclusively to artistic activity.

Nørregade 17
9800 Hjørring, Denmark

The following is a partial list of the artists who have worked at Vaerksted: Bruno Cassinari, Jean Dewasne, Jean Deyrolle, Svend Engelund, Paul René Gauguin, Arne L. Hansen, Henry Heerup, Piet Hein, Gerhard Henning, Johannes Hofmeister, Oluf Høst, Paul Janus Ibsen, Bent Karl Jacobsen, Robert Jacobsen, Asger Jorn, Vilhelm Lundstrøm, Richard Mortensen, Rolf Ness, Jens Nielsen, Jean Piaubert, Lennart Rohde, Alf Rolfsen, Axel Salto, Allan Schmidt, Ole Schwalbe, Jens Søndergaard, Sigurd Winge, Sven Erixson X'et, Hugo Zuhr.

Venetian Glass-Works #1 (1970), Arne L. Hansen, 20 x 16 in. (Courtesy of J. C. Sørensen)

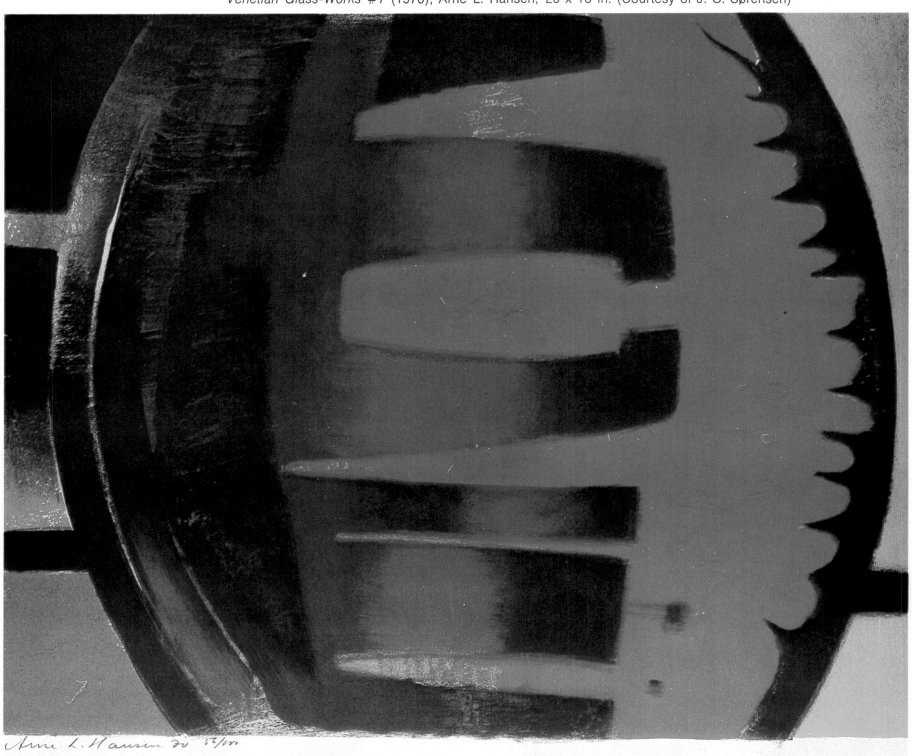

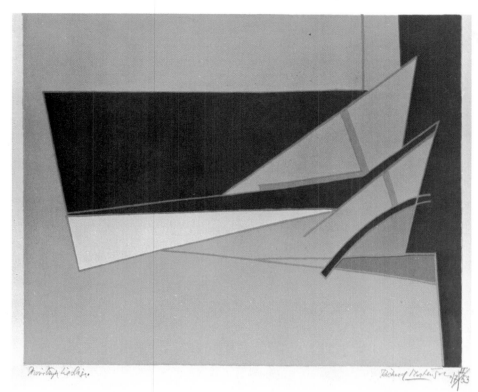

Composition (1953), Richard Mortensen,
22 x 17½ in.
(Courtesy of J. C. Sørensen)

Spanish Landscape (1956), Paul René Gauguin,
27 x 20 in. (Courtesy of J. C. Sørensen)

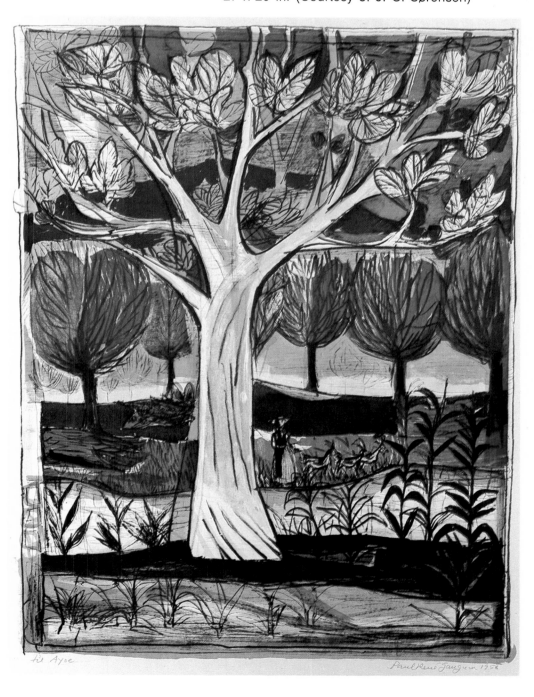

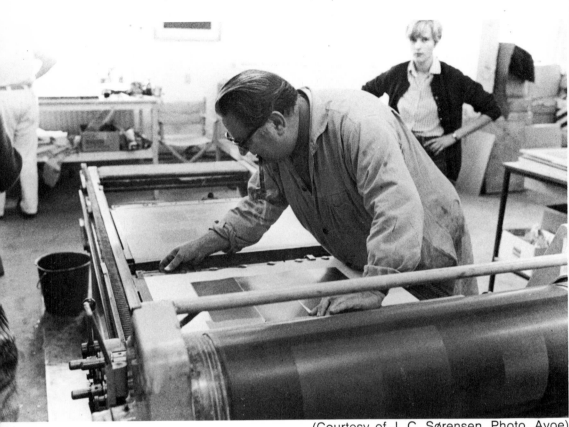

(Courtesy of J. C. Sørensen. Photo, Ayoe)

(Courtesy of J. C. Sørensen. Photo, Ayoe)

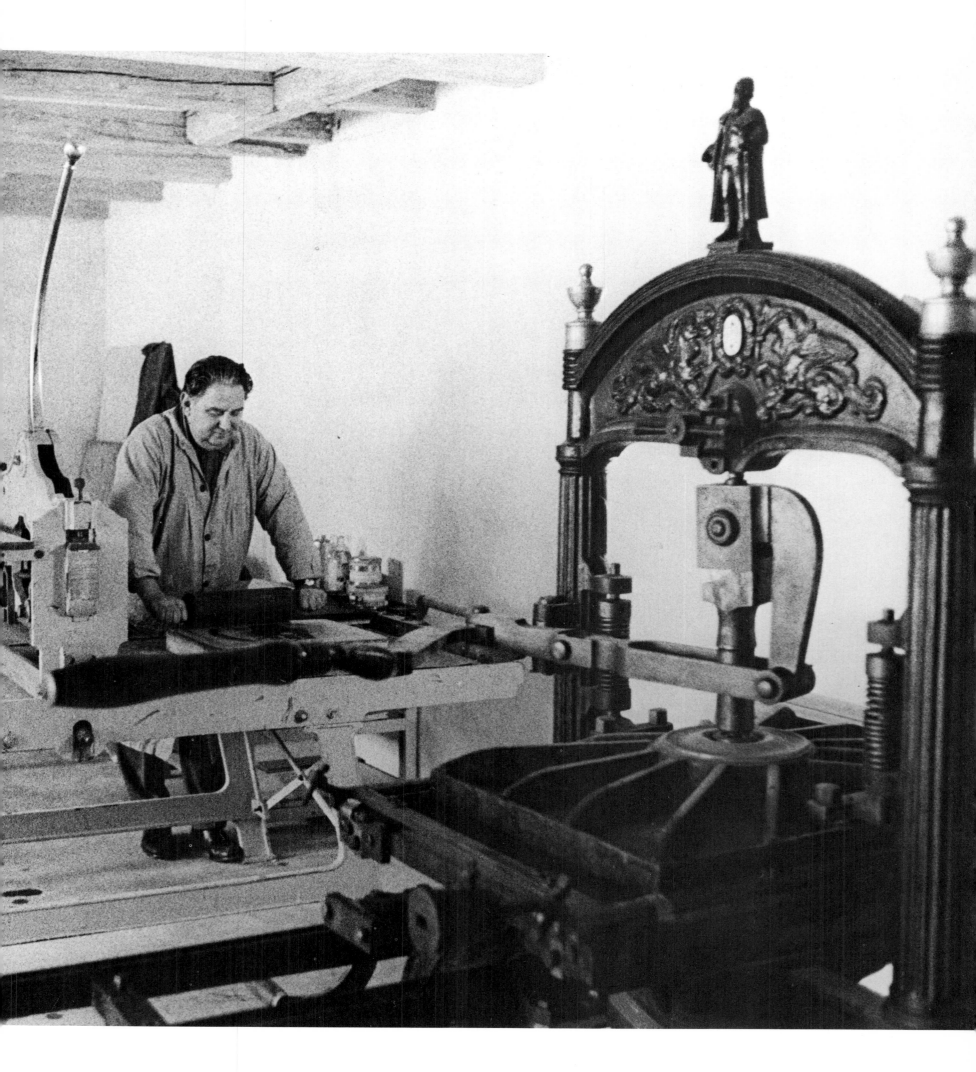

GRAPH. ANSTALT
J.E. WOLFENSBERGER AG

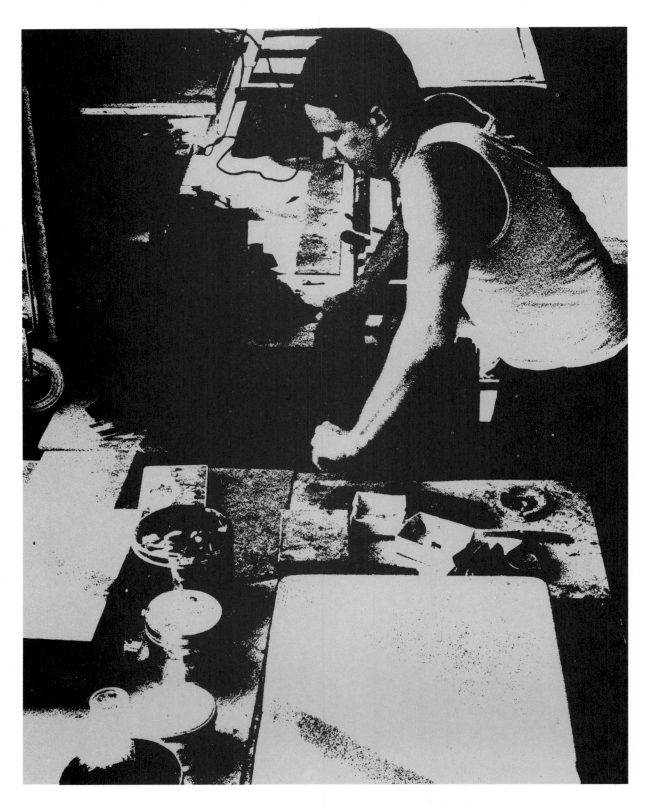

With the intention of printing good original lithographs and hand lithography, the procedure at the workshop is for the artist first to fix a date with the proofer to discuss the method of working. The artist then works directly on the stone, the proofing is done, and he remains to supervise the printing of the edition.

The atelier was founded in 1902 by J. E. Wolfensberger, the grandfather of the current director of the same name. He managed the company until his death in 1944. Printing is done on the shop's two hand presses and one automatic flat-bed press.

J. E. Wolfensberger, director of Wolfensberger AG. (Photo, M. Knigin)

Bederstrasse 109
8059 Zurich, Switzerland

The following is a partial list of the artists who have worked at Wolfensberger: Salvador Dali, Hans Erni, Oskar Kokoschka, Richard Lindner, Marino Marini, Henry Moore, Lars Norrmann, Fritz Wotruba.

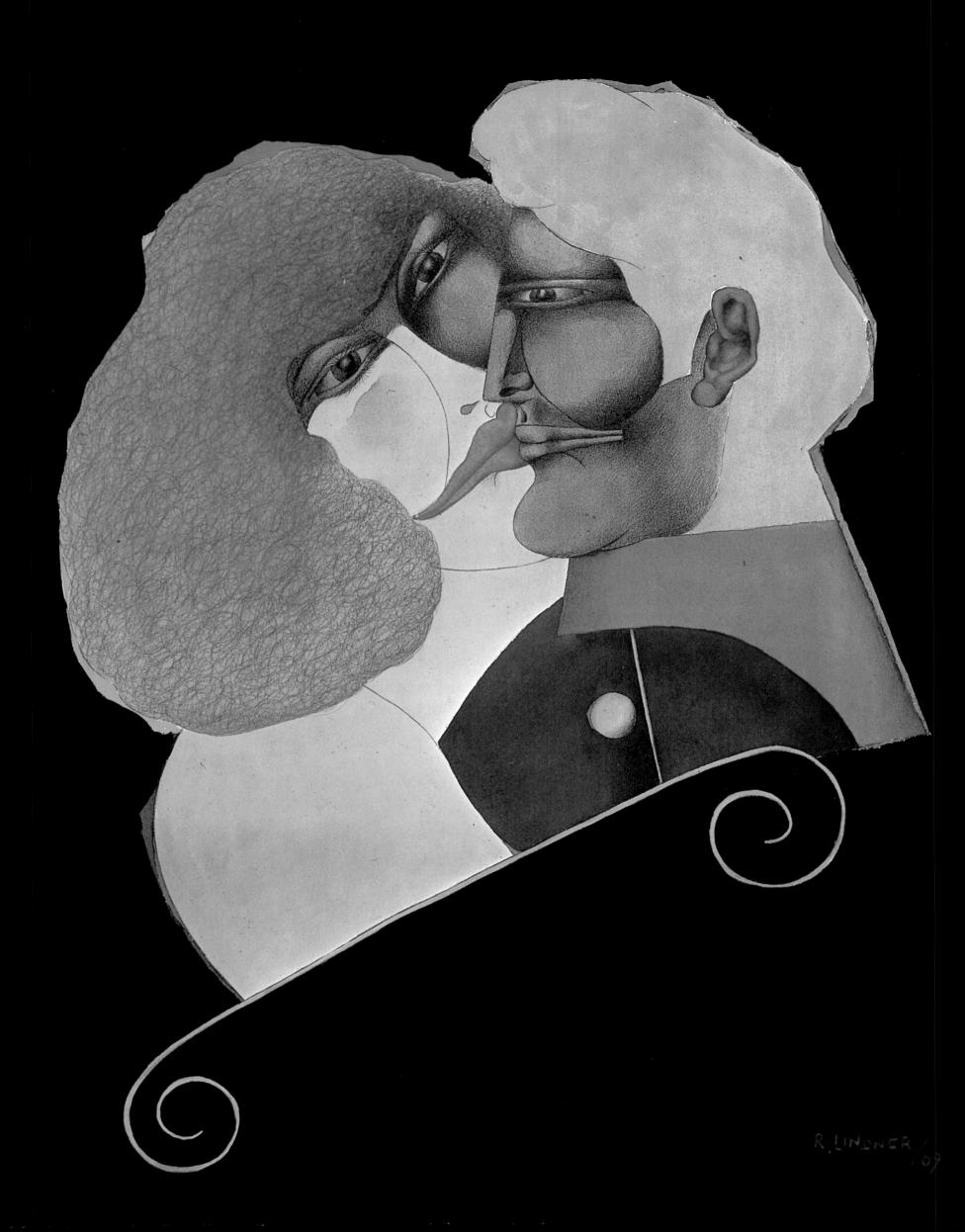

Fun City portfolio (1969),
Richard Lindner, 22 x 28 in.
(Courtesy of Wolfensberger AG)

Flowers, Oskar Kokoschka, 22 x 30 in. (Courtesy of Wolfensberger AG)

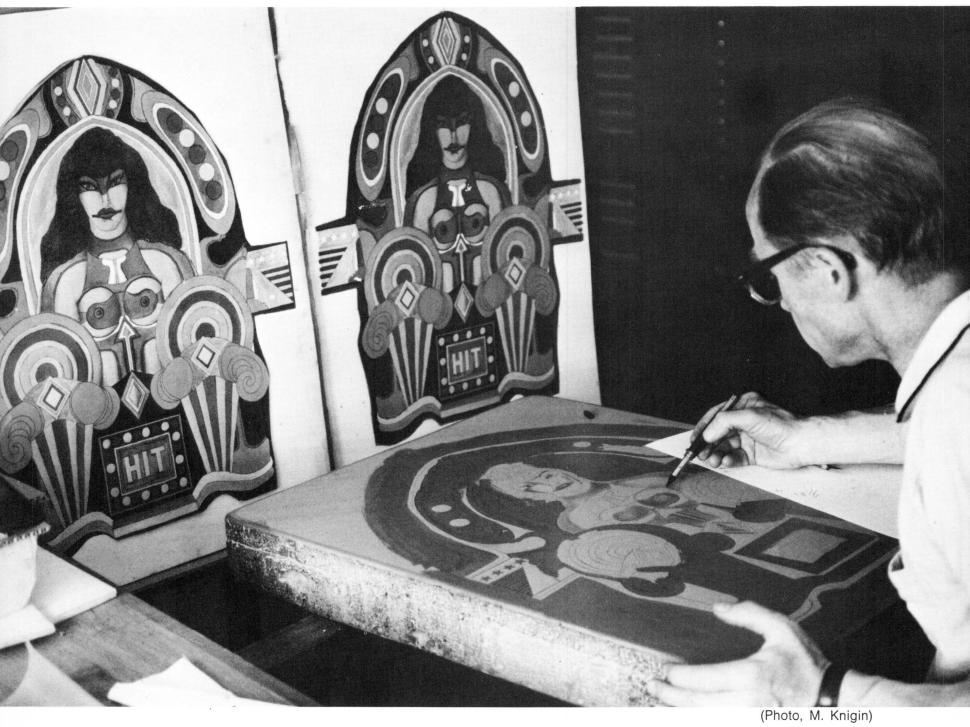

308

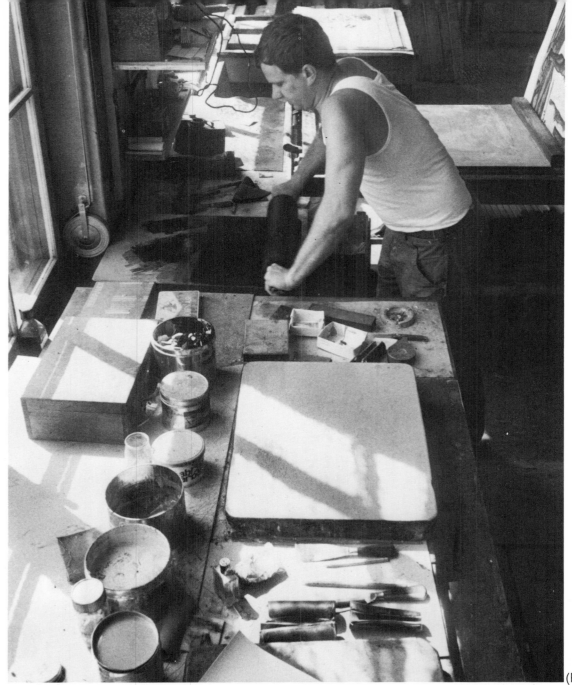

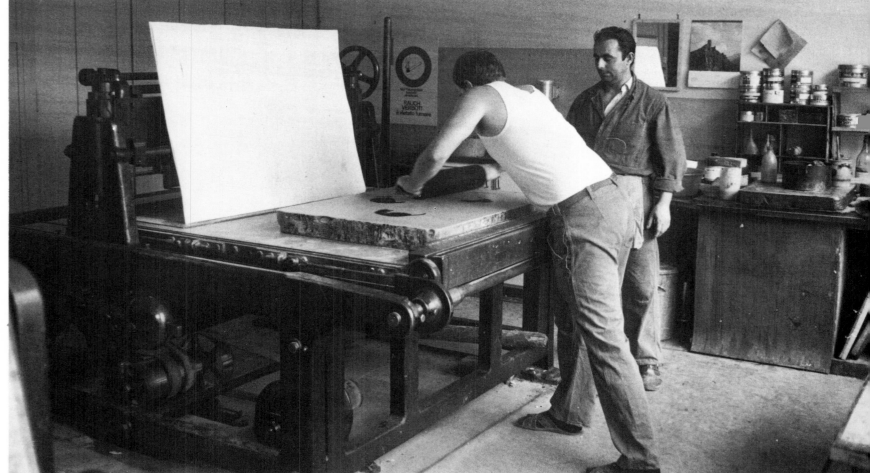

ALFREDO ZERKOWITZ

Adolfo Zerkowitz began to work on card printing in 1927. His first editions were black-and-white (bromide) post cards of art and landscape. Later production was expanded to include color and offset work, and editions were printed of all kinds of cards: Christmas greetings, art reproductions, postcards in full color, as well as other kinds of graphic arts. His son, Alfredo Zerkowitz, continuing the work his father started, is now established in a new workshop with modern installations and up-to-date lithographic systems, including three flat-bed offset presses. This modern set-up represents the atelier's departure from the old belief that only antiquated, unwieldy presses can produce good lithographs. Nevertheless, Zerkowitz does adhere to the traditional operating procedures and tested principles of workmanship. Directed by Vincente Aznar, the shop primarily prints editions for artists.

Calle Arenys 39
Barcelona 16, Spain

The following is a partial list of the artists who have worked at Zerkowitz: Marcos Aleu, Caraltó, Ramón Llovet, Norman Narotzky, Gabriel Portolés, Augusto Puig. Puigmarti, Vialhugas.

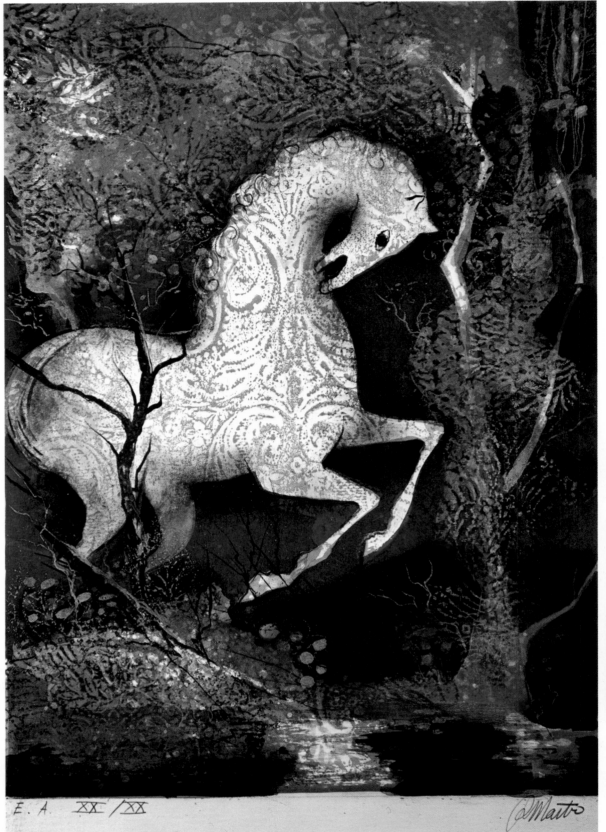

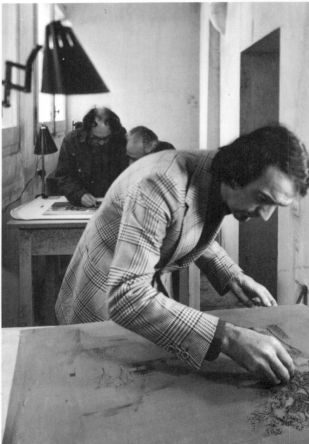

Caballo de la Selva (1971),
José Puigmarti, 15 x 20½ in.
(Courtesy of A. Zerkowitz)

Artist José Puigmarti.
(Courtesy of A. Zerkowitz)

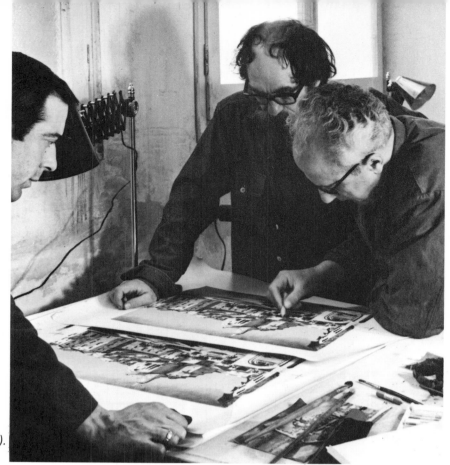

Artist Eduardo Vial Hugas *(center)*.
(Courtesy of A. Zerkowitz)

Cadaques (1971), Eduardo Vial Hugas, 15 x 20½ in. (Courtesy of A. Zerkowitz)

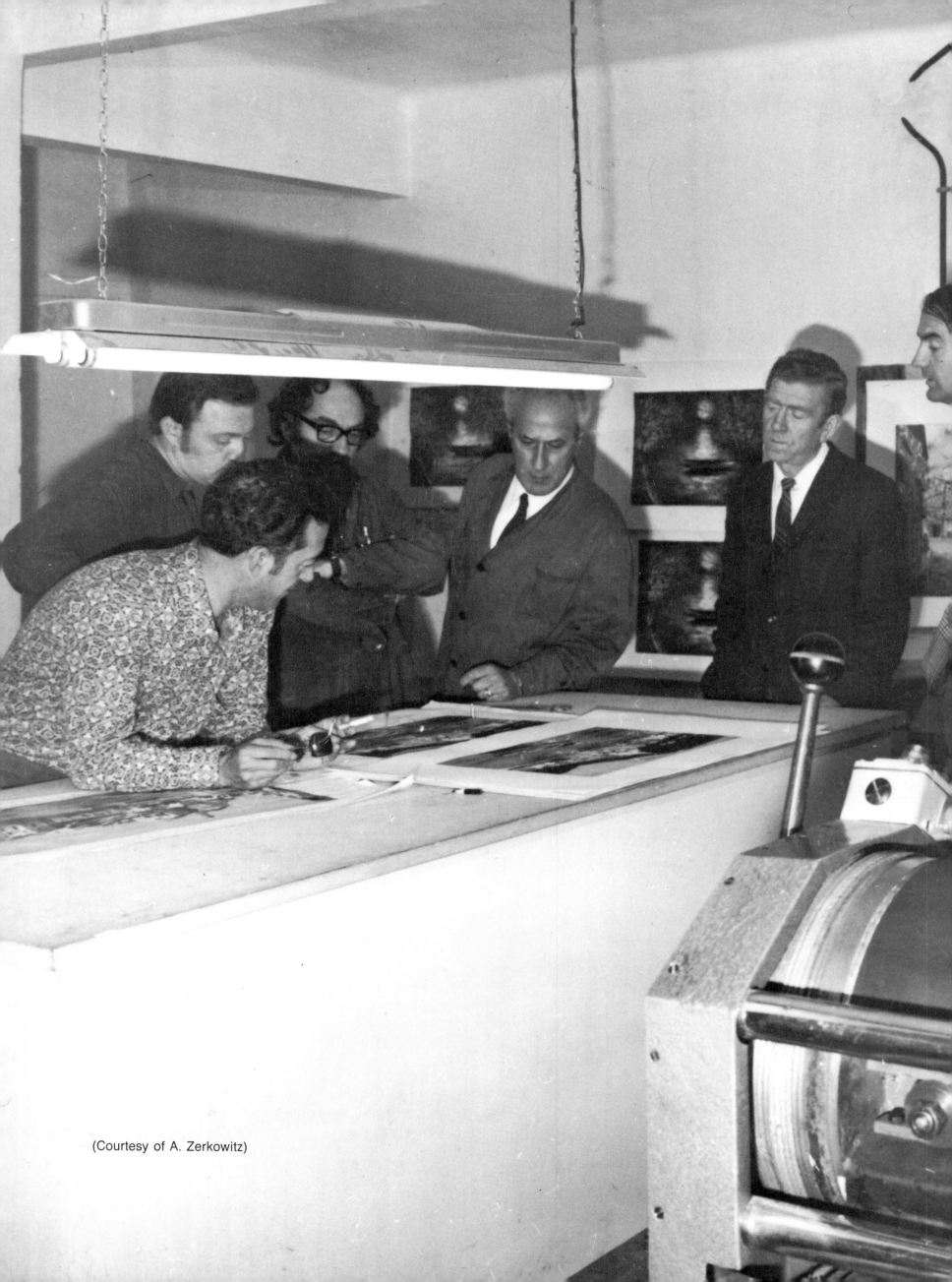